HOWARD HODGKIN PAINTINGS

HOWARD HODGKIN PAINTINGS

Michael Auping, John Elderfield, Susan Sontag
with a catalogue raisonné by Marla Price

with 353 illustrations, including 273 in duotone
and 80 in full colour

Thames and Hudson
in association with
The Modern Art Museum of Fort Worth, Texas

British Library Cataloguing-in-Publication Data

A catalogue record for this book is available from the British Library

ISBN 0-500-09256-7

Printed and bound in Singapore

CONTENTS

FOREWORD AND ACKNOWLEDGMENTS

It is a great pleasure to present the first major exhibition in ten years of the paintings of Howard Hodgkin. When the British Council mounted an exhibition of Hodgkin's work for the British Pavilion at the 1984 Venice Biennale, the critic Robert Hughes observed: "Not since ... the Biennale 20 years ago has a show by a single painter so hogged the attention of visitors or looked so effortlessly superior to everything else on view by living artists." The exhibition, which subsequently toured Europe and the eastern United States, was the last major survey of this important artist's work.

As organizer of this exhibition, it has been my privilege to work closely with the artist, and my most sincere thanks must go to him for the enthusiasm, intelligence, and generosity he has brought to this project.

This catalogue represents the most extensive study to date of Hodgkin's work, particularly with the catalogue raisonné, which is the first introduction to all of his oil paintings. I gratefully acknowledge the contributions of Michael Auping, Chief Curator at the Modern Art Museum of Fort Worth, for his overview of Hodgkin's work; John Elderfield, Chief Curator at Large at the Museum of Modern Art, New York, for an exchange with the artist; and novelist and cultural historian Susan Sontag for an essay on Hodgkin and his work.

At the Metropolitan Museum of Art, Philippe de Montebello, Director, Mahrukh Tarapor, Associate Director for Exhibitions, and William S. Lieberman, the Jacques and Natasha Gelman Chairman of the Department of Twentieth-Century Art, have been enthusiastic supporters of this project from the earliest stages. In the Department of Twentieth-Century Art, Nan Rosenthal, Consultant, and Anne L. Strauss, Research Associate, have guided the project through its phases in New York with the assistance of Kay Bearman, Administrator for the department.

In Düsseldorf, I am grateful to my colleagues Raimund Stecker and Juergen Harten for their support and partnership in the exhibition tour.

At the Modern Art Museum of Fort Worth, Michael Auping has assisted with all phases of the exhibition. Lindsay M. Joost has played a key role in assembling information, documentation and photographs, and I am grateful for her contribution to this project. The administration of loan requests and the transportation of works has been supervised by Andrea Karnes, Registrar, assisted by Christine Berry. Amy Riley, Administrative Assistant, has provided valuable help throughout the organization process. I would also like to thank Robert Bowen, Assistant to the Director for External

Affairs; Anthony Wright, Head of Design and Installation; Bill LeSueur, and James Corser, Business Manager, Susan Colegrove and Ruth Andry.

A number of individuals in London have made valuable contributions to the research for the exhibition and the catalogue raisonné. First and foremost is Peter Cochrane, former Director of Arthur Tooth and Sons Ltd, London (Hodgkin's first dealers). Mr. Cochrane allowed me access to his own records on Hodgkin at an early stage of the research for the catalogue raisonné and, in effect, made this catalogue possible. Because of his generosity, photographs of and information on Hodgkin's early works could be included, and I extend to him my deepest appreciation.

I am also grateful to Antony Peattie for his help, and to Honey Luard, who compiled the bibliography which follows the catalogue raisonné and collaborated in countless ways on this project. Special thanks are due to Nicholas Serota, Director of the Tate Gallery and also to the staff of the Tate Gallery Library; Anthony d'Offay, Jim Cohan, Robin Vousden and Harriet Laver of the Anthony d'Offay Gallery; John Kasmin; Leslie Waddington and the staff of Waddington Galleries Ltd; and Jenny L. Blyth, Curator at the Saatchi Collection. The staff of Thames and Hudson have been helpful and efficient partners at all stages in the course of preparing this publication. It has been a great pleasure to work with them.

Other friends and colleagues who have contributed to this project include Nancy M. O'Boyle, Dallas; Lawrence Rubin, Zurich; and in New York, Larry Gagosian and Andrew Fabricant of the Gagosian Gallery; Ann Freedman and Carol Corey of M. Knoedler and Co., Inc.; Diane Upright, Senior Vice President, and Laura Paulsen of Christie's; André Emmerich; Joan Washburn; and Anthony Grant, formerly Vice President of Sotheby's.

Finally, I extend my heartfelt appreciation to the lenders of this exhibition whose generosity has made this presentation possible.

A LONG VIEW

... to be an artist in England is perhaps, even certainly, special, more difficult, more traumatic and probably more fraught with the absolute certainty of failure than in any other country.[1]

Howard Hodgkin

Howard Hodgkin's statement in a lecture to students at the Slade School of Fine Art in 1981 is a matter of practical realization rather than bitterness. He is well aware that his remarks echo similar ones by Constable, Hogarth, Turner, Sickert, and Bacon. Artists have often wrestled with their need to forge a relationship between their personal identity as an artist and that of their homeland, and none more so than in England. As one British newspaper recently reported, "The British have always been deferential about their art (those that is who have a taste for it); the rest have been, if not indifferent, antagonistic."[2] This has particularly been the case in the twentieth century, when the forces of the avant-garde have pushed art into an accelerated state of continual experimentation and change. Although the situation has improved in recent years, the British have historically demonstrated a skeptical attitude toward the new, preferring to allow their past achievements in architecture, literature and theater to represent their taste. As such, collecting modern and contemporary art has had little social cachet or community interest in Britain. Hodgkin's remark was no doubt a reminder to himself, and a warning to the aspiring British artists in the audience, that his relatively recent successes, however fleeting they may be, have been hard won and a fairly long time coming. Fortunately, Hodgkin is a painter for the long haul.

In a time when artists seem to take center stage on the international art scene at the age of 25, Hodgkin has demonstrated a surprising patience with his career and the development of his imagery. He was 45 when he had his first major one-person exhibition in New York, and 52 when his exhibition at the British Pavilion of the 1984 Venice Biennale exposed his work to an international audience. Being a late bloomer, however, has its advantages. Hodgkin has always been deeply engaged in art, but he has taken his time to figure out how he might contribute to its tradition rather than futilely attempting to dismantle it (a strategy that so often afflicts younger artists). This time

1 Howard Hodgkin, The William Townsend Memorial Lecture, given at the Slade School of Fine Art, University College, London, December 15, 1981.
2 David Storey, "On the Expanding British Tradition," *Guardian*, October 17, 1981, p. 17.

element, and the maturity that has gone with it, has afforded Hodgkin a special insight into himself, as well as his Britishness. The result is a mischievous and erudite conservative, qualities that fascinate and trouble his avant-garde critics. Moreover, in an era of Wagnerian scale and architectural theatrics, his paintings are boldly condensed and intimate.

Born in London in 1932, Hodgkin, by his own estimate, "came from a fairly but not very wealthy middle-class background of the kind in which relatives help pay for your education; the picture over the mantlepiece in my parents' house was in fact a doubtful water-colour by David Cox which was a wedding present from a judge."[3] Some elaboration on this description is helpful. Hodgkin is in fact part of a well-established English family of considerable, if eclectic, talents. He has served as a trustee of the Tate Gallery and the National Gallery, London, and, with a studio in Bloomsbury near the British Museum, spends a good deal of time in museums, and is often quick to point out that understanding what is old in painting is as important as understanding what is new. At times, Hodgkin even assumes the stance of the classically trained artist of the academy, making paintings in homage to certain masters. He is in many ways a master in his own right at recycling the knowledge inherent in an understanding of a broad history of art. Yet Hodgkin accomplishes this through a series of reductions and conversions that give both his pictorial means and his emotional expression a new extremeness. His art lays bare the transformative processes between culture and self, past and present, with a radical clarity, a directness that is, if not avant-garde, at least thoroughly of its time. This kind of instinct and ability to consolidate does not come immediately, and Hodgkin has spent a good deal of his career in relative anonymity studying and experimenting to make it all look as casual and as easy as possible.

According to the artist, "my real career as a painter began by looking at pictures in New York."[4] A refugee from wartime London, Hodgkin spent three years on Long Island, occasionally commuting to Manhattan, where an expatriate European avant-garde mixed with a new generation of Americans who were forging the breakthrough images that would come to be known as abstract expressionism. Hodgkin arrived in New York in 1940—the same year as Mondrian and Léger came from Europe and Motherwell from the west coast of the United States. At eight years old, needless to say, Hodgkin was hardly a participant in this heady milieu. Living on Long Island and visiting Manhattan, it is unclear based on his few statements and interviews precisely what he would have seen and remembered. Hodgkin does remember visits to the Museum of Modern Art and the Metropolitan Museum of Art. Those familiar with Hodgkin's work have suggested a number of formative influences, as Hodgkin might have discovered them in New York. These possible inspirations range widely, including Peter Blume, Stuart Davis, Kandinsky, Miró, Picasso and Matisse.

Hodgkin returned to London in 1943, and two events between 1943 and 1949 seem to stand out in his memory. In 1945, he visited an exhibition of Picasso and Matisse at the Victoria and Albert Museum. He was particularly inspired by the paintings of Matisse, which he had apparently seen earlier at the Museum of Modern Art, New York. Of perhaps equal significance was Hodgkin's introduction to Indian painting by his art master, Welfrid Blunt. It would be several decades before these divergent influences would come together to help form the artist's mature vision.

3, 4 Hodgkin, The William Townsend Memorial Lecture.

Hodgkin's career is often simplified into two basic phases: before 1975 and from 1975 to the present. Although 1975 does seem to constitute a breakthrough year for the artist, Hodgkin's development has demonstrated a number of significant shifts of emphasis over his forty years of painting that benefit from a decade-by-decade breakdown. It can also be argued that to appreciate truly the nature of Hodgkin's ultimate accomplishments requires us to look at his early career almost as closely as his later, highly prized work, regardless of the fact that the early work is sometimes dismissed as preliminary.

A particularly telling beginning to Hodgkin's development is a small gouache on board, which the artist completed in 1949 at the age of 17. *Memoirs*, 1949, represents a memory from a summer holiday on Long Island. His hostess, sporting a huge and presumably expensive ring, lies on her sofa, as if in a psychiatrist's office. A male figure is seated near her, his eyes staring lasciviously toward the sofa. Although angular and somewhat abstract, the interior of the room is remarkably precise in its attention to furnishings and patterns, including a somewhat detailed view out of a window to what appears to be an enclosed lawn or garden. Stylistically, the painting would appear to pay tribute to the mosaic-like compositions of Stuart Davis or the British modernists Wyndham Lewis and David Bomberg. Although painted very early in Hodgkin's artistic career, *Memoirs* is remarkably prophetic in setting out the essential elements that have preoccupied Hodgkin's imagery over the past four decades. The artist's interest in puzzling together various zones of a room is initiated in this early painting. *Memoirs* also introduces the artist's continual fascination with depicting memory, and the specific events that make up the history of one's memory. The most poignant quality of *Memoirs*, however, is its representation of figures in an interior space, and more specifically his exploration of the psychology of that space. What would become apparent later in the artist's development is that he is not simply depicting a room and describing the people in it. The underlying subject of the image is the ethereal psychology of a moment of personal interaction between two people. This meeting between friends veils an almost wicked sense of voyeurism and erotic tension. Hodgkin has made us both detached and somehow a part of this strange moment, as we watch Hodgkin watch him watch her. Regardless of its technical rigidity, *Memoirs* reveals that Hodgkin's artistic yearnings—his interest in reconstructing visually the psychological conditions of one or more individuals in an enclosed space—were fairly clear to him long before he could satisfy them with his vocabulary of formal elements.

Hodgkin studied art at the Camberwell School of Art, London, and the Bath Academy of Art, Corsham, between 1949 and 1954. At the time, the Camberwell School of Art was still under the influence of the Euston Road tradition. Established in the late 1930s as a reaction to the avant-garde extremes of pure abstraction and surrealism, the Euston Road School (founded in 1937 at 316 Euston Road) centered around the teachings of William Coldstream, Graham Bell, Claude Rogers, and Victor Pasmore. The Euston Road artists advanced an almost puritanical denial of painterly abstraction or surrealist fancy, promoting a form of disciplined "realism" based on acute observation and delicate formal adjustments. Euston Road painters favored scenes of everyday London life, in much the same way as Sickert and the painters of Camden Town had, earlier in the century. Although Hodgkin has never expressed an attraction to the Euston Road philosophy, he has noted an appreciation of Pasmore's work. Pasmore's paintings of the Thames at Chiswick, where he was living in the early 1940s, acknowl-

edge Whistler and Turner in their acute sensitivity to color and atmosphere. Pasmore's art quickly evolved toward an increasingly thin line between observed realism and painterly abstraction, a sensitivity that Hodgkin would also embrace later in his career.

According to Richard Morphet, organizer of Hodgkin's first museum retrospective, the 1950s constituted "a decade of painful isolation"[5] for Hodgkin. Like so many artists, Hodgkin's early support came primarily from teaching, a career which often has the ironic effect of forcing one to think about how to make art, without allowing one the time to actually make it. He was also starting a family. In 1955, he married Julia Lane, a fellow student at the Bath Academy of Art, and thereafter had two sons. As a result, relatively few paintings were completed (or survive) prior to 1960.

The paintings that do exist, however, further reveal the dynamics of Hodgkin's vision. *114 Sinclair Road*, 1957–58, and *Interior of a Museum*, 1956–59, are significant on a number of counts. They are the first works within his œuvre to be worked on over an extended period of time. An irony that Hodgkin constantly plays on is his ability to make a painting seem almost casually rendered, while revealing its most significant details slowly. More often than not, this is the result of the artist's patient reworking and subtle adjustment of various marks. *114 Sinclair Road* depicts a group of people sitting around in a drawing room at the artist's home in West London. As with *Memoirs*, the image is an attempt to depict a personal event in the artist's memory. As viewers once removed, we are challenged to reconstruct the interaction. A female appears to be positioned on a striped sofa in odalisque fashion, while across the room, a dark, seated form with a blue head chatters away. The odalisque may be nudging a man at the end of the sofa with her feet. At the other end of the room, two vaguely defined forms are engaged in a private dialogue. The more closely one looks at the picture, the more comical and seemingly disjointed this play on human social interaction becomes. Whether Hodgkin has inserted himself into the comedy is unclear, but the effect is distinctly voyeuristic. This sly watchfulness continues in a public space in *Interior of a Museum*. "I have always been fascinated by the relation of people to things," Hodgkin has written, "and in museums would often look through the glass cases at people looking in at the objects from the other side."[6] The painting in fact represents figures seen through a glass case containing ancient Greek painted pots in the British Museum, though the artist has made it difficult to tell the difference between the faces and the ceramic forms. To the left of the case is Hodgkin's wife, Julia, and in front of it, in profile, a man with his finger in his mouth. Through Hodgkin's art we are often reminded that what catches our eye and what we remember of a given situation can be as funny as it is mysterious.

If the space and rich coloration of *114 Sinclair Road* hints at Hodgkin's growing appreciation of Vuillard, the light-filled sensuality and simplicity of *Interior of a Museum* reveals the artist's admiration of Bonnard and perhaps Morandi. At this point, however, the connection is tenuous, as both pictures are far more brut and child-like than the pedigree to which they refer. *114 Sinclair Road* and *Interior of a Museum* are flat and painterly, allowing figures and forms to be as radically malleable as paint itself. The

5 Richard Morphet, "Introduction," in *Howard Hodgkin: Forty-five Paintings, 1949 to 1975* (London: Arts Council; Oxford: Museum of Modern Art, 1976), p. 8.
6 Hodgkin quoted in *The Tate Gallery 1976–78: Illustrated Catalogue of Acquisitions* (London: Tate Gallery Publications, 1978), p. 96.

effect is that of something primitive created with utmost consideration and control. By the late 1950s, Francis Bacon's grandly tortured human forms had become icons of postwar angst. If Bacon can be thought of as the Picasso of British painting during the 1950s, Hodgkin for that time might be seen as the Rousseau. Picasso remarked that Rousseau's "psychological portraits" represented "the perfection of a certain order of thought."[7] This is not to suggest that Hodgkin's early works necessarily look like Rousseau's or that he approached painting with the same child-like innocence as the French painter, but rather that the parallel is one based on the complex terms—particularly when used in relation to painting—of simplicity and purity. As in Rousseau's great masterpieces, there is a disarming directness in Hodgkin's work of this period that turns the corner from humor to something more questioning and mysterious.

Dancing, 1959 (p. 33), given its date, stands as one of Hodgkin's brashest paintings and clearly predicts the artist's interest in reconciling figure and abstraction during the 1960s. Consisting of a background of alternating green and black stripes, with a cartoon-like female figure carrying big hair and whirling her brush-stroke arms and legs like an anatomically incorrect doll, it is as dumbly funny as it is artistically smart. Although isolated by choice and circumstance during the 1950s, by the end of the decade Hodgkin was intuitively sensing the aesthetic shifts that would mark the 1960s. The bands of alternating color running from top to bottom bear an ironic relation to Frank Stella's concurrent black paintings, though Hodgkin was apparently unaware of Stella's work at that time.[8] In its own intimate way, *Dancing* reflects some of the flat-footed power and compositional design integrity of Stella's early designs. The web-like headdress of the female figure and the striped dress may also be the first appearance in Hodgkin's work of patterns within patterns, a characteristic that would be common in all of the artist's later work. *Dancing* is typical of his decision early on to work with a mixed formal language that included geometry, gesture and figuration, demonstrating an intention to exploit abstraction and graphic figuration without ever completely yielding to either pole.

Hodgkin began exhibiting his work in the early 1960s—primarily portraits, domestic interiors and gardens. Although his titles would later become increasingly mysterious and elusive, these early designations are relatively straightforward in terms of people and events. Along with images of his wife, Hodgkin's portraits have come to constitute a kind of family album of the British art world at the time. The recognizability of Hodgkin's subjects, however, is often more a function of titling than appearance: he does not allow illustration to interfere with the making of a painting. Memory and metaphor are his preferred terrain. The subject is a catalyst for imagery, but how that image is brought forth is usually a surprise, even to the artist. Hodgkin has remarked, "Figurative painting is about a specific experience involving the figure. The most complete expression of such a subject would not necessarily involve description. Nor would it require the use of one kind of language rather than another. ... The difference between abstract painting and figurative painting need not be a physical one."[9] In many of Hodgkin's depictions it is not always readily apparent what is being depicted, even to

7 Roger Shattuck, *The Banquet Years: The Origins of the Avant Garde in France, 1885 to World War I*, rev. ed. (New York: Vintage Books, 1968), pp. 66–67.

8 Morphet, "Introduction," in *Howard Hodgkin: Forty-five Paintings, 1949 to 1975*, p. 10.

9 Hodgkin quoted in Jasia Reichardt, ed., "On Figuration and the Narrative in Art: Statements by Howard Hodgkin, Patrick Hughes, Patrick Procktor, and Norman Toynton," *Studio International*, September 1966, p. 140.

those who are part of the depiction. A tribute to the cunning of Hodgkin's visual metaphors, however, is that some of his most oblique representations are sometimes instantly recognized by the sitters and their friends. As one of his subjects said recently, "I knew fairly quickly which gestures represented me although I don't think anyone else would necessarily see it."[10]

It has been said that, "The future of realism in the arts of the twentieth century may lie in the ease with which it can sustain the carefully timed commentary of humor."[11] Although it is seldom remarked on, Hodgkin is a master of the visual pun. In much of Hodgkin's work, and particularly that of the 1960s, it is difficult to suppress a smile at his humorous take on the act of perception. The result of Hodgkin's blurring of the boundaries between figuration and abstraction during this period is somewhere between the satiric and the visionary. The 1960s portraits are at once spontaneously sensual and lighthearted in their execution. This is not simply expressionist rawness, but a curious mix of fantasy and materiality. The vibrant, abstracted caricatures of the British painter Robyn Denny and his wife, Anna, bob like finger puppets in a sea of blue and white patterning that is somewhere between crude geometry and over-organized gesture. The image is an ironic commentary on Denny's paintings and the pop-celebrity milieu of which he and his wife were a part.

Many of Hodgkin's images do not focus on a specific individual or couple, but rather on an event or social activity. *Dinner at West Hill*, 1963–66, commemorates a dinner party given by the painter Bernard Cohen and his wife Jeanie in 1964, which Hodgkin describes as "a nervous and glittering evening in a green and white room full of small B. Cohens on the wall."[12] In order to reconstruct the visual texture of the moment, Hodgkin has mixed his own invented marks and coded patterns with ambiguous scribblings reminiscent of Cohen's paintings. In *Large Staff Room*, 1964–69, the depiction of specific individuals or even general figures has essentially been eliminated. What remains—a large table and a knee—were apparently the remembered details of that event. Similarly, *Small Japanese Screen*, 1962–63 (p. 35), is reduced to a rectangle of overlaid patterns of black and red spots. Eye and head forms float in the lower right-hand section of the picture, and the brushy suggestion of a green figure stares off to the left. The late writer Bruce Chatwin, who is represented in *Small Japanese Screen*, recalls a dinner he made in 1962 for Mr. and Mrs. Hodgkin and Mr. and Mrs. Cary Welch, and remarks on Hodgkin's peculiar way of condensing his representation of the event into painterly symbols:

I had recently come back from a desert journey in the Sudan and the sitting room had a monochromatic desert-like atmosphere and contained only two works of art—the arse of an archaic Greek marble kouros, and an early 17th-century Japanese screen. One evening, the Hodgkins and the Welches came to dinner, and I remember Howard shambling round the room, fixing it in his memory with the stare I came to know so well.

The result of that dinner was a painting called *The Japanese Screen* (*sic*) in which the screen itself appears as a rectangle of pointillist dots; the Welches as a pair of gun-

10 Taken from a telephone conversation between the author and Keith and Kathy Sachs, February 23, 1995.
11 Shattuck, *The Banquet Years: The Origins of the Avant Garde in France, 1885 to World War I*, p. 33.
12 Simon Wilson, *Tate Gallery: An Illustrated Companion* (London: Tate Gallery Publications, 1990), p. 223.

turrets, while I am the acid green smear on the left, turning away in disgust, away from my guests, away from my possessions ... and possibly back to the Sahara.[13]

It was also in the 1960s that Hodgkin investigated the intimacy of certain spaces or states of mind. *Bedroom*, 1960–61, *Undressing*, 1962, *Girl in Bed*, 1965, and *Mrs. Nicholas Munro*, 1966–69, allude verbally and pictorially to what one would normally think of as private rooms or private moments. In some cases it is a mysteriously undefined image of reverie (*Undressing* is a view out of the artist's bedroom window at 12 Addison Gardens); in others, it is a public/private moment in a bedroom (*Bedroom* depicts the artist, his wife and a friend in a hotel bedroom in Paris); or a moment of theatrical intimacy (*Mrs. Nicholas Munro* "commemorates," according to Hodgkin, "a moment in March, 1966, when Cherry stripped after lunch in the living room of their cottage in order to put on a 1938 crepe de chine dress"[14]). Even in these early pictures, we intuitively understand that Hodgkin came to rely on memory for the simple reason that he is not necessarily painting things but sensations; an accumulation of emotions that somehow reconstruct an event or environment for the artist. According to Hodgkin:

> As far as the subjects of my pictures go, they are about one moment of time involving particular people in relationship to each other and also to me. After that moment has occurred all the problems are pictorial. My pictures have become more elaborate because I want them to contain more of the subject, but for me the paramount difficulty is to make the picture into as finite and solid an object as possible in physical terms and to include nothing irrelevant or confusing. Ideally they should be like memorials.[15]

The art world's assessment of Hodgkin's paintings in the 1960s was that he was an "outsider," even within the somewhat eccentric confines of British painting. Certainly the artist's rubbery, child-like and often unstylish depictions gave some credence to the designation. Nonetheless, it seems inconceivable that his embrace of his subject matter could have occurred entirely independently or that his work did not feed a changing philosophy within contemporary painting. It is reasonable to assume that pop art, for instance, had a significant effect not only on the artist's daring use of color, but also by the freedom it offered, giving emphasis to subject matter. Pop had broken the stranglehold that pure, formalist abstraction held over the art world, and it would take many different types of artists over a number of years to explore the potential for reinventing subject matter for painting. A number of Hodgkin's paintings also flirt with the decorative banality and painterly caricature of early pop painting, though Hodgkin's imagery seems more quirky and personal than pop's early images of advertisements, pop stars and cartoon characters. Moreover, as opposed to pop's cool, somewhat cynical approach to content, Hodgkin gradually embraced an art that was increasingly romantic and even overheated in regard to its subjects.

13 Bruce Chatwin, "A Portrait of the Artist," in *Howard Hodgkin: Indian Leaves* (London and New York: Petersburg Press, 1982), p. 13.
14 Hodgkin quoted in *Tate Gallery Report—Acquisitions 1968–70* (London: Tate Gallery Publications, 1970), p. 89.
15 Hodgkin quoted in John Russell, "Hodgkin Color Locals," *ARTnews* 66, May 1967, p. 62.

Hodgkin's images are not so much a send up or critique of modern domesticity, but an attempt to sum up the feelings and psychology of a home or social gathering. While pop exploits the appearance of modern life, Hodgkin digs into the feeling of a place. He has said that he may be "a representational painter, but not a painter of appearances. I paint representational pictures of emotional situations."[16] While pop and color field grew in size throughout the decade, the size of Hodgkin's works seem to implode toward an imagery that was defiantly intimate and compressed. Typically, Hodgkin presents not simply a room, but a contained emotion.

It was during the 1960s that Hodgkin made his first trip to India. Having admired Indian art since he was a teenager, Hodgkin would eventually become a passionate collector of Indian paintings and drawings. Various memories of his trips to India would also be the subject of numerous subsequent paintings. His study of Indian painting, particularly its bold coloration, intimate size and qualities of patterned illusion, would later be noted as an important influence on his paintings during the 1970s and 1980s. While the comparison is compelling, the relationship between Hodgkin's art and the Indian painting he collects is a complex one. In fact, there are enough differences to suggest that Hodgkin's paintings are as much an act of rebellion as sympathy. As Chatwin poignantly reflects:

> I have sometimes thought that Howard's pictures are a declaration of war against his Indian ones. He is obscure where they are explicit. He is mute where they tell a story. He fudges where they are finicky. His colours are deliberately jarring where theirs seek to soothe. Perhaps it's a case of renouncing the thing you love?[17]

At the same time, it seems incorrect to think of the artist's relationship to Indian painting as completely reactionary. The connection is not so much evident as a list of specific traits, but as an elusive effect that is stubbornly visual and cantankerously non-verbal. It is a horrible cliché to refer to it as a "type of space," though that is what seems to be reflected. Although "intimate" has been the operative word in describing Hodgkin's paintings, compression and color density are perhaps more accurate. The space in these pictures is, in fact, quite expansive, opening up within the frame through scale rather than size. These characteristics, of course, are not limited to Indian painting, and Hodgkin is far too eclectic in his interests to take his cues from a single source. Along with the influence of Indian painting, for instance, it would be difficult to minimize the effect on Hodgkin's work of the artist's appreciation of Vuillard, Matisse, cubism and, in a more latent way, abstract expressionism.

Every artist has a period during which they need to scrutinize and practice a physical manipulation of what their mind intuitively tells them to do. For Hodgkin, this period is roughly coincident with the 1960s. It was throughout this decade that the artist explored the basic techniques that would later be amplified, simplified and boldly extended: the use of patterning to establish pictorial environments; color to evoke mood; and surface to remind the viewer of the primacy of the painted object. It was in the 1970s, however, that all these elements would come together in a profound way.

16 Hodgkin quoted in Andrew Graham-Dixon, *Howard Hodgkin* (London: Thames and Hudson Ltd; New York: Harry N. Abrams, Inc., 1994), p. 7.
17 Chatwin, "A Portrait of the Artist," in *Howard Hodgkin: Indian Leaves*, p. 11.

Like many of his works of the 1960s, Hodgkin's images of the early 1970s have a relatively tight, geometric construction, with an image that involves either a relatively shallow illusionistic space or a space that is somewhat impeded. Matisse's use of windows to create a subtle layering of space and a sense of scenes within scenes is employed in a variety of ways by Hodgkin during the 1970s. *R.B.K.*, 1969–70, a portrait of the painter R. B. Kitaj, consists of a field of green diagonal stripes which diffuse our view through a window into a small, compact space. Within the space, a seated figure appears to be looking toward another rectangular space, which could be another window or a painting with a large heart floating in the distance. *R.B.K.* is one of the first works where Hodgkin painted in a border to help emphasize this window-like perspective. It may also mark the artist's first move from a canvas surface to wood. Wood appeals to Hodgkin because of the number of layers that he uses to build up his images. Wood retains its rigidity, its ability to hold up under the artist's constant revisions. His wood panels, which are often old pastry boards or table tops he has found, also emphasize the fact that what he is making is a painted object. It is as if Hodgkin wants to challenge the subtle illusions he creates to see if they can withstand or coexist with the impenetrable surface and weight of the object.

Hodgkin's approach to color from his early years has always had a Matissean quality; not so much in the character of particular colors—Hodgkin's colors were often harder and more intense, sometimes applied straight from the tube without mixing—but in his reliance on color to carry the emotional content of the work. By the mid-1970s, however, Hodgkin seems to have paid greater homage to Vuillard. *Intimisme* is the term often employed to describe the subtle moods evoked by Vuillard's best-known depictions of middle-class Parisian life. Gentle domestic scenes, which depict friends and family caught in moments of reflection in homey interiors, are brought to life through the soothing and illusionistic magic of Vuillard's subtle tonal variations and attention to patterning and light, so typical of his work after 1900. However, Hodgkin—who has described himself as "a fanatical admirer of Vuillard,"[18]—is less interested in the Vuillard who has been popularized in art history books and museum posters than in the lesser known and more radical work of Vuillard's early years; the Vuillard of the 1890s. It is in this period of Vuillard's art that the boundary between representation and abstraction—or what one of Vuillard's favorite critics called "unforeseen ... reality"[19] is intriguingly blurred. Rather than presenting a subject that is acutely modeled and absolutely apparent, Vuillard's early imagery looks as though it is in a constant process of formation. As Andrew Ritchie pointed out in his catalogue for a Vuillard retrospective at the Museum of Modern Art, "The secret charm of so many of Vuillard's small panels of the 1990s is the result of his never quite 'naming' an object, as Mallarmé puts it. He 'suggests' it, he 'evokes' it, by knitting it into an amazingly complex tapestry. And by a process of telescoping planes in a picture ... the foreground, middleground and background overlap and fuse into a pulsating space that bears a kind of relation to the fusion of imagery in a poem by Mallarmé."[20] Under Mallarmé's inspiration, Vuillard's introspective exploration of an intimate, interior reality is now seen as a significant contribution to the symbolist movement of the 1890s.

18 Hodgkin quoted in David Sylvester, "Howard Hodgkin Interviewed by David Sylvester," in *Howard Hodgkin: Forty Paintings: 1973–84* (London: Whitechapel Art Gallery, 1984), p. 100.
19 Andrew Carnduff Ritchie, *Edouard Vuillard* (New York: The Museum of Modern Art, 1954), p. 13.
20 Ibid, p. 16.

Like Vuillard, Hodgkin derives his subject matter from the environments, encounters and activities that make up his daily life. Often set in sitting rooms, bedrooms, bathrooms, kitchens, hotels, museums, gardens and parks, Hodgkin's combined memory of the environments, social interactions and artifacts in these settings allows him to recast the psychological and visual energy of a particular moment. What we see in a comparison of Hodgkin and early Vuillard is the glimpse of an affinity or sensibility that carries with it a flexibility in the definition of "representation," a flexibility that Hodgkin takes full advantage of. Hodgkin's vocabulary, having absorbed a century of fragmentation and abstraction, transforms Vuillard's interiors and landscapes into something more dream-like and condensed. Hodgkin speaks of portraying the "evasiveness of reality"[21]; a "realism which depends also a lot on illusionism"[22] and that is "evanescent, frail and difficult to establish."[23] It is not so much a fantasy of what is remembered as much as the extraordinary reality of how we actually perceive a given situation as a series of fragmented glimpses. Hodgkin's marks and gestures have the tactile and animated quality of Vuillard's carefully orchestrated strokes, but they are magnified and thickened, creating an even greater tension between illusionistic space and surface materiality. One's initial impression of Hodgkin's images is that there is something there waiting to be recognized.

Hodgkin's interest in Vuillard relates to the size of his pictures and the type of pictorial space he addresses in the 1970s. Hodgkin has always been more interested in scale than in size and, in this respect, he runs against the grain of so many of his contemporary colleagues. While contemporary painting has evolved into the condition of the mural, Hodgkin has often painted small pictures. He concentrates our focus and in so doing presents himself with a number of challenges. It is, after all, one thing to indicate the space of a room when you are virtually painting on an architectural scale, but it is quite another to evoke those sensations on the surface area of 24 inches.

What also becomes evident in Hodgkin's work of the 1970s is the artist's interest in creating zones of space which direct the viewer's eye through the picture and a potential narrative. When asked what he thinks about while working on a painting, Hodgkin responded, "I'm thinking about making illusionistic spaces."[24] Utilizing color to suggest depth and then rich textured surfaces to create a counterpoint, Hodgkin's space is complex and variable. "I should like," Hodgkin has said, "painting that is very illusionistic, very deceptive in its rendering of nearness and distance."[25] That Hodgkin is successful in this deception is evidenced by the fact that we are never quite sure where we stand pictorially in a Hodgkin painting. *Interior 9AG*, 1972 (p. 42), also consists of a window-like border bisected vertically in the center by red, yellow and black stripes reminiscent of Barnett Newman's planar divisions. To the right and left of these stripes, however, are various patterns and spaces, as if one is walking down a hallway looking simultaneously out of a window and into an apartment or room. On the left-hand side of the image, in a green enclosure which is inside another space, we are greeted by a banana-like paint stroke with pompom hair and small, spindly legs. In many of these works, certain patterns and oblique lines strategically help suggest a space, while others defeat it, keeping

21, 22, 23 Sylvester, "Howard Hodgkin Interviewed by David Sylvester," in *Howard Hodgkin: Forty Paintings: 1973–84*, p. 97.
24 Ibid, p. 101.
25 Hodgkin quoted in Lawrence Gowing, "Howard Hodgkin" in *Howard Hodgkin* (New York: M. Knoedler and Co., Inc., 1981), n.p.

our eyes on the surface of the painting. Such is the paradox within which Hodgkin's images often operate.

If some of Hodgkin's images seem hermetic, encapsulating a meaning known only to the artist, it may be because we look too eagerly for signs of the recognizable rather than allowing the color and form to effect us gradually. It is not as though Hodgkin is attempting to hide things from his audience. It is more accurate to say that he synthesizes description and metaphor in such a way that one does not necessarily "recognize" an emotion or scene as one senses it, the way we sense a coming wind without knowing exactly what direction it's coming from until we have tuned our senses into it more completely. It is this process of seeing that is clearly an important aspect of the content of Hodgkin's work. Having said this, more than a few of the artist's works seem instantly recognizable and profoundly universal in content. *Bombay Sunset*, 1972–73 (p. 44), is one of the artist's most accessible and romantic images. Here, Hodgkin's abstract language turns the corner into an image quite real and immediately recognizable. A field of simple brush strokes and layered stains divides the representation into land, horizon and sky. The liver-colored earth and the blood yellow sky evoke a dusty late Indian afternoon. Beyond that, however, Hodgkin captures a psychological moment in time, a touching glimpse of reverie and existential melancholy that is descriptive far beyond a more detailed illustration.

Hodgkin's color has a strange quality of simultaneously seeming totally invented, and yet completely natural. Aside from its general affinities with the heightened, decorative color of Matisse and Derain, Hodgkin's color is sometimes so far out, so blatantly charged with retinal stimulation, that it catapults him out of the context of the post impressionist and fauvist sensibility into a zone all his own. At times, this involves a density of color that may very well be related to Hodgkin's knowledge of the subtleties of Indian miniature painting, where the architectonics of pictorial construction are wedded to a metaphysics of color densities. In Hodgkin's case, however, the result is a kind of implosive baroque dynamic that makes his pictures often seem much larger than they are. No doubt one of the reasons Hodgkin is known for insisting that his pictures be installed with what would theoretically seem like a disproportionate amount of space surrounding them is that his colors need space to breathe; otherwise individual works fight each other on the wall. There are even pictures in which the artist's color appears on the verge of being out of control, but Hodgkin's studied talent for adjusting the size of his marks to the projective power of his color keep his images at just the right pitch. This was not always the case in his works of the 1960s.

In fact, it was not until 1975 that Hodgkin felt he was "beginning to be able to join everything up together."[26] In a work such as *Grantchester Road*, 1975 (p. 46), the artist seems to have created a seamless melding of color, gesture and scale to create a type of pictorial space that is more subtle, as well as more complex. The interior of an architect and collector's house, *Grantchester Road* is configured as a kind of stage set in which the viewer's eye is drawn into a large living room. The scale of the room is indicated by a small, standing figure in the lower right (the artist), partially hidden by a black vertical column. Although big by domestic standards, the room is compressed by the presence of large, color-field paintings and the visual energy they project in the space. A peculiar

26 Sylvester, "Howard Hodgkin Interviewed by David Sylvester," in *Howard Hodgkin: Forty Paintings: 1973–84*, p. 100.

telescoping occurs as we realize we are looking at a painting depicting a room covered with paintings we want to look into. The overall patterning, however, keeps us in a kind of limbo space; not too deep but not quite flat.

This is also the case with a painting of the same year, *Talking About Art*, 1975 (p. 47). Employing an eclectic inventory of shapes, colors and brush strokes in an unusually deceptive space, Hodgkin playfully expresses the animated and disputational character of art talk. Framed with a border of red and purple stripes, our eye is drawn into a series of overlapping planes of color, abruptly interrupted by the realization that a large, blond color zone in the lower left is in fact the wood support of the painting. A painter, Hodgkin seems to suggest, should look no further than the surface; it is there that all deception begins and ends.

Hodgkin restricts himself to a surprisingly limited vocabulary of marks and brush strokes. By the 1970s, line as contour had been essentially eliminated in favor of more discreet, collage-like facets—spots, stripes, commas, and planes. In such pictures as *Talking About Art*, *After Dinner*, 1976–77 (p. 49), *The Hopes at Home*, 1973–77 (p. 51), and *In a French Restaurant*, 1977–79 (p. 54), Hodgkin's efforts to veil the prosaic facts of everyday reality through an elusive shuffle of atmospheric planes and textures not only point to Vuillard, but also to elemental qualities associated with pointillism and cubism. Hodgkin once remarked, "At one time I thought I'd become a completely pointillist painter: a dot or a stripe is something over which one has infinitely more control than something which depends on the movement of the arm, which takes you back into auto-graph."[27] Indeed, Hodgkin's work from the 1970s onward clearly reveals an understanding of Seurat's ability to measure depth through subtly orchestrated dots of color, as well as the French artist's employment of patterned borders and frames to establish a stage-set space. It was also during the 1970s that Hodgkin came increasingly to rely on the frame as a means of isolating his domestic views, as well as establishing a kind of theatrical compression; a frame, along with the compressed scale of Hodgkin's paintings, increases the drama of an ordinary subject. For Hodgkin, it is also a matter of protection:

> My pictures often include a frame which I paint on as part of the painting. I sometimes go to immense lengths to, as it were, fortify them before they leave the studio. The more evanescent the emotion I want to convey, the thicker the panel, the heavier the framing, the more elaborate the border, so that this delicate thing will remain protected and intact.[28]

At the heart of all of Hodgkin's images is an emotional seed, which the artist has experienced in a particular setting. Re-creating that setting and its attendant emotional echo often involves for Hodgkin a dense layer of images built up, pieced together and revised. The result is a function of collage in the broad sense of a field of seemingly incongruous gestures coming together to form one distinct image. It is at least partially this quality that led Morphet to see a close parallel between Hodgkin's paintings and certain Indian paintings.

27 Sylvester, "Howard Hodgkin Interviewed by David Sylvester," in *Howard Hodgkin: Forty Paintings: 1973–84*, p. 106.
28 Hodgkin quoted in Patrick Kinmouth, "Howard Hodgkin," *Vogue* [UK] 141, June 1984, pp. 140–41.

An unusual sense of surface, a high degree of pictorial density and diversity, and the reconciliation of bold decorative vitality with assertion of subject are common to both. ... In both Indian paintings and Hodgkin's own, pictorial elements interlink to form emphatic patterning which continuously denies and affirms the picture plane.[29]

The comparison notwithstanding, these characteristics are even more closely associated with cubism and its tightly knit configurations of painted planes of texture and color. While Hodgkin's works are not literally collage, they partake in the basic principles of that technique. His approach is intuitive, involving a continual working and reworking of metaphoric fragments until they are woven into a kind of tapestry of paint, a kind of liquid collage. The painting is finished when this activated field of interlocked images coalesces into a decisive feeling for the place and moment that originally inspired the beginning of the painting.

Along with a general similarity to the synthetic cubism of Braque and Picasso, certain of Hodgkin's paintings have a resemblance to the decorative and applied art of the Englishman Duncan Grant in their mixture of organized gesture and geometric form. Hodgkin suggests this may be the residual effect of fond memories of seeing Grant's designs as a child in the home of a relative.[30] The most convincing parallel, however, is with Juan Gris, who was so instrumental in bringing the lyric quality of light and color into cubism. Indeed, in their jewel-like luminosity and intimacy, Hodgkin's paintings play a similar role in late twentieth-century abstraction. It is clear from analysis of individual pictures, however, that Hodgkin's sensibility is a moving target, never settling on a specific individual or style. *The Moon*, 1978–80 (p. 58), for example, is cubist and dada in spirit, with a special nod to Kurt Schwitters, the lyric saint of reclamation and collage. In the spirit of Schwitters' constructions of found objects, Hodgkin has redeemed the weathered back of an old clock and transformed it into the image of the moon seen through a murky Indian twilight known as "the hour of cowdust," named for the dust raised by returning herds of cattle.[31] The result is an oddly beautiful object that convincingly stands in for a melancholic atmosphere of browns and greens. It is only poetic justice that a deconstructed clock should refer to the moon, its ancient predecessor.

Hodgkin's paintings of outdoor settings often evoke the same sense of enclosure and privacy depicted in his interiors, and gardens are a favorite recurring motif in Hodgkin's œuvre. Hodgkin employs the image of a garden as a place where nature and culture are intertwined in a harmonious, if sometimes humorous way. *A Henry Moore at the Bottom of the Garden*, 1975–77 (p. 53), for example, is a lush, abbreviated description of two figures admiring the view from an interior space onto a sunny garden, the horizon being abruptly interrupted by the large phallic form of a Henry Moore bronze. Moore's sculpture is comical in the exaggerated isolation and reverence with which it has been sited. Hodgkin instinctively knows that art cannot compete with nature. At best, it can mimic it, which is why his "landscapes" always seem to evoke a slightly tongue-in-cheek romanticism. *Foy Nissen's Bombay*, 1975–77, depicts a view through the apartment of an Indian friend to a window planter of vegetation. Utilizing wild colors and simple, flat

29 Morphet, "Introduction," in *Howard Hodgkin: Forty-five Paintings, 1949 to 1975*, p. 18.
30 Taken from a telephone conversation between the author and Howard Hodgkin, March 15, 1995.
31 John McEwen, "Introduction," in *Howard Hodgkin: Forty Paintings: 1973–84* (London: Whitechapel Art Gallery, 1984), p. 12.

brush strokes, Hodgkin creates a field of visual energy that approximates with cubistic fragmentation and good humor, a memorable glimpse, ostensibly in the direction of the city of Bombay.

Hodgkin's works underwent another transition between the 1970s and the 1980s. His works of the 1970s often involved various levels of fragmented surveillance, in which the artist is more a reacting witness than a participant. Increasingly this watchfulness became more psychologically charged, with Hodgkin himself central to the action. Heated emotional, often erotic, subjects began to permeate his landscapes and interiors. Often the more delicate the subject addressed, the more hermetically expressive the image. *Tea*, 1977–80, which can be thought of as a transitional work, consists of a warm pattern of red pompoms over a dark ground. The vague suggestion of furniture and human forms is less revealing than the overall tone of the image, which evokes a thick and intense atmosphere. What is being depicted is not so much a scene as a moment of feeling. The title, which suggests a conservative social gathering, is in this case as ironic as it is descriptive of an event. Hodgkin recounts the bizarre circumstances that inspired *Tea*.

I went round to these friends to have tea and this person they hardly knew, who was a male prostitute, though they didn't seem to know that at the time, came round to see them, and we were making sort of ordinary fatuous social conversation and he said what do you do and I said I'm a painter, what do you do, and he said I'm a prostitute, and he seemed a very respectable and intelligent person and I said you must be joking, what do you mean you're a prostitute, and for the next six hours he described what his life as a prostitute was like. It was like something out of Mayhew's London. And nobody moved. I think that was the last voyeuristic painting I made.[32]

Increasingly, Hodgkin's domestic interiors became stage sets for the depiction of raw emotional states. *Jealousy*, 1977 (p. 50), does away with figures and interior props altogether in an effort to translate an intense emotion into pure color and gesture. The result is a small stage with a backdrop of green dots on a yellow ground. Against this patterning, a small gestural blob of red paint recoils from a turbulent cloud of yellow-orange brush strokes. *Reading the Letter*, 1977–80 (p. 57), consists of a moody configuration of rich greens, yellows, and reds partially obscured by dark shadowy presences. Hodgkin describes the work as "a picture about a very anguished and personally unpleasant experience—a letter written to someone else which, without being too specific about it, was very unpleasant for me to hear, and the picture is about the moment when it was being read aloud and I was in the room."[33]

Throughout his career, Hodgkin has returned to his memories of specific people for inspiration; and some of his strangest renditions occur in the 1980s. Baudelaire observed that there are basically two ways of approaching portraiture: either as "history" (and by implication verisimilitude) or as "fiction." "The first is to set forth the contours and the modelling of the subject faithfully, severely and minutely. ... The second method, which is the special province of the colourists, is to transform the portrait into a picture—a poem with all its accessories, a poem full of space and reverie. This is a more difficult art,

32, 33 Sylvester, "Howard Hodgkin Interviewed by David Sylvester," in *Howard Hodgkin: Forty Paintings: 1973–84*, p. 99.

because it is a more ambitious one."[34] Hodgkin travels the more arduous path. His portraits involve layers of memory that are evoked through the process of painting, and vary immensely in their readability and the way they refer. The artist may depict an individual by establishing a pictorial mood, a series of symbols or both. In the painting *D.H. in Hollywood*, 1980–84, Hodgkin depicts his friend, David Hockney, as a combination of personality, celebrity, and context. One of England's most established and well-known artists, Hockney's career has been a brilliant success story; an artist ripe for attracting an entourage of admirers. In 1964, Hockney discovered southern California and began to make its people and landscape a central aspect of his imagery. The geometry of suburban Californian architecture and landscaping, in particular, provided his paintings with a strong, graphic construction which was at the same time semi-naturalistic. He frequently painted swimming pools, partly because the depiction of water, like glass and other transparent substances, posed a fascinating formal challenge, and partly because they were a convenient setting for his principal interest, the male figure.

In Hodgkin's painting, the flamboyant Hockney is depicted as a large orange phallus created by two or three dominant brush strokes placed in the center of the painting. He is situated on a lawn made of simple green stripes and against a background of green hedges or palm trees. Hockney overlooks his famous swimming pool created by a line of blue brush marks, while surrounded by a crowd of cylinder forms. Using a remarkably simple vocabulary of brush strokes, Hodgkin evokes the sunlit, pool-side theater that we associate with Hockney's identity and that he has himself made famous through his own paintings.

The portraits of Terence McInerney demonstrate how Hodgkin can adjust his relationship to the subject and, as a result, its legibility. Both works were initially, according to the artist, "incredibly representational,"[35] but evolved into more ethereal presences, each suggesting a potentially different relationship between the artist and his subject. The *First Portrait of Terence McInerney*, 1981 (p. 60), shows the artist's close friend and dealer of Indian miniatures as a warm orangish glow subtly emerging from the background of the picture. McInerney gently leans to stage right on a brightly colored sofa. The *Second Portrait of Terence McInerney* (p. 61) of the same year shows the subject surrounded by a border of blue-white pompoms and a halo of rich green and black. Acting as a backdrop for McInerney's head and shoulders, the subject's bearded face and brightly colored clothing jump out at us in a more distinct and dominant manner. Metaphorically, the *First Portrait of Terence McInerney* would appear to represent a friendship that is typically warming, though somewhat lacking in clarity. The second portrait shows a more distinct grasp of its subject. It is also more aggressive. While neither image is in any way detailed in its rendering, each allows a personality to emerge mysteriously from semi-abstract gestures.

Hodgkin is a master at reducing his subjects to indexical marks, thus subsuming them into the flow of the painting process. In *Paul Levy*, 1976–80, Hodgkin condenses his depiction of the well-known food writer into a small gesture of pink placed inside a proscenium-like border that could be a television set. *The Spectator*, 1984–87 (p. 91), formerly titled *Portrait of the Artist*, is a strictly symbolic self-portrait created from an

34 Charles Baudelaire, *Art in Paris 1845–1862* (London: Phaidon Press Ltd., 1965), p. 88.
35 Hodgkin quoted in Asmund Thorkildsen, "En Samtale med Howard Hodgkin," *Kunst og Kultur* 4 (Oslo: University Press, National Gallery), April 1987, p. 10 (of English transcript).

inventory of the kinds of marks—dots, stripes, commas, etc.—for which Hodgkin's paintings have become known.

As was the case in the 1970s, Hodgkin's technique became more loose and gestural through the 1980s. Figures, whether in portraits or group scenarios, became absorbed into increasingly dynamic and less rigid gestural fields of painterly activity. Joyfully and thoughtfully, Hodgkin allowed his expressionist side to come forward. Depicting a sun bather in Central Park, New York, *Red Bermudas*, 1978–80 (p. 64), is a collage of disparate visual information puzzled together to make a vibrantly patterned composition. It also pokes fun at Hodgkin's quirky visual memory, as two bright red brush strokes pop out of this raucous mosaic of gestural incidents representing the most important visual element in the scene. *In the Black Kitchen*, 1984–90 (p. 114), similarly favors the visual feeling of a moment over the description of individuals. As Hodgkin describes it:

> There are people in the kitchen, and they gave me the motivation for the picture, but they are no longer visible. The kitchen in question is in New York, and it's a wonderfully warm room, with a lot of glossy black in it, and the emotional charge in the picture comes above all from the people who were there. But you don't see them.[36]

Discarded Clothes, 1985–90 (p. 115), is also about creating the emotional presence of an individual, although they are physically absent from the image. The identity of the subject is depicted twice removed: the echo of their presence as clothes piled around the room, and as paint applied to evoke the existence of the garments; both coverings or stand-ins, of sorts, for the illusive spirit of an unnamed individual. The group portrait one might expect from a painting titled *In a Crowded Room*, 1981–86 (p. 93), is almost entirely camouflaged by a nuanced tapestry of paint, which, initially inspired by things actually seen—the patterns of clothing, wallpaper, drapes and furniture—soon absorbs the human players in a surface of pigments that re-creates for the artist the visual energy of the room. So pervasive is the overall weave of paint that the geometries of walls, tables, windows dissolve into hazy after-images and the figures become delicate, barely discernible silhouettes, suggested by the peculiar twist of a brush stroke.

Hodgkin's autobiographical imagery often includes views from his travels to a number of exotic destinations. References to Indian, African and Mediterranean journeys are particularly prominent. It is, of course, human nature to embrace the adventures of travel. It is also an important aspect of the British psyche. Perhaps because they live on an island and are keenly aware of the finite character of their landscape, travel has always been a particularly important aspect of British life. For Hodgkin, who often uses his travels to generate new challenges in depicting situations of light and color that are not typical of Britain, the fleeting reverie and mobile character of traveling present particular dilemmas. In forging his memories into painted equivalents, Hodgkin affirms the authenticity of a certain feeling in a strange place, while acknowledging the impossibility of adequately representing all that contributed to that special moment. Perhaps this is why Hodgkin typically gives us a view through a window, using the device of the frame to restrain the image to a specific setting, as well as to suggest a kind of cinematic minimalism, acknowledging that this is only one very special frame among many that the

36 Hodgkin quoted in John Russell, "A Hodgkin Original," *The New York Times Magazine*, November 11, 1990, pp. 57–58.

traveler glimpsed. The rest are on the cutting room floor, as it were. Hodgkin's images of Naples, for example, are some of his most luxuriantly compact depictions. *In the Bay of Naples*, 1980–82, is a powerful, mood-inducing abstraction containing rich patterns of color and gesture that are precisely filled into a window or terrace view of the great Bay of Naples. The fact that the image offers few recognizable forms makes remarkably little difference. His patchwork of aquatic blues, greens, yellows, and oranges captures perfectly the mood of a twilight ocean view. Although upon close inspection the image includes a number of semi-descriptive clues—patches of dark blue ocean, trees or lights dotting the coastal hills, the wall of a terrace or a window frame looking through or down on a garden reflecting night light—the picture is more evocative than descriptive. Each viewer takes away their own imagined view, as is clear from the diverging descriptions of this painting by various critics. One sees "the great curve of Via Caracciolo,"[37] while another sees "the wake of a speedboat, tracing its phosphorescent gesture on the night water."[38] As in the painterly theater of Dufy and Matisse, who reinvented and invigorated the imagery of the coast of the south of France, Hodgkin internalizes and touches upon a universal quality we associate with such luxurious and grand views.

It is in his Venice paintings, however, that Hodgkin seems most comfortable and confident in integrating description with the autonomous qualities of color and texture. Some of these works flicker deceptively between astute description and abstraction. *Rain in Venice*, 1983–85, *Small View in Venice*, 1984–86, *House Near Venice*, 1984–88 (p. 97), *Venice Grey Water*, 1988–89, *Venice Sunset*, 1989 (p. 103), *Venice/Shadows*, 1984–88, and *Fire in Venice*, 1986–89, are all amazingly literal depictions of their titles, and yet they are created with a summary scaffolding of wide, simple brush strokes. In *Venice Evening*, 1984–85, a rich red boundary frames a window view of one of the canals at night, which is rendered as a mysteriously black-green presence. The Venice paintings echo Turner's atmospheric depictions not just of Venice, but of water scenes in general. The result, in both cases, though using very different means, is a thickened and charged atmosphere that is not simply a reflection of humidity, but of a dream-like state of reverie. The Venice pictures are characterized by the thickness of their frames and painted borders. Again, Hodgkin refers to protecting the fragility of his subjects. "One of the reasons I use frames in the way that I do—and I think it goes back to romantic artists like Turner, who deliberately chose very sturdy, thick frames for some of his smallest, most evanescent pictures—has to do with my instinct that the more tenuous or fleeting the emotion you want to present the more it's got to be protected from the world."[39]

A number of Hodgkin's paintings are more bold and are direct homages to his artistic heroes. Hodgkin is not a cynical post modernist casually quoting the past—his tribute comes in his studious attempt to reinvent them through his own eyes and hands. Hodgkin takes such challenges seriously, as he knows the potential for failure. When asked whether he has ever seen pictures by other artists and thought to himself, "I can do that," he responded, "only in front of very bad pictures."[40] *After Degas*, 1993 (p. 127), is an intense summarization of the artist's perception of Degas, his peculiar green frames

37 Frederick Hartt, *Art: A History of Painting, Sculpture, Architecture* (New York: Harry N. Abrams, Inc., 1985), vol. II, p. 953.
38 Robert Hughes, "A Peeper into Paradise," *Time*, November 29, 1982, p. 88.
39 Hodgkin quoted in Andrew Graham-Dixon, "On the Edge," *Independent*, April 5, 1988, p. 13.
40 Antony Peattie, "A Conversation with Howard Hodgkin," *Howard Hodgkin* (London: Anthony d'Offay Gallery, 1993; New York: M. Knoedler and Co., Inc., 1994), p. 67.

and luminous, yet slightly dusty, oranges. It is a distillation of flesh and landscape combined into a few raw, unified gestures of paint handling. *After Corot*, 1979–82 (p. 59), is a homage to Corot's Roman period, in which relatively minimalist landscapes are imbued with a sunstruck softness and otherworldly remoteness. Hodgkin further condenses Corot's sensibility to a zen-like elegance and simplicity: brush strokes layered with creamy beige, silver grey-blues and off-whites, and rich humid browns. Like his paintings of domestic interiors and exotic destinations, these images have an elegiac tone; visual poems and condensations devoted to special people and moments of the past. Such works are not simply exercises in visual deconstruction, they are sincere attempts by Hodgkin to pay homage; to admit that his taste and sensibility is made of artists who came before him. The memory of these artists, among others, will often be lurking in the shadows of his brush strokes.

Also lurking in these shadows is an erotic tension that balances between concealment and self-exposure. While many of his paintings of the 1970s involved an implicit voyeurism in which Hodgkin was essentially an observer of various psycho-social environments, the paintings of the 1980s indicate a more direct emotional, at times erotic, first-person involvement with the subject. Typically, however, Hodgkin employs his talent for pivoting his imagery between glimpses of frank depiction and a sly, painterly distortion, leaving some of his viewers in the delicate position of being almost sure they are looking at the depiction of a moment of highly charged eroticism without being able to substantiate precisely what is going on in the image. One hundred and twenty-seven pages into his recent book on Hodgkin, the chief art critic of the *Independent*, Andrew Graham-Dixon, finally blurts out, as if holding in a secret begging to be told, "There are a lot of pictures about fucking."[41] Graham-Dixon's assertion is in equal degrees accurate and inaccurate. Many of Hodgkin's works of the 1980s are about bodily pleasures, which may or may not refer to intercourse.

None But the Brave Deserves the Fair, 1981–84 (p. 87), is one of the artist's most literal depictions of a sexual moment. A naked figure leaning on its back in the lower left corner of the picture, with a fairly obvious erection, gazes towards a flesh-colored presence wrapped in a towel or robe made of two green strokes of paint that is emerging from the rear of the painting. Hodgkin compresses the space with a lacy border of dark blue highlighted with white, and depicts the interior atmosphere as an electric orange glow. It clearly does not stretch the imagination to see this as a warm moment of sexual anticipation and/or erotic reverie.

In a Hot Country, 1979–82 (p. 62), is similarly provocative, though more symbolic in its depiction. A hot pink arrow penetrates a compact, stage-like space bordered with rich gestures of red, orange, and yellow. Graham-Dixon describes *In a Hot Country* as "a picture that is also a dream of sexual consummation, a picture in which Hodgkin's device of the heavily framed image becomes charged with sexual, physical intimacy. The inside of the painting is the inside of a body. A body penetrated."[42] These leaps of imagination are clearly a part of what Hodgkin's works are all about. To keep us on our toes, Hodgkin seems to provide a confiding intimacy while never giving away too much.

Waking Up in Naples, 1980–84 (p. 86), and *Interior with Figures*, 1977–84, would, again, appear to be more literal in their description of an erotic scene. *Interior with*

41 Graham-Dixon, *Howard Hodgkin*, p. 127.
42 Ibid, p. 133.

Figures is similar in orientation to *None But the Brave Deserves the Fair*, in that a naked form lying on its back or side, depending on how you read it, looks back into the space of the painting toward a dark figure in a doorway, window or mirror. It is also possible to read the foreground form as in fact two figures intertwined. *Interior with Figures* has something of the quality of 1940s de Kooning. Sexy and calligraphic (by Hodgkin's standards), it goes beyond pat categories of abstract and figurative to evoke obliquely a felt presence of the body. Part of what keeps us looking into Hodgkin's imagery is the way basic gestures do double duty in terms of image and forms. His figures are at once erotic emblems and passages of painterly expression. In a similar fashion, *Waking Up in Naples* depicts a reclining nude (or nudes) in the foreground gazing out a window into an aquatic mist. The rich flesh color of the figure is not paint, but the bare wood of the painting's support. Hodgkin's fortuitous use of accident to support depiction can be seen on the raw wood, where the oil from the surrounding paint gives "an impression of seeping from the figure like sweat from skin."[43]

There is a quality in these works that points indirectly, but poignantly, to Sickert. Hodgkin has not only assimilated Sickert's voyeuristic, keyhole perspective and gritty impressionism, but he has also embraced some of the psychological tensions evident in various aspects of Sickert's imagery. Considered a seminal figure in the history of English modernism, Sickert's autobiographical imagery introduced the English to the pictorial innovations of Degas and Whistler. His fascination with the human form in various interior settings was not only illustrative of how we see and depict reality, but also of what an artist chooses to look at and his strong, subliminal feelings about it. Sickert's most controversial pictures, the Camden Town Series, which were provocative studies of female nudes posed on beds in dimly lit interiors, offended many of his Edwardian contemporaries. Like Sickert, Hodgkin has discovered that one way of making painting exciting is the intimation of a human drama through psychological and sexual innuendo.

Phallic brush strokes float discreetly around a number of Hodgkin's images, suggesting, without ever specifically defining, a precise sexual engagement. As Hodgkin well knows, it is imagination not veracity that fuels erotic feelings. The strength of those images is not the depiction of a blatant embrace, but the delicate allure of a suggested intimacy. *Waking Up in Naples*, along with such works as *In Bed in Venice*, 1984–88 (p. 96), and *Clean Sheets*, 1982–84 (p. 83), may refer to a remembered sexual liaison, but could just as easily be about an intimate sense of well-being, both mentally and physically, at a particular time of day, in a particular place. Regardless, Hodgkin's works of the 1980s project a greater metaphorical and emotional richness; a more focused and self-referential depiction of the psychological intimacies alluded to in the works of the 1970s. Throughout the decade and into the 1990s, Hodgkin has forged an unlikely coupling of intimism and expressionism.

Because Hodgkin came to the attention of the international art world in the 1980s, punctuated by the artist's highly praised exhibition at the British Pavilion of the 1984 Venice Biennale and his receipt of the coveted Turner Prize the following year, it is tempting to think of his work in the context of neo expressionism, which erupted as an international style during that decade. Painting has been the preferred medium of this loosely defined movement in Germany, Italy, England, and the United States, and Hodgkin's vigorous brush strokes and densely worked surfaces, as well as the erotic

43 McEwen, "Introduction," in *Howard Hodgkin: Forty Paintings: 1973–84*, p. 11.

undertones of his imagery, invite comparison with the stylistic imperatives and disjunctive use of image fragments of a younger generation of expressionists, including the American's Julian Schnabel and David Salle; the Italians Sandro Chia, Enzo Cucchi and Francesco Clemente; and with the Germans Georg Baselitz and Anselm Kiefer. However, the comparison is short lived. Although Hodgkin's works share a psychological intensity with those of his younger peers, his images do not indulge in their attraction to operatic extremes, stylistic mannerisms and apocalyptic subjects. His works have none of the historicism or the impacted overlays of big themes drawn from the larger culture which characterize the generally monumental canvases of much neo-expressionist painting. While most of the neo expressionists aim for operatic syntheses, complexity and grandeur, Hodgkin has always gravitated to an intimacy that appears simple and understated.

Hodgkin's aesthetic philosophy seems more comfortable with that of a generation of American artists that emerged in the wake of abstract expressionism, including Cy Twombly, Jasper Johns and Robert Rauschenberg. Given Hodgkin's penchant for French taste, Vuillard and Matisse specifically, it seems odd to think of his work as having an American component. Yet his painting carries many qualities that are American, qualities that are particularly related to the legacy of abstract expressionism. Like his American colleagues, Hodgkin inherited the unenviable task of assimilating the grand gestures of abstract expressionism and then reinventing those gestures, while retaining their essential humanistic meaning.

In general terms, Twombly offers an intriguing parallel. Essentially the same generation (Twombly was born in 1928 and Hodgkin in 1932), both artists spent a good deal of their early careers in relative isolation. The development of their works can be related to various movements, from pop to minimalism to neo expressionism, yet they have followed very individual paths based on their particular passions for earlier art and their own distinct sensibility of mark-making. Twombly's imagery is clearly more open and airy, while Hodgkin's is highly condensed and layered, and yet both artists focus on creating what Roland Barthes referred to simply as an intense "effect," created from a vocabulary of simple, almost child-like marks. While Twombly addresses the challenge of making large canvases intimate, Hodgkin takes intimately scaled objects and expands their potential for spatial and psychological intensity.

Hodgkin has acknowledged his admiration for Johns, and one can see how Hodgkin's interest in making "emotive-type marks but in quotation marks,"[44] would find great sympathy in Johns' deadpan brush strokes—a type of mark-making that has the effect of being cool and warm simultaneously. Hodgkin's vocabulary of seemingly simple dots, dashes, squares, and commas, when thought of separately, has the cool irony of cliched pictorial building blocks.

The bedrock of each of these artist's sensibilities is abstract expressionism. Hodgkin saw the traveling exhibition *The New American Painting* at the Tate Gallery, London, in 1959. Designed to introduce a European audience to the bold inventions of abstract expressionism, the exhibition had a profound effect on an entire generation of artists, Hodgkin among them. As Lawrence Alloway put it, "Even for conservative Brits the aftermath of seeing that exhibition at the Tate was enormous. No one who made art or

44 Sylvester, "Howard Hodgkin Interviewed by David Sylvester," in *Howard Hodgkin: Forty Paintings: 1973–84*, p. 105.

wrote about it (in London) did it quite the same after seeing that show. I particularly remember a lot of bad Pollocks being made. The point is that much of what was made—good or bad—was in some way a reaction to that show."[45]

Hodgkin was particularly impressed by the work of Newman and Pollock.[46] One can imagine that Newman's dense, saturated color planes affirmed Hodgkin's own reliance on color to carry meaning. In an exaggerated and abstracted Matissean manner, Newman prodded many postwar painters to re-examine the primary role of color in painting. Color is, of course, also at the core of Hodgkin's painting. It is what one responds to first, and, in retrospect, it is Hodgkin's chromatic inventiveness—his talent for freshly uniting sheer color with form—that one best recalls. Needless to say, Hodgkin handles color very differently from Newman, or any other postwar American painter for that matter. While Newman distributed color over huge areas of canvas to create the sensation of expansion and saturation, Hodgkin ignited color by compression, pressing brilliant colors into a small space without losing their intensity.

The heritage of Pollock's career is, of course, enormous. As so many artists who have followed Pollock have, Hodgkin inherited an understanding that pictorial space, at its most basic, involves a tension of opposites: between what is seen and what is hidden or obscured, as well as between something that is recognizable and something that is not. Hodgkin's consistent claims that his seemingly abstract and semi-abstract works are always representational, echoes Pollock's own statements about his ostensibly abstract imagery, "I'm very representational some of the time," Pollock once stated, "and a little all of the time."[47] Pollock's figuration takes the form of a kind of shadow dance; linear ghosts temporarily appear behind lattices of color, and then vanish into thin streaks of paint. Hodgkin's representations perform in a similar manner. It is often difficult to decide if what we are seeing is appearing or disappearing, being pulled out of the paint or obscured by it. Even more so than Pollock, however, Hodgkin finds himself on a thin edge between a European need for figuration and order and an American tendency toward freedom and chaos.

In the end, however, Hodgkin favors a cubist figuration, no matter how buried under layers of paint it may be. In this sense, it is difficult to overlook de Kooning as a potential influence. By pouring his paints, Pollock swept away a good deal of the rigorous proportion and compositional architecture that we associate with even the most modern European art. De Kooning's women, on the other hand, are rigorously composed and adjusted images. The Dutchman's perfectly forged brush strokes, calculated erotic gesturalism, and the tightly constructed proportions of his easel-sized canvases could represent a surprisingly apt role model for Hodgkin, particularly in regards to his most recent work. In looking at Hodgkin's works of the 1990s, there would appear to be an intuitive, if not studied, appreciation of de Kooning's abstract cityscapes and landscapes of the late 1950s and 1960s.

However, while the size of Hodgkin's paintings in recent years has expanded considerably, he has never been seduced by the scale of American painting. His approach to abstract expressionism has been deliberately anti-heroic, deflating its rhetoric, and

45 Taken from a tape-recorded conversation between Lawrence Alloway and the author, September 26, 1986.
46 Thorkildsen, "En Samtale med Howard Hodgkin," *Kunst og Kultur* 4, p. 9 (of English transcript).
47 Jackson Pollock quoted in Francis Valentine O'Conner and Eugene Victor Thaw, eds., *Jackson Pollock: A Catalogue Raisonné of Paintings, Drawings, and Other Works* (New Haven: Yale University Press, 1978), vol. 4, p. 275, D113.

condensing its spatial and spectral energies. The shoulder and elbow movements of Pollock and de Kooning are replaced by the finer motor movements of wrist and fingers. While abstract expressionism projects an almost violent and pent-up dynamism, Hodgkin's gesturalism is grounded in a profound gentleness, aspiring to the kind of spiritual poise and pictorial order he so admires in Vuillard and Matisse. Hodgkin's work testifies to the fact that an artist's private anguish does not always translate into scenarios of struggle, but is on occasion sublimated and transformed into something quite the opposite. Over the past decade, in particular, the tone of Hodgkin's paintings has been that of a jubilant, understated confidence.

Hodgkin's works of the 1990s have not only involved the depiction of a remembered visual moment, but have also reflected an accumulation of feelings and scenarios that make up the artist's extended relationship with a particular subject. Describing his more recent works, Hodgkin has said, "As I could include more of the subject, I was able to include more about myself. I was able to make the pictures much more expressive than making an image of something I had seen in a rather distant manner."[48] One of the ironies in this development is that while his subject matter has become more emotionally complex and involved, the imagery itself has in many cases become more simplified. A portrait such as *Keith and Kathy Sachs*, 1988–91 (p. 117), is a poignant example of how Hodgkin's approach to subject matter has evolved over the past three decades. A comparison of *Mr. and Mrs. Robyn Denny*, 1960 (p. 34), for example, with the Sachs' portrait of 1991 shows the degree to which Hodgkin has come to rely on metaphor. The former clearly depicts a male and female figure, and, although their features and clothing are cleverly abbreviated, a certain blunt realism is established. By contrast, *Keith and Kathy Sachs* is one of Hodgkin's most seemingly abstract paintings to date.

Hodgkin has come to savor and ruminate on his subjects, the result being an ironically and intensely condensed image. The Sachs commissioned the portrait in 1988 to commemorate their 20th wedding anniversary in 1989. The painting, which took three years to complete, began when the artist found an octagonal Louis XIV frame, the type that might have been used for a traditional wedding portrait. At no time did the Sachs actually sit for the portrait. They simply interacted with Hodgkin over an occasional lunch or dinner. According to the Sachs, there was an easy rapport between themselves and the artist, and they never felt as though they were under surveillance, as it were. The resulting portrait was a delightful surprise, although the subjects have yet to resolve exactly who is who in the picture. The Sachs own three paintings by the artist and are not novices to Hodgkin's coded formal language, but confess that even after four years the picture has not completely revealed itself to them.[49]

Keith and Kathy Sachs essentially consists of two large, ribbon-like brush strokes of paint against a dappled background of yellow, orange, and gold. To our right is a shapely blue curve that on prolonged inspection looks very much like a nude torso from the back. To our left is a vertical green brush stroke wrapped in a swirl of yellow-green and orange. Mr. Sachs feels certain he is the "figure" on the left, but prefers not to say why. Those who know Hodgkin, readily acknowledge his penchant for introducing private clues and anecdotes that the artist only half buries in his final image. Traditionally, the male is placed on the left and the female on the right, supporting his reading. Mrs.

48 Thorkildsen, "En Samtale med Howard Hodgkin," *Kunst og Kultur* 4, p. 5 (of English transcript).
49 Conversation with Keith and Kathy Sachs.

Sachs, who points out that the figure on the right could be a male or female torso, suggests that both figures have mixed characteristics.[50]

According to Mrs. Sachs, *Kathy at the Ritz*, 1991–93, was much more immediately apparent in its reference when she saw it. The painting consists of black and yellow dots peeking out from behind warm billowy strokes of orange and red and brown. It reminded her very much of a sultry day in Paris when they met Hodgkin and his companion for lunch at the Ritz. She was wearing a black and yellow patterned dress. There is perhaps a similarly specific moment related to the wedding portrait that the Sachs have forgotten, but Hodgkin has not. It is often the case that Hodgkin magnifies the elusive, finding the essence of a moment in a fleeting detail.

It is also a fact that Hodgkin, at times, veils the obvious. He apparently remarked at one point that the portrait was becoming "too realistic,"[51] which for Hodgkin would detract from the fact that it is, above all, a painting. Even in these recent, seemingly abstract works, Hodgkin may begin the image with a fairly realistic drawing of his subject, bringing it more fully to life with patches of remembered color. Eventually, the paint takes over completely, creating dense layers of overpainting.[52] The result is a free-floating collage of color puzzled together to form, in a cleverly Rorschachian manner, the presence of a person or place.

The larger size of Hodgkin's recent paintings indicates his need to stretch himself, creating works that are grand by Hodgkin standards. As the size of his paintings has grown, so has the size and boldness of his brush strokes. Although underpainting may tell a different story, it is as if in these later works he needs fewer strokes to achieve the same emotional pitch. *Snapshot*, 1984–93 (p. 125), projects an almost zen-like efficiency. One of Hodgkin's largest pictures, *Snapshot* is a richly blurred field of tightly compacted brush strokes. Its vocabulary of broad translucent strokes forming curtains of green and blue-gray paint and a sphere of orange and yellow beg to be scrutinized, but the figure or representation seems too internalized and transformed to be read as figure or scene; they are gestures that simply declare themselves as gestures. *Snapshot* is a painting about scale; about the ability to take something small (a snapshot, for instance) and magnify its effect—not to make something big for bigness sake, but to create something bold and declarative and at the same time intimate. *Snapshot*, perhaps more than any other of Hodgkin's paintings, is a grand attempt to merge the intimate and the epic. The title, *Snapshot*, may also be a metaphor of how perception operates; as a series of cumulative snapshots or vignettes. Like Hodgkin's paintings, memory is an accumulative blending of glancing episodes.

Hodgkin has scaled up his gestures to correspond to the increased size of the paintings. The result is a kind of molecular indwelling. Rather than losing contact with the personality of individual marks as he has scaled up the image, Hodgkin has made them even more evident. The subtle transparencies evident in such earlier paintings as *Clean Sheets* is expanded on in *Snapshot*. We are given an inside view, as it were, of how the artist allows marks to show through other marks, how he half buries and obliterates, leaving only what is necessary to re-engage his memory of the subject, though that memory and its relation to the title remains mysterious.

50, 51 Conversation with Keith and Kathy Sachs.
52 Taken from a radio interview, *Conversations with Artists: Edward Lucie-Smith Talks to Howard Hodgkin*, British Broadcasting Corporation, Radio Three, broadcast February 1, 1981.

Hodgkin's early titles were fairly explicit, if often terse, in their references. A title might be as explicit as a country and an event (*Bombay Sunset*), as a street (*Grantchester Road*) or simply a zip code (*Interior 9AG*). If nothing else, such titles gave us the security of knowing that this image did in fact derive from a specific place and if we look at the painting patiently we can at the very least pretend to relocate that place. In recent years, however, the titles have become far more elusive and open to interpretation. Such titles as *It Can't Be True*, 1987–90 (p. 116), *When Did We Go to Morocco?*, 1988–93 (p. 129), or *Haven't We Met?*, 1985–88 (p. 94), offer us the sensation of feelings and memories as they slip in and out of consciousness. At this point in Hodgkin's development, the artist's titles and images are supporting echoes that operate in the vicinity of memory. *It Can't Be True* is even echo-like in its composition. It is composed of a series of tilting frames jostling each other for position within the whole. The eye is teased back to a bright yellow frame in the center of the painting and stopped short by a series of abrupt strokes that violate its containment. What "can't be true" is not altogether clear, unless it is Hodgkin's hesitant acknowledgment that the voyeuristic tendencies that inspired an early work like *Memoirs* have for a number of years been turning increasingly inward. In these latest works, Hodgkin is at his boldest, as well as his most vulnerable.

Hodgkin's paintings have clearly evolved into a mature and more liberated expressionism. Poignantly tentative in his representations of the 1960s, from the mid-1970s to the present, his images increasingly possess a lushness of color, a perfectly studied scale and a painterly ease that suggests the rare coordination of discipline and playfulness. There is something inward and natural about the genesis of these mature works, if one can use "natural" to describe such highly developed artifice and such an elaborately indirect use of direct perception.

Over his four decades as a painter, Hodgkin has watched and considered the changes in art around him, but he has never let fashion dictate his fundamental interests; he has kept to himself. Aware that art's major enemy is pretension, Hodgkin steadfastly appreciates the elegance and fact of using limited means to send complex signals. In this sense he is an idealist, attempting to regain the freshness, craft and intellect of early modernism. In its thoughtfulness, steady development, benign lucidity, and range of historical inspirations, Hodgkin's work refutes the notion that the high ground of late modernism is necessarily made by rejecting the past. In the footsteps of his modernist heroes—Vuillard, Cézanne, Matisse and their immediate progeny, the cubists—Hodgkin has resisted the risky conceptual ambiguities of pure abstraction. He remains conservatively and stubbornly attached to the world of appearances. Like his elders, he maintains the possibility that abstraction and representation can coexist. Indeed, it is on this thin edge of perception that painting must balance if it is to remain anything more than decoration or illustration.

Hodgkin's conservative adherence to the description "representational" painter may be an oblique nod to his Britishness. Like English art in general—and so much American, German and Italian art of the past two decades—Hodgkin's paintings depict portraits and landscapes, but Hodgkin sees these images through a very modern lens of fragmentation, abstraction and an existentialist's concern for self-realization. The result is a telling hybridization that should be seen as one of the more erudite achievements in contemporary art of the past two decades.

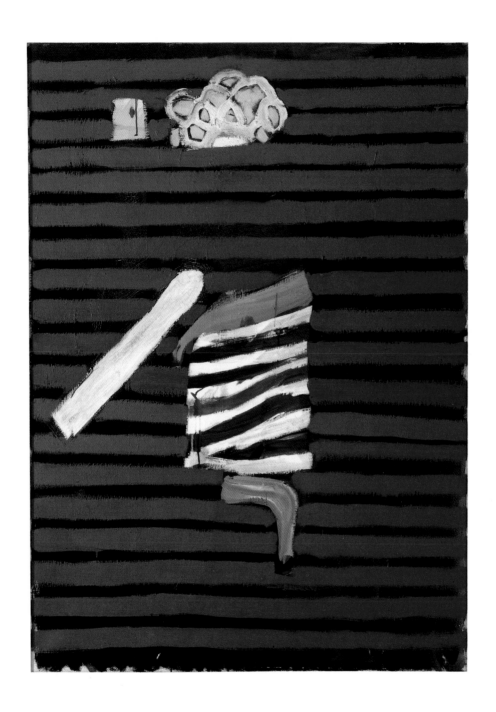

DANCING
1959

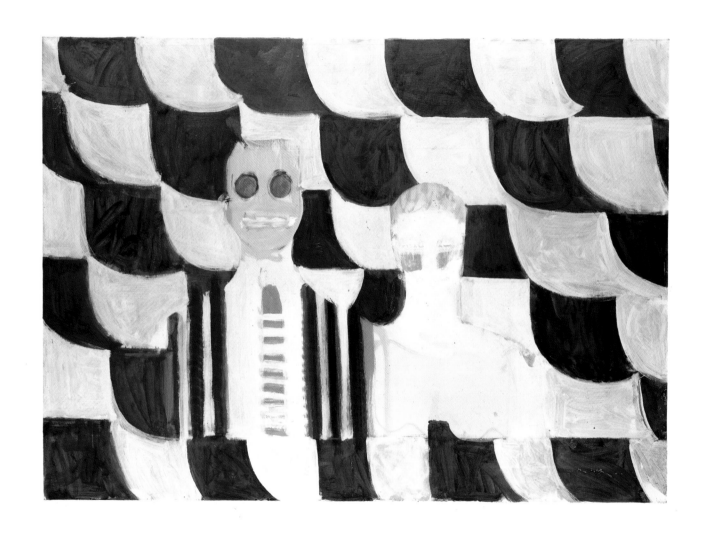

MR. AND MRS. ROBYN DENNY
1960

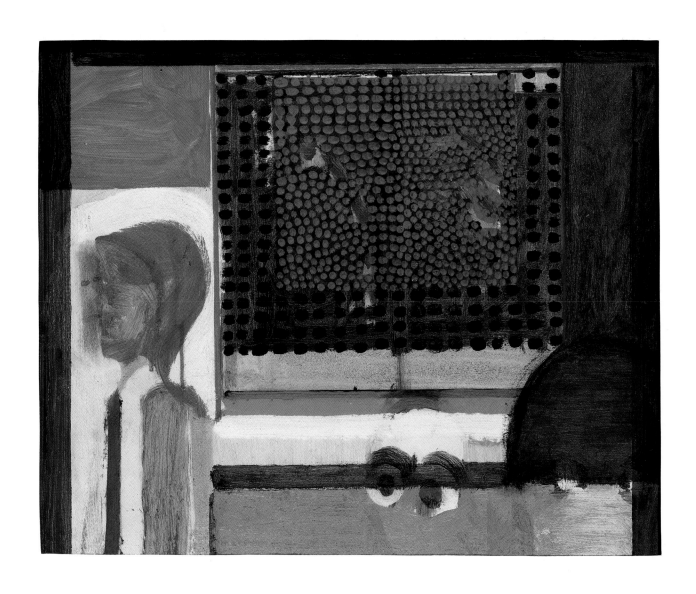

SMALL JAPANESE SCREEN OR THE JAPANESE SCREEN
1962–63

GARDENING
1963

PORTRAIT
1962–63

ACACIA ROAD
1966

ANTHONY HILL AND GILLIAN WISE
1964–66

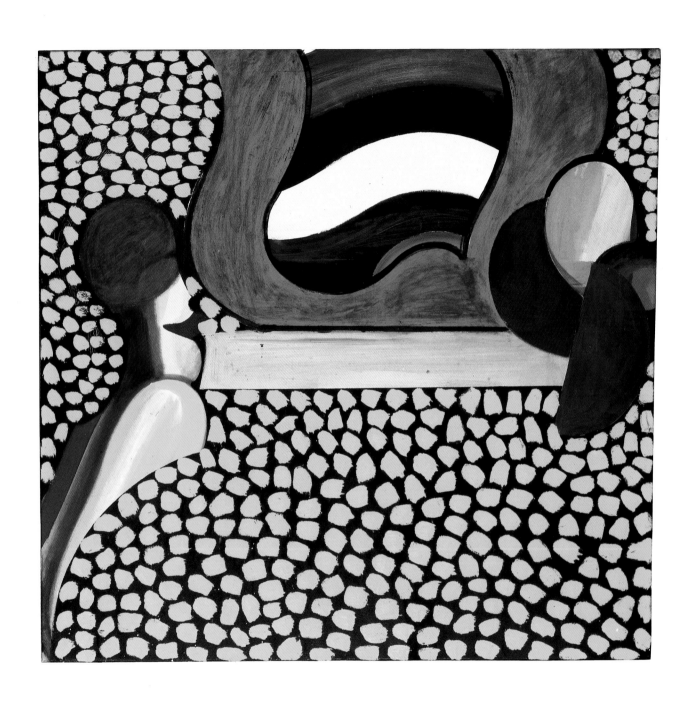

MR. AND MRS. P. STRINGER
1966–68

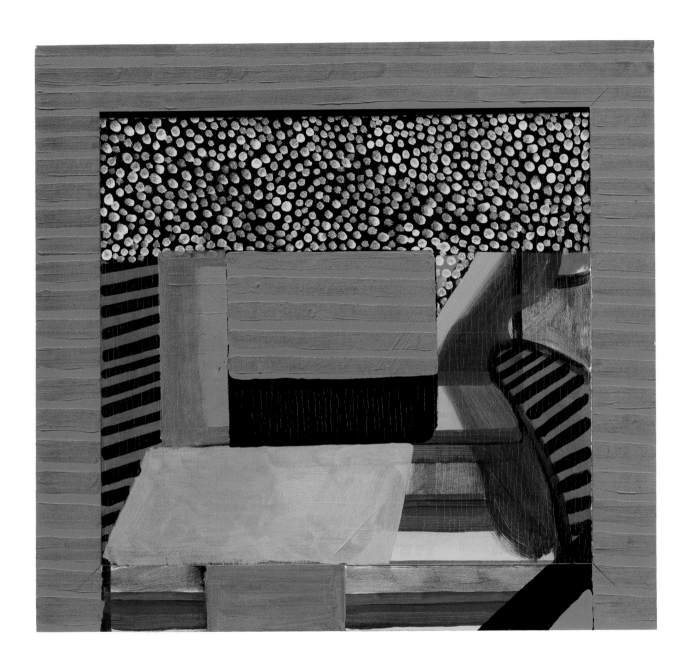

LUNCH
1970–72

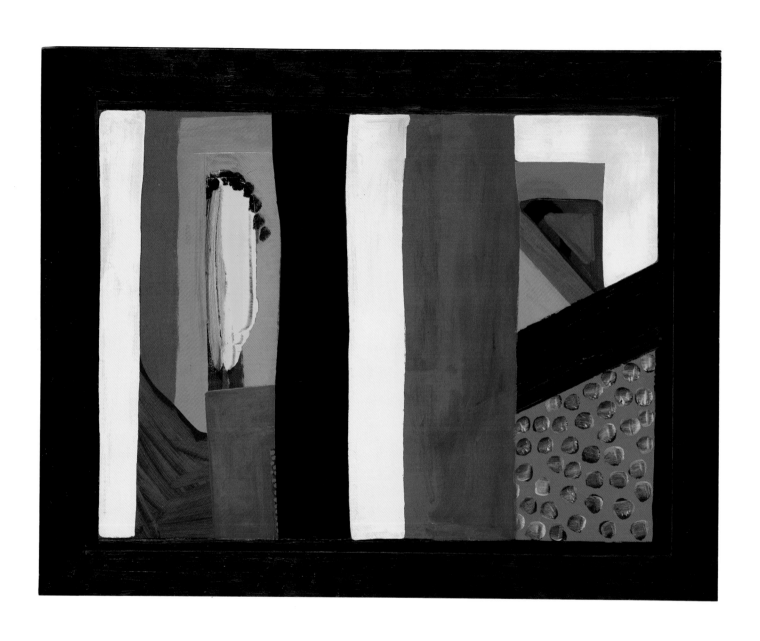

INTERIOR 9AG
1972

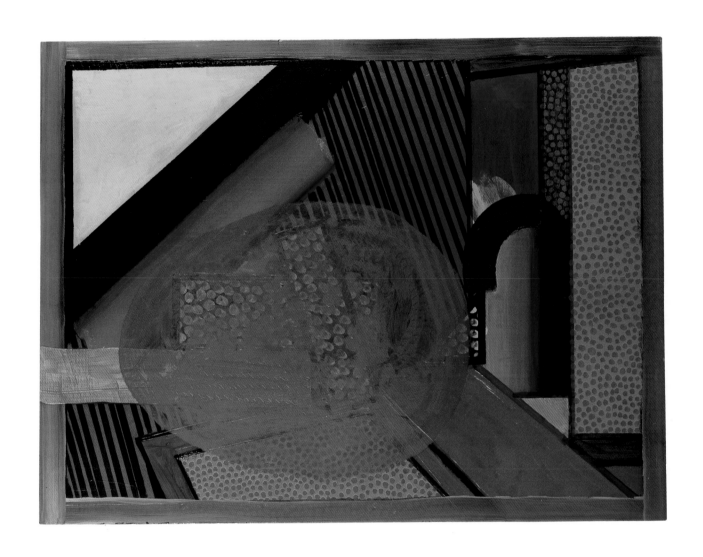

MR. AND MRS. E.J.P.
1972–73

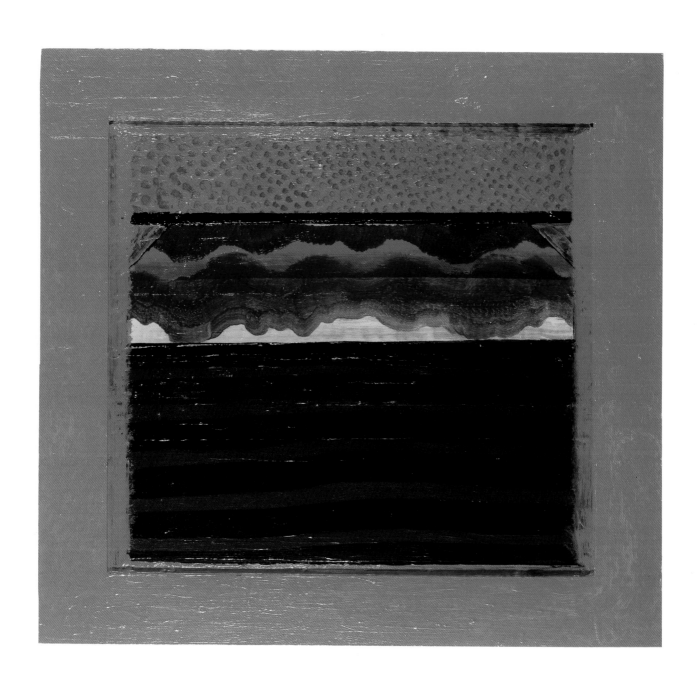

BOMBAY SUNSET
1972–73

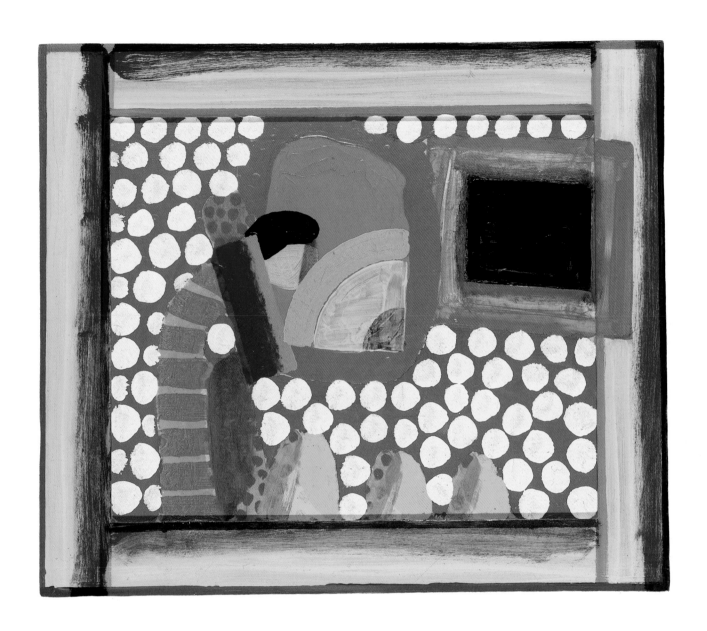

SMALL DURAND GARDENS
1974

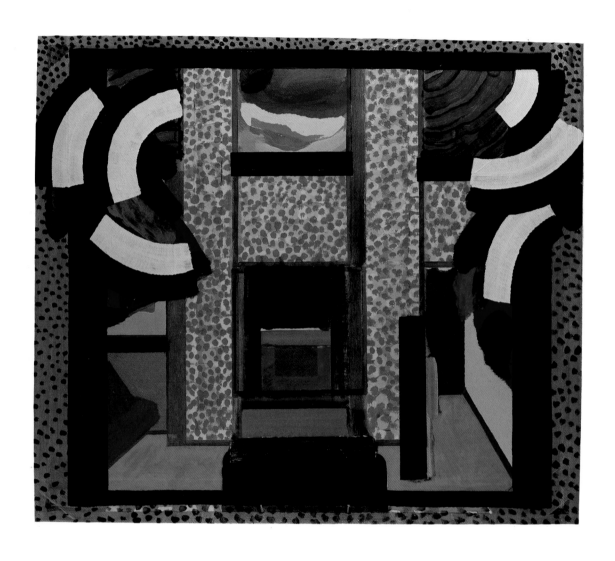

GRANTCHESTER ROAD
1975

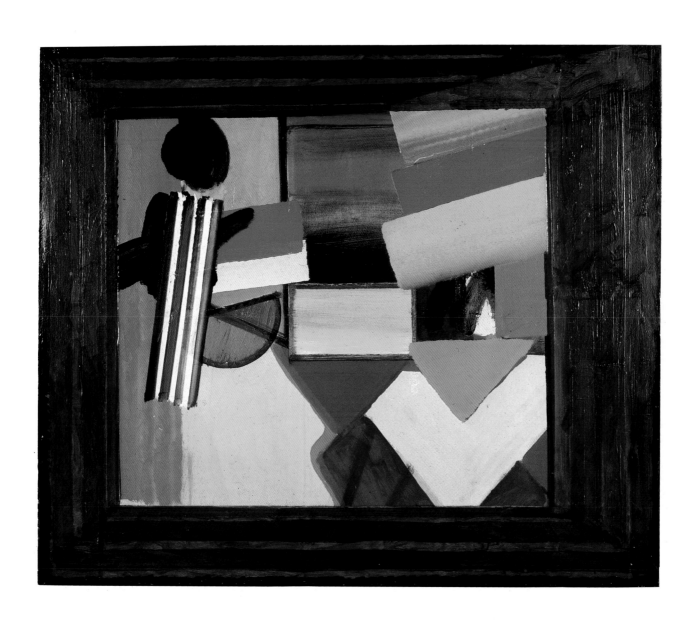

TALKING ABOUT ART
1975

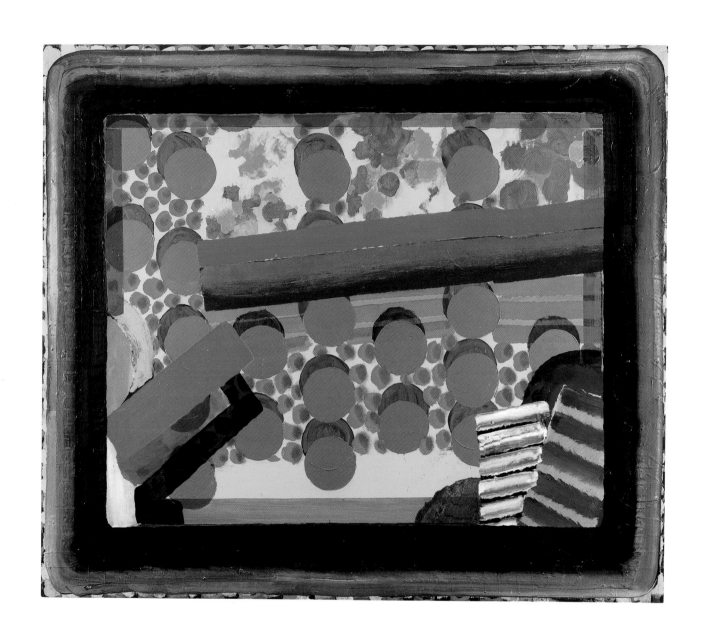

CAFETERIA AT THE GRAND PALAIS
1975

AFTER DINNER
1976–77

JEALOUSY
1977

THE HOPES AT HOME
1973–77

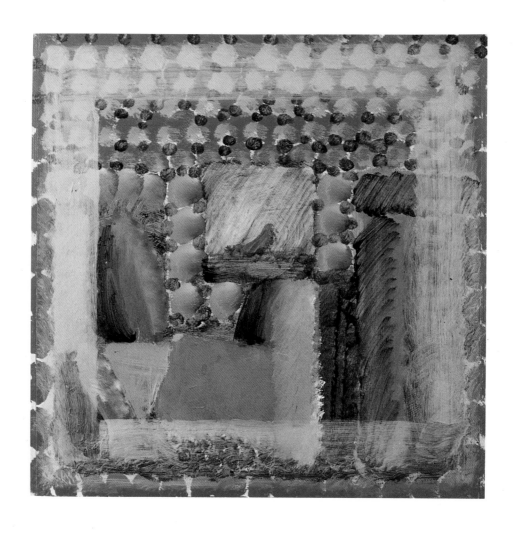

A SMALL HENRY MOORE AT THE BOTTOM OF THE GARDEN
1975–77

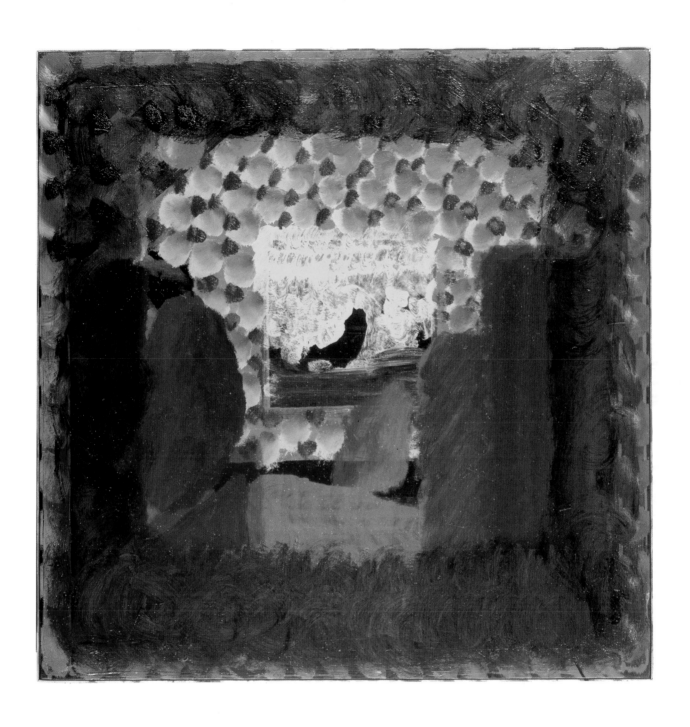

A HENRY MOORE AT THE BOTTOM OF THE GARDEN
1975–77

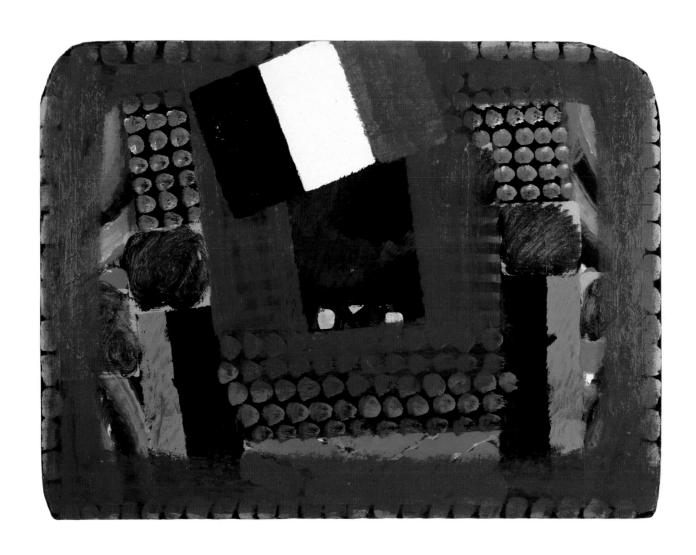

IN A FRENCH RESTAURANT
1977–79

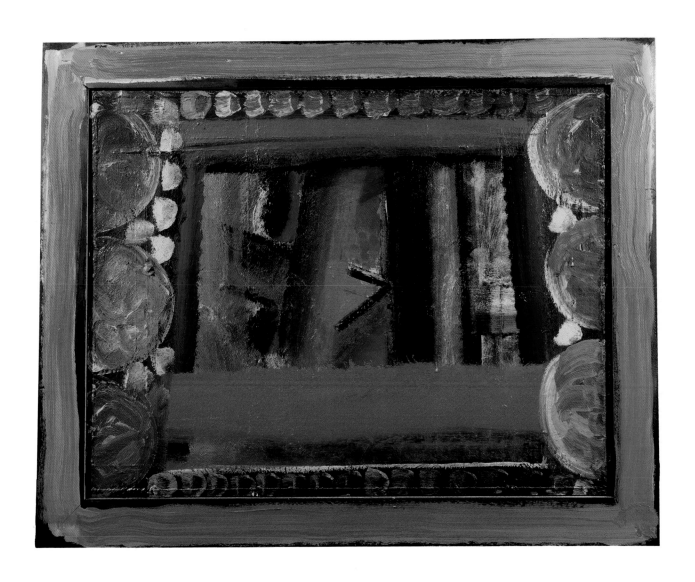

THE GREEN CHATEAU
1976–80

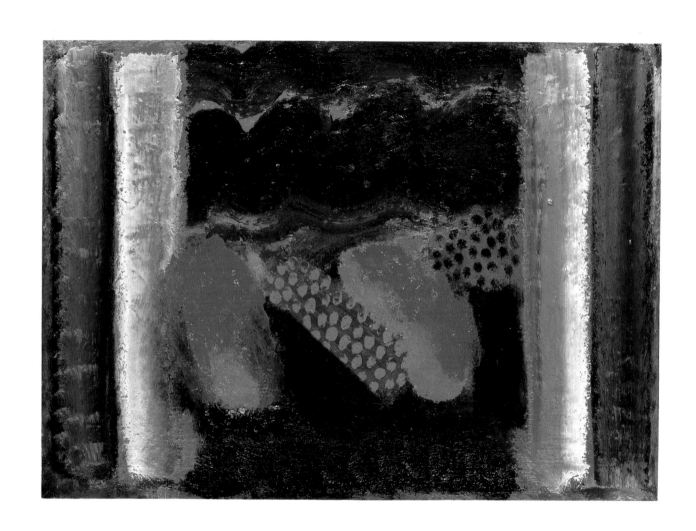

DAY DREAMS
1977–80

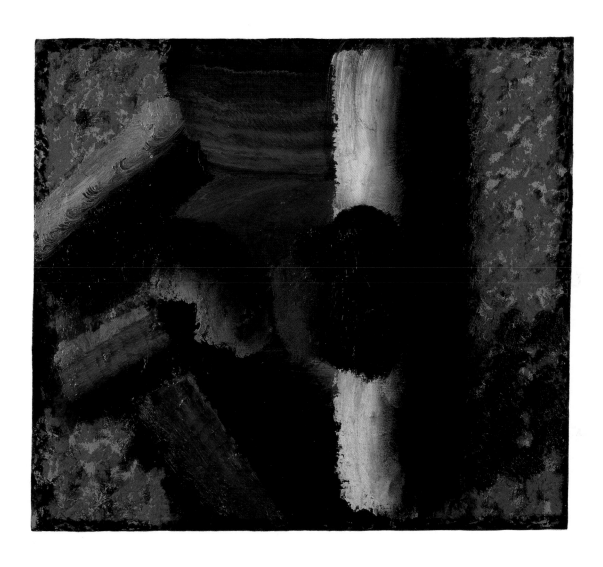

READING THE LETTER
1977–80

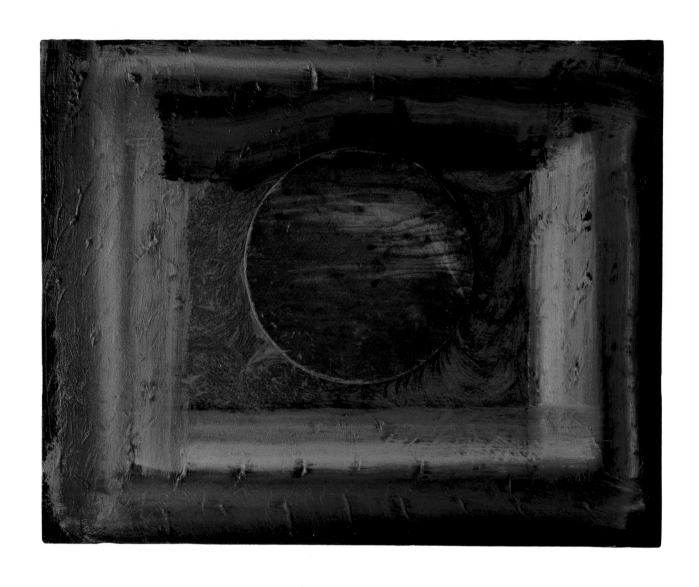

THE MOON
1978–80

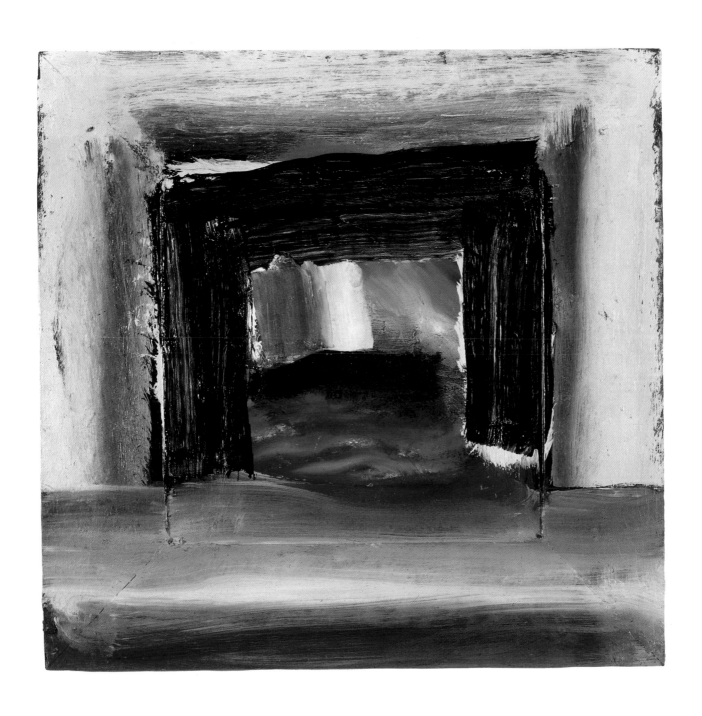

AFTER COROT
1979–82

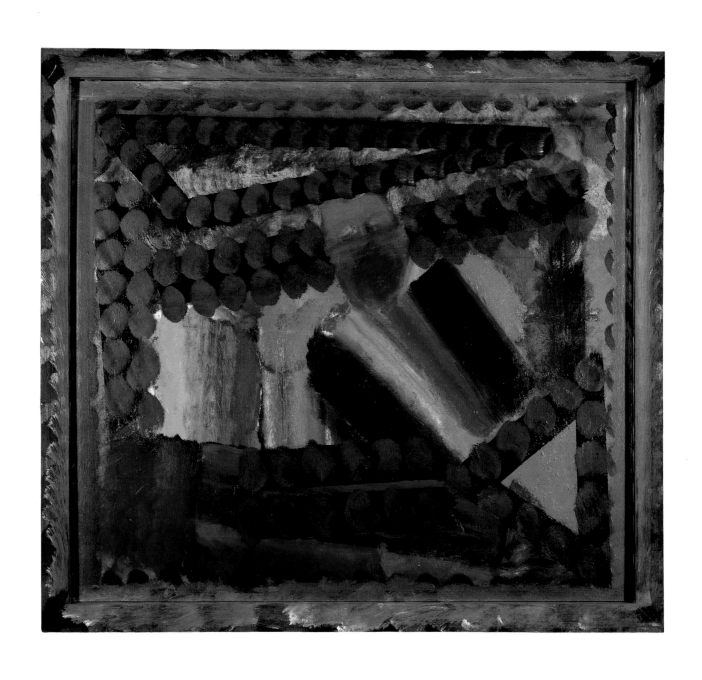

FIRST PORTRAIT OF TERENCE McINERNEY
1981

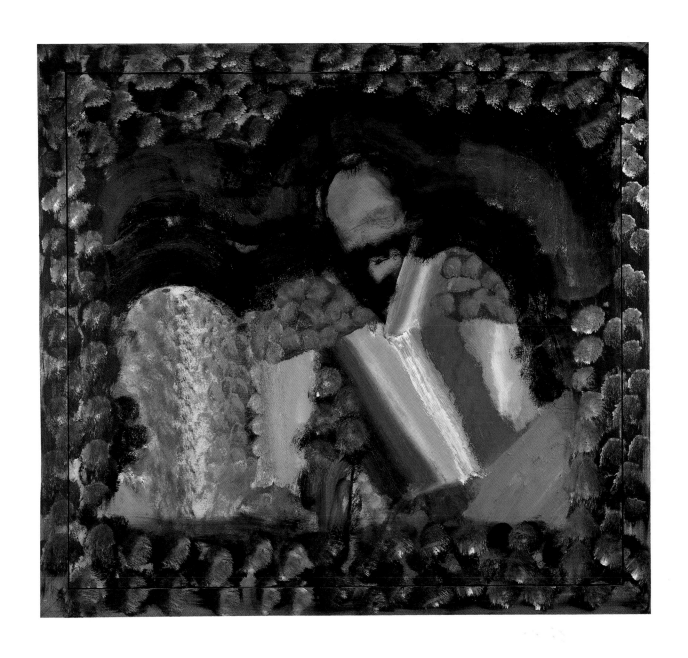

SECOND PORTRAIT OF TERENCE McINERNEY
1981

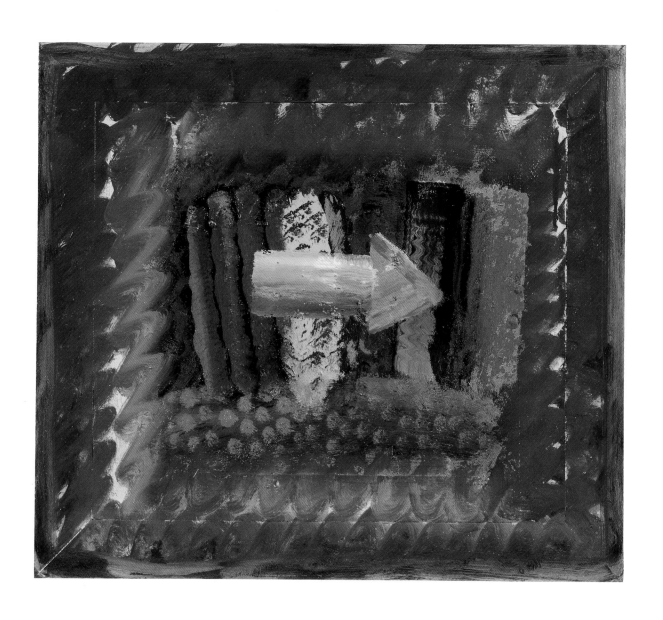

IN A HOT COUNTRY
1979–82

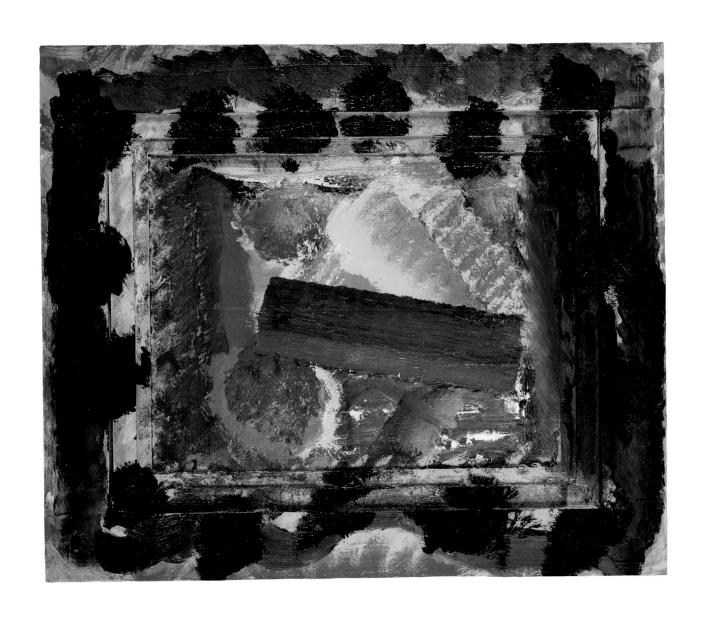

GOODBYE TO THE BAY OF NAPLES
1980–82

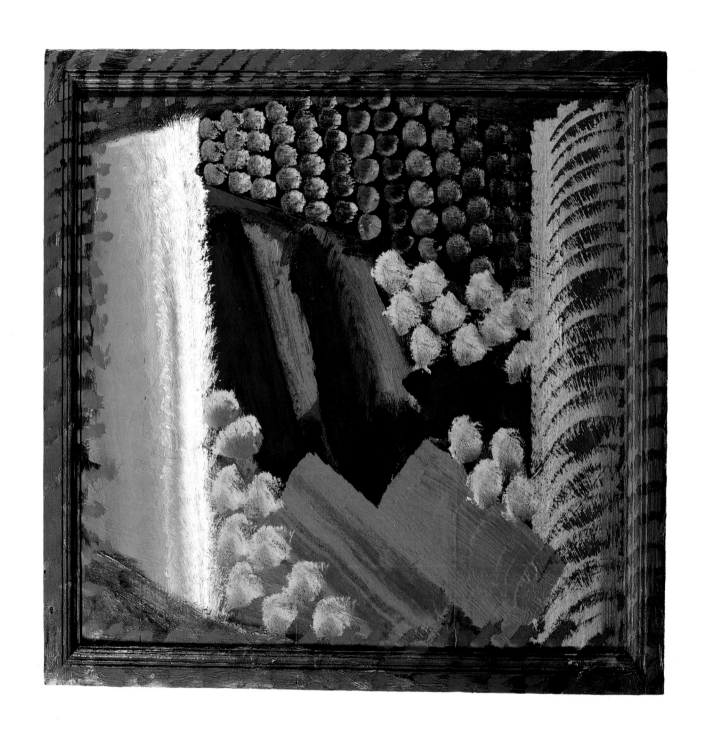

RED BERMUDAS
1978–80

John Elderfield
and
Howard Hodgkin

AN EXCHANGE

New York, January 22, 1995

Dear Howard,

I was reading a recent, 1993, interview you gave to Antony Peattie, and was amused to find that his first question to you referred to your disinclination to provide information about your pictures, especially about the specific elements in them. He also referred to your having spoken about "the tyranny of words in England." I would like to come back, later on, to the problems of Englishness; as an expatriate Englishman, I have some views on this subject myself. But now, beginning to write, I am interested in the question of words and pictures since placing words in some useful relationship with your pictures is precisely the task we have set ourselves.

I wonder whether part of the issue is a specifically modern one, namely the modern attraction to difficulty. Many of the modern works we deem most important are precisely those most resistant to narrative explanation, where we feel no single story-line will suffice. I am thinking, for example, of the difference between Matisse's *Le Luxe*, which can be explained as a version of the myth of Venus emerging from the waves (whether it should be thus explained is another matter), and his incomparably greater (to my mind) *Bathers with a Turtle* at St. Louis, whose narrative—feeding a turtle—does not get us very far in understanding the meaning of the picture. I do realize that great earlier works, too, afford a comparable sense of providing meanings that exceed those conventional to the subject, but at least their extraordinary meanings are more firmly anchored to, and accessible from, their conventional ones. And I am not suggesting, of course, that the subjects of modern pictures are unimportant. Only, I wonder whether, in your case, you are reluctant to provide information about specific elements in your pictures lest people do read them literally, as genre scenes, say; that is, as narrative illustrations. If you were a painter of subjects intrinsically more resistant to narrative interpretation (still-lifes, say) or of narrative subjects more resistant to single interpretation (like Kitaj, say), presumably this would be less of a problem.

As an art historian, I find myself in two minds about this. On the one hand, I am interested in the raw materials of an art, which means observed or remembered imagery as well as paint. Thus, for example, I am interested in the narrative imagery that Kandinsky "veiled" in his early *Compositions*. On the other hand, I do think it is pointless to try to

be more specific than the painting itself, from which in Kandinsky's case (and yours, too, I think) the artist eliminates anything that would individualize the imagery. This is to say, the more I look at his and at your paintings, the more intrigued I am by trying to understand what has been veiled—and, simultaneously, the less pronounced their narrative content becomes, which leads to an increasingly strong sense that their logic is internal. The former reaction (being intrigued by the imagery) is, I take it, one that makes you somewhat uncomfortable—very reasonably so, I think, if that is the only or dominant reaction. And yet, that reaction is surely part of the experience of your pictures, which cannot, I think, be experienced solely as internal, hermetic constructions; they do attach to the external world. My own conclusion is that, by affording and then denying (both in the act of painting and in your words of denial) the option of narrative reading, you want your paintings to testify to whatever in the external world is unavailable, or cannot be reduced, to a narrative reading. Am I putting words into your mouth?

What I am broadly arguing, I suppose, is that artists, however reticent or unwilling to speak of their purposes, must have a "theory" about what they are doing. Having read a number of interviews you have given, and Andrew Graham-Dixon's recent book on you, it seems self-evident to me that you do, and that part of it (possibly a large part) is a belief in the necessity of refusing to particularize imagery, on the one hand, in order to particularize in paint the meaning, to you, of that imagery, on the other.

I read this, for example, in your saying to David Sylvester in 1984 that your pictures are finished when the subject comes back—a very Proustian thing to say, I think, and not dissimilar to what Matisse said about his own understanding of a picture's completion. This means, presumably, that the picture tells you when it is completed not (or not only) when you sense formal resolution in it but when your experience of it (like Proust's madeleine) reminds you of something else, namely your feeling about the subject from which you started. Is that reasonable?

I have wondered, in fact, why (to my knowledge, at least) nobody has asked you about Proust. Much of what Graham-Dixon writes in his book on your work alludes to themes that are Proustian (time, memory, absence, and so on), and rightly so, I think; but he doesn't mention Proust's name. So I do wonder why. Interestingly, when he gets to the subject of sexuality, he seems to drift into a quasi-Freudian mode, talking about the body penetrated, a bed that has become a forest, and so on. Quite frankly, I think that is a mistake because I have to believe that if your conception of memory is Proustian not Freudian, your conception of the unconscious must be, too.

What I am getting to is, I believe, that what may be characterized as your "veiling" of particularized imagery in the "screen" of the surface is not, in fact, that at all, for that would be to imply some filtering of worldly sensations, some shielding against stimuli, some kind of defence mechanism. If anything, the opposite seems to be happening. There exists no prior image, which is then concealed in the process of painting; rather, the process of painting is precisely about revealing the image in the exact form you remembered it—it is not about veiling and concealing but about nakedness and exposure. Of course, after the completion of the painting may come nervousness about that exposure. Perhaps not wanting to talk about imagery is part of that, too?

This said, I was somewhat taken aback to read, in the interview with David Sylvester I mentioned earlier, your utterly frank description of the experience that provoked your 1977–80 painting, *Tea*, which you described as the last "voyeuristic" painting you had

made. You said that your earlier works were more voyeuristic, dealing with situations where you tended to function as an observer, and that your more recent works were much more about you or about incidents which personally involved you. And you implied, if I understood you correctly, that the voyeuristic paintings came to an end, with *Tea*, not exactly because the experience that engendered it was personally anguishing (although obviously it was; and you did say that you prefer not to remember painful experiences), but because the anguish you felt was in response to something reported and therefore experienced at second-hand, something you had to imagine which was so anguishing because it hardly seemed imaginable. You then said that, subsequently, you were able to put more of yourself into your paintings, and described that as a liberation. Am I correct in taking all this to mean that you have come to believe that functioning as an observer now seems somehow inauthentic because it implies the kind of screened experience that I referred to earlier? And, whether or not this is what you mean, how does all this bear on the actual appearance of the paintings?

This last point truly puzzles me. If you had referred to your paintings through, say, the mid-seventies as "voyeuristic" and the subsequent ones as having more of you in them, I would have understood because the earlier paintings do seem more distanced, shall we say, more literal in the representation of their parts. Not that their parts are necessarily more decipherable, but they seem to be products of an act of representation in a way that the parts of later paintings do not. And not only because their parts seem more autonomous; unquestionably they do, as you have pointed out, in the sense of their working against the wholeness of the painting. But they also seem to be—as made, painted marks—actually less autonomous in offering themselves as products of a rather similar marking process for all the diversity of shape that is produced. In this respect, your work after the mid-seventies seems to turn the situation on its head: the painted marks which form the parts of a picture are often more unlike each other in their making (and, in this sense, are more autonomous) and come together in a wholeness perceived as having been found in its making. That is what the pictures after the mid-seventies seem to represent—which is what I meant by saying that they are the ones that seem to begin to have more of you in them. What I don't understand, as I say, is how your paintings after 1980 can be thus divided from what went before. Do you mean to say, simply, that their subjects are more directly autobiographical? And if so, do you think that has affected how the pictures are made?

Part of the reason for my asking this is your having said, again to David Sylvester, that you want your language to be as impersonal as possible; that every mark should not be a piece of personal autograph, but just a mark because, then, it can be given meaning, can be used with other marks to contain something; that you are, therefore, especially suspicious of overtly linear marks. As you know, it is now commonly thought that the hand-made mark inevitably connotes individuality, unless either mechanized somehow or ironically framed. You suggested that both of these options attracted you, but also seemed to be suggesting a third possibility: that if a trace—the mark left by something moving—is what especially connotes individuality, then arresting or fixing a trace, showing and then stopping its movement, will depersonalize it. (Or perhaps this is not a third possibility but, rather, a means of achieving the other two?) In any event, you had discussed this subject with David back in 1984; I wonder whether you still feel the same. Then, you seemed also to be saying that, while your pictures had come to have more

of you in them, you didn't want them to present themselves simply as spaces of self-representation. I wonder whether you still feel the same about that, too.

I had forgotten, before looking at the Graham-Dixon book, that you had made a picture called *The Cylinder, the Sphere, the Cone.* It reminded me how it is now commonly assumed that Cézanne made his famous statement on this subject to Emile Bernard (that an artist must learn from these simple figures) in part at least because he was exasperated with Bernard's theorizing and came up with a cliché to try to shut him up. I hope that what I have written will not provoke similar exasperation. The next time that I write, I would like to raise more specific questions, but thought it useful to begin with a broad brush.

Regards,

John

London, February 2, 1995

Dear John,

Your meditation on subject/object in my paintings leaves me at something of a disadvantage in trying to answer all the implied questions; to some extent your alternative possible explanations are in themselves answers. When I was a schoolboy in America there was a system of tests or exams, which for some reason or other the evacuated English children became very good at; instead of having to write a correct answer you were given a choice of five possible answers out of which you chose or more likely guessed the right one. In this case, however, they are all to some extent correct, so no doubt I shall repeat myself in what follows as well as paraphrase you.

Of course there is a "modern attraction to difficulty", but I hope not in my own case as I long to make pictures that will speak for themselves and have the finality of something (an object) that observes the classical unities. The subject matter of my pictures is of primary importance—I couldn't make a picture that was not "about" anything; I wouldn't even know how to begin a picture without a subject. And you are of course right in saying that my pictures *are* attached to the real world. Some are quite representational in a limited visual sense, others hardly at all, or not at all. But what does this mean? What do depictions of clouds or vapour (I think of the under-arm cloud in Correggio's *Io,* for example) or flying draperies or tousled hair in Old Master paintings mean? When a brush stroke itself is just a mark, or a mark which, when repeated at fairly frequent intervals, adumbrates the picture plane, or simply expresses the personality of the artist and yet also does all of the above—when and how is it possible to separate the mark from its context and not lose its meaning immediately? Apart from expression of personality (i.e., autograph marks), which I try to avoid, I like to feel that for me any kind of mark is possible and useful. And sometimes, of course, they correspond with something we think we see in the natural world. My first teacher Clifford Ellis used to tell a story (perhaps apocryphal) attributed to the philosopher Alfred North Whitehead:

the normal person sees a chair, immediately identifies it by function and wants to sit down; the artist, on the other hand, simply sees a series of shapes and colours which only after transcription become identified as what we call a chair.

Though no doubt ridiculous as a description of how an artist who paints from a motif works—so many are far more concerned with the verbal identity of the chair than how it appears—the Whitehead story evokes fairly exactly the separate autonomy of the brush strokes in a Velazquez or a Rembrandt, for example, which only when *combined* add up to something else.

This leads me on to fragments—a very twentieth-century taste. Fragmented images surely have their ancestors in the kind of half-finished and so called "fresh", "sketchy" and "incomplete" depictions where all the strokes of the brush have not yet been harnessed to a whole image. Rembrandt perhaps started it all, but eventually it grew more self-conscious and more daring till in the works of Fragonard and Tiepolo you find that the spectator is expected to fill in the visual gaps for himself. The marks I use are sometimes fragments of this kind of image, and sometimes not.

But you really want to talk about subject matter so this must be rather off the point—but is it?

For me, as I have often said, the subject and object must become one *thing*. If this doesn't happen then for me there is nothing—the picture doesn't exist.

How irritating it is to be constantly told that my pictures are beautiful; this either suggests that they have no meaning and are therefore failures, or that no one cares whether they mean anything or not, or that if they look "pretty" they cannot have any content. Also, particularly in England, a feeling exists that the use of colour as a pictorial device suggests a fundamental lack of seriousness; also that the overt emotions and feelings expressed in painting are in some way elitist.

I have never read Proust, or Freud for that matter, but I think I know what you are saying or rather asking. My subject matter is simple and straightforward. It ranges from views through windows, landscapes, even occasionally a still-life, to memories of holidays, encounters with interiors and art collections, other people, other bodies, love affairs, sexual encounters and emotional situations of all kinds, even including eating.

From this incomplete and random list it's clear that even in human terms some of these situations would be more veiled (as you put it) than others. All these subjects have one thing in common—seen through the eyes of memory they must be transformed into things, into pictures using the traditional vocabulary of painting, where scale and illusionism, among many other ingredients, play their part.

Yours,

Howard

New York, February 5, 1995

Dear Howard,

I know what you mean about those multiple-choice questions; after having sent my letter, I began to worry that it might provoke a one-word response: "perhaps." So, thank-you for a very generously detailed reply.

What you wrote about marks, and especially your moving immediately to the subject of fragments, made me think of your admiration of Vuillard. I had been reading something that Matisse said about him: that in 1905, making his first so-called fauve paintings, he had been helped by something Vuillard had called "the definitive brush stroke." He meant by this an additive painting method of putting down one color stroke, then a second; if the second was not in accord with the first, it would not be redone, rather, a third color stroke would be chosen to associate the first two, and so on. The third color stroke was "the definitive brush stroke." Am I right in assuming that your process is mainly one of accretion? And is your admiration of Vuillard mainly for that? Or is it also for the kinds of marks, including his limiting the use of lineally defining marks, as you do?

I know that your reference to fragmented images was in the context of "unfinish." But I seem to remember your once having agreed to the suggestion that you had, in effect, moved in up close to a Vuillard surface. (Ellsworth Kelly once told me that he sometimes thought of himself as moving in up close to a Léger.) I wonder, do you think of the idea of fragments in that sense, too?

Your reference to color made me think, of course, of how different you are to Vuillard in this respect. This is not to say that you haven't made some paintings with a muted polychromaticism, and more where the patterns of strokes, however bright, have a hushed voice. But usually, there are not only more saturated colors, but also more contrasted colors. Didn't you almost agree with someone who had described your earlier work as a kind of brutalization of *intimisme*? I know that you have said that you have never been able to see the physical influence of Matisse on your work that others have seen. But is not the distinction between your work and Vuillard's, in this respect, somewhat analogous to that between Matisse's and Vuillard's?

As you know, Matisse said that it was oriental art that helped him find a way out of *intimisme* because it suggested a greater space. Given another of your admirations, I wonder if there isn't a connection there, too.

This said, I find myself curious about when you started looking at Matisse as well as at Vuillard. I do remember your having said recently that your first exposure to Matisse's art in bulk was seeing Alfred Barr's book *Matisse: His Art and his Public*. Was this in 1951, when it first appeared? I believe you were then at Corsham.

I do realize that you were young when you lived in the United States, but I wonder if you visited The Museum of Modern Art? Of all the Matisses there, the one I find closest to you in spirit, in many ways, *The Moroccans*, came into the collection later; but *Gourds* was there then, as well as *Blue Window*. (The only Vuillard painting in the collection at that time was the mid-nineties *Mother and Sister of the Artist*.)

I suppose I had better explain what I just said about *The Moroccans*. I can best do so by referring, first, to another comparison. When I first saw Degas' extraordinary

painting, *Bath*, in Pittsburgh, I thought immediately of your work. It was a strange reaction: not only wondering whether you had seen the painting (this was before the 1988–89 retrospective), but also finding it difficult to disengage my (remembered) response to your paintings from my response to the Degas; his intentions seemed filtered through yours, almost as if he were the later artist. (Subsequently, I read with recognition Norman Bryson saying a similar thing about Raphael and Ingres and about Velazquez and Francis Bacon.) The Matisse comparison doesn't work like that, at least for me. I recognize a certain community of purpose, but no overlay, as it were, of one on the other.

I do see certain formal affinities with Matisse (looking at *The Moroccans*, I am reminded of some of your earlier paintings, for example, the 1974 *Small Durand Gardens*), but his and your work offer themselves as not overlaid but, rather, juxtaposed in experience (and memory), as if the connection between them is that you both have a similar source. Not necessarily an art historical source (despite what I said earlier about Vuillard), or not only that; rather, that you both paint out of a similar conception of painting, which has to do with what you described in your letter as the transformation of memory. In this respect, I find you closer to Matisse than to Vuillard.

Seeing at the Metropolitan Museum, the other day, your recent *When Did We Go to Morocco?*, and thinking about these things, I was struck by how the repetitive arc brush strokes reminded me of the left side of Matisse's *Bathers by a River*. (Perhaps the vertical division of your picture, and next to it the accretion of green such brush strokes, prompted the association, too.) But again, it was as if two artists with similar backgrounds and yet different temperaments were working a similar subject. (I fear this will definitely provoke the answer: perhaps.)

One topic which the subject of Matisse inevitably raises is one you raised in your letter, when you said that it was irritating to be constantly told how beautiful your paintings are. I have to confess to having felt a similar irritation when told how beautiful the big Matisse exhibition I organized was. And for similar reasons: being asked to share in a sense of relief that the paintings were supposedly easy and undemanding. It all sounds so dull.

I suppose that high color is, indeed, the problem, and I suppose that it has two parts: some people think that highly colored paintings are insufficiently serious and distrust them for that reason; others like highly colored paintings because they think such paintings can be trusted not to be serious. You have spoken, I know, about an in-built English puritanism with respect to high color. I don't think this is only an English problem, although it may be an Anglo-Saxon one. I also wonder whether the root problem is the association of high color with decoration: whether you like or dislike high-colored paintings, they can't be serious because they are "decorative." (Of course, this is a prejudiced view of decoration, too.) I know that you have collected textiles and I wonder whether you have pondered over the association.

In this regard, I found myself looking up these three sentences on Delacroix by Meier-Graefe, "Finally, in all appreciations of Delacroix's color, now the central point of interest, we must be careful not to value him only for his palette. We can make carpets of colors, but not pictures. There are people who forgive Delacroix all the rest for the sake of his color. But the rest is everything, just as with Rembrandt." I take this not as a repudiation of color but, rather, as a request that attention be paid to the effect of

color, including its pictorial, form- and space-making effect. Do you find this as wonderful as I do?

I should stop here before I find myself drifting even further back into the nineteenth century.

<div align="center">With best regards,</div>

<div align="center">John</div>

London, February 13, 1995

Dear John,

How nice to start talking about other painters. Vuillard's description of a brush stroke as "definitive" could be slightly misleading—it was probably something said at exactly the right moment for Matisse. But nearly all painted marks are definitive, even when they are smudged or elided in some way. At least this was what I was trying to get at, when attempting to describe the strange and mysterious function of the "definitive" marks in the work of Rembrandt, Tiepolo, etc. And when Francis Bacon said, "I think that painting to-day is pure intuition and luck and taking advantage of what happens when you splash the stuff down", he was referring to "definitive" marks.

The third colour involved (I hardly dare say this) is a red herring. Though any colour will do. ...

I don't think of Vuillard or Matisse in detail or close up in spite of our general twentieth-century love of fragments. Details, however enticing, can be misleading to an extent that precludes seeing a picture as more than the sum of its parts.

Of course Matisse's *Blue Window* was very important in my childhood and I was given various general MOMA publications at that time (1940–43)—it was probably reproduced in colour in one of them. Certainly that picture and his *Piano Lesson* meant much to me. I am very untrustworthy about dates, but I don't think I read Alfred Barr's remarkable book (about Matisse) until the mid-fifties when I was given a copy and stayed in bed for two days, in order to give my full attention to reading it and looking at it. Though there were a few colour reproductions, it was really like looking at his life's work in grisaille.

Like nearly everybody else, I didn't really begin to experience Matisse's work until the great posthumous exhibition at the Grand Palais in 1970. By then, perhaps, many of my ideas about the use of colour were more than half formed.

I, too, find Meier-Graefe on Delacroix deeply sympathetic. It is "the rest", as he calls it, that as an artist one is denied once colour comes into the equation. That one can manipulate the picture surface, work on the emotions, express them, draw, etc., with colour, seems to arouse the most extraordinary resentment, though not so much among the public, as among those that come between.

Perhaps part of the reason is that the use of colour in painting performs so many different functions at different periods that Maurice Denis' famous statement gets forgotten (i.e., "It is well to remember that a picture—before being a battle horse,

a nude woman, or some anecdote—is essentially a plane surface covered with colours assembled in a certain order"). All painting can be reduced to that. When Matisse referred to oriental art as a way out of *intimisme*, I don't quite know what he was referring to. Both he and the Nabis rediscovered the space which is on the picture surface, rather than behind it. Certainly Japanese prints (beloved of the Nabis) are very different in feeling from the Persian miniatures that Matisse found so liberating, but the spatial mechanisms are surely much the same. The colour schemes, however, are *totally* different. The gentle muted tones of the Japanese prints compared with the brilliant mineral hues of Islamic painting could hardly be further apart. Perhaps that is what he meant.

But why is colour so difficult as an idea, so verbally otiose? Most colour theories are by their very nature somehow ridiculous. It seems almost impossible to talk about colour rationally or sympathetically, but nothing (for a painter) can compare with its infinite possibilities, its infinite seductions; the multiplicity of its possible meanings from the most profound to the exceedingly trivial. Can you imagine a serious pink next to a trivial blue or even a ridiculous black? All these randomly chosen colours can *be* any number of other things depending on shape, context, scale, etc.

Never underestimate the heroism demanded of the artist who is faced with these infinitely various means of expression, at a time when no one tells the artist what to do, except himself—or else he is told, yet again, that painting is dead or irrelevant. It isn't either of these, of course.

But I can't say another word about the pictorial uses of colour except to paraphrase a letter I wrote to a friend long ago talking about a visit to Naples, "two or three smudges of blue and green paint rubbed into this wooden panel, and I begin to feel I am there."

I look forward to your next letter.

Yours,

Howard

New York, February 20, 1995

Dear Howard,

Thank you for your letter; certain phrases stuck fast in my mind, and I would like to reintroduce one or two as I proceed. But first, with your encouragement, I would like to continue talking about other painters.

To begin with, I was most interested that, of the painters I had mentioned, you implied that it was Degas you esteemed most. I remember your having said to David Sylvester that you admired the "evasiveness of reality" in Degas' pictures. Is it also, I wonder, the extraordinary technical invention in Degas, who is, more and more, looking like the most inventive of all nineteenth-century painters? And is it also the way in which touch carries expression, not only in the representation of the nominal, principal subject, but across the surface as a whole?

After discussing Degas, you then went on to talk about *alla prima* painting, saying that it doesn't contain enough. (I presume you meant something similar to what Matisse said about being dissatisfied with "the first impression" because, when he looked at it later, it didn't seem properly representative of his state of mind; i.e., all he felt about the subject.) However, right at the end of your last letter (and this was one of the phrases that stuck in my mind), you wrote of a visit to Naples and said that, putting down two or three marks, "I begin to feel I am there." So what is it that is dissatisfying about leaving those first two or three marks?

On the opposite side: you had been discussing with David Sylvester the Degas portrait of Hélène Rouart at the National Gallery, London, and it reminded me of the joke reported by Valéry that her father had a Degas painting padlocked to the wall so that Degas couldn't take it back to rework it. Knowing how extensively you rework your pictures, I wonder whether you ever feel you want them back to keep on going.

In this context, Valéry said something fascinating about Degas' never being satisfied with the first impulse, "There are people who cannot feel they have acted, accomplished anything, unless it be in spite of themselves." He was talking about Degas' relationship to the art of the past; his need to be connected there. The implication is that the first impulse is too individual and personal. Remembering what you had said about not wanting autographic marks, I wonder if this strikes a chord.

But Valéry then associates this with the tedium of method. He recounted seeing a Douanier Rousseau in Degas' company and having said: what a bore; how tedious to make all those leaves. And Degas replying: rubbish. If there were no tedium, there'd be no enjoyment in it. This makes me wonder, of course, whether you feel any affinity with such a view.

It also makes me wonder about your feelings about another artist, whose working process was certainly tedious, namely Seurat. I hesitate to bring up his name because the association seems such a literal one: dots. But they do come and go, and come back, in your work. I do realize that yours are rarely Seurat's *points*, and your work suggests that you may be more interested in his oil sketches than in the finished compositions. But, coming back to something we touched on earlier, is the dot useful because it is at once a brush mark and an area but not an autographic trace?

There are times, I notice, when the entire front surface of one of your pictures is a dotted screen, as it were. More often, though, there are drifts of dots. Meyer Schapiro famously said that Seurat revolutionized painting by inventing a homogeneous pictorial material for all parts of a painting. Am I right to presume that you welcome the idea of the homogeneous marked surface but not, by and large, of homogeneous method because it may imply an "all-over," evenly accented painting?

This brings me back to a phrase in your letter, your reference to the "mineral hues" of Islamic painting in relation to Matisse. The use of areas of such hues, in juxtaposition, seems generally to work against all-overness and toward compositional inflection (unless, of course, they are used repetitively). Am I right in thinking that no matter how much you want a homogeneous marked surface, you want to retain "composition."

This reminds me to ask what you think about Mondrian. As you know, I was one of a group of curators responsible for the exhibition now in The Hague. (It will be seen subsequently in Washington and New York.) The more I have seen of his pictures, the more I feel that the "design" (so overemphasized in reproductions to the extent that he

is frequently treated as if he were a graphic designer) carries the surface as an almost sculptural, tactile unit: and the design then falls away in one's perception of the pictures as the perception of the surface, as a totality, grows.

Returning to "mineral hues": clearly, they produce a very different kind of surface, and light and space, to that of more muted, "organic" hues. One of the things that Matisse meant, I think, in saying that oriental art suggested a greater space, and helped him find a way out of *intimisme*, was that contrasted, saturated colors allowed him to generate (rather than imitate) an effect of light; consequently to create space that expands forward and outward from the surface as well as an illusion of space within the surface. For me, your pictures have a similar effect—which is one of the reasons, I think, why they demand a lot of physical space around them.

I know that you do feel strongly about this. Do you also have strong views about the height your pictures are shown, especially the smaller ones? Bill Rubin once wrote about one of our Klee paintings, *Cat and Bird*, that it had as though a mental space; that you imagined the imagery as somehow located in your forehead. Two painters I know in New York are very particular about wanting their (small) paintings hung high, at eye-level, and it has occurred to me that this has something to do with their being memory images of a sort. Certainly, their pictures make a very different effect hung lower. So I wonder what you feel about yours.

Before leaving, for the moment, other painters, may I ask a final question: one of your paintings is called *After Corot* and another *After Degas*. Did you think of these as in homage, in competition?

<div align="right">

With all best wishes until next time,

John

</div>

London, February 23, 1995

Dear John,

Degas has always been one of my heroes—perhaps more than almost any other artist. We all live on wish fulfilment in this regard and Degas allows us to get closest to his art without ever for a moment allowing us past the classical wall of expressed feeling that he has built for us.

This facade is a *pictorial* expression of feeling; it is in no way what we now call expressionist. My painting called *After Degas* is of course meant to be an evocative homage—competition? Forget it.

His (Degas') technique is amazingly inventive, but surely without conscious virtuosity; it was a search for a language of maximum directness and simplicity as, for example, in his monotype of factory chimneys when the smoke in each case is a single stroke of the brush. Too much perhaps has been made of the modernity (a terrible word) of his marvelous monotype landscapes.

There is a tradition equating marks in nature and marks made by an artist which goes back to Leonardo and his blotchy wall, to Hercules Seghers, Turner, etc. But there is

something of a painter's "philosopher's stone" about the mark which is itself a final pictorial statement, *and* something representational in itself, *and* also emotionally expressive. Degas looked for different ways of making these marks all his life and kept finding new solutions.

The smudges of paint which brought me back to Naples were only a beginning. If for a moment I was there, nobody else (i.e., the spectator) could be anywhere near, until I had done infinitely more. Sadly it's not that simple. Degas was a classical artist—something I have always wanted to be—and so naturally he thought the first impulse was perhaps too personal? As for being tied to the art of the past, what other home have we got?

But I have no time for the tedium of method. My dream has always been to paint quickly and succinctly—but, except on very rare occasions, this is still only a dream.

My feeling about Seurat is almost total admiration, though his actual pointillism only works for him! Otherwise, dots are after all dots—one of several useful ways of marking the picture plane. Seurat's drawings are such an astonishing solution to the problem of describing three-dimensional forms on a flat surface, yet somehow his paintings (to me among the great paintings of all time) often seem to have started from almost a different premise, certainly growing more and more linear as time went by.

How I wish I could say I was influenced by Seurat; but looking at some of my early work I suspect it was the more meretricious charms of Signac's portrait of Felix Fénéon which affected me.

What Meyer Schapiro said about Seurat is, to some extent, given the lie by Seurat's own paintings and certainly by those of his followers. Of course there isn't anything homogeneous about painting, ever; any more than there is a universal language of expressive forms, such as both Seurat and Piero pretended.

Asserting the presence of the picture plane is another so-called twentieth-century manifestation, but it has always been around—as I think I said in a earlier letter. You can't have any kind of *trompe l'oeil* without it; indeed, any recessional composition requires it in one way or another.

I find what you say about Matisse and Mondrian both very sympathetic and not entirely unconnected. The "mineral hues" in Persian painting must include pure ground lapis lazuli which, lying on the surface of the paper, reflects light to such an extent that it seems to contain it. This is true of many fine quality oil colours in primary hues used by artists in the West, when used opaquely, as in the work of Mondrian and in the work of Matisse, who also used to juxtapose opaque and transparent colours, often of the same hue—but we could talk more about technique in our future letters.

Mondrian's paintings are certainly harmed by reproductions which, no matter how faithful, are totally inaccurate. Also the textures produced by his endlessly mobile methods of working don't show either; the fact that, though his pictures rigorously define the picture plane they are spatially very complex, is totally concealed in reproduction. Mondrian is another one in my pantheon—described once by Kenneth Clark as the greatest Dutch painter since Vermeer. Ignoring the obvious omission, Mondrian and Vermeer certainly had things in common when arranging pictorial space.

Very best wishes,

Howard

New York, March 1, 1995

Dear Howard,

Your invitation to talk more about technique is irresistible. I've often wondered, for example, about something as basic as whether your process involves a lot of subtraction as well as addition, i.e., whether you keep scraping out as well as painting over. I was recently cross-checking Matisse's 1908 "Notes of a painter" and his 1939 "Notes of a painter on his drawing," an update of the earlier text, and was amused to find that in 1908 he quotes Chardin, saying, "I apply color until there is a resemblance"; but in 1939 he writes, "As Chardin used to say, 'I add (or I take away, because I scrape out a lot) until it looks right'." That reminded me to ask whether you have found that your methods have changed.

You referred to Mondrian and Matisse juxtaposing opaque and transparent colors. One revelation of seeing all those Mondrians together in the Hague exhibition was the extent to which he would make his black lines glossier than the prismatic color areas, dematerializing them. And I have noticed that for you, too, it is not just the colors but also the color surfaces (including matte and glossy) that get adjusted to each other. Knowing that paintings have a way of surprising the painter in this respect when they are drying, I have wondered whether this is one of the reasons (the quality of the color and not just the color) that causes you to keep on revising.

Related to this: in one of Matisse's letters to Alexandre Romm, he talks of avoiding mixing colors lest it render them dull, recommending instead superimposing colors, including making two colors act as one—but avoiding the uppermost color looking like colored varnish. Until one gets to that last phrase, it sounds a lot like you; not that you do that all the time, but you don't seem to feel that anything is prohibited—except that color has to determine form from the inside, as it were, only finding its intelligible shape as it hits the surface. Am I right?

This leads me to a subject that I fear you are weary of discussing—your painting on wood. It does occur to me, though, that there is something about getting the color down in that way that makes a very resistant surface especially useful. Painting on canvas seems to call for covering and delineating, whereas a harder surface additionally calls for pushing and prodding the paint about. This, in turn, leads me to wonder what you think of Klee, particularly in this respect. For whatever else Klee was doing, he did often seem to be addressing the picture surface as a resistant, responsive thing; a sort of block.

I notice that in the Graham-Dixon book on you, there is a reproduction of *The Moon* in side view. I presume that picture was selected for such a treatment because it has a wooden disc attached to the surface. But all your paintings, self-evidently, have the quality of objects, which causes normal reproductions of them to look somewhat peculiar, as if the front surface had been shaved off and only that shown. A couple of pages on from that reproduction of *The Moon* in Graham-Dixon's book is reproduced Picasso's *Still Life with Chair Caning*. I have to presume that the Cubist *tableau-objet* concept interests you but I wonder, additionally, whether that specific work, with its rope frame and its "quoted" *trompe l'oeil*, is of particular interest.

I don't know of any other of your paintings with collaged objects. Is there, in fact, a limit beyond which you don't want object-quality to go? Your use of frames clearly

contributes to object-quality: when they are very noticeable, they seem to connote both the traditional picture-as-window and cancellation of that concept by virtue of stressing object-quality. But again, I wonder if there is a limit there, too, beyond which you don't want to go. Your making larger pictures clearly alters this aspect of your work; they are thinner in relation to their size. As you moved to making larger pictures, I have to presume that this alteration was an important issue you had to deal with.

Painting on wood (before I leave this subject) has always seemed to me to bring with it an association of the palette, the wooden object where paint can be put down directly without any thought of the autographic mark. (Hence, I think, those wonderful curiosities of paintings done on palettes; there is a charming Pissarro of this type in Williamstown where he left visible its six component pigments arranged along the edges.) If there is any merit in this suggestion, it means association with the raw, primary source of painting—whereas the frame, of course, brings association with the very end of the painting process. I wonder if your wood and your frames have provoked such associations in your mind, too.

On the subject of frames: do you find yourself looking a lot at how other artists' works are framed? Some artists do seem to have been blissfully indifferent to questions of framing, but the inside–outside aspect of the art object obviously means a lot to you. This leads to a further question. Much has been written of late on the importance of boundaries and margins to the effect that places of transition are where any structures prove most vulnerable. Needless to say, the ultimate model is the human body. You are quoted in the Graham-Dixon book, on the subject of frames, as saying that you think of them as fortifying your paintings and that the more evanescent the emotion you want the paintings to convey, the more fortification is needed "so that this delicate thing will remain protected and intact." It sounds as if you are talking about something alive and vulnerable?

Another association of frames, of course, is collecting. I know that you have collected Indian art, but much of it, I understand, low-toned and linear; therefore, not what one would expect from your own paintings. I am curious about that, but also about what you feel about the whole business of collecting, including whether you find yourself wanting to keep your own paintings. I am thinking, in part, of that well-known statement by Picasso to the effect that a painter is a collector who makes his own collection. Some painters do seem to need to retain some of what they do.

With all best wishes,

John

London, March 13, 1995

Dear John,

I am very aware that this is the last letter for the moment; and as for all artists "Everything you (I) say may be used in evidence. ..."

To start backwards—with your questions about collecting—I have absolutely no desire to collect my own work, but do have what with age seems an almost unquenchable thirst for acquiring other things to look at. My only real collection is of Indian paintings and though the pictures themselves haven't influenced me very much, I think the act of collecting certainly has. One is continually making the kind of value judgments, asking the same old questions: is this picture better than that one? Why? Is it more expressive? Is it of better quality? And of course the best is the enemy of the good, etc.

This is quite daunting as a way of looking at one's own work, and often discouraging. It also brings a new edge to the self-criticism essential to all artists. Sometimes I have felt that this critical eye for quality was an enormous handicap and probably more responsible than anything else for my small output. But once a picture is finished, I feel it should be strong enough to look after itself in the outside world. So a picture as a lump of wood seems reasonably logical.

It is the firmness of surface—the feeling that anything is possible, from a mark like a caress to one more like a punch on the jaw, that is the ultimate attraction. Canvases, on which I used to paint, are simply an unnecessary complication. They are almost temperamental in the way they physically react to changes of atmosphere, and their innate fragility and lack of resistance make it almost impossible to paint many layers on top of one another.

You are exactly right in what you say about my use of frames, though I would add that I find it essential to make the frame part of the picture. So, as my pictures are not exactly framed in the normal sense of the word, I can't really look much at how other artists frame their work. The exception to this is Matisse who clearly loved old carved wood frames and sometimes used them almost as an extension of the picture. It would be fascinating to know which of his pictures are still in their original frames. I have often tried to guess.

Back to techniques: *The Moon* is, as far as I can remember, the only painting I have ever made with a collaged object, but I have just finished a very simple painting called *Evening* which is almost more object than picture.

The principal reason for my endless and often painful revisions when I am finishing a picture is to somehow "unlock" the imagery. "Unlock" is an unsatisfactory word, but I can't at the moment think of another. Other changes do occur through endless adjustments of colour, which either reflects light itself—so called opaque colour—or in its transparent version colours a reflective undercoat. This simple process can be carried on (perhaps unfortunately) ad infinitum, because opaque colour can always obliterate transparent colour and vice versa, so I never or almost never, wipe out, but just keep on piling Pelion on Ossa till I get there. Where *there* is, is impossible to describe; it is simply a matter of seeing and feeling.

Your quotations from Matisse are apt and you are also right about form being determined by colour and that for me technically "anything goes". I have just finished what

for me is a comparatively large, medium-sized picture called *Gossip* (46 x 65½ inches). The painting was very hard to resolve. The subject, though anchored to a particular incident, seemed at times almost impossibly nebulous. My feelings about the victims didn't make it any easier. As so often, the whole enterprise seemed fruitless, while I searched, apparently in vain, for the right scale. In the end I felt that I had succeeded, but in the context of what we have both been talking about, I don't quite know why—or how.

Perhaps one day we can go on talking like this at greater length. To my surprise I have begun to enjoy it.

<div style="text-align: center;">

Thank you,
yours ever,

Howard

</div>

P.S. Obviously, my "language of forms" has far more than a physical purpose. Alone in my studio, working on my pictures, more than anything, I long to share my feelings.

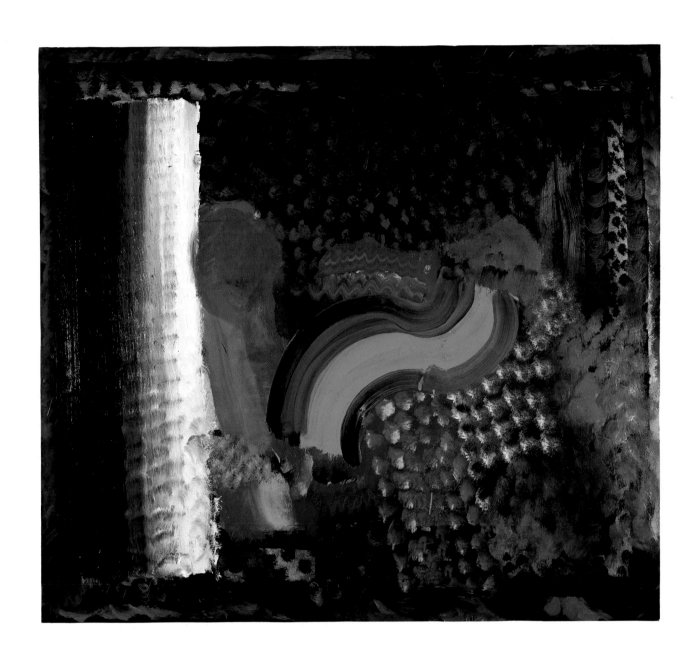

IN THE BAY OF NAPLES
1980–82

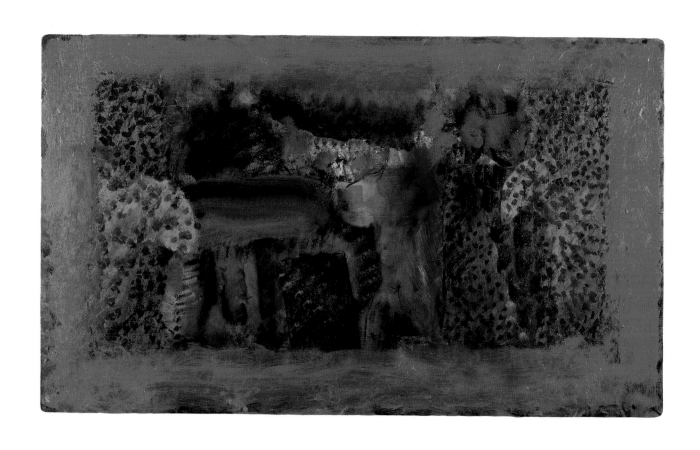

INTERIOR AT OAKWOOD COURT
1978–83

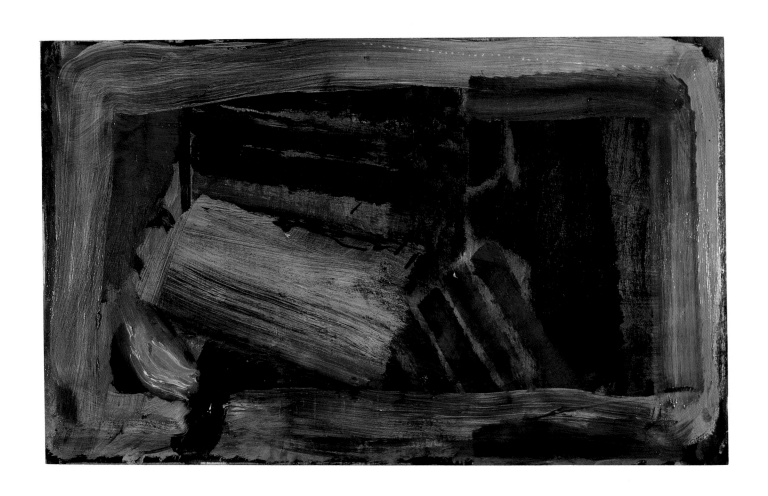

CLEAN SHEETS
1982–84

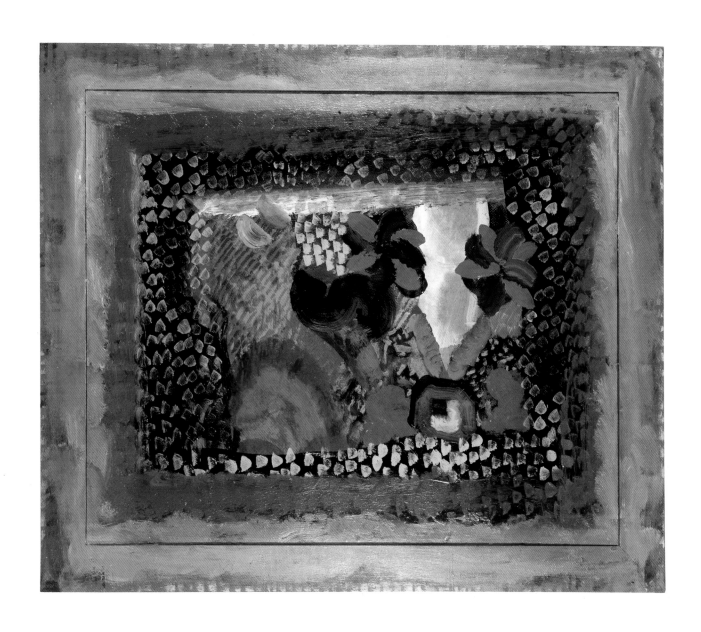

MR. AND MRS. JAMES KIRKMAN
1980–84

IN THE HONEYMOON SUITE
1983–85

WAKING UP IN NAPLES
1980–84

NONE BUT THE BRAVE DESERVES THE FAIR
1981–84

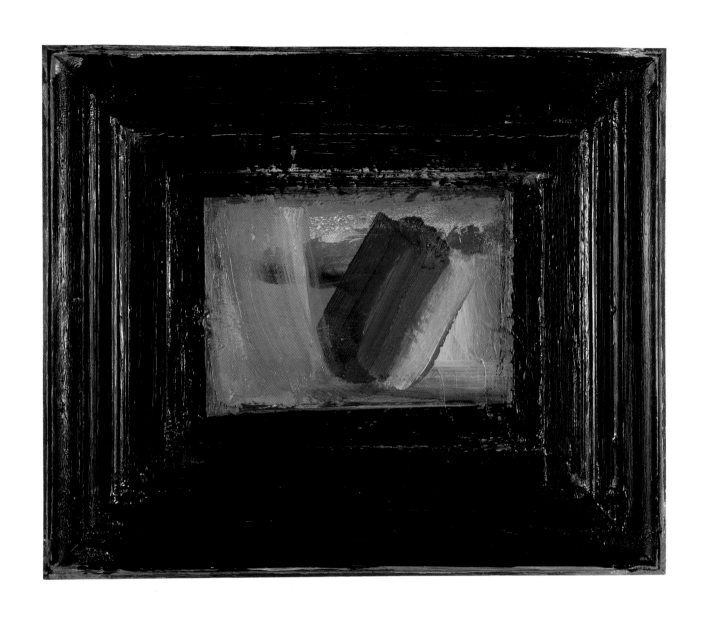

A SMALL THING BUT MY OWN
1983–85

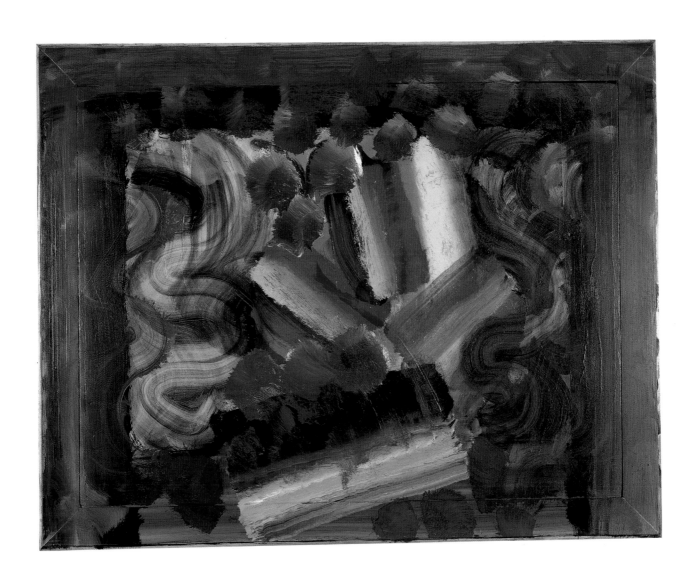

SAD FLOWERS
1979–85

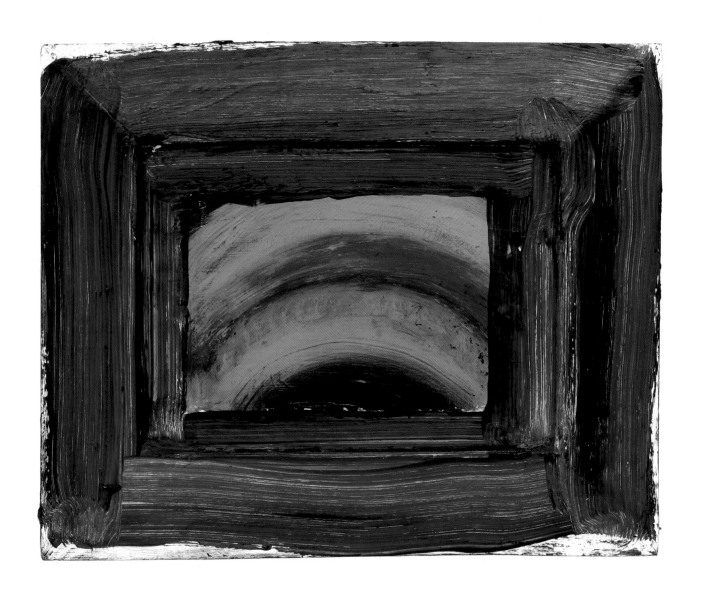

VENETIAN GLASS
1984–87

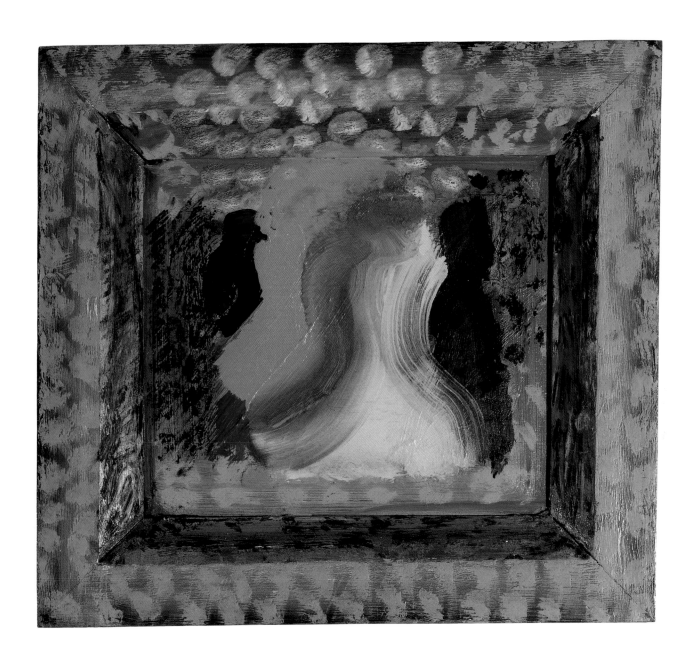

THE SPECTATOR
1984–87

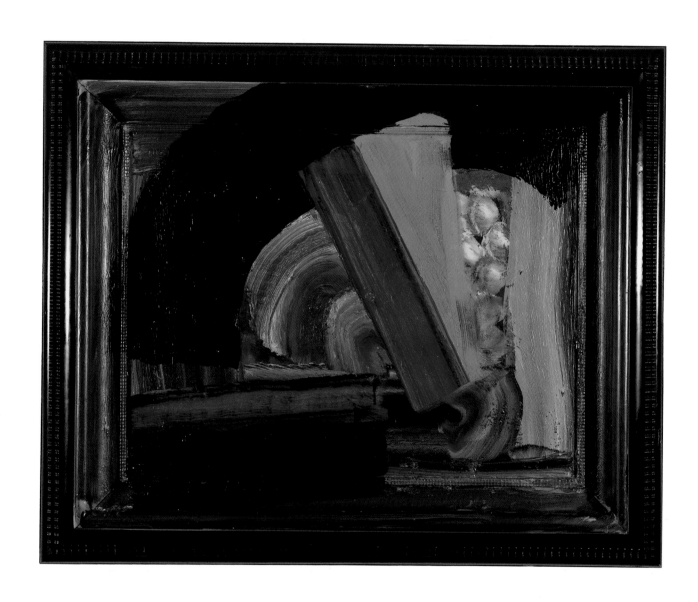

DOWN IN THE VALLEY
1985–88

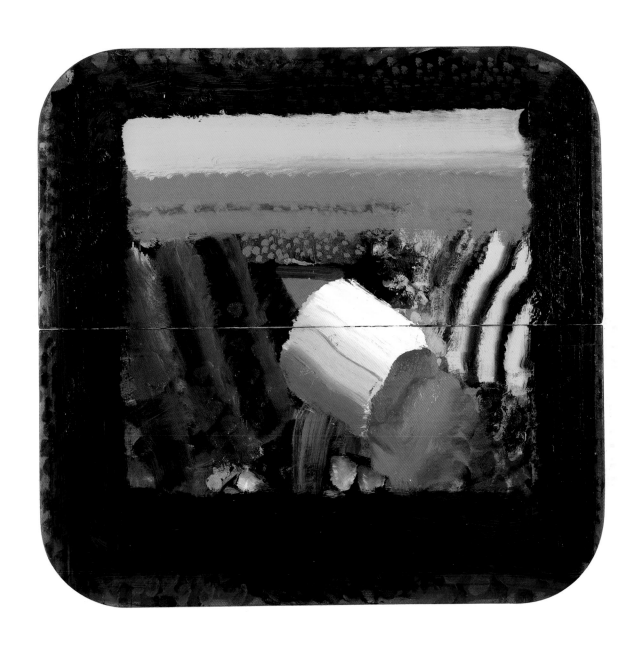

IN A CROWDED ROOM
1981–86

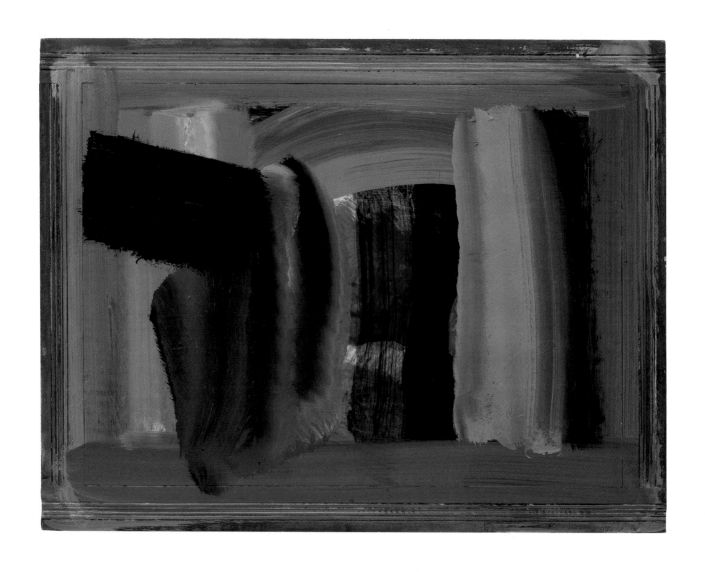

HAVEN'T WE MET?
1985–88

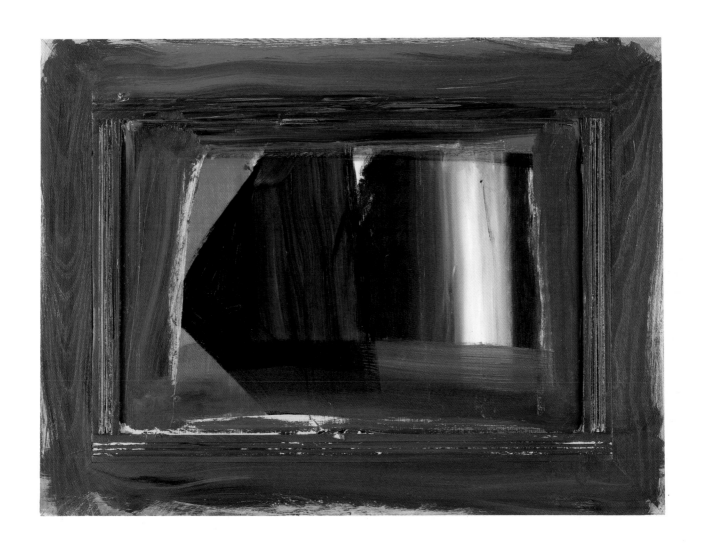

HAVEN'T WE MET? OF COURSE WE HAVE
1994

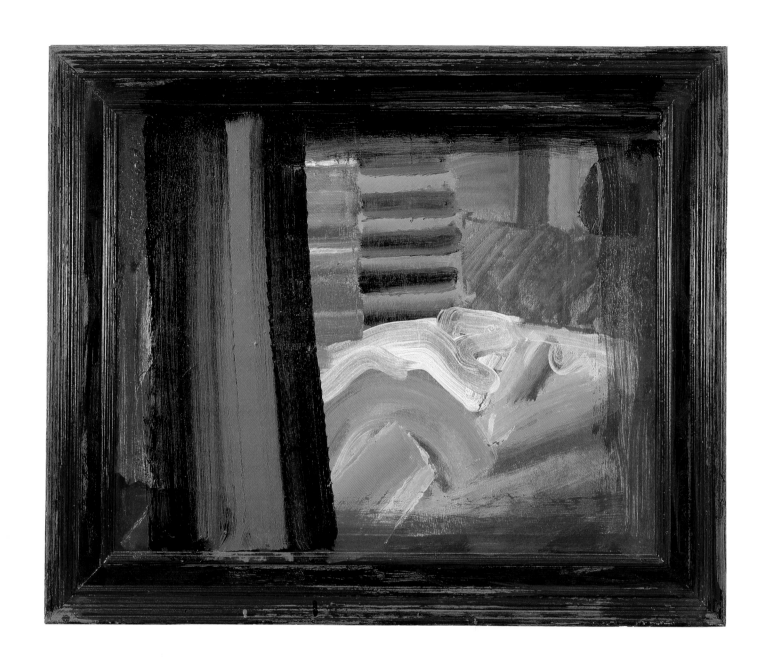

IN BED IN VENICE
1984–88

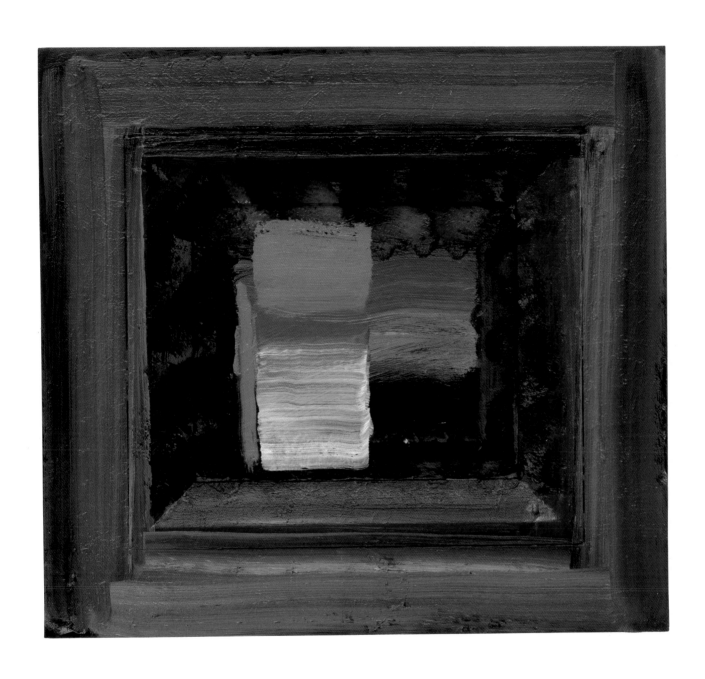

HOUSE NEAR VENICE
1984–88

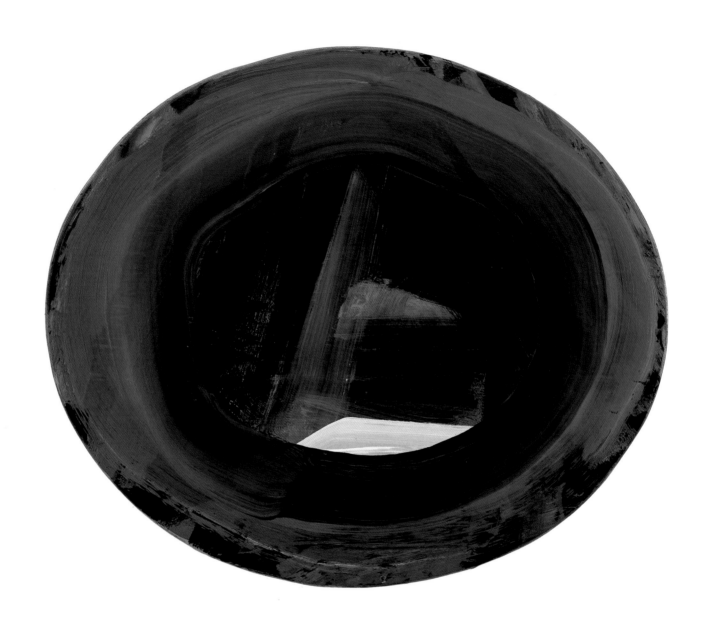

LOVE LETTER
1984–88

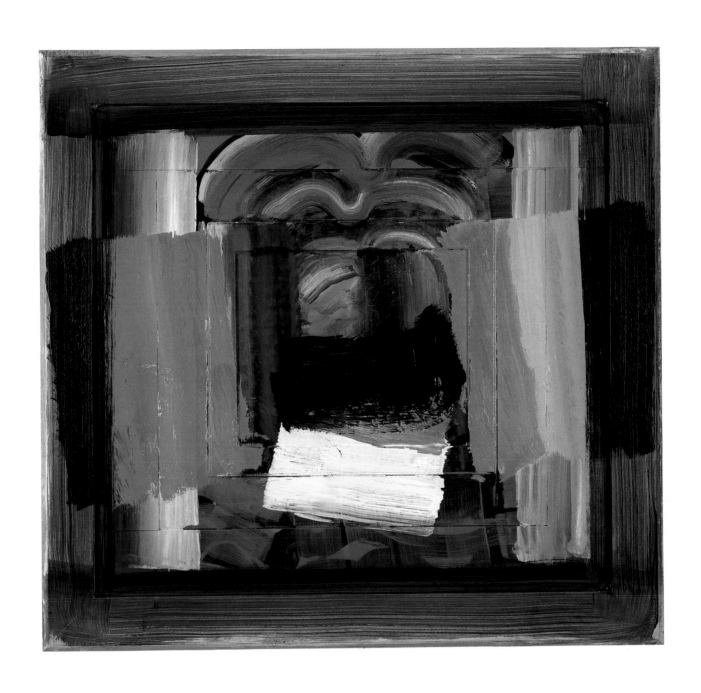

ON THE RIVIERA
1987–88

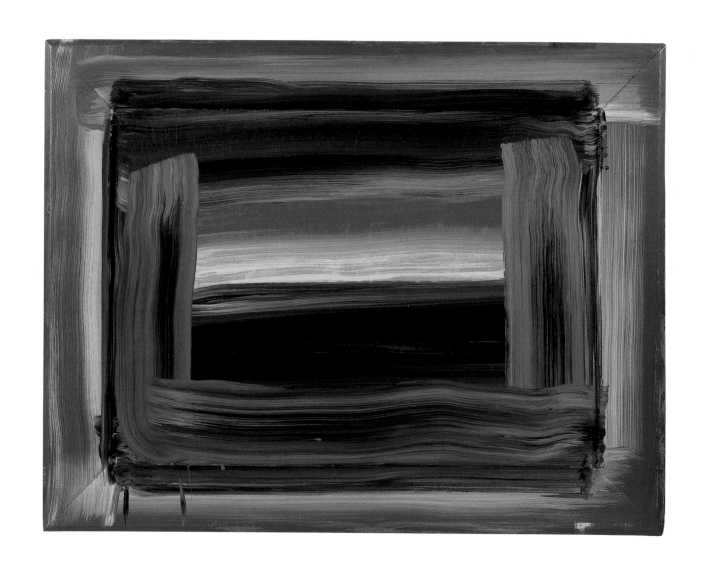

INDIAN SKY
1988–89

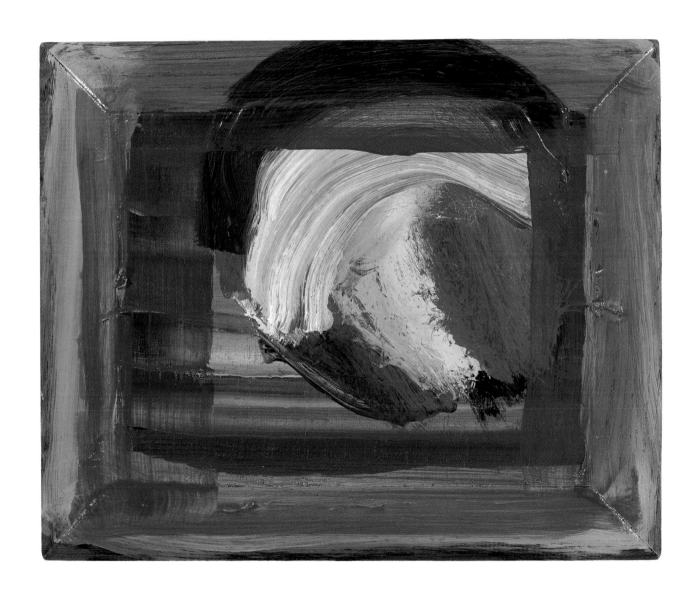

FRUIT
1988–89

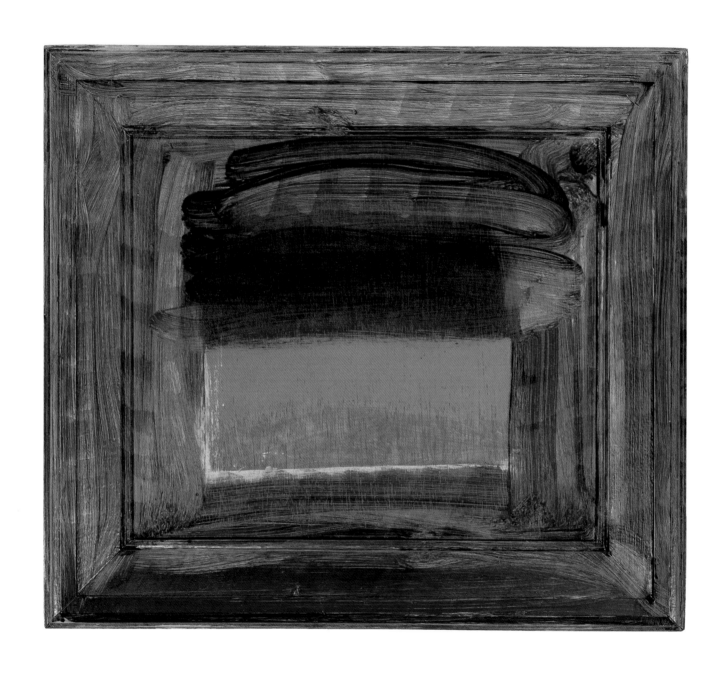

VENICE IN THE AUTUMN
1986–89

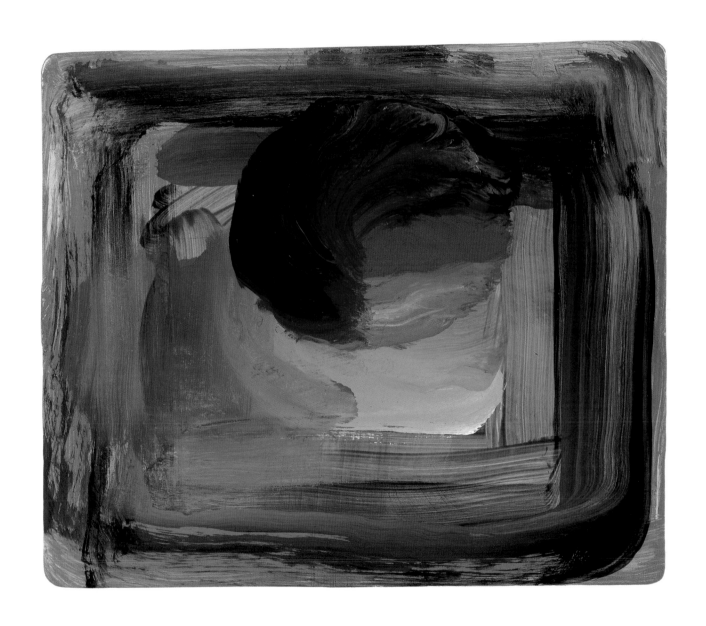

VENICE SUNSET
1989

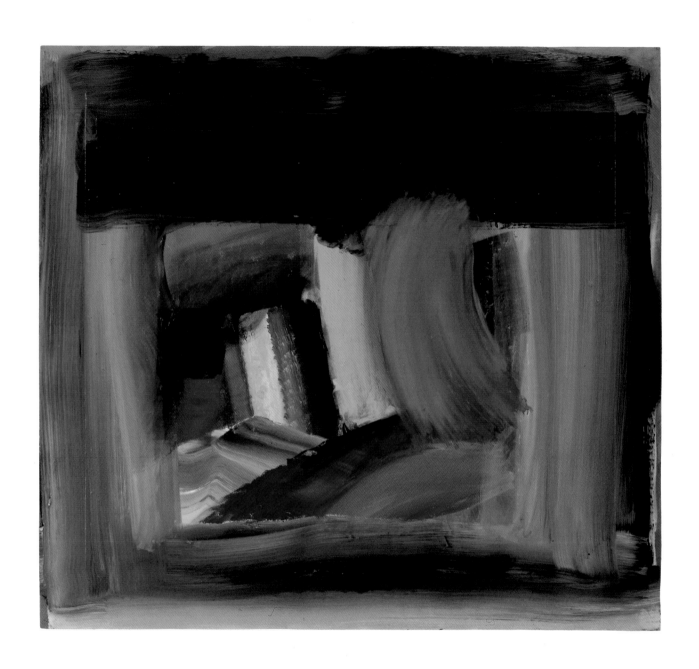

RAIN
1984–89

1

Devolving now, the modernist tasks and liberties have stirred up a canny diffidence among painters of the largest accomplishment when pressed to talk about their art. It appears unseemly, or naïve, to have much to say about the pictures or to attach to them any explicit "program." No more theories expounding an ideal way of painting. And, as statements wither and with them counter-statements, hardly anything in the way of provocation either. Decorum suggests that artists sound somewhat trapped when being drawn out, and venturing a few cagey glimpses of intention. Complementing that venerable fortress of modernist taste, the white wall of the gallery, is a final redoubt of modernism under siege, the white mind of the painter. And the thoughtful—as distinct from the inarticulate—may have good reason to be wary, anxious, at a loss (for words).

2

Earlier in the century, it was the most responsive writers who might begin their setting of the encounter with a much admired body of pictures to words by paying tribute to painting as a form of the *unsayable*.

As Paul Valéry wrote in 1932 (it's the first sentence of "About Corot"): "One must always apologize for talking about painting."

From the summoning of each art to what its means only could enact, it follows that nothing can be paraphrased or transposed into another medium. Painting, like music and dance, does not signify in the verbal sense: what you see is what you get. "A work of art, if it does not leave us mute, is of little value" (Valéry again). Of course, we don't *stay* mute.

But there is a further incentive to be self-conscious about what can be said now, as the aim and justification of art after modernism becomes precisely to generate talk—about what is not art. A mighty repudiation of the idea of art pursued out of reverence for art has overwhelmed art-making and critical discourse in the last decade. It has centered

around the equating of aesthetic purposes, and their unforgivingly "high" standards, with illegitimate or indefensible (in truth, dysfunctional) forms of social privilege. For those whose principal interest is neither to come clean about adventures in selfhood nor to speak on behalf of fervent communities but, rather, to perpetuate the old, semi-opaque continuities of admiring, emulating, and surpassing, prudence may suggest saying less rather than more.

3

The attack on art—for being, just, art—has to have been abetted by modernism's peculiar, reductive way of affirming the autonomy of art, which derived much of its energy by denying the idea of hierarchy among kinds of art. Shorn of the support of received ways of discriminating among subjects and destinations, the nature of pictures was inexorably subjectivized; and archly plebeianized.

The two leading assertions in this reduced field of saying for the painter. The painter asserts that the pictures don't need to be "explained." The painter explains that the pictures should, properly, be regarded as "things."

4

There's one just ahead ... or nearby ... or over there. ...

And perhaps not in the obvious place, such as a museum or the collector's living room; it may be on the wall of a restaurant or a hotel lobby.

But wherever we see it, we know *what* it is. We may not know *which* one. But we know, even from far across the room, *who* did it.

In contrast to the painting of earlier eras, this is one of the regulating aspects of the experience—and making—of art in this century. Each artist is responsible for creating his or her unique "vision"—a signature style, of which each work is an example. A style is equivalent to a pictorial language of maximum distinctiveness: what declares itself as *that* artist's language, and nobody else's. To reuse again and again the same gestures and forms is not deemed a failure of imagination in a painter (or choreographer) as it might be in a writer. Repetitiveness seems like intensity. Like purity. Like strength.

5

A first observation about Hodgkin's work: the extent to which everything by Hodgkin looks so unmistakeably by him.

That the pictures are done on wood seems to heighten their rectangularity—and their "thingness." Usually modest in size by current standards, they seem boxy, blunt, even heavy sometimes, because of the proportions of frame to interior of the picture, with something like the form, if not the scale, of a window, displaying a ballet of plump shapes which are either enclosed within thickly emphatic brush strokes that frame (or shield) or are painted out to the edge of the raised frame. The pictures are packed with cunning design and thick, luscious color. (Hodgkin's green is as excruciating as de Kooning's pink and Tiepolo's blue.) Having renounced painting's other primary resource, drawing, Hodgkin has fielded the most inventive, sensuously affecting color repertory of any contemporary painter—as if, in taking up the ancient quarrel between *disegno* and *colore*, he had wanted to give *colore* its most sumptuous exclusive victory.

6

"My pictures tend to destroy each other when they are hung too closely together," Hodgkin has remarked. No wonder. Each picture is, ideally, a maximum seduction. Harder for the picture to make its case if, at the distance from which it is best seen, one is unable to exclude some adjacent solicitations. But the viewer may be tempted to solve the problem, abandoning the proper distance from which all the picture's charms may be appreciated to zero in for immersion in sheer color-bliss—what Hodgkin's pictures can always be counted on to provide.

7

Too close a view of the picture will not only yield a new round of voluptuous sensation (say, the streaks of salmon-pink now visible beneath what read, then feet away, as cobalt blue). It will also remind the viewer of what is written beside or below: its title.

Leaves, Interior with Figures, After Dinner, The Terrace, Delhi, Venice/Shadows, Clean Sheets, Red Bermudas, Mr. and Mrs. James Kirkman, After Corot ... titles like these indicate a pleasingly large range of familiar subjects: the still life, the *plein-air* scene, the intimate interior, the portrait, the art history homage.

Sometimes the title corresponds to something that can be discerned.

More often, it doesn't. This is most obviously true of the portraits—that is, the pictures whose titles are someone's name; usually two names, a couple. (The names, those of friends and collectors, will be unfamiliar to viewers.)

Some titles that are phrases, such as *Like an Open Book*, *Haven't We Met?*, *Counting the Days*, seem to be drawn from the history of a love life. *In Central Park*, *Egypt*, *On the Riviera*, *Venice Evening* ... many titles evoke a very specific world, the world known through tours of seeing and savoring. (We hear about quite a lot of meals.) Some titles hint at a submerged story, which we can be sure we're not going to hear—like the glimpses, in several of the pictures, of the form of a body on a bed. But there's as much an impulse to play down as to reveal the charge of some of the pictures. Thus, one of the largest of Hodgkin's recent pictures, and one of the most glorious and emotionally affecting, has the title *Snapshot*. While offering a shrewd spread of signals, from the diaristically off-hand, like *Coming Up from the Beach* and *Cafeteria at the Grand Palais*, to the bluntly plaintive, like *Passion*, *Jealousy* and *Love Letter*, the majority of the titles are casually nominative or slightly ironic, which makes them nicely at variance with the pictures' proud exuberance of feeling, their buoyant, ecstatic palette.

Of course, the fact that a person or place is named does not mean it is depicted.

In the Bay of Naples, *Still Life in a Restaurant*, *In a Hot Country* ... the "in" in a fair number of titles carries a dual meaning. It signifies that the artist has been "in" these places, on these fortunate holidays. (We don't expect a Hodgkin title that tells us we are "in" a dungeon.) And that, whether the space named is outdoors or indoors, the picture itself is a kind of interior. One looks into the picture, to something which is both disclosed and hidden.

Some titles—*Lovers*, for instance—confirm the suggestiveness of certain enlacing shapes. A few titles—like *Egyptian Night* and *House Near Venice*—succeed in making the pictures seem representational in the conventional sense. But, exception made for such bravura performances as *Venetian Glass*, Hodgkin is not offering the *look* of the world, an impression. (An emotion is not an impression.) Hardly any of Hodgkin's paintings harbor mimetically distinct shapes, and only a few have shapes which would seem even allusively distinct without the clue supplied by the title. The subjectivism of these pictures is the opposite of the one associated with Impressionism: to preserve the visual freshness of the first fleeting moment that something is seen. Hodgkin aims to reinvent the sight of something after it has been seen, when it has acquired the heavy trappings of inner necessity.

8

Operating on a border very much of his own devising between figuration and abstraction, Hodgkin has made a sturdy case for regarding his choreography of spots, stripes, discs, arcs, swaths, lozenges, arrows, and wavy bands as always representational.

"I am a representational painter, but not a painter of appearances," is how he puts it. "I paint representational pictures of emotional situations." Note that Hodgkin says "emotional situations," not "emotions"; he is not licensing the attempt to read a specific emotion from a given picture, as if *that* were what the picture was "about."

Hodgkin's formula is as elegantly withholding as it is incisive and alert.

Whose emotional situations? The artist's?

Obviously, titles like *After Visiting David Hockney* or *Dinner in Palazzo Albrizzi* or *Indian Sky* would seem to be deceptions if the painter had never met David Hockney, had never visited Italy or India. One has to assume that, in that sense, all the pictures are autobiographical, though only some of the titles make this explicit. Still, few of them are self-referential in the narrow sense. What's on display is not the emotional state of the artist. And the pictures offer the most earnest, emphatic tribute to the world *outside*, its treasurable objects and beauties and opportunities. Indeed, the sublimity of the color in Hodgkin's pictures can be thought of as, first of all, expressive of gratitude—for the world that resists and survives the ego and its discontents. Two passions which we associate with this painter, traveling and collecting, are both expressions of ardent, deferential feeling for what is *not* oneself.

9

So many of the pictures refer to "abroad," as it used to be called. To sites of dalliance already consecrated by great painters of the past, which one never tires of revisiting: India, Italy, France, Morocco, Egypt. Seasons in their foreign plumage: fruit, palm trees, a searingly colored sky. And home pleasures consumed on foreign premises. (*In Bed in Venice* ... not in bed in London; the painter is not traveling alone.) There is love-making and dining and looking at art and shopping and gazing out over water. The sites bespeak an avid eye, and a taste for the domesticated; gardens and terraces, not forests and mountains. The evocation of sensuous, fortunate tourism—dinner parties, nocturnal promenades, cherished art, memorable visits—boldly affirms the idea of pleasure.

But the titles also intimate another relation to pleasure, with their naming of weather and seasons and times of day. The most common weather is rain; the season is invariably autumn; if a time of day is cited, it's usually sunset—which, apart from being the biggest color story in the daily existence of most people, has a large place in the thesaurus of melancholy.

All those titles with "sunset," "autumn," "rain," "after ...," "goodbye to ...," "the last time ..." suggest the rueful shadow cast on all pleasures when they are framed, theatricalized even, as acts of memory.

Hodgkin may often be *en voyage*, but not as a beholder (the Impressionist project). In place of a beholder, there is a rememberer. Both pursuits, that of the traveler and the collector, are steeped in elegiac feeling.

10

After the Shop Had Closed, The Last Time I Saw Paris, When Did We Go to Morocco?, Goodbye to the Bay of Naples ... many titles focus on time ("after"), on the awareness of finalities.

Art made out of a sense of difference, a sense of triumph, a sense of regret.

If there are so many pictures which offer homage to the feelings and sensations that Venice inspires, it is because that city is now, as it could never have been for Turner, a quintessential evoker of the sentiment of loss.

11

It's not that the exotic, or the southern, is required to release the impulse of this "northern" sensibility to paint.

But it may be that this painter needs to travel.

A trip is an intensifier, license to the avid eye (and other senses). You need the separation, from home. And then you need the return home, to consider what you have stored up.

In principle, the painter could make pictures out of everything he has lived through and done and seen. This creates an unbearably acute pressure to paint, and an equally acute feeling of anxiety.

Travel, the impression that one has ventured outside oneself, can be used as a filter and goad. It organizes the desire to paint. It gives it a rhythm, and the right kind of delay.

It is important not to see *too much*. (And there is nothing to reproduce.) Hence, Hodgkin doesn't sketch, doesn't take photographs, doesn't do anything obvious to commit to memory the scene or an interior or a view or a face—instead trusting what will happen when the sight of something has burrowed itself deep down in memory, when it has accumulated emotional and pictorial gravity.

A way of feeling is a way of seeing.

What is worth painting is what remains in, and is transformed by, memory. And what survives the test of long-term deliberation and countless acts of re-vision. Pictures result from the accretion of many decisions (or layers, or brush strokes); some are worked on for years, to find the exact thickness of a feeling.

12

Looking closely at what the swipes and plunges of Hodgkin's brush have deposited on a surface is to feel, sometimes, that one has divined the brush's itinerary, starting from the first, generative surge of feelings. The distinctive shapes in Hodgkin's pictures read like a vocabulary of signals for the circulation, collision, and rerouting of desire.

Sometimes it feels as if the flooding or brimming has spilled over onto the frame. Sometimes it is the frame that has moved inward, thickened, doubled, as if to contain what cannot be contained. (The fat verticals of *Snapshot*, like the sides of a proscenium stage or a gate; the thick oval frame of *Love Letter* that squeezes, crowds the heart of what lies pulsing in the center. ...)

Framing hems in, keeps one from falling off the edge of the world. And framing gives permission to emote.

It makes possible the ambitiousness of Hodgkin's work, and its tight, cunningly judged compactness of statement. Hodgkin has understood that if the pictures are dense enough, they can go in two directions, doing justice to intimate textures as well as to emotions of a large expressiveness. (Both Vuillard *and* opera, so to speak.)

13

Venice: once, again. Imagining the imagined. When you want to see Venice again, and you have seen it many times, rising out of the sea, in winter perhaps, semi-deserted, what you appreciate is that it will not have changed at all.

Or you stand at the railing of the boat going up the Nile, a day's journey from Luxor, and it's sunset. You're just looking. There are no words you are impelled to write down; you don't make a sketch or take a photograph. You look, and sometimes your eyes feel tired, and you look again, and you feel saturated, and happy, and terribly anxious.

There is a price to be paid for stubbornly continuing to make love with one's eyes to these famous tourist-weary old places. For not letting go: of ruined grandeur, of the imperative of bliss. For continuing to work on behalf of, in praise of, beauty. It's not that one hasn't noticed that this is an activity which people rather condescend to now.

Indeed, one might spend a lifetime apologizing for having found so many ways of acceding to ecstasy.

14

The idea is to put as much as possible, of color, of feeling, in each picture. It's as if the pictures need their broad border to contain so much feeling. As if they need to be painted on something hard, wood, since they embody such a large sense of vulnerability.

The sense of vulnerability has not diminished. Nor has the sense of gratitude: for the privilege of feeling, the privilege of voluptuousness, the privilege of knowing more rather than less. There is heroism in the vehemence and the lack of irony of Hodgkin's pictures. He labors over them as if painting could still be a vehicle of self-transcendence.

In such matters, with such purposes, the race is to the slow.

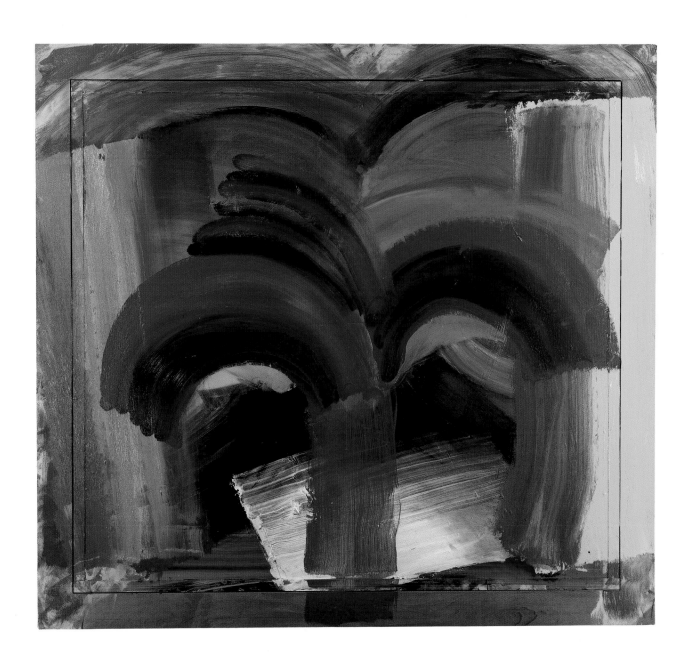

IN TANGIER
1987–90

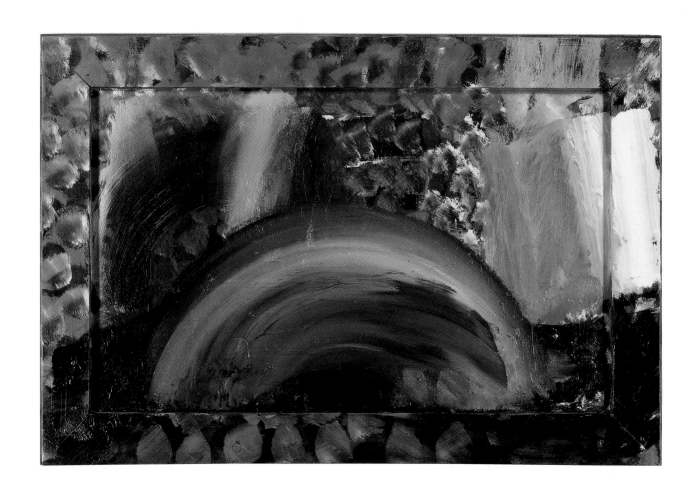

IN THE BLACK KITCHEN
1984–90

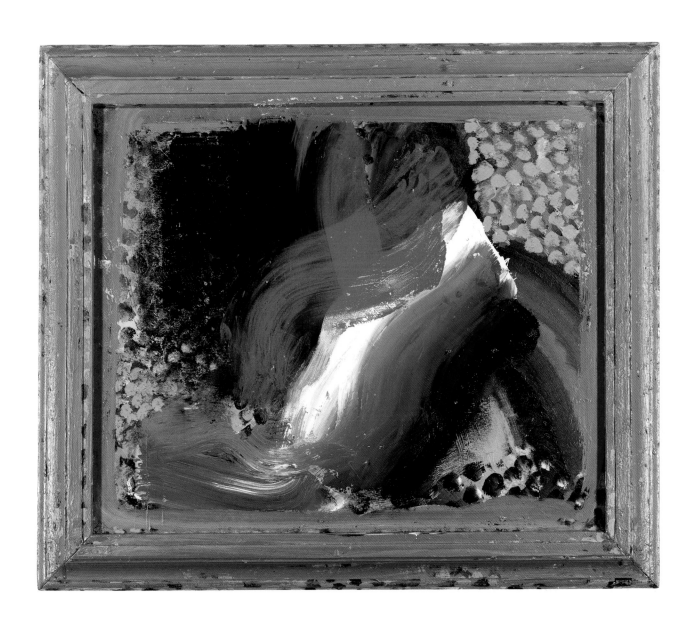

DISCARDED CLOTHES
1985–90

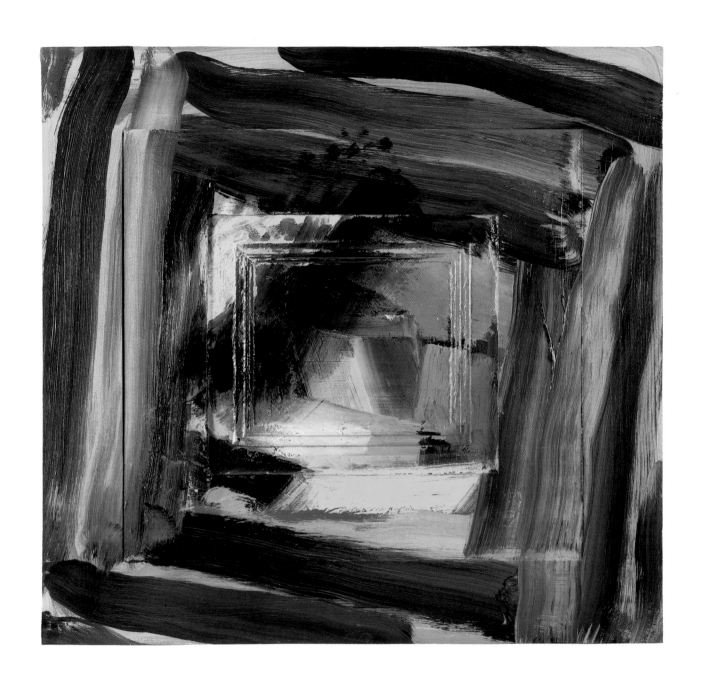

IT CAN'T BE TRUE
1987–90

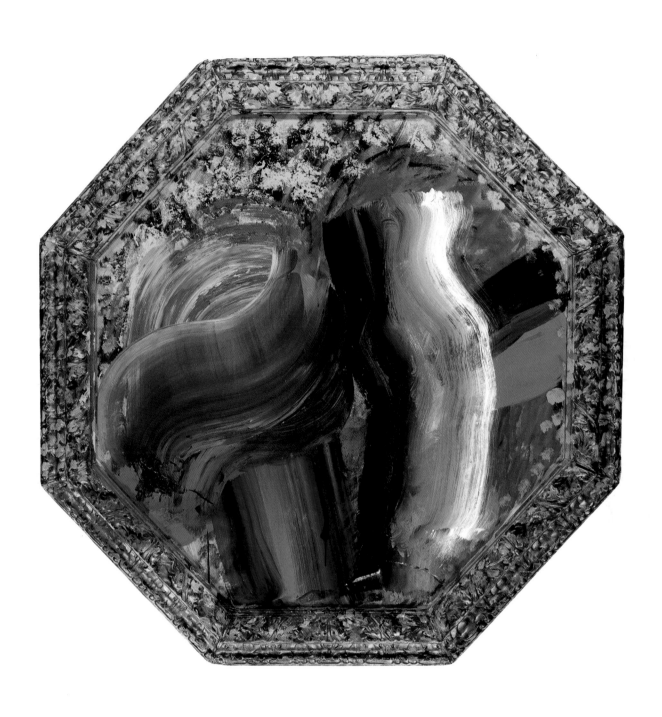

KEITH AND KATHY SACHS
1988–91

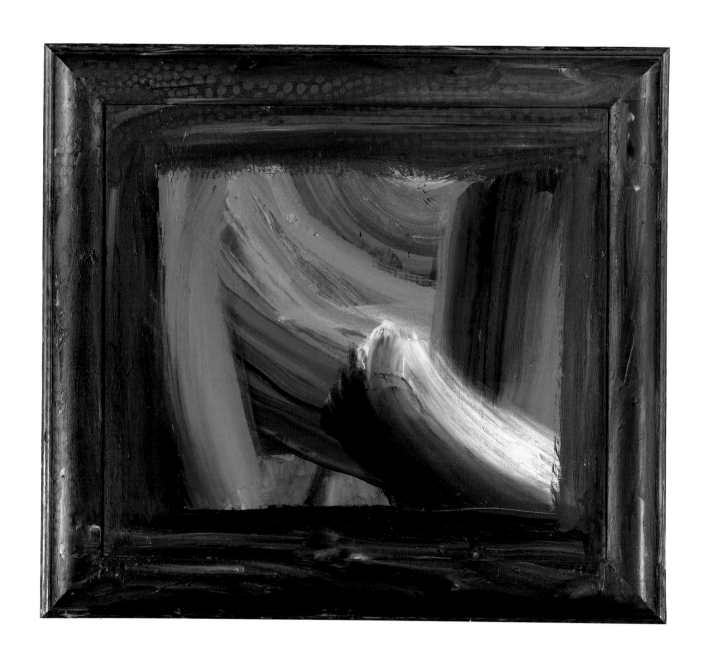

THE LAST TIME I SAW PARIS
1988–91

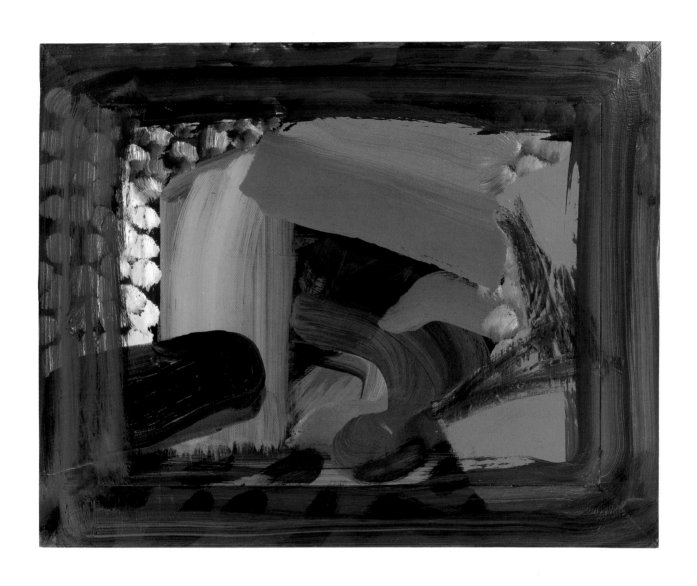

AFTER VISITING DAVID HOCKNEY
1991–92

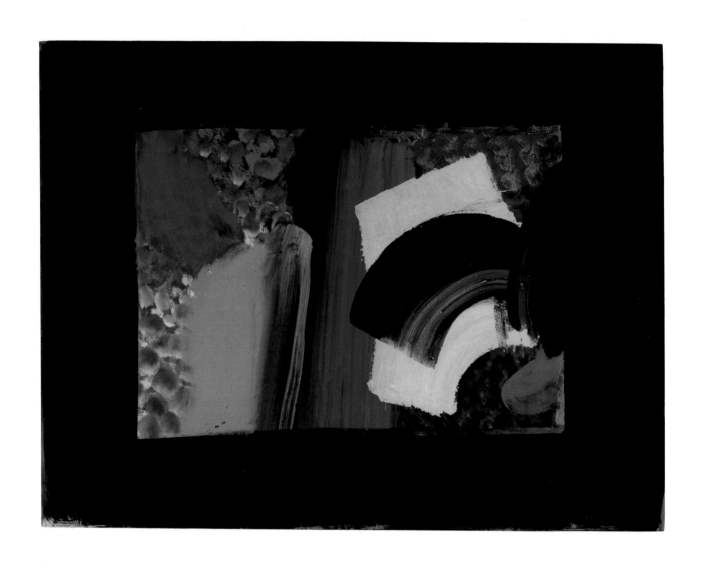

PATRICK CAULFIELD IN ITALY
1987–92

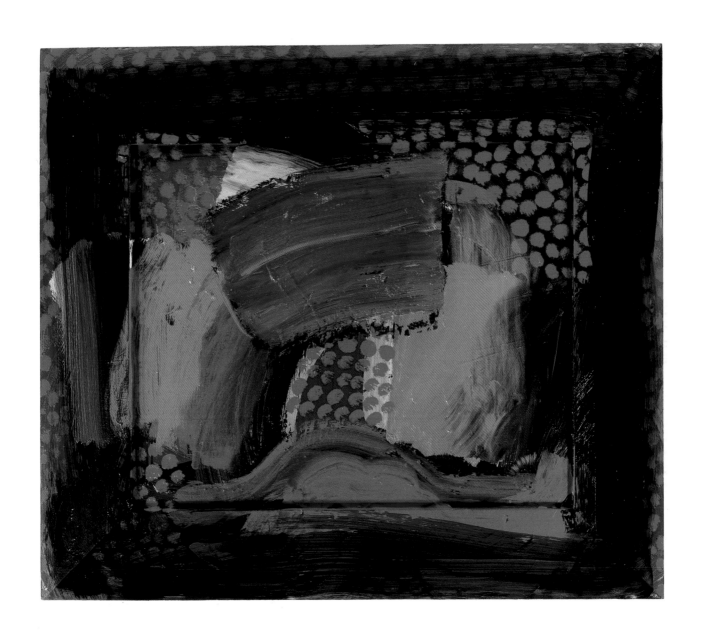

PATRICK IN ITALY
1991–93

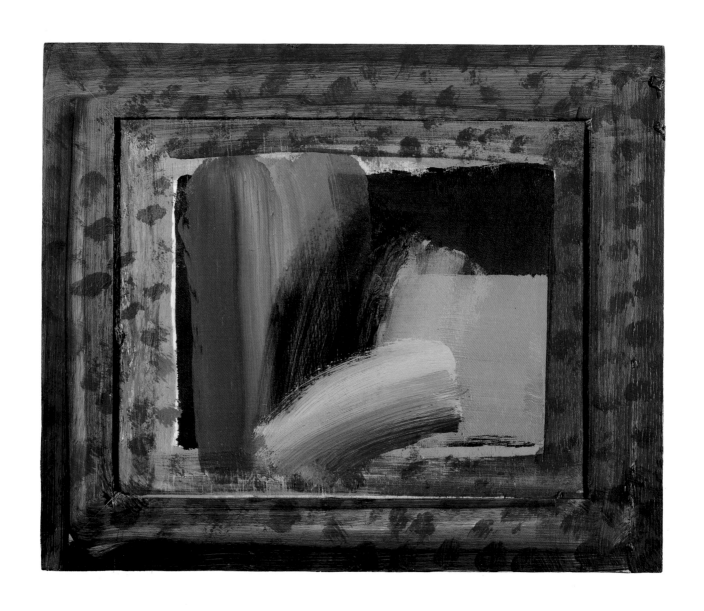

A LEAP IN THE DARK
1992

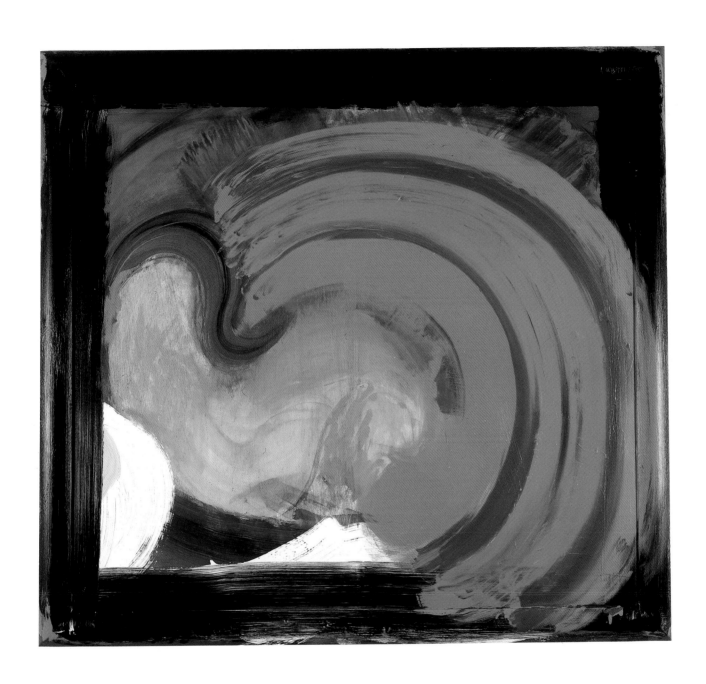

LOVERS
1984–92

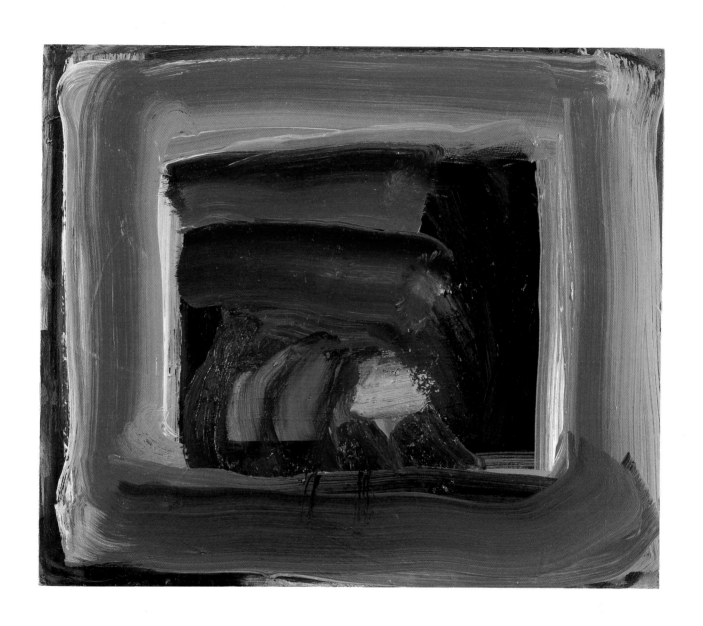

WATERFALL
1991–92

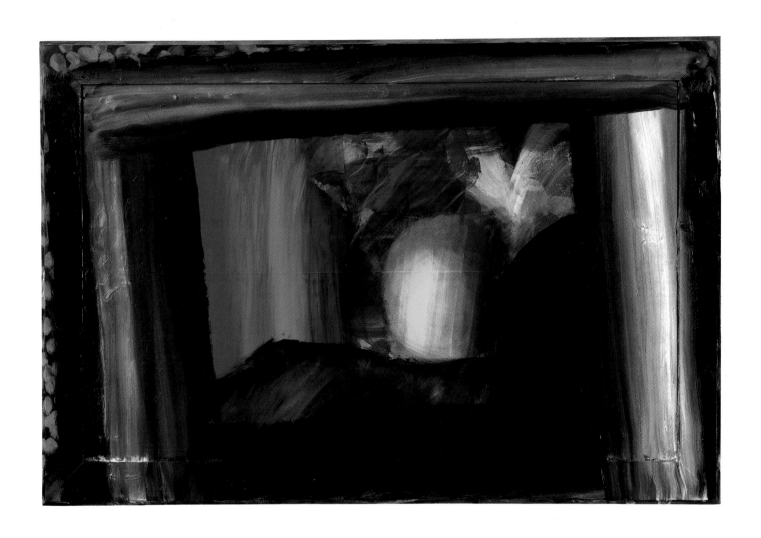

SNAPSHOT
1984–93

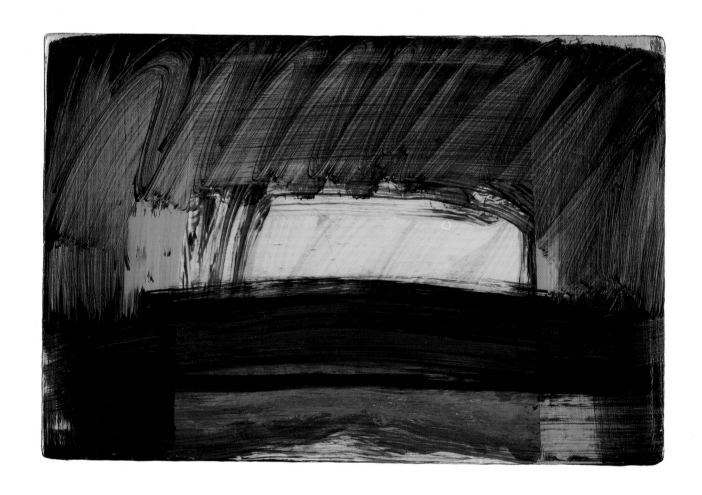

KERALA
1992

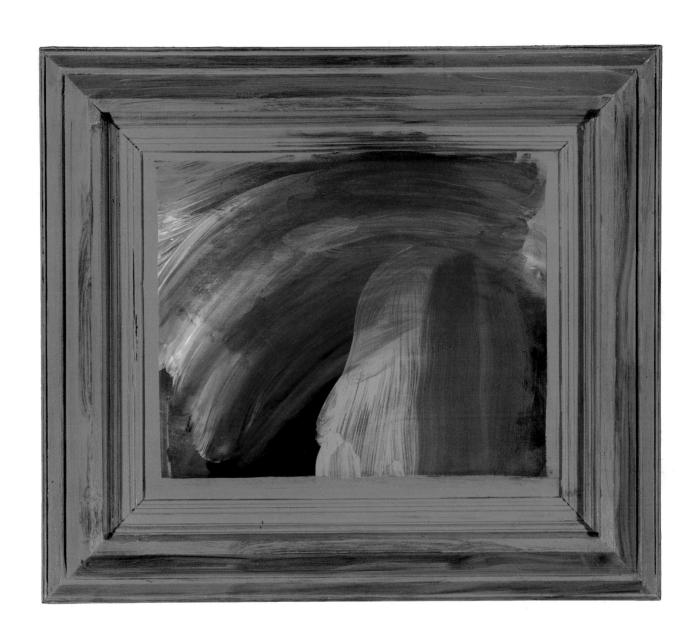

AFTER DEGAS
1993

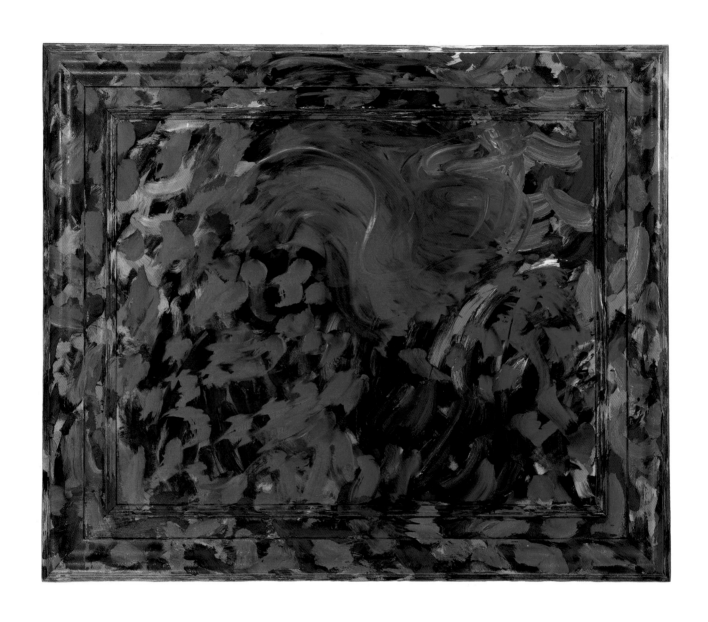

WRITING
1991–93

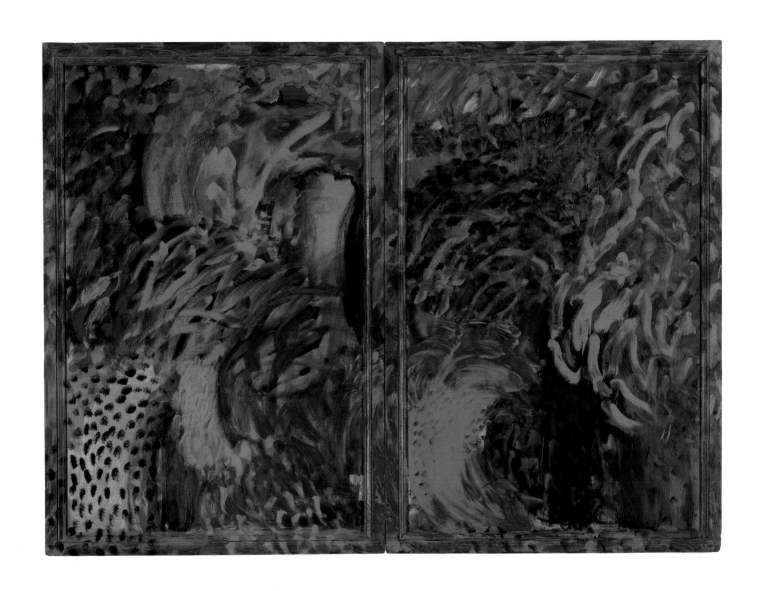

WHEN DID WE GO TO MOROCCO?
1988–93

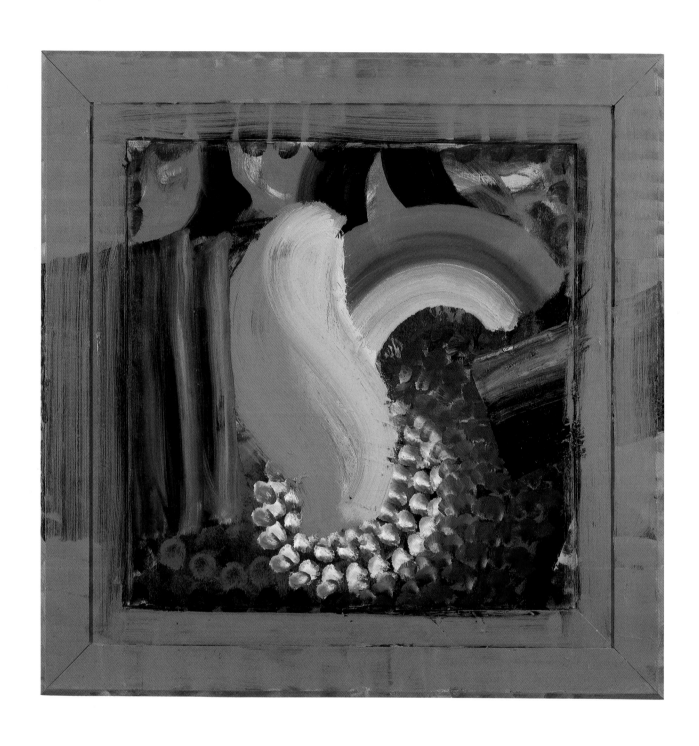

DINNER IN PALAZZO ALBRIZZI
1984–88

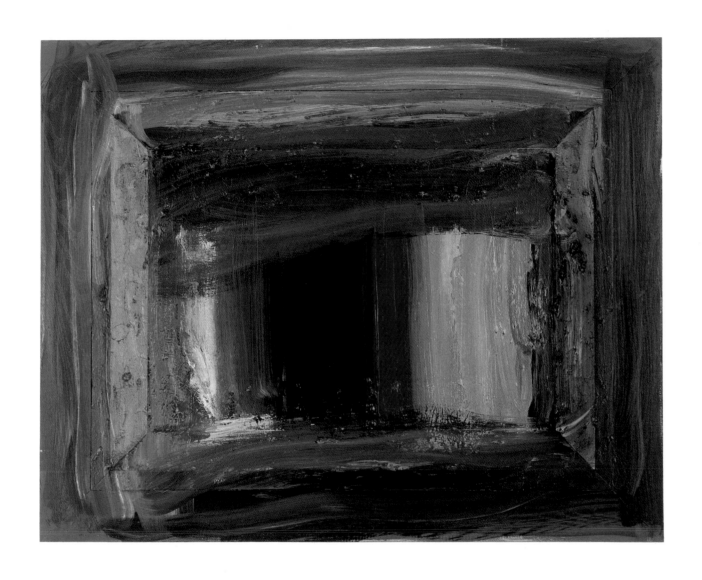

AFTER MORANDI
1989–94

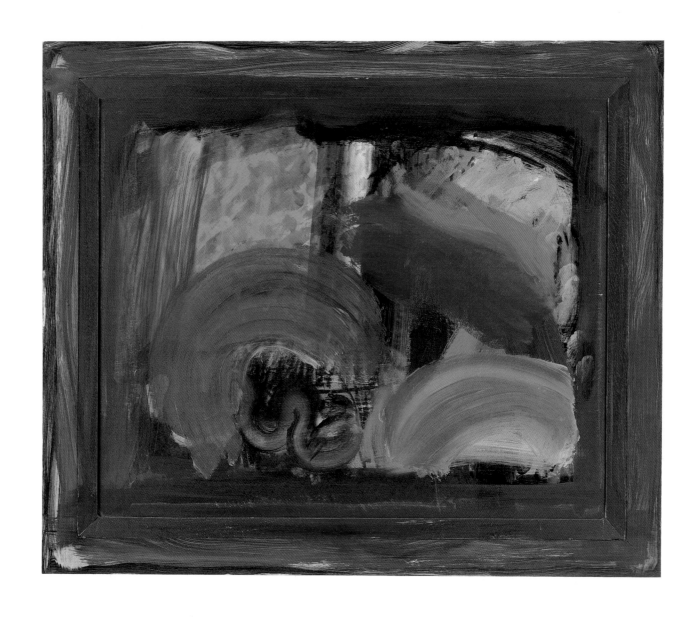

RAIN IN RUTLAND GATE
1992–94

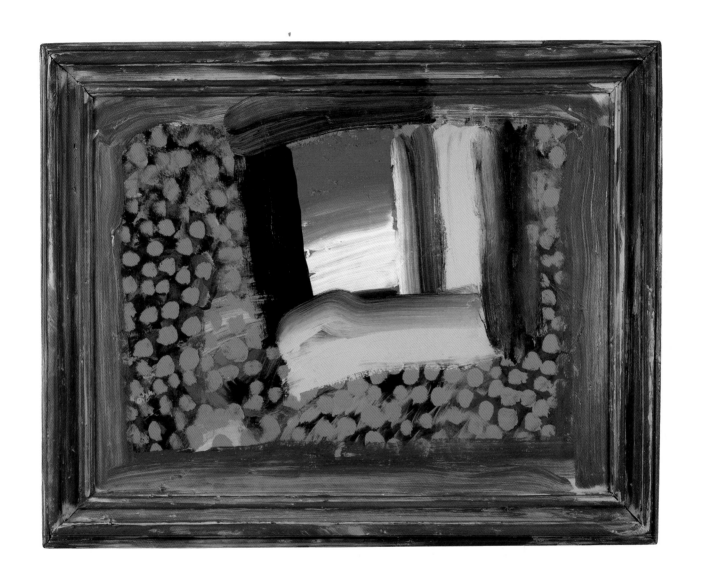

BEDROOM WINDOW
1992–94

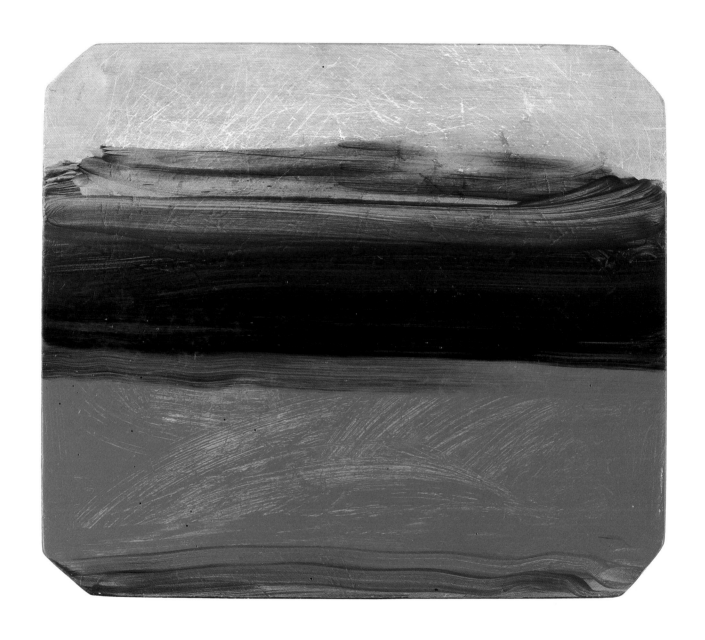

EVENING
1994–95

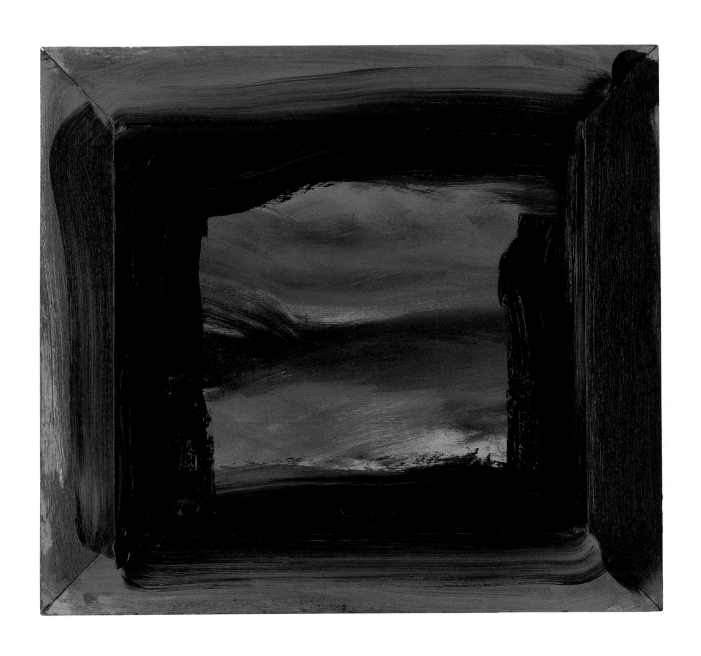

SCOTLAND
1994–95

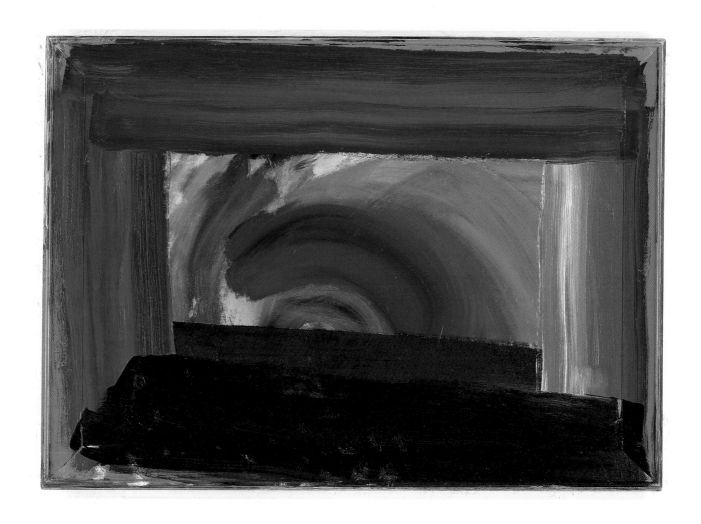

GOSSIP
1994–95

CATALOGUE RAISONNE

The literature on Howard Hodgkin's work is extensive, consisting largely of exhibition catalogues and reviews. Since his first exhibitions in London in the early 1960s, Hodgkin's work has been discussed in a wide variety of English newspapers as well as the international art press, with an ever-increasing volume as his work has become more generally known. In compiling the following entries, general exhibition notices or articles that only report an exhibition without offering any critical insight into the artist or into specific works have not been included. Also omitted are general profiles of the artist or of his activities and considerable achievements as a collector of Indian miniatures, a stage and furniture designer, and a printmaker, unless there is some direct relevance to the oil paintings. The one exception is *Howard Hodgkin: Indian Leaves*, a group of 30 paintings made in India in 1982, using freshly made paper painted with fabric dyes, that were exhibited in the same year at the Tate Gallery, London. The accompanying publication contains a perceptive essay by Bruce Chatwin, as well as a text by Hodgkin.

There is one monograph on Hodgkin's work, by Andrew Graham-Dixon, which was published in 1994. As a large number of works are discussed and illustrated therein, this work has been cited as Graham-Dixon, 1994. There have been three major museum exhibitions of Hodgkin's work, each accompanied by important publications: (1) *Howard Hodgkin: Forty-five Paintings, 1949–75*, organized by the Arts Council of Great Britain and touring to the Serpentine Gallery, London; Turnpike Gallery, Leigh; Laing Art Gallery, Newcastle-upon-Tyne; Aberdeen Art Gallery, Aberdeen; and Graves Art Gallery, Sheffield. (2) *Howard Hodgkin: Forty Paintings, 1973–84*, organized by the British Council and touring to the British Pavilion, Venice Biennale; Phillips Collection, Washington, D.C.; Yale Center for British Art, New Haven, Connecticut; Kestner Gesellschaft, Hannover; and Whitechapel Art Gallery, London. In the Whitechapel Art Gallery ten paintings were added to the exhibition—these are indicated in their respective entries. (3) *Howard Hodgkin: Small Paintings*, organized by the British Council and touring to the Musée des Beaux-Arts, Nantes; Caixa de Pensions, Barcelona; Scottish National Gallery of Modern Art, Edinburgh; and Douglas Hyde Gallery, Trinity College, Dublin. These have been abbreviated and cited in the following entries as Arts Council, 1976; British Council, 1984; and Nantes, 1990, respectively. Finally, the important exhibition organized by the Walker Art Center in 1965, *London: The New Scene*, has been abbreviated to Minneapolis, 1965. Full citations for each of these exhibitions can be found in the bibliography.

1 · TEA PARTY IN AMERICA
1948
Gouache on board
10¼ x 14⅜ in. (26 x 36.5 cm.)
Collection: Private Collection.
Provenance: Sold Sotheby's, London, November 11, 1987, lot 268, ill.
Notes: Signed and dated 1948; signed, titled and dated on the reverse.

2 · MEMOIRS
1949
Gouache on board
8⅝ x 9⅞ in. (22 x 25 cm.)
Collection: The artist.
Exhibitions: Arts Council, 1976, no. 2, ill. color.
Literature: William Feaver, "Hodgkin's Intelligence Tests," *Observer*, March 21, 1976, p. 30: "A little painting of a lady in the psycho-analysis position on a couch, which contains the essential of the later work: the fervent colours, the flattenings, patternings and what comes to look like the intrusion of the room upon the self."; Marina Vaizey, "Kaleidoscopes," *Sunday Times*, April 4, 1976, p. 39: "It sets out some of his continuing pre-occupations. A woman with huge bejewelled hands is stretched on a couch. Nearby a man crouches on a chair. Bold black outlines frame each object within the picture. The domestic interior and its inhabitants continue to fascinate Hodgkin, but the element of caricature vanishes in later work, though wit remains."; John McEwen, "Art: Winning," *Spectator* 236, May 15, 1976, p. 29: "A key to the understanding of all his subsequent work."; Richard Cork, "Every Blob

Counts," *Evening Standard* (London), May 20, 1976, p. 24: "Apart from its cartoon-like emphasis on line, which would later be replaced by an even more pronounced preference for broadly handled brushwork, this little study is astonishingly prophetic. The concentration on figures in a room, the need to stress the objects inhabiting that room as much as its human occupants, the reduction of furnishings and people alike to a flat pattern, the odd decision to let the picture-frame (*sic*) slice off the head of the lady reclining on the sofa—all these elements can be found in Hodgkin's mature work. But perhaps the most telling pointer which this gouache contains is its fascination with memory. As the title suggests, Hodgkin is already taking a scene he experienced at first-hand (when he stayed at the decapitated lady's Long Island home) and using it as a springboard for his own meditation on how he proceeds to select, rearrange, and finally transform the meaning of that scene in retrospect."; Bruce Chatwin, "A Portrait of the Artist," in *Howard Hodgkin: Indian Leaves*, London and New York: Petersburg Press, 1982, pp. 7, 9, ill. color p. 8; Judith Higgins, "In a Hot Country," *ARTnews* 84, Summer 1985, pp. 56–65, ill. p. 59: "It represents his memory of that Long Island summer [1947]. His hostess lies on a sofa in a red drawing room, which is both her prison and a projection of her ego. Beside her in the attitude of voyeur-psychiatrist sits a repressed-looking man. Highly stylized, fiercely outlined and angular, humming with erotic currents, *Memoirs* announces the subject of all Hodgkin's subsequent work: the great tradition in French painting—figures in an interior—transmuted, in Hodgkin's case, by memory."; Timothy Hyman, "Making a Riddle Out of the Solution," in *Howard Hodgkin: Small Paintings 1975–1989*, London: The British Council, 1990, ill. p. 10 (essay reprinted in *Howard Hodgkin*, New York: M. Knoedler and Co., Inc., 1990, pp. 7–13); Graham-Dixon, 1994, pp. 13–14, ill. color p. 15: "*Memoirs*, as its title indicates, is also the first painting to explore what will become an obsession with remembrance, the first picture that begins to define the uneven texture of memory and to find ways of communicating that in the refractory medium of paint."
Notes: The artist has said of this painting: "It took me years to get back to the intensity of that picture. But I wanted to get there from another direction. I wanted to use paint as a substance." (Quoted from Timothy Hyman, "Making a Riddle Out of the Solution," in *Howard Hodgkin*, New York: M. Knoedler and Co., Inc., 1990, p. 8.)

3 · IN THE LUXEMBOURG GARDENS
1957
Oil on canvas
32⅞ x 41⅛ in. (83.5 x 104.5 cm.)
Collection: Michael Goddard, London.
Provenance: The artist; James Lynch, Oxford, acquired directly from the artist; sold Christie's, London, June 29, 1989, lot 635, ill.
Notes: In a letter of July 18, 1989, Hodgkin stated that this was a student work acquired from him while he was still studying—"It is a self-portrait 'seen from the back'—so to speak." Painted in 1957, but signed on the reverse by the artist in 1987.

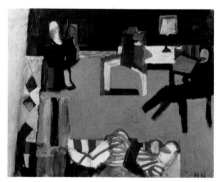

4 · 114 SINCLAIR ROAD
1957–58
Oil on canvas
35 x 44 in. (89 x 112 cm.)
Collection: Unknown.
Provenance: James Lynch, Oxford; Saatchi Collection, London; sold Sotheby's, New York, *Contemporary Art Part II*, Sale 6617, November 2, 1994, lot 114, ill. color.
Exhibitions: *London Group 1959. Annual Exhibition*, RBA Galleries, London, April 18–May 8, 1959, cat. no. 221; Arts Council, 1976, no. 3, ill. color.
Literature: Alistair Hicks, *New British Art in the Saatchi Collection*, London: Thames and Hudson Ltd, 1989, no. 29, ill. color p. 48.
Notes: The title refers to Hodgkin's London address at the time the painting was made; signed with initials.

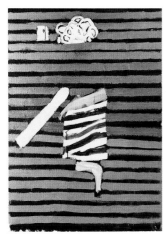

5 · DANCING
1959
Oil on canvas
50 x 36 in. (127 x 91.5 cm.)
Collection: Private Collection.
Provenance: (Arthur Tooth and Sons Ltd, London).
Exhibitions: *Two Young Figurative Painters* [with Allen Jones], ICA Gallery, London, February 14–March 24, 1962, cat. no. 11; *British Painters*, Arthur Tooth and Sons Ltd, London, January 12–30, 1965, no. 19; Arts Council, 1976, no. 4, ill. color.
Literature: Edward Lucie-Smith, "White Magic," *New Statesman*, February 16, 1962: "A very witty picture called *Dancing*, in which a single vertical figure is both positioned, and galvanized into movement, by the use of horizontal lines which interlace and intersect it."; Edward Lucie-Smith, "Howard Hodgkin," *London Magazine* 4, March 1965, pp. 71–75, ill. p. 72: "A work ... which is painted, nonetheless, with the exhilarating bravura which we find in a good Van Dongen."; Richard Morphet, "Introduction," in *Howard Hodgkin: Forty-five Paintings: 1949–75*, London: Arts Council, 1976, p. 10: "It is perhaps with *Dancing* ... that Hodgkin established the type of painting which he has developed, with enrichments, ever since. The parallel and essentially regular bands of alternating colour running from top to bottom and from edge to edge of the canvas (a curious unknowing link—even to the broken edges—with Frank Stella's concurrent *Black* paintings, and especially with his paintings of 1957–58) are an extraordinarily bold device for British painting of their period. They do, in Hodgkin's words, 'bind the painting together and make it exist from edge to edge.' ... Moreover, foreshadowing the completion of so many of Hodgkin's later paintings, it was in this striking device, this final act of obliteration of most of the painting ... that the picture and, paradoxically, the subject were suddenly realised.

Everything in *Dancing* combines to accentuate each component's literal reality. ... If we compare *Dancing* with a painting of 1975, the language has grown richer and more confident, but already in *Dancing* we are totally in Hodgkin's world of uniquely united form and content."; Richard Shone, *The Century of Change: British Painting Since 1900*, Oxford: Phaidon, 1977, ill. plate 173; Graham-Dixon, 1994, ill. color p. 9.
Notes: A double portrait of Cathie Hayes and Jasper Jewitt, friends of the artist.

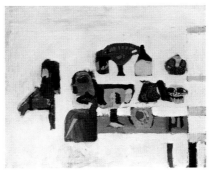

6 · INTERIOR OF A MUSEUM
1956–59
Oil on board
40 x 50 in. (101.5 x 127.1 cm.)
Collection: Tate Gallery, London.
Provenance: (Kasmin Gallery Ltd, London).
Exhibitions: *London Group 1960. Annual Exhibition*, RBA Galleries, London, January 15–February 5, 1960, cat. no. 140; Arts Council, 1976, no. 5, ill. color; *The Hard-Won Image: Traditional Method and Subject in Recent British Painting*, Tate Gallery, London, July 4–September 9, 1984, no. 74, ill. p. 64.
Literature: Richard Morphet, "Introduction," in *Howard Hodgkin: Forty-five Paintings: 1949–75*, London: Arts Council, 1976, p. 9: "A key painting in the emergence of the mature Hodgkin. ... In this picture of human heads and painted pots seen in and around a glass case we see form and representational image coalescing to their individually enhanced articulation, with a freedom which reveals the limitations of *Memoirs*. Further advances since the early period are indicated in the affinity with Bonnard—the identification of sensuous paint quality and of a powerful sense of the seen world with a rigorous pictorial structure."; Richard Shone, "Current and Forthcoming Exhibitions: London," *Burlington Magazine* 121, July 1979, p. 456; *The Tate Gallery 1976–78: Illustrated Catalogue of Acquisitions*, London: Tate Gallery Publications, 1978, p. 96, ill., quotes a letter from the artist of May 2, 1978: "'I have always been fascinated by the relation of people to things and in museums would often look through the glass cases at people

looking in at the objects from the other side.' In a 1975 conversation, Hodgkin noted that the painting represents figures seen through a glass case in the British Museum containing ancient Greek painted pots, suggesting an equivalence between ancient two-dimensional images of faces painted on the pots and the real contemporary faces seen with them simultaneously. ... To the left of the case is Hodgkin's wife Julia and in front of it, in profile, finger in mouth, an unknown man."
Notes: Unsigned.

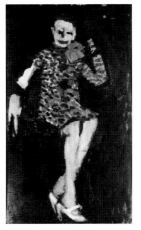

7 · PORTRAIT OF MRS. WALL
1959
Oil on panel
31⅝ x 18⅞ in. (80.3 x 48 cm.)
Collection: Unknown.
Provenance: Sold Sotheby's, London, 1984, lot 611, ill.
Notes: Dr. and Mrs. Errol Wall are friends of the artist.

8 · DOWNSTAIRS
1958–60
Oil on canvas
20 x 30 in. (51 x 76 cm.)
Collection: Private Collection.
Provenance: (Arthur Tooth and Sons Ltd, London).
Exhibitions: *Two Young Figurative Painters* [with Allen Jones], ICA Gallery, London, February 14–March 24, 1962, cat. no. 12.

9 · GIRL IN A MUSEUM
1958–60
Oil on canvas
40 x 28 in. (102 x 71 cm.)
Collection: Private Collection, London.
Exhibitions: *Two Young Figurative Painters* [with Allen Jones], ICA Gallery, London, February 14–March 24, 1962; *Howard Hodgkin*, Arthur Tooth and Sons Ltd, London, October 16–November 10, 1962, no. 4, ill.; *Englische Kunst der Gegenwart*, Stadtische Kunstgalerie, Bochum, April–July 1964, no. 78, ill.; Arts Council, 1976, no. 19, ill. p. 41.
Literature: Harold Osborne, "Howard Hodgkin," *Arts Review* 28, May 14, 1976, p. 239.

10 · MR. AND MRS. ROBYN DENNY
1960
Oil on canvas
36 x 50 in. (91.5 x 127 cm.)
Collection: Saatchi Collection, London.
Provenance: Mr. and Mrs. Robyn Denny; (Waddington Galleries, London); sold Sotheby's, London, December 6, 1984, lot no. 544, ill.
Exhibitions: *Two Young Figurative Painters* [with Allen Jones], ICA Gallery, London, February 14–March 24, 1962, cat. no. 6; Minneapolis, 1965, no. 32; Arts Council, 1976, no. 6, ill. color; *The Sixties Art Scene in London*, Barbican Art Gallery, London, March 11–June 13, 1993, ill. color p. 85.
Literature: Toni del Renzio, "Away from Kitchen-Sink Realism," *Topic* 1, February 10, 1962, p. 30, ill. as "Portrait of Roby and Anna Denny"; Keith Sutton, "Around the London Art Galleries,"

Listener 117, March 1, 1962, p. 382, ill.: "In order to touch our imaginations he [Hodgkin] makes reference to what we think we already know about the plasticity of people and things. In this way he exposes his own highly personal and imaginative handling of his subject matter, and particularly his handling of the paint itself, to criticisms of incompetence or uncertainty. Such criticism would be foolish. The 'hesitancies' that remain visible on the canvas are clues to the ambiguities of reality which he has searched for with virile brushwork and a sensitive awareness of the equally real character of paint."; Alistair Hicks, *New British Art in the Saatchi Collection*, London: Thames and Hudson Ltd, 1989, p. 47, ill. color no. 28, p. 48: "The double portraits in the Collection span the crucial period of Hodgkin's development. *Mr. and Mrs. Robyn Denny* (1960) confront us full on. There are tricks. The background pattern is not as straightforward as it at first looks, nor are Denny's red eyes as flatly painted as they appear, but by 1974 when *Dick and Betsy Smith* was finished [see cat. no. 114] there is not a trace of such crude confrontation. The traditional representation of the sitters, again a painter and his wife, has all but disappeared. The success of the picture now totally depends on the marks of paint and the way they interact with each other."; Pauline Peters, "The Collector," [profile of Charles Saatchi] *Telegraph Weekend Magazine*, October 28, 1989, pp. 18–27, ill. color p. 18; Graham-Dixon, 1994, p. 13, ill. color p. 12: "Even the vivid geometries that surround the marionette figures of *Mr. and Mrs. Robyn Denny* (1960) are, while exuberant, also tyrannical. Hodgkin has invented a scheme of colour and form that serves to fix the subjects (who both stare into space, one through sunglasses, the other with boss-eyed dumbness), to immobilize them like a pair of pinned butterflies. Stranded in these acres of crude pattern, a whole interior condensed to a sign for one, they are people who seem victimized by their own taste for brashness, trapped by their environment."
Notes: Alternative titles are *Robyn and Anna Denny* and *Portrait of Robyn and Anna Denny.*

11 · THE ROOM
1960
Oil on hardboard
28½ x 33½ in. (72 x 85 cm.)
Collection: Unknown.
Provenance: (Arthur Tooth and Sons Ltd, London); Charles Ewart, London; (Kasmin Gallery Ltd, London); (Odette Gilbert Gallery, London); Saatchi Collection, London; sold Sotheby's, New York, November 2, 1994, lot 130, ill.
Exhibitions: *Contrasts: An Exhibition of Work by Members of the AIA*, AIA Gallery, London, May 1961; *Twenty Painters*, AIA Gallery, London, September 1961, checklist no. 44; *British Painters*, Arthur Tooth and Sons Ltd, London, January 12–30, 1965, no. 20; *First Triennale—India 1968*, Lalit Kala Akademi, New Delhi and National Gallery of Modern Art, New Delhi, February 11–March 31, 1968, cat. no. 10.
Notes: A portrait of the artist and his wife at their home at 114 Sinclair Road, London, W14.

12 · STAFF MEETING, CORSHAM
1959–60
Oil on canvas
44 x 60 in. (112 x 152 cm.)
Collection: Kettering Art Gallery, gift of the Contemporary Art Society, London.
Provenance: (Arthur Tooth and Sons Ltd, London); Contemporary Art Society, London.
Exhibitions: *London Group 1961. Annual Exhibition*, RBA Galleries, London, March 9–29, 1961, cat. no. 236; *Contrasts: An Exhibition of Work by Members of the AIA,* AIA Gallery, London, May 1961, cat no. 2; *Two Young Figurative Painters* [with Allen Jones], ICA Gallery, London, February 14–March 24, 1962, cat. no. 5; *British Painting in the Sixties: An Exhibition Organized by the Contemporary Art*

Society, Section Two, Whitechapel Art Gallery, London, June 1–30, 1963, cat. no. 148 as *Staff Meeting*; *The New Image*, Arts Council Gallery, Belfast, September 1964, cat. no. 13; *Corsham Painters and Sculptors* (organized by the Arts Council), Bath Festival, June 1965; *Corsham: A Celebration, The Bath Academy of Arts 1946–72*, Victoria Art Gallery, Bath, December 10, 1988–January 14, 1989; Brighton Polytechnic Gallery, Brighton, January 23–February 14, 1989; Michael Parkin Gallery, London, February 22–March 24, 1989, no. 57; *British Contemporary Art 1910–1990. 80 Years of Collecting in the Contemporary Art Society*, Hayward Gallery, London, December 3, 1991–January 19, 1992.

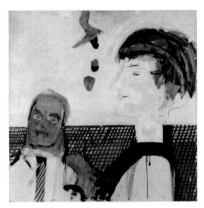

13 · ADRIAN AND CORINNE HEATH
1960–61
Oil on canvas
30 x 36 in. (76 x 91 cm.)
Collection: Corinne Heath.
Provenance: Acquired directly from the artist.
Exhibitions: *Two Young Figurative Painters* [with Allen Jones], ICA Gallery, London, February 14–March 24, 1962, cat. no. 7.
Literature: Roger Coleman, "Introduction," in *Two Young Figurative Painters: Howard Hodgkin, Allen Jones*, London: ICA Gallery, 1962: "The backgrounds always perform three functions but not always arranged in the same hierarchy: (1) as the demonstration of surface through pattern (2) to imply some identifiable environment—a room, a settee, a bed, and (3) as a reinforcement of the mood, or if you like, the 'content' of the figures in that environment. ... In the portrait of Adrian and Corinne Heath the red cross-hatching behind the figures function as (1) pattern, and (2) a screen, wall, settee-back, but hardly at all as (3)."

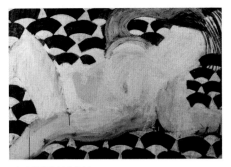

14 · AFTERNOON
1959–61
Oil on board
36 x 50 in. (91 x 127 cm.)
Collection: Private Collection, London.
Exhibitions: *Two Young Figurative Painters* [with Allen Jones], ICA Gallery, London, February 14–March 24, 1962, cat. no. 1; *Figuratie en Defiguratie*, Museum voor Schone Kunsten, Ghent, 1964; *Op & Pop, Aktuell Engelsk Konst*, Riksforbundet für bildande konst och SAN, Stockholm, 1965, no. 18, ill; *British Painters*, Arthur Tooth and Sons Ltd, London, January 12–30, 1965, no. 18.
Literature: Robert Melville, "Gallery: Objets d'Art," *Architectural Review* 137, April 1965, pp. 291–93, ill. p. 293.

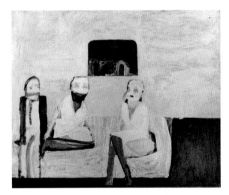

15 · BEDROOM
1960–61
Oil on canvas
42 x 50 in. (107 x 127 cm.)
Collection: The artist.
Exhibitions: *Twenty Painters*, AIA Gallery, London, September 1961, checklist no. 43; *Britisk Kunst*, Sammenslutningen af Danske Kunstforeininger, Denmark, 1962–63, no. 26, ill.; *Two Young Figurative Painters* [with Allen Jones], ICA Gallery, London, February 14–March 24, 1962, cat. no. 4.
Notes: The artist, his wife and a friend, Mrs. Burt, in a hotel bedroom in Paris.

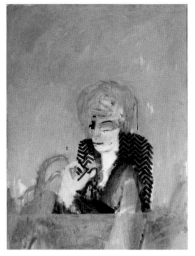

16 · CATHIE HAYES
1961
Oil on canvas
40 x 30 in. (102 x 76 cm.)
Collection: Kronos Collection.
Provenance: The artist; Mr. and Mrs. G. B. Cooke, by descent; sold Sotheby's, London, Contemporary Art, Part I, November 30, 1994, lot 24, ill. color p. 53, as *The Yellow Lady*, dated 1965–70.
Exhibitions: *Two Young Figurative Painters* [with Allen Jones], ICA Gallery, London, February 14–March 24, 1962, cat. no. 10.
Notes: Cathie Hayes, a friend of the artist, is the subject of *Dancing*, cat. no. 5. Unsigned.

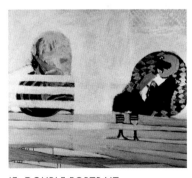

17 · DOUBLE PORTRAIT
1961
Oil on canvas
36 x 40 in. (91 x 102 cm.)
Collection: Private Collection, England.
Provenance: (Arthur and Tooth and Sons Ltd, London); Lord Croft; (Redfern Gallery, London).
Exhibitions: *Two Young Figurative Painters* [with Allen Jones], ICA Gallery, London, February 14–March 24, 1962, cat. no. 8.
Notes: A portrait of Clifford and Rosemary Ellis; Ellis was principal of the Bath Academy of Art and an important influence for Hodgkin.

18 · MARTIN FROY
1961
Oil on canvas
45 x 45 in. (114 x 114 cm.)
Collection: Destroyed by the artist.
Exhibitions: *Two Young Figurative Painters* [with Allen Jones], ICA Gallery, London, February 14–March 24, 1962, cat. no. 9.
Notes: The subject was a colleague of Hodgkin's at the Bath Academy of Art, Corsham, who has now retired as professor of Fine Art at Reading University, England.

19 · THREE O'CLOCK
1960–61
Oil on canvas
41 x 52 in. (104 x 132 cm.)
Collection: Destroyed by the artist.
Provenance: Collection of the artist.
Exhibitions: *Britisk Kunst*, Sammenslutningen af Danske Kunstforeininger, Denmark, 1962–63, no. 27; *Two Young Figurative Painters* [with Allen Jones], ICA Gallery, London, February 14–March 24, 1962, cat. no. 2.
Notes: A portrait of W. G. Archer, Keeper of the Indian Department of the Victoria and Albert Museum, London, and a friend of the artist.

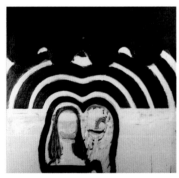

20 · TRAVELLING
1961
Oil on canvas
50 x 52 in. (127 x 132 cm.)
Collection: The artist.
Exhibitions: *Two Young Figurative Painters* [with Allen Jones], ICA Gallery, London, February 14–March 24, 1962, cat. no. 3.

21 · BEDROOM
1962
Oil on canvas
20 x 24 in. (51 x 61 cm.)
Collection: Destroyed by the artist.
Exhibitions: *Howard Hodgkin*, Arthur Tooth and Sons Ltd, London, October 16–November 10, 1962, cat. no. 3.

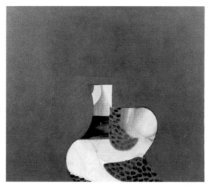

22 · BRIGID SEAGRAVE
1961–62
Oil on canvas
34 x 39 in. (86 x 99 cm.)
Collection: Mrs. Roger Coleman, gift of the artist.
Exhibitions: *Howard Hodgkin: Recent Paintings*, Arthur Tooth and Sons Ltd, London, February 28–March 25, 1967, cat. no. 7.
Notes: A portrait of a friend of the artist.

23 · FUSINA
1962
Oil on canvas
28 x 40 in. (71 x 102 cm.)
Collection: Destroyed by the artist.
Exhibitions: *Howard Hodgkin*, Arthur Tooth and Sons Ltd, London, October 16–November 10, 1962, no. 2.
Notes: The painting was returned to the artist in February 1964 by Arthur Tooth and Sons Ltd, London, and was subsequently destroyed. The title refers to a port near Venice.

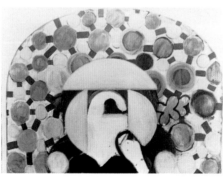

24 · GARDEN
1960–62
Oil on canvas
41 x 57 in. (104 x 145 cm.)
Collection: Private Collection, London.
Exhibitions: *Howard Hodgkin*, Arthur Tooth and Sons Ltd, London, October 16–November 10, 1962, cat. no. 13, not ill.; *British Painting in the Sixties: An Exhibition Organized by the Contemporary Art Society*, Section Two, Whitechapel Art Gallery, London, June 1–30, 1963, cat. no. 149; *Profile III: Englische Kunst der Gegenwart,* Stadtische Kunstgalerie, Bochum,

April–July 1964, no. 79; Minneapolis, 1965, no. 34, ill. color p. 23; Arts Council, 1976, no. 7, ill. color.
Literature: Norbert Lynton, "London Letter," *Art International*, December 1962; Martin Friedman, *London: The New Scene*, Minneapolis: Walker Art Center, 1965, p. 22; Patricia Boyd Wilson, "The Home Forum," *The Christian Science Monitor*, July 17, 1965: "'Garden,' a large oil, was painted from memory, as are all of Hodgkin's paintings; it is a crowded canvas filled with vermilion, chrome yellow, and green forms, which suggest trellis and flowers."

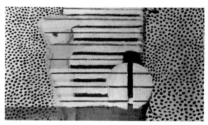

25 · INTERIOR
1962
Oil on board
18 x 31½ in. (46 x 80 cm.)
Collection: Private Collection.
Exhibitions: *Howard Hodgkin*, Arthur Tooth and Sons Ltd, London, October 16–November 10, 1962, no. 6.

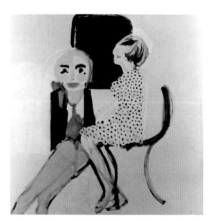

26 · JULIA AND MARGARET
1962
Oil on canvas
40 x 40 in. (102 x 102 cm.)
Collection: Private Collection, England.
Provenance: (Arthur Tooth and Sons Ltd, London); Charles Ewart.
Exhibitions: *Howard Hodgkin*, Arthur Tooth and Sons Ltd, London, October 16–November 10, 1962, cat. no. 12; *Critic's Choice: An Exhibition of Contemporary British Painting and Sculpture Selected by Philip James, C.B.E.*, Stone Gallery, St. Mary's Place, Newcastle-upon-Tyne, July 1963, cat. no. 12, p. 8; *Britische Malerei der Gegenwart,*

Kunstverein für die Rheinlande und Westfalen, Düsseldorf, May 24–July 5, 1964, no. 40, ill.
Literature: Edward Lucie-Smith, "The Impact-Makers," *Vogue* (UK), August 1963, pp. 58–59, ill. p. 57: "Hodgkin is perhaps the nearest thing to a really classical artist at present working in England. He uses figures and objects as elements in a strict design. The tension in his pictures comes from the need to reconcile what we actually see, the world of appearances, with the need for flat pattern and absolute order. ... It is only when we look at his shapes carefully that they resolve themselves into a recognisable image. Yet curiously enough, this rather severe artist likes bright colour and also likes themes which are hedonistic in themselves. The picture shown here, for example, bears a more than superficial resemblance to that interesting (and rather underrated) painter of fashionable life, Van Dongen. The ambiguity makes us look and look again."
Notes: This painting is partly a study for *Hotel*, cat. no. 43. The subjects are the artist's wife, Julia, and Margaret Coleman.

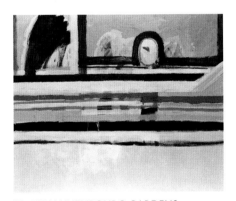

27 · THE LUXEMBOURG GARDENS
1960–62
Oil on canvas
42 x 50 in. (107 x 127 cm.)
Collection: Arts Council Collection, South Bank Centre, London.
Provenance: (Arthur Tooth and Sons Ltd, London).
Exhibitions: *Howard Hodgkin*, Arthur Tooth and Sons Ltd, London, October 16–November 10, 1962, no. 5, ill.; *New Painting 1961–1964*, Arts Council, July 11–October 24, 1964; Minneapolis, 1965 (including tour), no. 33; *Peter Moores Liverpool Project 5: The Craft of Art*, Walker Art Gallery, Liverpool, November 3, 1979–February 13, 1980; *British Art 1940–1980* (Arts Council Collection), Hayward Gallery, London, July 9–August 10, 1980.
Literature: Denis Bowen, "William Brooker and Howard Hodgkin," *Arts Review* 14, October 20–November 3, 1962, p. 19, ill.; *New Painting*

1961–64, London: Arts Council, 1965, ill.; *Arts Council Collection, A Concise, Illustrated Catalogue*, London: Arts Council, 1979, p. 129, ill.

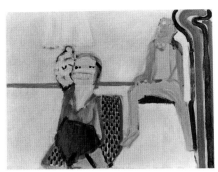

28 · MR. AND MRS. JAMES TOWER
1962
Oil on canvas
36 x 48 in. (91 x 122 cm.)
Collection: Saatchi Collection, London.
Provenance: (Arthur Tooth and Sons Ltd, London).
Exhibitions: *British Painting and Sculpture, Today and Yesterday*, Arthur Tooth and Sons Ltd, London, April 3–28, 1962, no. 8; Arts Council, 1965; *AIA Retrospective 1930–1970*, AIA Gallery, London, October 1970, cat. no. 10.
Literature: Robyn Denny, "London Letter," *Kunstwerk* 16, November–December 1962, pp. 70–80: "Hodgkin's work develops slowly, and some of the paintings on view have been evolved over two or three years. They are not continuously worked on during this time but he likes to experience a strong 'physical' sensation of his subject combined with a sort of feedback between himself and it to determine the direction the work will take. Many of his pictures are 'portraits' in the sense that the subject's name becomes the title of the painting ... but they do not derive from visual analysis except in that visual observation suggests a range of painterly analogies which are manipulated to convey a highly subjective interpretation of his own responses. Some of his figures verge on caricature and seem on the edge of triviality without ever actually being trivial. They are in fact subtle and meaningful statements of a shrewd and perceptive curiosity, and this immediately separates him from the other more doctrinaire, more frivolous image painters with whom he has recently been associated and whose works are sometimes to be seen in the same gallery."; "New Year Exhibitions in London," *Apollo* 127, January 1963, p. 54, ill. no. 8.
Notes: James Tower was a well-known sculptor and colleague of Hodgkin's at Corsham.

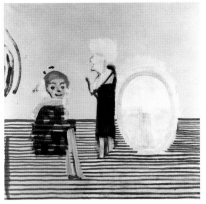

29 · MR. AND MRS. NEVILLE VINCENT AND MRS. ADRIAN HEATH
1962
Oil on canvas
36 x 36 in. (91 x 91 cm.)
Collection: Bruce and Judith Eissner.
Provenance: (Arthur Tooth and Sons Ltd, London); Dr. R. Taylor; (M. Knoedler and Co., Inc., New York).
Exhibitions: *British Painting and Sculpture, Today and Yesterday*, Arthur Tooth and Sons Ltd, London, April 3–28, 1962, cat. no. 10, ill.
Literature: "The World of Art," *Sunday Times*, April 8, 1962, ill. as *Mr. and Mrs. Neville Vincent*; Jasia Reinhardt, "Pop Art and After," *Art International* 7, February 1963, pp. 42–47, ill.
Notes: Originally titled *Mr. and Mrs. Neville Vincent*, Mr. Vincent threatened defamation as the painting apparently represented two figures in skirts. He was actually the egg-shaped head-form on right—thus the title was changed in explanation. A correction was published in *The Times* (London) on May 6, 1962. The Vincents are friends of the artist. Signed on the reverse.

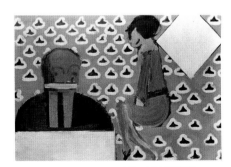

30 · MR. AND MRS. ROGER COLEMAN
1962
Oil on board
30 x 44½ in. (76 x 113 cm.)
Collection: Fundacao dos Museus, Regionais da Bahia.
Provenance: (Arthur Tooth and Sons Ltd, London).
Exhibitions: *Howard Hodgkin*, Arthur Tooth and Sons Ltd, London, October 16–November 10,

1962, no. 1; *Britische Malerei der Gegenwart*, Kunstverein für die Rheinlande und Westfalen, Düsseldorf, May 24–July 5, 1964, no. 39; *Trends in Contemporary British Painting*, Bear Lane Gallery, Oxford, June 1965, no. 37; *London Under Forty*, Galleria Milano, Milan, June 7–25, 1966, ill. p. 176.

Notes: Roger Coleman was instrumental in arranging Hodgkin's first exhibition, with Allen Jones, at the ICA in London in 1962.

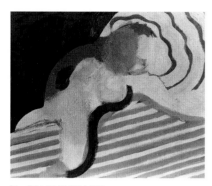

31 · ON THE BEACH
1962
Oil on board
18 x 21 in. (46 x 53 cm.)
Collection: Unknown.
Provenance: (Arthur Tooth and Sons Ltd, London); Mrs. G. B. Cooke; The Cooke Family Collection; sold Sotheby's, London, May 24, 1990, lot 760.
Exhibitions: *Howard Hodgkin*, Arthur Tooth and Sons Ltd, London, October 16–November, 1962, cat. no. 10, ill.

32 · PARIS
1962
Oil on canvas
36 x 40 in. (91 x 102 cm.)
Collection: Destroyed by the artist.
Exhibitions: *Britisk Kunst*, Sammenslutningen af Danske Kunstforeininger, Denmark, 1962–63, no. 28; *British Painting and Sculpture, Today and Yesterday*, Arthur Tooth and Sons Ltd, London, April 3–28, 1962, cat. no. 13.
Notes: The painting was returned to the artist by Arthur Tooth and Sons Ltd, London, on July 31, 1964, and was subsequently destroyed.

33 · PORTRAIT
1962
Oil on canvas
36 x 36 in. (91 x 91 cm.)
Collection: Unknown.
Provenance: (Arthur Tooth and Sons Ltd, London); Private Collection, Chicago.
Literature: "One Choice of British Art: Formula Changed," *The Times* (London), January 30, 1963, p. 13; Edward Lucie-Smith, "Howard Hodgkin," *London Magazine* 4, March 1965, pp. 71–75.
Notes: A portrait of Kate Gordon-Cumming, a friend of the artist.

34 · PORTRAIT OF MRS. RHODA COHEN
1962
Oil on canvas
36 x 36 in. (91.5 x 91.5 cm.)
Collection: Scottish National Gallery of Modern Art, Edinburgh, presented by the Contemporary Art Society, London.
Provenance: Ind. Coope Art Collection; (Kasmin Gallery Ltd, London); (Waddington and Tooth, London); Contemporary Art Society, London.
Exhibitions: *1962: One Year of British Art Selected by Edward Lucie-Smith*, Arthur Tooth and Sons Ltd, London, January 22–February 9, 1963, cat. no. 11.
Literature: Robert Melville, "Exhibitions," *Architectural Review* 133, April 1963, pp. 288–90, ill.: "Hodgkin, in his 'Portrait of Mrs. Rhoda Cohen', 8, seemed to be using painting as black

magic, for if appearances are anything to go by he was bent on replacing Mrs. Cohen's identity with a somewhat obscure display of his own."
Notes: A portrait of the former Mrs. Bernard Cohen, later Mrs. William Brooker.

35 · PORTRAIT OF S.D.
1962
Oil on canvas
48 x 48 in. (122 x 122 cm.)
Collection: Private Collection, England.
Provenance: (Galerie Müller, Stuttgart); (Arthur Tooth and Sons Ltd, London).
Exhibitions: *Howard Hodgkin*, Arthur Tooth and Sons Ltd, London, October 16–November 10, 1962, cat. no. 11, ill.; *British Painting in the Sixties: An Exhibition Organized by the Contemporary Art Society*, Section Two, Whitechapel Art Gallery, London, June 1–30, 1963, cat. no. 150, ill.; *Britische Malerei der Gegenwart*, Kunstverein für die Rheinlande und Westfalen, Düsseldorf, May 24–July 5, 1964, no. 38.
Literature: Robyn Denny, "London Letter," *Kunstwerk* 16, November–December 1962, pp. 70–80, ill.
Notes: A portrait of Sue Dunkley, a student of Hodgkin's at Corsham.

36 · POSTCARD VENICE OR IN VENICE
1962
Oil on canvas
36 x 72 in. (91.5 x 183 cm.)
Collection: Private Collection.
Provenance: (Arthur Tooth and Sons Ltd, London); J. Blond.
Exhibitions: *Howard Hodgkin*, Arthur Tooth and Sons Ltd, London, October 16–November 10, 1962, no. 9; Arts Council, 1976, no. 8, ill. color.

Literature: Edwin Mullins, "Other Exhibitions: Two Painters at Tooth's," *Apollo* 76, November 1962, p. 714.

Notes: A portrait of Dr. and Mrs. Errol Wall.

37 · ROGER AND MARGARET COLEMAN

1962

Oil on canvas

42 x 50 in. (107 x 127 cm.)

Collection: Private Collection, London.

Exhibitions: *Howard Hodgkin*, Arthur Tooth and Sons Ltd, London, October 16–November 10, 1962, no. 8, ill.; *Nieuwe Realisten*, Haags Gemeentemuseum, The Hague, June 24–August 8, 1964, cat. no. 23; *Pop Art, Nouveau Realisme, etc...*, Palais des Beaux-Arts de Bruxelles, Brussels, February 5–March 1, 1965, no. 66; *The Sixties Art Scene in London*, Barbican Art Gallery, London, March 11–June 13, 1993, no. 127.

Literature: Herbert Read, *Contemporary British Art*, Harmondsworth: Penguin Books, 1964, plate 61b; *Das Kunstwerk*, November 1963; John McEwen, "Four British Painters," *Artforum* 17, December 1978, pp. 50–55, ill. p. 53.

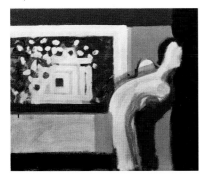

38 · UNDRESSING

1962

Oil on canvas

20 x 24 in. (51 x 61 cm.)

Collection: Unknown.

Exhibitions: *1962: One Year of British Art Selected by Edward Lucie-Smith*, Arthur Tooth and Sons Ltd, London, January 22–February 9, 1963, cat. no. 12, ill.

Literature: J. P. Hodin, "Londres: Pop-Art or Art," *Quadrum* 14, 1963, pp. 161–64, ill. p. 161;

Norbert Lynton, "London Letter," *Art International* 7, March 25, 1963, p. 58, ill. p. 59: "High praise goes to Howard Hodgkin for his little picture *Undressing*; by means of broad colour harmonies and an equality of emphasis he has fused his figure with its semi-geometrical backing without either of them losing its particular character."

Note: A view out of the window, 12 Addison Gardens, London, W14—Hodgkin's then address.

39 · WILLIAM BROOKER

1962

Oil on canvas

42 x 48 in. (107 x 122 cm.)

Collection: Destroyed by the artist.

Exhibitions: *Howard Hodgkin*, Arthur Tooth and Sons Ltd, London, October 16–November 10, 1962, no. 7.

Literature: Robyn Denny, "London Letter," *Kunstwerk* 16, November–December 1962, pp. 70–80, ill.

Notes: A portrait of the painter, William Brooker.

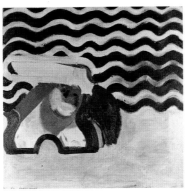

40 · ELECTRIC LIGHT

1960–63

Oil on board

36 x 36 in. (91 x 91 cm.)

Collection: Private Collection.

Provenance: The artist; donated to ICA, London, for auction at Sotheby's, London, June 23, 1966; Piccadilly Gallery, London; sold Sotheby's, London, May 8, 1989, lot 101; Saatchi Collection, London; (Waddington Galleries, London); sold Sotheby's, New York, October 3, 1991, lot 22, ill. color.

Exhibitions: *Two Young Figurative Painters* [with Allen Jones], ICA Gallery, London, February 14–March 24, 1962; *Howard Hodgkin: Recent Paintings*, Arthur Tooth and Sons Ltd, London, January 21–February 15, 1964, cat. no. 3; Minneapolis, 1965, no. 35.

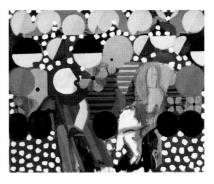

41 · GARDENING

1963

Oil on canvas

40 x 50 in. (101.6 x 127 cm.)

Collection: Waddington Galleries, London.

Provenance: (Arthur Tooth and Sons Ltd, London); E. J. Power.

Exhibitions: *Howard Hodgkin: Recent Paintings*, Arthur Tooth and Sons Ltd, London, January 21–February 15, 1964, cat. no. 7, ill. color on cover; Arts Council, 1976, no. 14, ill. color; *The Sixties Art Scene in London*, Barbican Art Gallery, London, March 11–June 13, 1993, no. 128; *Peter Blake, Patrick Caulfield and Howard Hodgkin: Paintings from the 60s and 70s*, Waddington Galleries, London, February 22–March 25, 1995.

Literature: Roger Coleman, "Up with the Jones's," *Arts Review* 16, January 12–February 8, 1964, ill. color p. 4: "Hodgkin's new paintings ... are the strongest he has so far shown. Intelligence is evident in practically every brush mark he makes and since he first exhibited his work has steadily progressed. Essentially, he is that rare bird nowadays, a classical artist and the basis of his painting is a reconciliation of the demands of the subject and the demands of the picture. ... The suggestion of caricature that hovered in his earlier work has almost disappeared."; Michael Levey, "Twist and Shout," *Sunday Times*, January 26, 1964, p. 32; Norbert Lynton, "Great High Spirits," *New Statesman* 67, January 31, 1964, pp. 179–80: "*Gardening* and related pictures like *The Japanese Screen* are descendants from the Intimism of Vuillard and Bonnard, though they have stronger colours and handling and a more patent vein of humour. These are rich and sonorous pictures whose beguiling patterns contain unusually complex design and space implications."; James Burr, "Round the London Galleries: Born of Stress," *Apollo*, February 1964; Peter Stone, "A Potential Renoir," [referring to Abraham Mintchine] *Jewish Chronicle*, February 6, 1964, p. 33: "He is a good designer, and his 'Gardening' is a fine piece of pattern-making, profuse with gay spheres, monocoloured and bicoloured."; Norbert Lynton, "London Letter," *Art International* 8, April 25, 1964, pp. 73–78,

ill.: "A female figure emerges pinkly out of a vivid setting consisting of stripes, simplified flower shapes, disks and half disks of colour as well as white patches on a green ground—all of which elliptically supports the idea of the title. The lady is almost immersed in the garden, which opposes her meekness of form and colour with broad and optimistic patterns. The general effect is mysterious. One cannot help seeing her as partially humorous; a throw-away image loaded with secret symbolism. ... But humour and the possibility of satire are here presented through sonorous chords of form and colour and combine in a poignancy that lingers with strange persistence. Memory keeps questioning the picture."; Edward Lucie-Smith, "Howard Hodgkin," *London Magazine* 4, March 1965, pp. 71–75, ill. p. 73 as *Maidening*: "In 'Gardening' foreground and background interweave with one another in an extraordinarily subtle way. The unified flat surface which says 'this is a picture' is carefully preserved, but the flatness, while remaining flat, also contrives to present us with various possibilities of distance—of nearness and farness. The eye never quite comes to rest. Each point it alights on sends it shuttling to another area of colour, and this second area persuades the spectator to examine yet a third, and so on."; John McEwen, "Art: Winning," *Spectator* 236, May 15, 1976, p. 29: "The last work [of 1976] to have an identifiable face in it."; Graham-Dixon, 1994, p. 13, ill. color p. 10: "The mood spreads outdoors, too, in *Gardening* (1963), a mock-pastoral portrait of a young woman surrounded by spreading floral patterns. Outside, here, feels like inside, nature remade as a form of decor that the painting ironically mimics by emphasizing the extravagance of its own artifice. This *hortus conclusus* is oppressively self-contained."
Notes: A portrait of the artist's wife, Julia.

42 · GIRL IN A HOTEL (IST STATE)
1963
Oil on canvas
40 x 36 in. (102 x 91 cm.)
Exhibitions: *Howard Hodgkin: Recent Paintings*, Arthur Tooth and Sons Ltd, London, January 21–February 15, 1964, cat. no. 1; Minneapolis, 1965, no. 37, ill. p. 24.
Literature: Martin Friedman, *London: The New Scene*, Minneapolis: Walker Art Center, 1965, p. 22.
Notes: A portrait of the artist's wife, Julia, in a Paris hotel room. The painting was altered by the artist in 1970; see *Girl in a Hotel* (2nd state), cat. no. 84.

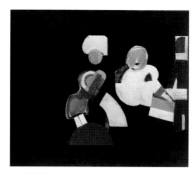

43 · HOTEL
1962–63
Oil on canvas
50 x 60 in. (127 x 152 cm.)
Collection: Private Collection, England.
Provenance: (Arthur Tooth and Sons Ltd, London); Mrs. J. Gauntlett; (Waddington Galleries, London).
Exhibitions: *Howard Hodgkin: Recent Paintings*, Arthur Tooth and Sons Ltd, London, January 21–February 15, 1964, cat. no. 2, ill.; Minneapolis, 1965, no. 36, ill. p. 24; Arts Council, 1976, no. 11, ill. color.
Literature: Jane Stockwood, "Sometimes it Makes a Good Portrait," *Harper's Bazaar*, November 1963, pp. 107–8, 110, ill.; Norbert Lynton, "London Letter," *Art International* 8, April 25, 1964, pp. 73–78, ill. p. 73; Martin Friedman, *London: The New Scene*, Minneapolis: Walker Art Center, 1965, p. 22; Timothy Hyman, "Howard Hodgkin," *Studio International* 189, May–June 1975, pp. 178, 180–81, 183: "In format it has obvious affinities to Indian miniatures; but in its infantile wit, it could be (and was) placed alongside Hockney and other young contemporaries. But it lacks the complexity of language of Hodgkin's later work, and the emotional and intellectual content is thereby greatly reduced."
Notes: *Julia and Margaret*, cat. no. 26, is partly a study for this painting. Signed, titled and dated on the reverse on the stretcher.

44 · HUSBAND AND WIFE
1963
Oil on board
18¼ x 24½ in. (46 x 62 cm.)
Collection: Oldham Gallery, gift of the Contemporary Art Society, London.
Provenance: (Arthur Tooth and Sons Ltd, London); Contemporary Art Society, London.
Exhibitions: *Howard Hodgkin: Recent Paintings*, Arthur Tooth and Sons Ltd, London, January 21–February 15, 1964, cat. no. 6, ill.; *The New Image*, Arts Council Gallery, Belfast, September 1964, cat. no. 14.
Notes: A portrait of William Brooker and Joe.

45 · PORTRAIT
1962–63
Oil on canvas
24 x 18 in. (61 x 46 cm.)
Collection: Private Collection, London.
Exhibitions: *1962: One Year of British Art Selected by Edward Lucie-Smith*, Arthur Tooth and Sons Ltd, London, January 22–February 9, 1963, cat. no. 10; *Howard Hodgkin: Recent Paintings*, Arthur Tooth and Sons Ltd, London, January 21–February 15, 1964, cat. no. 9; Arts Council, 1976, no. 10, ill. color.
Literature: "One Choice of British Art: Formula Changed," *The Times* (London), January 30, 1963, p. 13: "Howard Hodgkin has a large, full-face 'Portrait' painted with spectacular verve and assurance."; Edward Lucie-Smith, "Howard Hodgkin," *London Magazine* 4,

Notes: A portrait of Peter Cochrane, former director of Arthur Tooth and Sons Ltd, London, and loosely based on a Kitchener recruiting poster from World War I.

46 · THE SECOND VISIT
1963
Oil on hardboard
16 x 20 in. (40.5 x 51 cm.)
Collection: Private Collection.
Provenance: (Arthur Tooth and Sons Ltd, London); Miss Nancy Balfour.
Exhibitions: *Howard Hodgkin: Recent Paintings*, Arthur Tooth and Sons Ltd, London, January 21–February 15, 1964, no. 4, ill.; Arts Council, 1976, no. 13, ill. color.
Literature: Norbert Lynton, "Great High Spirits," *New Statesman* 67, January 31, 1964, pp. 179–80; "Howard Hodgkin," *Ark, the Journal of the Royal College of Art* no. 38, Summer 1965, pp. 18–21, ill. p. 19.

47 · SMALL JAPANESE SCREEN OR THE JAPANESE SCREEN
1962–63
Oil on hardboard
16 x 20 in. (41 x 51 cm.)
Collection: Private Collection, England.
Provenance: Justin Knowles, acquired from the artist; sold Sotheby's, New York, December 14, 1966, lot 145; (Kasmin Gallery Ltd, London); Charles Ewart, London; John Pearson, London; (Kasmin Gallery Ltd, London); sold Sotheby's, New York, May 4, 1994, lot 31, ill. color.
Exhibitions: *Howard Hodgkin: Recent Paintings*,

Arthur Tooth and Sons Ltd, London, January 21–February 15, 1964, cat. no. 5; *First Triennale—India 1968*, Lalit Kala Akademi, New Delhi and National Gallery of Modern Art, New Delhi, February 11–March 31, 1968, cat. no. 9; Arts Council, 1976, no. 9, ill. color; *British Painting 1952–1977*, Royal Academy of Arts, London, September 24–November 20, 1977, no. 189, ill. p. 74.
Literature: Michael Levey, "Twist and Shout," *Sunday Times*, January 26, 1964, p. 32: "Some of the small pictures, like the 'Japanese Screen', have the formal beauty and colouristic effects of brilliant mosaic; stacked beads of red and black, all the more intense for being flanked by a green figure."; Norbert Lynton, "London Letter," *Art International* 8, April 25, 1964, pp. 73–78: "For all its apparent clarity I do not begin to understand what is represented in *The Japanese Screen*. There is a double layer of spots, black and red, flecked with green, that must be the eponymous screen; there is also a nameable but surreptitious portrait of a man on the point of exiting stage right; the remainder of the shapes in the picture are totally unrecognisable. The joint effect of pattern, colour, composition and this elusiveness of content is extraordinarily rich and sustaining."; Bruce Bernard, "Personalities of British Painting," [a photo essay] *Sunday Times Magazine*, September 4, 1977, pp. 34–41, ill. pp. 40–41; Bruce Chatwin, "A Portrait of the Artist," in *Howard Hodgkin: Indian Leaves*, London and New York: Petersburg Press, 1982, p. 13, ill. color p. 12; Graham-Dixon, 1994, ill. color p. 16; A. S. Byatt, "The Colour of Feeling," *Independent on Sunday*, July 10, 1994, pp. 30–31, ill. color.
Notes: There is a larger version in the collection of the British Council. In "A Portrait of the Artist," published in 1982, Bruce Chatwin described the origins of this painting: "I had recently come back from a desert journey in the Sudan and the sitting room had a monochromatic desert-like atmosphere and contained only two works of art—the arse of an archaic Greek marble kouros, and an early 17th-century Japanese screen. One evening, the Hodgkins and the Welches came to dinner, and I remember Howard shambling round the room, fixing it in his memory with the stare I came to know so well. The result of that dinner was a painting called *The Japanese Screen* in which the screen itself appears as a rectangle of pointillist dots; the Welches as a pair of gun-turrets, while I am the acid green smear on the left, turning away in disgust, away from my guests, away from my possessions ... and possibly back to the Sahara."
Signed on the reverse.

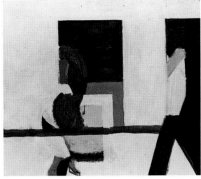

48 · THE VISIT
1963
Oil on hardboard
20¼ x 23 in. (51 x 58 cm.)
Collection: Unknown.
Provenance: (Arthur Tooth and Sons Ltd, London); (Galerie Müller, Stuttgart).
Exhibitions: *Howard Hodgkin: Recent Paintings*, Arthur Tooth and Sons Ltd, London, January 21–February 15, 1964, no. 8; Arts Council, 1976.
Literature: Norbert Lynton, "Great High Spirits," *New Statesman* 67, January 31, 1964, pp. 179–80; "Howard Hodgkin," *Ark, the Journal of the Royal College of Art* no. 38, Summer 1965, pp. 18–21, ill. p. 18 [a photo essay only]; Caroline Tisdall, "Howard Hodgkin," *Guardian*, May 27, 1976: "Some of them, like *The Visit* (1963), convey the tricks that memory can play: the retention of a particular detail that may not have seemed significant or remarkable at the time."

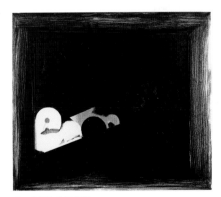

49 · GIRL ASLEEP
1964
Oil on canvas
20 x 24 in. (51 x 61 cm.)
Collection: Bernard Jacobson.
Provenance: Mrs. Harold Field, Minneapolis; (Kasmin Gallery Ltd, London); Joshua Mack, New York, sold via M. Knoedler and Co., Inc., New York; Mrs. Leslie Herman, Kansas City.
Exhibitions: Minneapolis, 1965, no. 39; *New Concepts for a New Art, Toyama Now 81*, Museum of Modern Art, Toyama, Japan, July 5–September 23, 1981, ill. p. 87.

Literature: Edward Lucie-Smith, "Howard Hodgkin," *London Magazine* 4, March 1965, pp. 71–75, ill. pp. 72–73: "In a real sense, all the figures, all the objects in his pictures, are described in a completely new way, seen afresh from the very beginning. A good instance of this ... is the picture called 'Girl Asleep'. ... What is depicted is the conventional reclining odalisque whom we meet so often in the paintings and prints of Matisse and Picasso. ... Yet—and here I can only speak from my own experience—the picture seems completely new, and completely convincing. It does not paraphrase, it entirely re-creates; and it succeeds both as an abstract design and as a representation of the girl's figure."

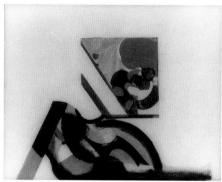

50 · GIRL BY A WINDOW
1964
Oil on board
20½ x 25¾ in. (52 x 65 cm.)
Collection: Private Collection.
Provenance: Charles Ewart; (Kasmin Gallery Ltd, London).
Exhibitions: Minneapolis, 1965, no. 40; *Howard Hodgkin: Recent Paintings*, Arthur Tooth and Sons Ltd, London, February 28–March 25, 1967, cat. no. 4.
Literature: Edward Lucie-Smith, "Howard Hodgkin," *London Magazine* 4, March 1965, pp. 71–75, ill. p. 74.

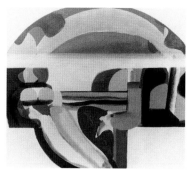

51 · IN THE TUILERIES
1963–64
Oil on canvas
36 x 40 in. (92 x 102 cm.)
Collection: Private Collection, London.
Provenance: (Arthur Tooth and Sons Ltd, London).
Exhibitions: *Howard Hodgkin: Recent Paintings*, Arthur Tooth and Sons Ltd, London, February 28–March 25, 1967, cat. no. 2, ill. color on cover.

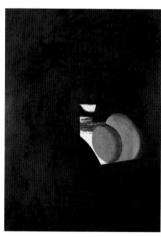

52 · LARGE PORTRAIT
1962–64
Oil on canvas
55⅝ x 39⅞ in. (140 x 102 cm.)
Collection: Walker Art Center, Minneapolis, gift of Mr. and Mrs. Louis Zelle.
Provenance: (Arthur Tooth and Sons Ltd, London); Collection of Ann, Louis and Charles Zelle, Minneapolis.
Exhibitions: *Howard Hodgkin: Recent Paintings*, Arthur Tooth and Sons Ltd, London, January 21–February 15, 1964, cat. no. 10; Minneapolis, 1965, no. 38.
Literature: Norbert Lynton, "Great High Spirits," *New Statesman* 67, January 31, 1964, pp. 179–80: "The other group—*Large Portrait*, *The Visit*, *The Second Visit* and others—is patternless. Large areas of each picture are painted out with black or white, leaving a few strong shapes and signs that one could mistake for abstract. Their mood is solemn and melancholic rather than spirited. Tempted to find a line of descent by

which to characterise these works, rather than to hint at derivations, I find myself thinking of Turner's interiors of Petworth, although Hodgkin's ways of indicating space by pictorial intervals (as opposed to Turner's use of solidified atmosphere) suggest the art of the Far East."
Notes: Unsigned.

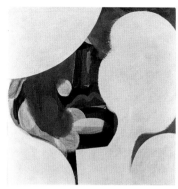

53 · FACE
1965
Oil on canvas
24 x 24 in. (61 x 61 cm.)
Collection: Private Collection.
Provenance: (Waddington Galleries, London, and Kasmin Gallery Ltd, London).
Exhibitions: *25 Peintres, 5 Pays, Château de la Sarraz, Prix International de Peinture*, Vaud, Switzerland, June 6–September 26, 1965, no. 17; *Colour, Form and Texture*, Arthur Tooth and Sons Ltd, London, February 1–19, 1966, no. 5, ill.
Literature: "Howard Hodgkin," *Ark, the Journal of the Royal College of Art* no. 38, Summer 1965, pp. 18–21, ill. color p. 21.
Notes: A portrait of Kate Gordon-Cumming, see also cat. no. 33.

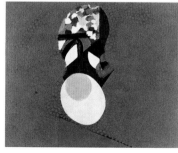

54 · GIRL IN BED
1965
Oil on canvas
28 x 36 in. (71 x 91.5 cm.)
Collection: Susan Kasen Summer and Robert D. Summer.
Provenance: N. A. Tooth, London; Saatchi Collection, London; sold Sotheby's, New York, April 30, 1991, lot 18.

Exhibitions: *25 Peintres, 5 Pays, Château de la Sarraz, Prix International de Peinture*, Vaud, Switzerland, June 6–September 26, 1965, no. 18; *Howard Hodgkin: Recent Paintings*, Arthur Tooth and Sons Ltd, London, February 28–March 25, 1967, cat. no. 1, ill.; Arts Council, 1976, no. 18, ill. color p. 40.

Literature: "Howard Hodgkin," *Ark, the Journal of the Royal College of Art* no. 38, Summer 1965, pp. 18–21, ill. color p. 20; "On Exhibition," *Studio International*, March 1967, p. 157, no. 12, ill.; Nigel Gosling, "Heroic Pessimism on a Bicycle," *Observer*, March 12, 1967, p. 25: "They are nursery-clean and dense, the forms jostling, and at their best, e.g., 'Girl in Bed', they have the freshness and sureness of a Léger."; Harold Osborne, "Howard Hodgkin," *Arts Review* 28, May 14, 1976, p. 239; Alistair Hicks, *New British Art in the Saatchi Collection*, London: Thames and Hudson Ltd, 1989, no. 30, ill. color p. 49.

Notes: Signed on the reverse on the stretcher.

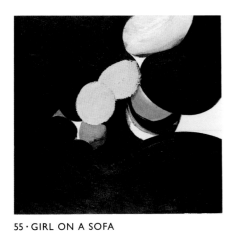

55 · GIRL ON A SOFA
1965
Oil on board
24 x 22¾ in. (61 x 58 cm.)
Collection: Private Collection.
Exhibitions: *25 Peintres, 5 Pays, Château de la Sarraz, Prix International de Peinture*, Vaud, Switzerland, June 6–September 26, 1965, no. 16; *Colour, Form and Texture*, Arthur Tooth and Sons Ltd, London, February 1–19, 1966, cat. no. 6; *London Under Forty*, Galleria Milano, Milan, June 7–25, 1966; *Howard Hodgkin: Recent Paintings*, Arthur Tooth and Sons Ltd, London, February 28–March 25, 1967.

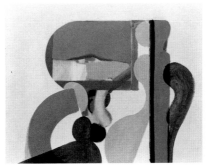

56 · INTERIOR WITH PAINTING BY DE STAEL
1965
Oil on canvas
28 x 36 in. (71 x 92 cm.)
Collection: Museu de Arte Contemporanea de Sao Paulo, Brazil.

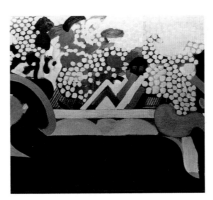

57 · THE MEETING
1963–65
Oil on canvas
40 x 44 in. (102 x 112 cm.)
Collection: Private Collection.
Provenance: M. André Goemmine, Lissone.
Exhibitions: *Quattordicesimo premio Lissone, Biennale internazionale di pittura*, Lissone, Italy, October 17–31, 1965, ill.

58 · SEATED FIGURE
1965
Oil on canvas
20 x 27 in. (50 x 68.5 cm.)
Collection: Private Collection.
Provenance: Private Collection, London.
Exhibitions: *Howard Hodgkin: Recent Paintings*, Arthur Tooth and Sons Ltd, London, February

28–March 25, 1967, cat. no. 5, ill; Arts Council, 1976, no. 19, ill. color.

Notes: A portrait of the artist, Robyn Denny.

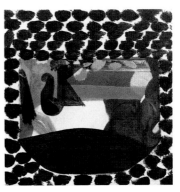

59 · SITTING ROOM AT WEST HILL
1964–65
Oil on canvas
9 x 9 in. (23 x 23 cm.)
Collection: Unknown.
Provenance: (Arthur Tooth and Sons Ltd, London); Cary Welch.
Notes: A portrait of Bernard Cohen and guests, on stretcher supplied by him.

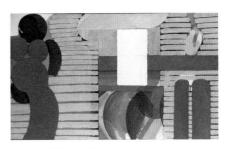

60 · ACACIA ROAD
1966
Oil on canvas
36 x 60 in. (91.5 x 152.5 cm.)
Collection: Private Collection, California.
Provenance: N. A. Tooth, London; (Waddington Galleries, London).
Exhibitions: *Howard Hodgkin: Recent Paintings*, Arthur Tooth and Sons Ltd, London, February 28–March 25, 1967, no. 10, ill; Arts Council, 1976, no. 22, ill. color.
Literature: David Thompson, "Art: Howard Hodgkin," *Queen* 428, March 15, 1967, p. 24, ill.; Susan Groome, "Howard Hodgkin," *Arts Review* 19, March 4, 1967, p. 64; Guy Brett, "Painter's Series of Shaped Canvases," *The Times* (London), March 11, 1967, p. 7: "Howard Hodgkin's is a laboured, disjointed way of painting. Or perhaps it only appears to be because it is a kind of painting which lets a prolonged, gradual process of working-out show in the final image. For Mr. Hodgkin allows the different parts he has added to a painting

over a period, perhaps of years, to knock against each other, asserting themselves. ... But it is by means of this 'clumsiness' that Mr. Hodgkin seems to communicate his strongest feeling. ... In two of the bigger paintings 'Dinner at West Hill' and 'Acacia Road', the construction is especially dense. Both pictures are crowded with forms ... associated, as the titles suggest, with some special moment for the artist, which the spectators can only penetrate in a general way. ... The horizontal yellow bars in 'Acacia Road', as solid as a gate, give the softer atmospheric parts of the painting emphasis by remaining distinct from them. This kind of surprise is Mr. Hodgkin's particular strength."; Bryan Robertson, "Howard's End?," *Spectator*, March 24, 1967, pp. 347–48: "But Mr. Hodgkin is a wag as well as a very good painter. ... For in describing what seem at first glance to be particular situations and locales, he is merely alluding to initial circumstances: what he presents us with is in fact a set of whittled-down anagrams projected in abstract shape, colour, and texture. ... 'Who do we know in Acacia Road?' springs only too glibly to mind. 'Can it be J*hn R*ss*ll standing bewilderedly up to the chin in golden rod ... with Mme R*ss*ll musing over a quiet organ solo indoors?' It *can't* be, and yet."; Edward Lucie-Smith, "London Commentary," *Studio International* 173, April 1967, pp. 196–98, ill. p. 196: "He's a figurative painter of the pop generation (but not a pop artist) who draws on very varied sources—Matisse chiefly, and Indian miniatures. He's learnt from Indian art the secret of combining very brilliant colours without diminishing their intensity. He's learnt from them, too, how to use swarming pattern."
Notes: A double portrait of Mr. and Mrs. John Russell.

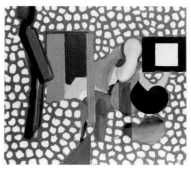

61 · ANTHONY HILL AND GILLIAN WISE
1964–66
Oil on canvas
42 x 50 in. (107 x 127 cm.)
Collection: Private Collection, Switzerland.
Provenance: (Arthur Tooth and Sons Ltd, London); Peter Stuyvesant Foundation; (Kasmin Gallery Ltd, London); William and Penelope Govett, London.
Exhibitions: *Howard Hodgkin: Recent Paintings*, Arthur Tooth and Sons Ltd, London, February 28–March 25, 1967, cat. no. 13, ill.; *Recent British Painting: The Peter Stuyvesant Foundation Collection*, Tate Gallery, London, November 15–December 22, 1967, no. 70, ill. p. 123; Arts Council, 1976, no. 15, ill. color.
Literature: Lynda Morris, "Hodgkin and Caulfield," *Listener* 95, April 1, 1976, p. 417, ill.; Graham-Dixon, 1994, p. 29, ill. color p. 27: "*Anthony Hill and Gillian Wise* ... departs so completely from the traditional form of the portrait that it ends up announcing the painter's apostasy from anything resembling traditional portraiture. Paint supplants and stands in completely for the subjects of its attention, and the result is a busy field of marks that suggests, in its jumpy collision of what could be anatomical fragments or details of dress on a spreading pattern of dots, a memory of people and a place so jumbled and distorted that it can only be remade as a pictorial chaos."

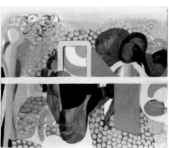

62 · DINNER AT WEST HILL
1963–66
Oil on canvas
42 x 50 in. (107 x 127 cm.)
Collection: Tate Gallery, London.

Provenance: (Arthur Tooth and Sons Ltd, London); Charles Ewart; Eliot Hodgkin, artist's father; presented to the Tate Gallery, London, by Eliot Hodgkin.
Exhibitions: *Howard Hodgkin: Recent Paintings*, Arthur Tooth and Sons Ltd, London, February 28–March 25, 1967, cat. no. 12, ill.; *Henry Moore to Gilbert & George, Modern British Art from the Tate Gallery*, Palais des Beaux-Arts, Brussels, September 28–November 17, 1973, no. 191, ill. p. 111; *Narrative Paintings: Figurative Art of Two Generations*, Arnolfini Gallery, Bristol, September 1–October 20, 1979, ill.
Literature: Susan Groome, "Howard Hodgkin," *Arts Review* 19, March 4, 1967, p. 64; Guy Brett, "Painter's Series of Shaped Canvases," *The Times* (London), March 11, 1967, p. 7, discussed in the *Tate Gallery Report—Acquisitions 1968–70*, London: Tate Gallery Publications, 1970, p. 89; Anne Seymour, "A New Approach to the Figurative Image," in *Henry Moore to Gilbert & George, Modern British Art from the Tate Gallery*, Brussels: Palais des Beaux-Arts, 1973, p. 107: "Hodgkin is obsessed with artefacts (*sic*), such as objects in people's houses, and with his pictures as objects. And while the paintings are composed of very formal ordered marks on a flat surface, as in Indian miniatures (on the subject of which Hodgkin is an expert) they are also views and contain quite complex illusionism. They frequently contain mirrors or paintings, as in the work of Matisse or Vermeer, both of whom were also engaged with the problem of rendering the minutely observed situation in terms of abstract construction."; Timothy Hyman, "Howard Hodgkin," *Studio International* 189, May–June 1975, pp. 178, 180–81, 183: "The scene is a dinner-party; the white line that divides the picture is simply the line of the dinner-table, across which, on the right, are the egg-like heads of the guests. On the left are other figures, a standing presence, and another, apparently in an armchair. But the red areas in the centre are what we focus on. ... In looking at a work like *Dinner at West Hill*, Matisse's definition of a painting as an 'ensemble of signs' seems peculiarly relevant; not signs in any static sense, but signs continually rediscovered and snatched at."; Timothy Hyman, "Correspondence: Howard Hodgkin," *Studio International* 190, July–August 1975, p. 88, ill. p. 69; Malcolm Quantrill, "London Letter," *Art International* 21, July–August 1977, p. 69.
Notes: Hodgkin has written: "'Dinner at West Hill' is perhaps the most complicated and delicately balanced picture I have so far allowed myself. It commemorates a dinner party given by Bernard and Jeanie Cohen (the painter Bernard Cohen and his wife) on March 15, 1964.

... Most of the forms in the painting, which are not part of my normal language, derive of course from Bernard's pictures. In some cases these even overlap (his and my forms). This painting was very difficult to conclude and I had to contend with a nervous and glittering evening in a green and white room full of small B. Cohens on the wall and Tony and Jasia R[eichardt] (to the L in the picture, Tony at Far L) and also Bernard's pictures which were particularly undisciplined and Dionysian at that moment and of course finally and most difficult to contain all these things inside an object as formally and physically solid as a table or chair.

The two figures of the Reichardts (collectors and writers on art) can be discerned on the left and other figures are perhaps represented by the round head-like forms on the right. The arch-like form may be a chair back, but also refers to similar forms typical of Bernard Cohen's paintings in the early sixties. The white line represents the edge of the table." (Quoted from Simon Wilson, *Tate Gallery: An Illustrated Companion*, London: Tate Gallery Publications, 1990, p. 223, ill. color.)

Inscribed on masking tape attached to canvas verso "Dinner at West Hill 1963–6 Howard Hodgkin", although the dinner party was on March 15, 1964.

Lynton, "Great High Spirits," *New Statesman* 67, January 31, 1964, pp. 179–80; Susan Groome, "Howard Hodgkin," *Arts Review* 19, March 4, 1967, p. 64: "One of the best paintings here, from all points of view, is *Large Japanese Screen*."; Keith Sutton, "Galleries," *London Look*, March 11, 1967, p. 44, ill.: "The exhibition of paintings by Howard Hodgkin at Tooth's is his most substantial and convincing to date."; Andrew Causey, "Contemporary British Art," in *Contemporary British Art*, Tokyo: National Museum of Modern Art, 1970, pp. 12–13: "Howard Hodgkin likes to play a game of hide-and-seek with the spectator. His subjects are people he has known and events he recalls, but in pictures like *Large Japanese Screen* and *Large Staff Room* he keeps them substantially hidden behind the broad areas of color that cover most of his canvases. Subject matter, we suspect, is still gestating in an inner area glimpsed at only through a kind of window in the canvas. A desire to express is balanced here against a reluctance to reveal, while the power of the imagery shown is greatly heightened by the smallness of the area that it is allowed to occupy."

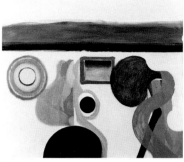

65 · MR. AND MRS. KASMIN
1965–66
Oil on canvas
42 x 50 in. (107 x 127 cm.)
Collection: Saatchi Collection, London.
Provenance: (Galerie Aujourd'hui, Brussels); Mr. and Mrs. Jean Dypreau, Belgium; sold Sotheby's, London, December 5, 1985, lot no. 385, ill.; (Waddington Galleries, London).
Exhibitions: *Howard Hodgkin, Peter Philips, Allen Jones*, Galerie Aujourd'hui, Brussels, 1966.
Literature: Alistair Hicks, *New British Art in the Saatchi Collection*, London: Thames and Hudson Ltd, 1989, no. 32, ill. color p. 50.
Notes: A portrait of the London art dealer, John Kasmin, and his wife, Jane.

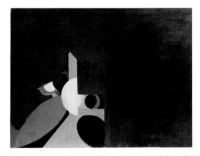

63 · JAPANESE SCREEN OR LARGE JAPANESE SCREEN
1964–66
Oil on canvas
40 x 52 in. (102 x 132 cm.)
Collection: The British Council.
Exhibitions: *Howard Hodgkin: Recent Paintings*, Arthur Tooth and Sons Ltd, London, February 28–March 25, 1967, cat. no. 14, ill.; *First Triennale—India 1968*, Lalit Kala Akademi, New Delhi and National Gallery of Modern Art, New Delhi, February 11–March 31, 1968, cat. no. 12; *Contemporary British Art*, National Museum of Modern Art, Tokyo, September 9–October 25, 1970, ill. p. 42; Arts Council, 1976, no. 16, ill. color; *To-day: Brittiskt 60-och 70-tal*, Lunds Konsthall, Sweden, April 7–May 6, 1979, no. 47.
Literature: Michael Levey, "Twist and Shout," *Sunday Time*s, January 26, 1964, p. 32; Norbert

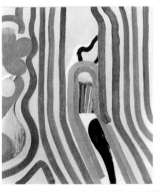

64 · MR. AND MRS. ALLEN JONES
1965–66
Oil on canvas
39 x 34 in. (99 x 86 cm.)
Collection: Unknown.
Provenance: (Galerie Aujourd'hui, Brussels).
Exhibitions: *Howard Hodgkin, Peter Philips, Allen Jones*, Galerie Aujourd'hui, Brussels, May 1966.

66 · MRS. C.
1966
Oil on canvas
20 x 24 in. (51 x 61 cm.)
Collection: Private Collection.
Exhibitions: *Howard Hodgkin: Recent Paintings*, Arthur Tooth and Sons Ltd, London, February 28–March 25, 1967, cat. no. 16, ill.; Arts Council, 1976, no. 23, ill. color.
Literature: Jasia Reichardt, ed., "On Figuration and the Narrative in Art: Statements by Howard Hodgkin, Patrick Hughes, Patrick Procktor, and Norman Toynton," *Studio International* 172, September 1966, pp. 140–44, ill. p. 140, dated 1964–66: "Figurative painting is about a specific experience involving the figure. The most complete expression of such a subject would not necessarily involve description. Nor would it require the use of one kind of language

rather than another. ... The difference between abstract painting and figurative painting need not be a physical one."

Notes: A portrait of Mrs. Bernard Cohen.

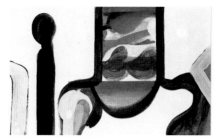

67 · WIDCOMBE CRESCENT
1966

Oil on canvas
16 x 26 in. (41 x 66 cm.)
Collection: Arts Council Collection, South Bank Centre, London.
Exhibitions: *Howard Hodgkin: Recent Paintings*, Arthur Tooth and Sons Ltd, London, February 28–March 25, 1967, cat. no. 9, ill.; *Peter Moores Liverpool Project 5: The Craft of Art*, Walker Art Gallery, Liverpool, November 3, 1979–February 13, 1980.
Literature: *Arts Council Collection, A Concise, Illustrated Catalogue*, London: Arts Council, 1979, p. 129, ill.
Notes: A portrait of Robyn and Anna Denny. Signed and dated on the reverse.

68 · CONVERSATION
1962–67

Oil on canvas
42¾ x 42¾ in. (109 x 109 cm.)
Collection: Unknown.
Provenance: (Arthur Tooth and Sons Ltd, London); Frank B. Porter.
Exhibitions: *British Painting and Sculpture, Today and Yesterday*, Arthur Tooth and Sons Ltd, London, April 3–28, 1962, cat. no. 15; *The New Image*, Arts Council Gallery, Belfast, September 1964.
Notes: A portrait of Julia Hodgkin and Mrs. Errol

Wall at Orto Chiuso, Venice. This is the second state of this painting; *Conversation*, 1962, was exhibited in *British Painting and Sculpture, Today and Yesterday*, Arthur Tooth and Sons Ltd, London, as cat. no. 15, 1962. The painting won an Arts Council prize at the Belfast exhibition in 1964.

69 · GRAMOPHONE
1964–67

Oil on canvas
28 x 36 in. (71 x 92 cm.)
Collection: Borough of Thamesdown; Swindon Public Library.
Provenance: (Arthur Tooth and Sons Ltd, London), in first state; returned to artist; (Kasmin Gallery Ltd, London).
Exhibitions: *Howard Hodgkin: Recent Paintings*, Arthur Tooth and Sons Ltd, London, February 28–March 25, 1967, cat. no. 3; Arts Council, 1976, no. 17, ill. color.
Literature: Harold Osborne, "Howard Hodgkin," *Arts Review* 28, May 14, 1976, p. 239.
Notes: The first state of this painting was dated 1964–66 and the final state was completed the next year. A portrait of Dr. and Mrs. Errol Wall. According to a letter from Hodgkin to the Thamesdown Museum Service, this painting "is a picture of two friends listening to the gramophone, and it did begin (far more than any picture of mine now) as a reasonably straightforward depiction of the two of them listening to music in their living room."

70 · MRS. K.
1966–67

Oil on canvas
34 x 39 in. (86 x 99 cm.)
Collection: Arts Council Collection, South Bank Centre, London.
Provenance: (Arthur Tooth and Sons Ltd, London).
Exhibitions: *Howard Hodgkin: Recent Paintings*, Arthur Tooth and Sons Ltd, London, February 28–March 25, 1967, no. 6; *Looking into Paintings: 2 Portraits*, Arts Council, Castle Museum, Nottingham, November 22, 1986–January 1, 1987; Shipley Art Gallery, Gateshead, January 10–February 8, 1987; Cartwright Hall, Bradford, February 14–March 15, 1987; City Museum and Art Gallery, Plymouth, March 21–April 26, 1987, no. 22.
Literature: *Arts Council Collection, A Concise, Illustrated Catalogue*, London: Arts Council, 1979, p. 129, ill.; Graham-Dixon, 1994, p. 29, ill. color p. 24: "*Mrs. K.* (1966–67) is recalled, in paint, as a solitary ghost, a blur of flesh and bright candy-coloured clothes occluded by a blue void that could be sky or the wall of a room. The painting belongs within a tradition of female portraits whose themes are aloneness and vulnerability and which includes, notably, David's *Madame Récamier* and Degas's *Hélène Rouart in Her Father's Study* (a picture which Hodgkin has admired for the way it conveys 'the kind of glancing, slightly dematerialised quality that one does actually see in reality')."
Notes: A portrait of Jane, Mrs. John Kasmin. Signed, titled and dated on the reverse.

71 · SUNSHINE
1966–67
Oil on canvas
34 x 39 in. (86 x 99 cm.)
Collection: Unknown.
Provenance: (Arthur Tooth and Sons Ltd, London); Mrs. Taylor.
Exhibitions: *Howard Hodgkin: Recent Paintings*, Arthur Tooth and Sons Ltd, London, February 28–March 25, 1967, cat. no. 15.

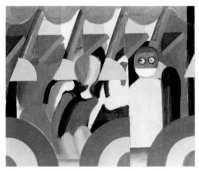

72 · THE TILSONS
1965–67
Oil on canvas
42 x 50 in. (107 x 127 cm.)
Collection: Private Collection, England.
Exhibitions: *Howard Hodgkin: Recent Paintings*, Arthur Tooth and Sons Ltd, London, February 28–March 25, 1967, cat. no. 8, ill.; *Recent British Painting: The Peter Stuyvesant Foundation Collection*, Tate Gallery, London, November 15–December 22, 1967, cat. no. 71, ill. color p. 124.
Literature: John Russell, "Hodgkin Color Locals," *ARTnews* 66, May 1967, p. 62; *Studio International*, December 1967, p. 259, ill. color: "As far as the subjects of my pictures go, they are about one moment of time involving particular people in relationship to each other and also to me. After that moment has occurred all the problems are pictorial. My pictures have become more elaborate because I want them to contain more of the subject, but for me the paramount difficulty is to make the picture into as finite and solid an object as possible in physical terms and to include nothing irrelevant or confusing. Ideally they should be like memorials." (Howard

Hodgkin quoted.); Timothy Hyman, "Howard Hodgkin," *Studio International* 189, May–June 1975, pp. 178, 180–81, 183: "The subject's spectacles stare comically out, from a build-up of Tilson-like repeated objects, carpentered and brightly coloured. Linguistic allusions of this kind are not, I think, in-jokes, but rather a natural extension of Hodgkin's concern with the subject."

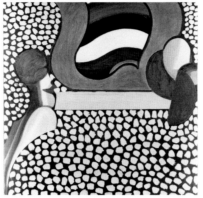

73 · MR. AND MRS. P. STRINGER
1966–68
Oil on canvas
48 x 50 in. (122 x 127 cm.)
Collection: Kronos Collection.
Provenance: (Kasmin Gallery Ltd, London); Mr. and Mrs. G. B. Cooke, London; sold Sotheby's, London, Contemporary Art Part I, November 30, 1994, lot 8, ill. color p. 25.
Exhibitions: *Contemporary Art Fair*, Palazzo Strozzi, Florence, November 16–December 8, 1968; *Howard Hodgkin: New Paintings*, Kasmin Gallery Ltd, London, March 1969; Arts Council, 1976, no. 24, ill. color.
Literature: Simon Field, "London: Objects—More or Less," *Art and Artists* 4, April 1969, p. 57, ill.; Robert Melville, "Problem Solved," *New Statesman* 77, April 4, 1969, p. 490; Guy Brett, "On and Off the Square," *The Times* (London), April 10, 1969, p. 7; Norbert Lynton, "Howard Hodgkin and Jeremy Moon Exhibitions," *Guardian*, April 11, 1969.
Notes: A portrait of friends of the artist. Signed on the reverse.

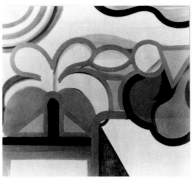

74 · INDIAN SUBJECT (BLUE)
1965–69
Oil on wood
48 x 54¼ in. (122 x 138 cm.)
Collection: Unknown.
Provenance: (Kasmin Gallery Ltd, London); Charles Ware, Bath; (Arthur Tooth and Sons Ltd, London); Lord Bathurst; (Kasmin Gallery Ltd, London).
Exhibitions: *Howard Hodgkin: New Paintings*, Kasmin Gallery Ltd, London, March 1969; Arts Council, 1976, no. 20, ill. color.
Literature: John Russell, "London," *ARTnews* 68, May 1969, p. 43: "His new paintings at the Kasmin Gallery include two versions of an Indian subject; more precisely, the memory of an evening on which he had sat out on the terrace of a Maharajah's palace and listened to Indian music. The paintings are, in a way, Hodgkin's Moroccans. They refer to architecture, they refer to vegetation, they refer to human beings and, I suspect, they refer to musical instruments, though none of these things is spelt out directly. ... It may well be that these are two of the most truthful portraits of Indian life at a certain level that any Englishman has made since the 18th century."; Mark Haworth-Booth, "Salon and Workshop," *Times Literary Supplement*, March 19, 1976, p. 318.
Notes: A scene at Kishangarh.

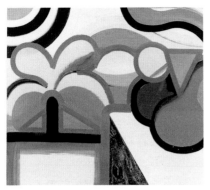

75 · INDIAN SUBJECT (BLUE AND WHITE)
1968–69
Oil on panel
48 x 54½ in. (122 x 138 cm.)
Collection: Unknown.
Provenance: (Kasmin Gallery Ltd, London);
Patricia C. Jones, U.S.A.; (M. Knoedler and Co.,
Inc., New York); sold Sotheby's, New York,
November 6, 1990, lot 69 ill., dated 1965–69.
Exhibition: *Howard Hodgkin: New Paintings*,
Kasmin Gallery Ltd, London, March 1969.
Literature: Edward Lucie-Smith and Patricia
White, *Art in Britain 1969–70*, London: J. M.
Dent and Sons, 1970, ill. p. 96; Richard Morphet,
"Howard Hodgkin: Assessment," *Studio
International* 191, May–June 1976, pp. 297–98,
ill. p. 297.
Notes: A scene at Kishangarh. See also the
discussion by John Russell in the entry for *Indian
Subject (Blue)*, cat. no. 74.

76 · LARGE STAFF ROOM
1964–69
Oil on canvas
48 x 72 in. (122 x 183 cm.)
Collection: Private Collection.
Exhibitions: *Howard Hodgkin: Recent Paintings*,
Arthur Tooth and Sons Ltd, London, February
28–March 25, 1967; *Howard Hodgkin: New
Paintings*, Kasmin Gallery Ltd, London, March
1969; *Contemporary British Art*, National
Museum of Modern Art, Tokyo, September 9–
October 25, 1970, ill. p. 43; *Art Spectrum South*,
Southampton City Art Gallery, June 5–July 4,
1971; Folkestone Arts Centre, July 9–August 1,
1971; Royal West of England Academy, Bristol,

August 20–September 18, 1971, no. 30.
Literature: Norbert Lynton, "London Letter," *Art
International* 11, April 20, 1967, pp. 46–50, ill.
p. 47: "The relatively large painting, *Large Staff
Room*, which has occupied Hodgkin over four
years and now appears with four-fifths of it
painted out with a heavy salmon colour, invites
interpretation even from those who have not sat
round that table. At any rate, one notes that
except for one big knee all the people have been
obliterated; the stuff swept under the table is left
to speak for itself. Hodgkin's sense of pictorial
structure is so strong that it can easily support the
leg-pull element. I know of no other painter who
can entertain one so well while offering images of
lasting visual power."; Guy Brett, "On and Off
the Square," *The Times* (London), April 10, 1969,
p. 7; Norbert Lynton, "Howard Hodgkin and
Jeremy Moon Exhibitions," *Guardian*, April 11,
1969; Timothy Hyman, "Howard Hodgkin,"
Studio International 189, May–June 1975, pp.
178, 180–81, 183: "*Large Staff Room* was begun
in 1964, and at six feet is one of Hodgkin's largest
works. In the state in which it was delivered and
exhibited at Tooth's in 1967, it had arrived at a
powerful statement, of the table around and
beneath which human presences meet and mingle.
But the process was incomplete; the painting was
taken back and further blanked out, reaching its
final state in 1969, when it was shown again at
Kasmin's. What has been emphasized is the
intellectual dimension; it is as though the moment
has been held between finger and thumb, the
great expanse of flat cadmium red suggesting
a kind of mind-space in which the memory—a
knee under a table—exists."; Timothy Hyman,
"Correspondence: Howard Hodgkin," *Studio
International* 190, July–August 1975, p. 88.
Notes: This is the second state of this painting.
The first state, dated 1964–67, was shown in
Howard Hodgkin: Recent Paintings, Arthur Tooth
and Sons Ltd, London, February 28–March 25,
1967, cat. no. 11; the alternative title, *Red Staff
Room* appears in the Kasmin Gallery records.
The subject is the staff room at Corsham
Court. A study for this painting was published
in Norman Blamey, "The Function of Drawing,"
monad 1, Summer 1964, p. 31, ill. (magazine
supported by the Chelsea Art School Students
Union). See also comments by Andrew Causey
in cat no. 63.

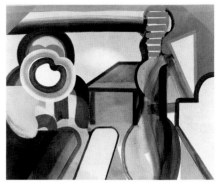

77 · MR. AND MRS. CORNWALL JONES
1967–69
Oil on canvas
42 x 50 in. (107 x 127 cm.)
Collection: Mr. and Mrs. Paul Cornwall Jones.
Provenance: (Waddington Galleries, London);
Gerald L. Lennard.
Exhibitions: *Howard Hodgkin: New Paintings*,
Kasmin Gallery Ltd, London, March 1969; Arts
Council, 1976, no. 26, ill. color.
Literature: Edwin Mullins, "Not What he
Thought," *Sunday Telegraph*, March 30, 1969, ill.;
R. C. Kenedy, "London Letter," *Art International*
13, Summer 1969, pp. 43–44, ill. p. 43; Timothy
Hyman, "Making a Riddle Out of the Solution,"
in *Howard Hodgkin: Small Paintings 1975–1989*,
London: The British Council, 1990, ill. p. 11.

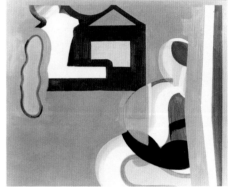

78 · MR. AND MRS. GAHLIN
1967–69
Oil on canvas
42 x 50 in. (107 x 127 cm.)
Collection: Unknown.
Provenance: (Kasmin Gallery Ltd, London); Mr.
and Mrs. Sven Gahlin; Private Collection; sold
Christie's, London, Contemporary Art Society,
London, December 6, 1983, lot 567.
Exhibitions: *Howard Hodgkin: New Paintings*,
Kasmin Gallery Ltd, London, March 1969; *Pop
Art-Nouveau Realisme*, Casino Communal,
Knokke-Le Zoute, June–September 1970, no. 55,
ill. p. 47.
Notes: A portrait of friends of the artist.

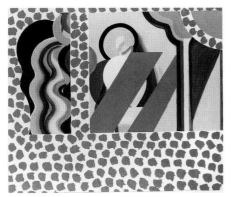

79 · MR. AND MRS. PHILIP KING
1969
Acrylic on canvas
42 x 50 in. (107 x 127 cm.)
Collection: Robert and Mary Looker.
Provenance: (Kasmin Gallery Ltd, London); Mr. Wasserman, U.S.A.; sold Sotheby's, New York, November 4, 1987, lot 59, ill. color.
Exhibitions: *Artists from the Kasmin Gallery*, Arts Council Gallery, Belfast, August 1–30, 1969, cat. no. 15, ill.; on extended loan to the Yale Center of British Art, New Haven, 1984–87.
Literature: Edwin Mullins, "Not What he Thought," *Sunday Telegraph*, March 30, 1969, p. 13, ill.

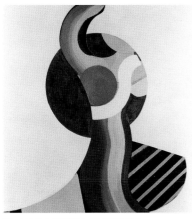

80 · MRS. NICHOLAS MUNRO
1966–69
Oil on canvas
50 x 48 in. (127 x 122 cm.)
Collection: Tate Gallery, London.
Provenance: (Arthur Tooth and Sons Ltd, London).
Exhibitions: *Howard Hodgkin: New Paintings*, Kasmin Gallery Ltd, London, March 1969; Arts Council, 1976, no. 25, ill. color.
Literature: *Tate Gallery Report—Acquisitions 1968–70*, London: Tate Gallery Publications, 1970, p. 89: "Hodgkin wrote 8 May 1970: '*Mrs. Nicholas Munro* commemorates a moment in March, 1966, when Cherry stripped after lunch in the living room of their cottage in order to

put on a 1938 crêpe de chine dress (I think by Norman Hartnell for whom her mother-in-law was once a model). The blue disk behind is a mirror which was hung about a year later. I have known Cherry for many years but the portrait is of that moment.

The picture has been very much altered while being painted because I wanted if possible to retain the whole figure by itself. I have only once otherwise tried anything at all similar and then all that was left was a fragment (Walker Art Gallery). I didn't want to depict her face.'"; Richard Cork, "Every Blob Counts," *Evening Standard* (London), May 20, 1976, p. 24: "Some of his pictures, like *Mrs. Nicholas Munro*, lose themselves in the labyrinthine complexity of their intentions."
Notes: Signed on the reverse.

81 · SMALL STAFF ROOM
1965–69
Oil on canvas
40½ x 60 in. (103 x 152 cm.)
Collection: Private Collection, London.
Exhibitions: *Howard Hodgkin: New Paintings*, Kasmin Gallery Ltd, London, March 1969; *La Peinture anglaise aujourd'hui*, Musée d'art moderne de la ville de Paris, Paris, February 7–March 11, 1973, cat. no. 41, ill. p. 30; Arts Council, 1976, no. 21, ill. color.
Literature: Robert Melville, "Problem Solved," *New Statesman* 77, April 4, 1969, p. 490; John Russell, "London," *ARTnews* 68, May 1969, p. 43: "The new pictures included one called *Small Staff Room* which seemed to me to evoke quite perfectly the look, at once cluttered and impersonal, of the common room at a modern-style art-school."; Mark Haworth-Booth, "Salon and Workshop," *Times Literary Supplement*, March 19, 1976, p. 318.
Notes: The staff room at Corsham Court.

82 · BATHROOM MIRROR
1969–70
Oil on wood
26¼ x 30½ in. (66.5 x 77.5 cm.)
Collection: Marchioness of Dufferin and Ava.
Provenance: (Kasmin Gallery Ltd, London).
Exhibitions: *Howard Hodgkin: Recent Paintings*, Kasmin Gallery Ltd, London, March–April 1971; *Art Spectrum South*, Southampton City Art Gallery, June 5–July 4, 1971; Folkestone Arts Centre, July 9–August 1, 1971; Royal West of England Academy, Bristol, August 20–September 18, 1971, no. 29, ill.; Arts Council, 1976, no. 30, ill. color.
Literature: Richard Cork, "Every Blob Counts," *Evening Standard* (London), May 20, 1976, p. 24: "Others, like *Bathroom Mirror*, exclude too much of the visual incident on which he thrives."
Notes: One of a series of portraits of Dick and Betsy Smith; see also *Room with Chair*, cat. no. 92, *Mirror*, cat. no 93, *Blue Evening*, cat. no. 99.

83 · DAVID HOCKNEY DRAWING
1968–70
Oil on panel
42 x 50 in. (107 x 127 cm.)
Collection: Ashley and Harriet Hoffman.
Provenance: N. A. Tooth, London; sold Sotheby's, New York, November 10, 1983, lot 84, as *David Hockney at Clandeboye.*
Exhibitions: *Howard Hodgkin*, Arnolfini Gallery, Bristol, September 16–October 22, 1970, cat. no. 7, ill. color overleaf; *Howard Hodgkin*, Galerie Müller, Cologne, January 15–February 25, 1971.
Literature: Eric Rowan, "Private Lives," *The*

Times (London), October 1, 1970, p. 15: "The most successful piece in the exhibition. Hockney is generally known to have a flamboyant character, and this painting, with the red coat, green trousers, yellow shoes and ... hair, and the flat, carpet-like setting of blues and pink, reinforces the impression. But there, again, is the esoteric significance of the yellow, toothsome oval with its phallic images. It is all so cosy and inbred, and there lingers a feeling that this is an exclusive world into which we are privileged to peer."
Notes: A portrait of David Hockney drawing at Clandeboye, Belfast.

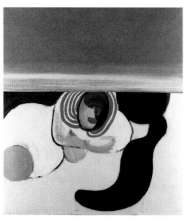

84 · GIRL IN A HOTEL (2ND STATE)
1963–70
Oil on canvas
40 x 36 in. (102 x 91 cm.)
Collection: Private Collection, England.
Provenance: Private Collection, London; Bernard Jacobson Gallery, London.
Exhibitions: *Art Spectrum South*, Southampton City Art Gallery, June 5–July 4, 1971; Folkestone Arts Centre, July 9–August 1, 1971; Royal West of England Academy, Bristol, August 20–September 18, 1971, no. 28.

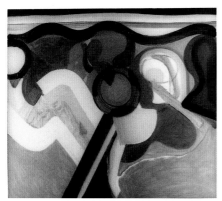

85 · LILAC TIME
1965–70
Oil on canvas
42 x 46 in. (107 x 117 cm.)
Collection: Private Collection, England.

Provenance: (Kasmin Gallery Ltd, London).
Exhibitions: *Howard Hodgkin*, Arnolfini Gallery, Bristol, September 16–October 22, 1970, no. 6; *Howard Hodgkin*, Galerie Müller, Cologne, January 15–February 25, 1971.
Literature: Eric Rowan, "Private Lives," *The Times* (London), October 1, 1970, p. 15: *Lilac Time* "seems to have been a portrait that went awry in its processing."

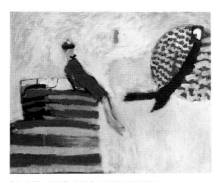

86 · MR. AND MRS. JACK SMITH
1969–70
Oil on board
38¼ x 50 in. (97.8 x 127 cm.)
Collection: Jan Krugier Gallery, Inc., New York.
Provenance: (Waddington Galleries, London).

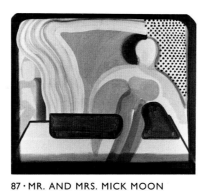

87 · MR. AND MRS. MICK MOON
1968–70
Oil on canvas
42 x 50 in. (107 x 127 cm.)
Collection: Unknown.
Provenance: E. J. Power.
Exhibitions: *Howard Hodgkin*, Arnolfini Gallery, Bristol, September 16–October 22, 1970, cat. no. 3; *Howard Hodgkin*, Galerie Müller, Cologne, January 15–February 25, 1971.

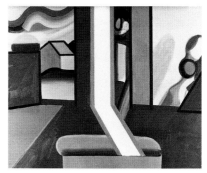

88 · MR. AND MRS. PATRICK CAULFIELD
1967–70
Oil on canvas
42 x 50 in. (107 x 127 cm.)
Collection: Centro de Arte Modernsa, Fundacao Calouste Gulbenkian, Lisbon.
Provenance: (Arnolfini Gallery, Bristol).
Exhibitions: *Howard Hodgkin*, Arnolfini Gallery, Bristol, September 16–October 22, 1970, cat. no. 5; *Critic's Choice: 1971*, Arthur Tooth and Sons Ltd, London, March 2–26, 1971, cat. no. 24, ill.; *To-day: Brittiskt 60-och 70-tal*, Lunds Konsthall, Sweden, April 7–May 6, 1979, no. 48; *Peter Moores Liverpool Project 5: The Craft of Art*, Walker Art Gallery, Liverpool, November 3, 1979–February 13, 1980; *The Proper Study: Contemporary Figurative Painting from Britain*, Lalit Kala Akademi, New Delhi, December 1–31, 1984, and Jahangir Nicholson Museum of Modern Art, Bombay, February 1–28, 1985.

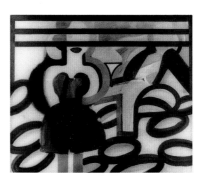

89 · MR. AND MRS. PETER BLAKE
1966–70
Oil on canvas
42 x 50 in. (107 x 127 cm.)
Collection: Private Collection, England.
Provenance: Mr. and Mrs. Peter Blake, London; (Waddington Galleries, London).
Exhibitions: *Howard Hodgkin*, Arnolfini Gallery, Bristol, September 16–October 22, 1970; *Howard Hodgkin*, Galerie Müller, Cologne, January 15–February 25, 1971; *Howard Hodgkin*, Kasmin Gallery Ltd, London, March–April 1971; *Pictures for An Exhibition*, Whitechapel Art Gallery, London, March 30–May 18, 1980.

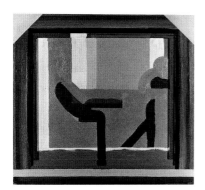

90 · MR. AND MRS. RICHARD SMITH
1969–70
Oil on wood
33 x 36 in. (84 x 92 cm.)
Collection: Private Collection.
Provenance: Charles Gordon, Spey Investments;
(Kasmin Gallery Ltd, London).
Exhibitions: *Howard Hodgkin*, Arnolfini Gallery,
Bristol, September 16–October 22, 1970, no. 2;
Howard Hodgkin, Galerie Müller, Cologne,
January 15–February 25, 1971, ill. b/w on
announcement; *Howard Hodgkin: Recent
Paintings*, Kasmin Gallery Ltd, London,
March–April 1971; Arts Council, 1976,
no. 29, ill. color.
Literature: Timothy Hilton, "UK Commentary,"
Studio International 181, June 1971, pp. 268–71,
ill. color p. 269.
Notes: See also *Dick and Betsy Smith*, cat. no. 114.

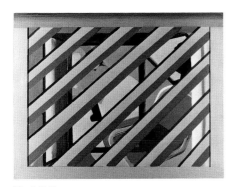

91 · R.B.K.
1969–70
Oil on wood
43 x 46 in. (109 x 117 cm.)
Collection: Private Collection.
Provenance: Charles Gordon, Spey Investments;
sold Sotheby's, London, March 16, 1977, lot 176;
(Waddington and Tooth, London).
Exhibitions: *Howard Hodgkin*, Arnolfini Gallery,
Bristol, September 16–October 22, 1970, cat. no.
1; *Howard Hodgkin*, Galerie Müller, Cologne,
January 15–February 25, 1971; *Howard Hodgkin:
Recent Paintings*, Kasmin Gallery Ltd, London,
March–April 1971; *John Moores Liverpool
Exhibition 8*, Walker Art Gallery, Liverpool,
April 27–July 2, 1972, cat. no. 21, ill.; Arts

Council, 1976, no. 28, ill. color; *British Painting
1952–1977*, Royal Academy of Arts, London,
September 24–November 20, 1977, cat. no. 190.
Literature: Bryn Richards, "Bristol Art—Howard
Hodgkin," *Manchester Guardian*, October 2,
1970: "*R.B.K.*, for example, has to be perceived
through broad, distracting bars of paint.";
Richard Cork, "An English Game—Keeping All
the Options Open," *Evening Standard* (London),
April 21, 1971, p. 16: "A painting called *RBK* is
dominated by a strident grid of mint diagonal
stripes; but in between the bars a diffuse, almost
whimsical scene is glimpsed, with meandering
forms and even a heart-shape floating in the
distant space."; John McEwen, "Art: Winning,"
Spectator 236, May 15, 1976, p. 29: "With it
[*R.B.K.*] he finally adopted wood instead of
canvas—often bits of wood of predetermined
shape to emphasize further the singularity of
each work—and he painted in a border for the
first time. This border specifies the subject as the
wood does, but as a painted frame it also draws
attention to the surface of the picture, to the
subtleties of the colour and in the later work
to the variety of the brushstrokes."
Notes: A portrait of the artist, R. B. Kitaj.

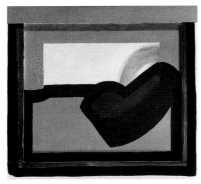

92 · ROOM WITH CHAIR
1969–70
Oil on wood
26 x 29 in. (66 x 74 cm.)
Collection: Private Collection.
Provenance: (Kasmin Gallery Ltd, London);
Private Collection, London; (Albemarle Gallery,
London).
Exhibitions: *Howard Hodgkin: Recent Paintings*,
Kasmin Gallery Ltd, London, March–April 1971;
Howard Hodgkin, Galerie Müller, Cologne,
January 15–February 25, 1971.

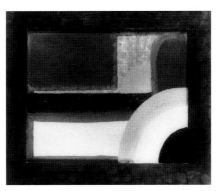

93 · MIRROR
1970–71
Oil on panel
26 x 30 in. (66 x 76 cm.)
Collection: De Beers.
Provenance: (Kasmin Gallery Ltd, London);
(Waddington and Tooth, London).
Exhibitions: *Howard Hodgkin*, Kasmin Gallery
Ltd, London, March–April 1971; *Critic's Choice:
1971*, Arthur Tooth and Sons Ltd, London,
March 2–26, 1971, cat. no. 25; *Art Spectrum
South*, Southampton City Art Gallery, June 5–July
4, 1971; Folkestone Arts Centre, July 9–August 1,
1971; Royal West of England Academy, Bristol,
August 20–September 18, 1971, no. 29, ill.;
*Patrick Caulfield, Howard Hodgkin, Michael
Moon*, Galerie Stadler, Paris, March 21–April
15, 1972; *Contemporary Art for 17 Charterhouse
Street*, Mall Galleries, London, May 21–25, 1979,
no. 72, ill. color.

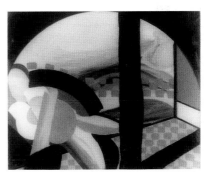

94 · MRS. ACTON IN DELHI
1967–71
Oil on canvas
48 x 58¼ in. (122 x 148 cm.)
Collection: J. Walter Thompson, London.
Provenance: (Kasmin Gallery Ltd, London).
Exhibitions: *Howard Hodgkin: Recent Paintings*,
Kasmin Gallery Ltd, London, March–April 1971;
La Peinture anglaise aujourd'hui, Musée d'art
moderne de la ville de Paris, Paris, February
7–March 11, 1973, cat. no. 42.
Literature: Richard Cork, "An English Game—
Keeping All the Options Open," *Evening
Standard* (London), April 21, 1971, p. 16, ill:

"When he calls one of his finest pictures *Mrs. Acton in Delhi*, the title sums up the peculiar brew of disparate ideas that make up his own individuality."; Bernard Denvir, "London Letter," *Art International* 17, April 1973, pp. 42–47, ill. p. 47; Julien Clay, "La Peinture anglaise aujourd'hui," *XXᵉ Siècle* 41, December 1973, pp. 174–76, ill. p. 175; Graham-Dixon, 1994, p. 29: "*Mrs. Acton in Delhi* (1967–71) is an abstract odalisque occupying a dream world of Matissean *luxe* and *volupté*, not an image of a person so much as the image of an *idea* of a person, indolent in exotic surroundings, as self-consciously decorative as the place she inhabits." Notes: See also *The Terrace, Delhi*, cat. no. 96.

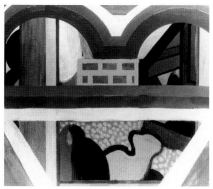

95 · SATURDAYS
1969–71
Oil on board
52 x 60 in. (132 x 152 cm.)
Collection: Art Gallery of South Australia.
Provenance: (Kasmin Gallery Ltd, London); Contemporary Art Society, London.
Exhibitions: *Howard Hodgkin*, Galerie Müller, Cologne, January 15–February 25, 1971; *Howard Hodgkin: Recent Paintings*, Kasmin Gallery Ltd, London, March–April 1971; *Patrick Caulfield, Howard Hodgkin, Michael Moon*, Galerie Stadler, Paris, March 21–April 15, 1972; Arts Council, 1976, no. 31, ill. color.
Literature: Richard Cork, "An English Game—Keeping All the Options Open," *Evening Standard* (London), April 21, 1971, p. 16: "In ... *Saturdays* the huge bands of colour which enclose the entire composition are prevented from bullying by the deliberate unevenness of Hodgkin's handling, dragging the brush over the more organic elements beneath so that they show through and are not cowed. In this ability to combine the unity with the magisterial lies his greatest triumph: the pictures may take him years to complete, and contain an almost eccentric number of diverse references, but they are never afraid to take sweeping decisions."; William Feaver, "Art: Exhibitionism," *London Magazine* 11, August–September 1971, p. 120, ill.

Notes: The sitting room in the flat of Mr. and Mrs. Peter Kinley, friends of the artist, at Rugby Mansions, London.

96 · THE TERRACE, DELHI
1967–71
Oil on canvas
48 x 58 in. (122 x 147 cm.)
Collection: Private Collection, London.
Provenance: Charles Gordon, Spey Investments; (Kasmin Gallery Ltd, London); (Bernard Jacobson Gallery, London).
Exhibitions: *Howard Hodgkin: Recent Paintings*, Kasmin Gallery Ltd, London, March–April 1971; Arts Council, 1976, no. 27, ill. color; *La peinture anglaise aujourd'hui*, Musée d'art moderne de la ville de Paris, Paris, February 7–March 11, 1973, cat. no. 43, ill. p. 31.
Literature: *London Magazine*, 1971, ill. p. 120; Timothy Hilton, "UK Commentary," *Studio International* 181, June 1971, pp. 268–71: "Hodgkin's well-known admiration for Matisse and for Eastern miniature painting came together most successfully in *The Terrace, Delhi*, with its reminder of Matissean window perspectives."; Julien Clay, "La Peinture anglaise aujourd'hui," *XXᵉ Siècle* 41, December 1973, pp. 174–76; Keith Clements, "Artists and Places Nine: Howard Hodgkin," *Artist* 101, August 1986, pp. 12–14, ill. pp. 12–13.
Notes: A portrait of Mr. and Mrs. John Acton, British Council representatives in Delhi at the time.

97 · VIEW
1970–71
Oil on board
33 x 78 in. (84 x 198 cm.)
Collection: Private Collection.
Provenance: (Kasmin Gallery Ltd, London); Paul Cornwall-Jones, England; (Kasmin Gallery Ltd, London); sold Sotheby's, New York, May 7, 1992, lot 295.
Exhibitions: *Critic's Choice: 1971*, Arthur Tooth and Sons Ltd, London, March 2–26, 1971.
Literature: Timothy Hilton, "UK Commentary," *Studio International* 181, June 1971, pp. 268–71: "Any relaxation from this tightness therefore had a curious effect, as in *View*, which put one in mind of a Milton Avery landscape in a very hot climate."
Notes: A view near Mahabalipuram; the alternative title *Southern Indian Sunrise: View* appears in the Kasmin Gallery records.

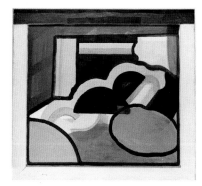

98 · BEDROOM IN CARENNAC
1971–72
Oil on wood
42½ x 47 in. (108 x 119 cm.)
Collection: Waddington Galleries, London.
Provenance: N. A. Tooth, London; sold Sotheby's, London, June 29, 1989, lot 525.
Exhibitions: *Patrick Caulfield, Howard Hodgkin, Michael Moon*, Galerie Stadler, Paris, March 21–April 15, 1972, listed as *Bedroom at Carennac*; *Peter Blake, Patrick Caulfield and Howard Hodgkin: Paintings from the 60s and 70s*, Waddington Galleries, London, February 22–March 25, 1995.
Notes: Signed, titled and dated on the reverse.

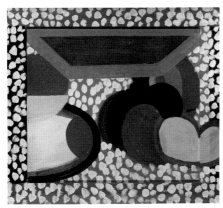

99 · BLUE EVENING
1972
Oil on wood
26 x 29 in. (66 x 74 cm.)
Collection: Unknown.
Provenance: (Kasmin Gallery Ltd, London);
Jill Kornblee, New York; Saatchi Collection,
London; sold Sotheby's, New York, May 7,
1992, lot 292.
Exhibitions: *Howard Hodgkin*, Kornblee Gallery,
New York, February 17–March 8, 1973; *Art of
Our Time, The Saatchi Collection*, Royal Scottish
Academy, Edinburgh, 1988, pp. 14–18, ill. p. 16.
Literature: Alistair Hicks, *New British Art in the
Saatchi Collection*, London: Thames and Hudson
Ltd, 1989, no. 34, ill. color p. 51; Pauline Peters,
"The Collector," *Sunday Telegraph Magazine*,
October 28, 1989, pp. 18–27, ill. color.
Notes: A portrait of Dick and Betsy Smith.

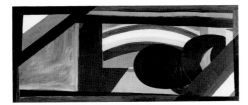

100 · COMING UP FROM THE BEACH
1970–72
Oil on wood
33 x 78 in. (84 x 198 cm.)
Collection: Unknown.
Provenance: (Kasmin Gallery Ltd, London);
Galerie Stadler, Paris.
Exhibitions: *Patrick Caulfield, Howard Hodgkin,
Michael Moon*, Galerie Stadler, Paris, March 21–
April 15, 1972; Arts Council, 1976, no. 34, ill.
color; *Narrative Paintings: Figurative Art of
Two Generations*, Arnolfini Gallery, Bristol,
September 1–October 20, 1979, and tour, ill.
color.
Literature: Timothy Hyman, "Howard Hodgkin,"
Studio International 189, May–June 1975, pp. 178,
180–81, 183; Timothy Hyman, "Correspondence:
Howard Hodgkin," *Studio International* 190,
July–August 1975, p. 88; Paul Overy, "Josef

Albers: Round and Round the Square," *The Times*
(London), March 30, 1976, p. 14, ill.; William
Feaver, "Loiterings with Deep Intent," *Observer*,
September 16, 1979, p. 15, ill. p. 34; Timothy
Hyman, in *Narrative Paintings: Figurative Art of
Two Generations*, Arnolfini Gallery, Bristol, 1979:
"Hodgkin's work shared with Paolozzi's and
Kitaj's a quality of being obviously impenetrable
or hermetic in its reference, of both demanding
and rebuffing interpretation; yet it diverged, not
only in that it was less immaculate, but that in
relation to its subject matter it was much less
distanced. His choice of a subject ostensibly less
urgent or 'important' allowed him to create an
art whose warmth and vulnerability now seems in
some respects more nourishing, more emotionally
charged. *Coming Up from the Beach* is like all his
works, about a specific occasion (as it happens,
a journey he made in India with Kasmin, so this
might be seen as another 'portrait'). In the figure
who climbs up and looks behind to see the
curving horizon of the ocean shining beneath him,
Hodgkin captures a very characteristic kind of
pleasure; the moment when, as we move from one
world to another, we look back, with nostalgia
and recognition, at the world we have left. The
picture went on for more than three years. Only
by desperate remedies could this difficult space
be made to work; apart from the figure and the
sea, everything else has become frame.

Like many of the artist's works, then, the
painting is about a break-through, a moment
of 'grace'. But it is the language that defines the
subtle emotional content.

On the one hand the picture has obviously
been allowed to take on a formidable autonomy;
it has a very solid, sculptural presence. Yet one
has only to look a little closer to see how much
has gone on underneath, how whole areas have
slid or been covered up, how unstable it all is.
Despite the definiteness of the final image, the
strong colour and the geometric shapes, we feel
that each of these signs has not been made, but
broken through to. It is a language of unknowing,
refusing any systematic or ready-made language
of forms."; Adrian Searle, "London: Narrative
Paintings," *Artforum* 18, January 1980, pp.
76–77, ill. p. 77.

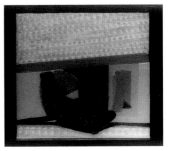

101 · FAMILY PORTRAIT
1972
Oil on wood
26 x 29 in. (66 x 74 cm.)
Collection: Unknown.
Provenance: (Kasmin Gallery Ltd, London); E. J.
Power.
Exhibitions: *Howard Hodgkin*, Kornblee Gallery,
New York, February 17–March 8, 1973; *Peter
Blake, Patrick Caulfield and Howard Hodgkin:
Paintings from the 60s and 70s*, Waddington
Galleries, London, February 22–March 25, 1995.

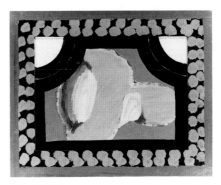

102 · GUEST
1972
Oil on panel
22¾ x 29 in. (57.5 x 73.5 cm.)
Collection: Private Collection.
Provenance: N. A. Tooth, London; (Kornblee
Gallery, New York); sold Sotheby's, London,
June 30, 1988, lot 642, ill. color; (Waddington
Galleries, London).
Exhibitions: *Howard Hodgkin*, Kornblee Gallery,
New York, February 17–March 8, 1973; Arts
Council, 1976, no. 37, ill. color p. 59; *Twentieth-
Century Works*, Waddington Galleries, London,
April 26–May 20, 1989, no. 44, ill. color p. 93.
Notes: Signed on the reverse.

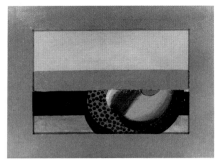

103 · IN THE KITCHEN
1970–72
Oil on wood
23¾ x 32½ in. (60 x 83 cm.)
Collection: Private Collection, England.
Provenance: (Kornblee Gallery, New York);
(Waddington Galleries, London).
Exhibitions: *Howard Hodgkin*, Kornblee Gallery,
New York, February 17–March 8, 1973; Arts
Council, 1976, no. 35, ill. color.

104 · INTERIOR 9AG
1972
Oil on wood
43 x 54 in. (109 x 137 cm.)
Collection: Private Collection, England.
Provenance: (Arthur Tooth and Sons Ltd,
London); E. J. Power.
Exhibitions: *La Peinture anglaise aujourd'hui*,
Musée d'art moderne de la ville de Paris, Paris,
February 7–March 11, 1973, cat. no. 44; Arts
Council, 1976, no. 36, ill. color; *Peter Blake,
Patrick Caulfield and Howard Hodgkin: Paintings
from the 60s and 70s*, Waddington Galleries,
London, February 22–March 25, 1995.
Literature: John Russell, "The English Conquest,"
Sunday Times, February 11, 1973, p. 27: "Howard
Hodgkin, who wields the laden brush in what
that Sonia Delaunay would understand if she
crossed the river to see the exhibition. That
slow, heavy movement of the brush intensifies
and concentrates emotion in ways that just
don't exist elsewhere in the show."; Richard Cork,
"Trapped in the Old-boy Net," *Evening Standard*
(London), October 10, 1974, pp. 24–25, ill. only;
William Feaver, "Hodgkin's Intelligence Tests,"
Observer, March 21, 1976, p. 30; John McEwen,
"Introduction," in *Howard Hodgkin: Forty*

Paintings: 1973–84, London: Whitechapel Art
Gallery, 1984, p. 10: "*Interior 9AG* is a notably
bold example from 1972, in which the surface
elements of the design—the black borders and
central tricolour division—dominate the
composition, and yet the division of the picture
into forward frame and background view—for
all the interior correspondence of bands of scarlet
and black—remains unabridged."; David
Sylvester, "Howard Hodgkin Interviewed by
David Sylvester," in *Howard Hodgkin: Forty
Paintings: 1973–84*, London: Whitechapel Art
Gallery, 1978, p. 100: "I saw last night a portrait
of 1972 called *Interior 9AG* which I hadn't seen
for a very long time. I had terrible trouble with
that picture and I resolved it eventually as a flat
design, whereas now I would have used all kinds
of illusionistic devices."
Notes: The title for this painting was suggested
by its subject, the noted art collector E. J. Power,
as 9AG was his London postal code.

105 · LUNCH
1970–72
Oil on wood
33 x 36 in. (84 x 91 cm.)
Collection: Friends of the Neuberger Museum,
State University of New York at Purchase.
Provenance: (Kornblee Gallery, New York).
Exhibitions: *Howard Hodgkin*, Kornblee Gallery,
New York, February 17–March 8, 1973; Arts
Council, 1976, no. 33, ill. color; *The Window in
Twentieth-Century Art*, Neuberger Museum, State
University of New York at Purchase, New York,
September 21, 1986–January 18, 1987, and
Contemporary Arts Museum, Houston, April 24–
June 29, 1987.
Literature: Fenella Crichton, "London Letter,"
Art International 20, Summer 1976, ill. p. 14.

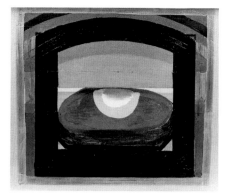

106 · MOONLIGHT
1971–72
Oil on wood
26¼ x 30½ in. (67 x 77.5 cm.)
Collection: Unknown.
Provenance: (Kornblee Gallery, New York).
Exhibitions: *Howard Hodgkin*, Kornblee Gallery,
New York, February 17–March 8, 1973.

107 · MRS. SHETH ON THE TERRACE
1970–72
Oil on wood
33 x 78 in. (84 x 198 cm.)
Collection: Private Collection; on loan to the
Scottish National Gallery of Modern Art,
Edinburgh.
Provenance: (Kasmin Gallery Ltd, London).
Exhibitions: *Patrick Caulfield, Howard Hodgkin,
Michael Moon*, Galerie Stadler, Paris, March 21–
April 15, 1972, as *Mrs. Sheth on Her Terrace*; Arts
Council, 1976, no. 32, ill. color.
Literature: Caroline Tisdall, "Howard Hodgkin,"
Guardian, May 27, 1976: "'Mrs. Sheth on the
Terrace' (1970–72) is a scene shot with something
approaching the colour auras that theosophists
pick up and which fascinated Kandinsky. Mrs.
Sheth herself is not there in any recognizable
form, but you get the feeling she must have been a
highly theatrical and totally bourgeois character."
Notes: Mrs. Sheth is a friend of the artist and a
resident of Bombay.

108 · NOT AT TABLE
1972
Oil on wood
33 x 36 in. (84 x 91.5 cm.)
Collection: Unknown.
Provenance: (Kasmin Gallery Ltd, London);
Patricia C. Jones, New York.
Exhibitions: Arts Council, 1976, no. 38, ill. color

109 · READING
1972
Oil on wood
22³⁄₄ x 29 in. (58 x 74 cm.)
Collection: Private Collection.
Provenance: (Kasmin Gallery Ltd, London);
(Kornblee Gallery, New York); William O'Reilly;
(André Emmerich Gallery, New York); sold
Sotheby's, New York, May 4, 1987, lot 60, ill.
Exhibitions: *Howard Hodgkin*, Kornblee Gallery,
New York, February 17–March 8, 1973; *The
British are Coming*, De Cordova Museum,
Lincoln, Massachusetts, 1975.
Notes: Signed on the reverse.

110 · SUNSET
1970–72
Oil on wood
26 x 30¹⁄₄ in. (66 x 76.5 cm.)
Collection: Private Collection.
Provenance: (Kasmin Gallery Ltd, London);
(Kornblee Gallery, New York).
Exhibitions: *Howard Hodgkin*, Kornblee Gallery,
New York, February 17–March 8, 1973.
Literature: Sanford Schwartz, "New York Letter,"
Art International 17, May 1973, ill. p. 42.

111 · WINDOW
1972
Oil on wood
32¹⁄₄ x 36¹⁄₄ in. (82 x 92 cm.)
Collection: The Roc Group, Paris.
Provenance: (Kasmin Gallery Ltd, London);
(Waddington Galleries, London).
Exhibitions: *Howard Hodgkin*, Kornblee Gallery,
New York, February 17–March 8, 1973.

112 · BOMBAY SUNSET
1972–73
Oil on wood
33¹⁄₂ x 36¹⁄₄ in. (85 x 92 cm.)
Collection: Private Collection, London.
Provenance: E. J. Power; Charles Ewart;
(Waddington Galleries, London).
Exhibitions: Arts Council, 1976, no. 39, ill.
color; British Council, 1984, p. 18, ill. color.
Literature: Bruce Chatwin, "A Portrait of the
Artist," in *Howard Hodgkin: Indian Leaves*,
London and New York: Petersburg Press,
1982, p. 14, ill. color p. 15; John McEwen,
"Howard Hodgkin—Indian Leaves," *Studio
International* 196, January–February 1983,
p. 57, ill. color; John McEwen, "Introduction,"
in *Howard Hodgkin: Forty Paintings: 1973–84*,
London: Whitechapel Art Gallery, 1984, p. 11:
"What view could be more immediately
recognisable, and yet so minimally contrived
and described? The threatening clouds, the
depth of space, the coming night, each suggestion
made by marks not one of which is descriptive
in itself. And yet no one, surely, could fail to
identify with its mood of loneliness and regret.";
Kenneth Baker, "Too Much and/or Not Enough:
A Note on Howard Hodgkin," *Artforum* 23,
February 1985, pp. 60–61; Vivien Raynor, "At
Yale, the 'Afterthoughts' of Howard Hodgkin,"
The New York Times, February 10, 1985, C24,
ill.; Judith Higgins, "In a Hot Country,"
ARTnews 84, Summer 1985, pp. 56–65: "A
painting whose intense mood and directness
look forward to his work in the '80s. The colors
are literally Indian. ... 'It represents a moment
of great loneliness on the part of the artist,'
Hodgkin once explained."; Marina Vaizey,
"The Intimate Room Within," *Sunday Times*,
September 29, 1985; Keith Clements, "Artists
and Places Nine: Howard Hodgkin," *Artist* 101,
August 1986, pp. 12–14, ill. color on cover;
Asmund Thorkildsen, "En Samtale med Howard
Hodgkin," *Kunst og Kultur* 4, Oslo: University
Press, National Gallery, April 1987, pp. 220–34,
ill. color p. 228; Graham-Dixon, 1994, p. 114, ill.
color p. 111: "As Bruce Chatwin wrote, 'Painted

in the colours of mud, blood, and bile.'"
Notes: In the 1987 interview with Asmund Thorkildsen, Hodgkin was asked if the forms in this work were ironic references to the stylistic characteristics of artists like Jasper Johns. He replied: "There was no conscious irony in it. I think the striped ocean and the dotted sky in *Bombay Sunset* are simply part of the language that I was trying to evolve for myself, using very simplistic means. ... A sunset in Bombay really does—curiously enough—look like that. ... It's the only thing I can think of in any of my pictures which has a specific likeness to an Indian miniature." (English transcript in Hodgkin's archives)

113 · MR. AND MRS. E.J.P.
1972–73
Oil on wood
35½ x 48 in. (90.5 x 122 cm.)
Collection: Unknown.
Provenance: (Kasmin Gallery Ltd, London); A. N. Tooth, London; E. J. Power.
Exhibitions: Arts Council, 1976, no. 40, ill. color; *The Artist's Eye: An Exhibition selected by Howard Hodgkin*, National Gallery, London, June 20–August 19, 1979, p. 23, ill.; British Council, 1984, p. 19, ill. color; *Peter Blake, Patrick Caulfield and Howard Hodgkin: Paintings from the 60s and 70s*, Waddington Galleries, London, February 22–March 25, 1995.
Literature: Timothy Hyman, "Howard Hodgkin," *Studio International* 189, May–June 1975, pp. 178, 180–81, 183; Timothy Hyman, "Correspondence: Howard Hodgkin," *Studio International* 190, July–August 1975, p. 88; Fenella Crichton, "The Artist's Eye: An Exhibition Selected by Howard Hodgkin," *Pantheon* 37, October–December 1979, p. 326; John McEwen, "Introduction," in *Howard Hodgkin: Forty Paintings: 1973–84*, London: Whitechapel Art Gallery, 1984, p. 10: "Mr. and Mrs. E.J.P., for instance, have gathered together probably the most distinguished art collection to have been privately assembled in England since the Second World War. The haze of green, which describes the enveloping conversation of Mr. E.J.P. makes reference also to

a sculpture by Brancusi."; Paul Richard, "Howard Hodgkin's Art: Shining Light at the Phillips Collection," *The Washington Post*, October 11, 1984, B1; Asmund Thorkildsen, "En Samtale med Howard Hodgkin," *Kunst og Kultur* 4, Oslo: University Press, National Gallery, April 1987, pp. 220–34: "Take the red, black and yellow stripes in Mr. and Mrs. E.J.P. Does this use of colour suggest a linking with Germany?: Absolutely none, whatever. It is a pure coincidence."; Graham-Dixon, 1994, p. 13, ill. color p. 11: "*Mr. and Mrs. E.J.P.* (1972–73) is another essay in the observation of claustrophobia, but tinged with surrealism: a large green egg-shaped cloud seems to be expanding, like a mist or fog, to fill a space of cramped and confining pattern." (p. 2 of English transcript in Hodgkin's archives)
Notes: This is one of a series of portraits of Mr. and Mrs. E. J. Power, commissioned by Power. Hodgkin has recalled that he painted four portraits in all, over a period of eight years.

In the catalogue for the 1979 exhibition at the National Gallery, London, *The Artist's Eye: An Exhibition Selected by Howard Hodgkin*, Hodgkin described this painting as follows: "An interior containing two sculptures by Westerman, a Brancusi, a Pollock, a panelled wooden ceiling, etc. as well as the owners; the wife slipping away to the right and the husband talking in green in the foreground." The composition is the reverse of *Interior 9AG*, cat. no. 104.

114 · DICK AND BETSY SMITH
1971–74
Oil on wood
23¼ x 29 in. (59 x 74 cm.)
Collection: Saatchi Collection, London.
Exhibitions: *Group Exhibition Selected by Peter Blake*, Festival Gallery, Linley House, Bath, August 23–September 14, 1974, no. 5; *Howard Hodgkin: New Paintings*, Waddington Galleries II, London, May 5–28, 1976, cat. no. 8.
Literature: John McEwen, "Introduction," in *Howard Hodgkin: Forty Paintings: 1973–84*, London: Whitechapel Art Gallery, 1984, p. 11: "In *Dick and Betsy Smith* one character is

presented as a profile of a mouth, the other as the suggestion of a figure apparently peppered to bits by the mouth's invective. Mrs. Smith is a famous talker."; Alistair Hicks, *New British Art in the Saatchi Collection*, London: Thames and Hudson Ltd, 1989, p. 47, ill. color no. 31, p. 49; Graham-Dixon, 1994, pp. 29–30, ill. color p. 28: "*Dick and Betsy Smith* (1971–74) are reconfigured as unrecognizable marks lost in a paradise garden of painted forms, or tiles in a mosaic of oriental complexity. They are people recalled in a painting that attempts to create an equivalent, perhaps, for the sort of world that might please them."

115 · IN A HOTEL GARDEN
1974
Oil on wood
42⅛ x 50 in. (107 x 127 cm.)
Collection: Tate Gallery, London.
Provenance: (Kasmin Gallery Ltd, London); Alex Reid & Lefevre Ltd.
Exhibitions: *An Exhibition of Contemporary British Painters and Sculptors*, Lefevre Gallery, London, April 18–May 18, 1974, no. 15, ill. and dated 1974; *New Image in Painting: 1st International Biennial Exhibition of Figurative Painting*, Tokyo Department Store, Tokyo, September 6–18, 1974, ill. in catalogue; Arts Council, 1976, no. 41, ill. color.
Literature: *The Tate Gallery 1974–6: Illustrated Catalogue of Acquisitions*, London: Tate Gallery Publications, 1976, p. 112, ill.: "The painting represents the artist and John Kasmin sitting under palm trees in the courtyard of the Grand Hotel in Calcutta in October of 1968. Hodgkin notes: 'The courtyard of the Grand Hotel was shabby and full of green shutters on the surrounding windows, and palm trees. The floor of the courtyard was occupied by a terrazzo pool in characteristic Indian Hotel sub Art Deco style.' Hodgkin began work on his return from India, but recalled great difficulty in completing the work. Hodgkin remembers showing it to a friend when it was half completed, and feeling as he showed it that he might never be able to finish it. 'The brown paint was a final desperate attempt

to contain the intensity (in every sense) of the scene. But all the original ingredients of the view were once present.'"; "Paintings by Numbers," *Observer Magazine*, February 13, 1994, p. 44, ill. color.
Notes: Unsigned.

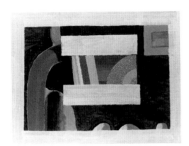

116 · INTERIOR DURAND GARDENS
1972–74
Oil on wood
36 x 48 in. (91.5 x 122 cm.)
Collection: Private Collection.
Provenance: (Kasmin Gallery Ltd, London); (Arnolfini Gallery, Bristol); Marchioness of Dufferin and Ava; Lefevre Gallery, London; William and Penelope Govett, London.
Exhibitions: *John Moores Liverpool Exhibition 9*, Walker Art Gallery, Liverpool, June 13–September 15, 1974, cat. no. 86; *Howard Hodgkin: New Paintings*, Waddington Galleries II, London, May 5–28, 1976, cat. no. 5; *Alistair Smith, A Personal Selection*, Ulster Museum, Belfast, May 29–August 23, 1981, p. 40.
Notes: See *Small Durand Gardens*, cat. no. 119.

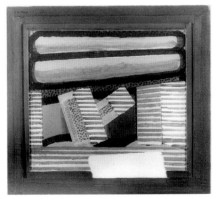

117 · INTERIOR GROSVENOR SQUARE
1971–74
Oil on wood
31½ x 34½ in. (80 x 87.5 cm.)
Collection: Private Collection, Belgium.
Provenance: (Kasmin Gallery Ltd, London).
Exhibitions: *Group Exhibition Selected by Peter Blake*, Festival Gallery, Linley House, Bath, August 23–September 14, 1974, no. 6;

Contemporary Arts Society Art Fair, Mall Galleries, London, January 15–23, 1975, no. 65; *British Exhibition Art 5'75*, Schweizer Mustermesse, Basel, June 18–23, 1975, no. 24, ill. Literature: Timothy Hyman, "Howard Hodgkin," *Studio International* 189, May–June 1975, pp. 178, 180–81, 183, ill. color p. 178.

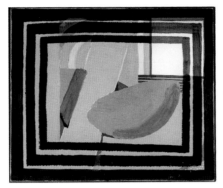

118 · ON THE TERRACE
1971–74
Oil on board
42 x 50 in. (107 x 127 cm.)
Collection: Unknown.
Provenance: (Kasmin Gallery Ltd, London); Max Gordon, London.
Exhibitions: *New Image in Painting: 1st International Biennial Exhibition of Figurative Painting*, Tokyo Department Store, Tokyo, September 6–18, 1974; *1977 Hayward Annual. Current British Art Selected by Michael Compton, Howard Hodgkin and William Turnbull*, Hayward Gallery, London, Part Two: July 20–September 4, 1977, ill. p. 110, but not exhibited.

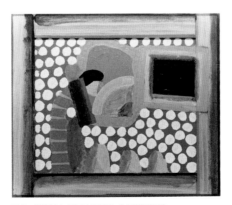

119 · SMALL DURAND GARDENS
1974
Oil on wood
22¼ x 26¼ in. (56.5 x 66.5 cm.)
Collection: Private Collection, London.
Provenance: (Kasmin Gallery Ltd, London).
Exhibitions: *British Art mid-70s, Englische Kunst Mitte der Siebzigerjahre*, Jahrhunderthalle Hoechst, March 26–April 25, 1975, and Forum Leverkusen, May 7–28, 1975; Arts Council, 1976,

no. 42, ill. color; British Council, 1984, p. 21, ill. color.
Literature: Timothy Hyman, "Howard Hodgkin," *Studio International* 189, May–June 1975, pp. 178, 180–81, 183, ill. color p. 178; James Burr, "Round the Galleries: Bold Banalities," *Apollo* 103, May 1976, ill. p. 444; John McEwen, "London: Howard Hodgkin at the Serpentine Gallery," *Art in America* 64, July–August 1976, pp. 103, 113: "It is in this complexity of content that Hodgkin's work transcends its peculiarly English celebration of domesticity and privacy—an evening dinner party in *Small Durand Gardens*, the cobalt blue eye of a London evening glowing in the window—and promotes Hodgkin to the front rank of figurative artists working anywhere in the world today."; Richard Shone, *The Century of Change, British Painting Since 1900*, Oxford: Phaidon, 1977, p. 208, ill. color plate 196 and on cover; John McEwen, "A Letter from London," *Artscanada* 34, May–June 1977, pp. 31–32, ill. p. 31; Lawrence Gowing, "Howard Hodgkin," in *Howard Hodgkin*, New York: M. Knoedler and Co., Inc., 1981: "Happening to recognise, in a mosaic of bright-spotted blue, framed in mustard yellow that is moulded with brown and linked in scarlet with a sunlit window and a sunless picture, in one of those collocations of forbidden colours that are meat and drink to the painter, a highly intelligent Senior Civil Servant, I leave her to entertain her marmalade-coloured guests. It is the totality of the mosaic that entertains us. ... Absorbed in the simultaneous flat-and-deep of Hodgkin's colour one no longer seeks to decode it. One dwells on it for itself."; Mary S. Cohen, "The General Effect is One of Celebration," *The Christian Science Monitor*, December 31, 1984, pp. 22–23, ill. p. 22; Graham-Dixon, 1994, ill. color p. 163.
Notes: Durand Gardens was the address of Richard and Sally Morphet at the time. Mr. Morphet, curator at the Tate Gallery, London, was the curator of Hodgkin's first retrospective exhibition in 1976.

120 · ARTIFICIAL FLOWERS
1975
Oil on wood
14¾ x 20 in. (37.5 x 51 cm.)
Collection: Waddington Galleries, London.
Provenance: (Kasmin Gallery Ltd, London).
Exhibitions: *Howard Hodgkin: New Paintings*,
Waddington Galleries II, London, May 5–28,
1976, cat. no. 6, ill. color cover of announcement.

121 · CAFETERIA AT THE GRAND PALAIS
1975
Oil on wood
49 x 57 in. (124.5 x 145 cm.)
Collection: Mr. Alex Bernstein.
Provenance: (Kasmin Gallery Ltd, London).
Exhibitions: *John Moores Liverpool Exhibition
10*, Walker Art Gallery, Liverpool, May 6–August
8, 1976, cat. no. 4, ill.; *1977 Hayward Annual.
Current British Art Selected by Michael Compton,
Howard Hodgkin and William Turnbull*, Hayward
Gallery, London, Part Two: July 20–September 4,
1977, ill. p. 111; *The Granada Collection: Recent
British Painting and Drawing*, Whitworth Art
Gallery, University of Manchester, England,
January 15–February 26, 1983, cat. no. 6.
Literature: William Feaver, "Over and Out,"
Observer, May 9, 1976, p. 27; Paul Overy,
"Moores the Pity: Time to Change the Rules?,"
The Times (London), May 11, 1976, p. 13; Jane
Clifford, "Exhibition Shows Patrons Generosity,"
Daily Telegraph (Manchester edition), May 13,
1976, p. 6, ill.: "Second prize has gone to
'Cafeteria at the Grand Palais' by Howard
Hodgkin whose retrospective exhibition will
shortly be touring the North. This smaller, more

intimate, but punchy and colourful painting, we
are told, is commemorating a lunch with Louis
Hodgkin during a visit to the exhibition 'Le
Centenaire de l'Impressionisme.' Hodgkin uses
spots, stripes and blocks of colour to give an
impression of two people in an interior and their
relationship to the room and to one another.";
Margo Ingham, "John Moores Liverpool
Exhibition 10," *Arts Review* 28, May 28, 1976,
ill. p. 264; Norbert Lynton, Francis Golding, and
Paul Overy, "How Newspaper Critics Paint Art,"
Guardian, July 23, 1977; Richard Shone, "Gallery:
Painting and Performance," *Architectural Review*
162, September 1977, pp. 184–86, ill. p. 184;
Graham-Dixon, 1994, p. 36, ill. color p. 32.
Notes: This painting was awarded second prize
in *John Moores Liverpool Exhibition 10*, 1976.

122 · GRANTCHESTER ROAD
1975
Oil on wood
49 x 57 in. (124.5 x 145 cm.)
Collection: Private Collection, London.
Provenance: (Kasmin Gallery Ltd, London).
Exhibitions: Arts Council, 1976, ill. color no. 45;
British Council, 1984, ill. color p. 25.
Literature: Mark Haworth-Booth, "Salon and
Workshop," *Times Literary Supplement*, March
19, 1976, p. 318, ill.; William Feaver, "Hodgkin's
Intelligence Tests," *Observer*, March 21, 1976, p.
30; Richard Cork, "London Art Review," *Evening
Standard* (London), May 20, 1976, p. 24; Caroline
Tisdall, "Howard Hodgkin," *Guardian*, May 27,
1976; John McEwen, "Four British Painters,"
Artforum, December 1978, pp. 50–55, ill. p. 51;
John McEwen, "Introduction," in *Howard
Hodgkin: Forty Paintings: 1973–84*, London:
Whitechapel Art Gallery, 1984, p. 11:
"*Grantchester Road* features another collector's
home. He is a well-known architect, reference to
his profession being alluded to by the inclusion of
Hodgkin himself, half hidden by a black vertical,
to give scale in the manner of an architect's
drawing."; Eric Gibson, "The Hodgkin Paradox,"
Studio International 198, March 1985, pp. 23–25:
[Compared to *Interior with Figures* (1977–84)]

"Both are interior pictures, the former is a
rigorously rectilinear painting, its spaces clearly
articulated, and its repeated verticals relieved only
by dappled planes in the background and in the
foreground a series of frame-hugging, exuberant
arcs."; Gisela Burkamp, "Durch und durch
sinnenhaftes Ereignis," *Lippische Landeszeitung*,
April 30, 1985, ill. p. 23; Judith Higgins, "In a
Hot Country," *ARTnews* 84, Summer 1985, pp.
56–65, ill. color p. 59: "*Grantchester Road* (1975)
was a breakthrough. Contour lines have become
shapes; the marks are released from captivity. ...
A less insistent way of sustaining flatness, the
frame also sets up an illusory space that is deeper
and more varied than the previous peepholes and
slots. *Grantchester Road* is the first of Hodgkin's
stage-set paintings. There is even a character:
in this interior of the house of a well-known
architect and collector, Hodgkin has hidden a
depiction of himself almost completely behind
a black vertical."; John Russell, "London and
Yale, Hodgkin at the Whitechapel," *Burlington
Magazine* 127, October 1985, pp. 729, 731–32;
Brian Sewell, "The Mark of a Hypnotist,"
Evening Standard (London), October 3, 1985,
ill. p. 23; Michael McNay, "Howard Hodgkin,"
Guardian, October 12, 1985, p. 10; Asmund
Thorkildsen, "En Samtale med Howard
Hodgkin," *Kunst og Kultur* 4, Oslo: University
Press, National Gallery, April 1987, pp. 220–34:
"And do the black and pink Art Deco circle-
segments in 'Grantchester Road' suggest that the
owner of this house collects Art Deco objects?: 'I
think that in actual fact, the owner of the house in
Grantchester Road would have apoplexy if it were
thought he had anything to do with Art Deco at
all.'" (p. 2 of English transcript in Hodgkin's
archives); Graham-Dixon, 1994, ill. color p. 72.
Notes: Grantchester Road was the address of the
architect and art collector, Colin St. John Wilson.

123 · ON THE EDGE OF THE INDIAN OCEAN
1974–75
Oil on panel
17½ x 38½ in. (44.5 x 98 cm.)
Collection: The Roc Group, Paris.
Provenance: Private Collection; Bruce and Judith Eissner; (Waddington Galleries, London).
Exhibitions: Arts Council, 1976, no. 43, ill. color.
Literature: Mark Haworth-Booth, "Salon and Workshop," *Times Literary Supplement*, March 19, 1976, p. 318; Keith Clements, "Artists and Places Nine: Howard Hodgkin," *Artist* 101, August 1986, pp. 12–14, ill. p. 12; Andreas Beyer, "An Interview with Howard Hodgkin," *Kunstforum* 110, November–December 1990, pp. 210–222, ill. p. 212.

124 · ROBYN DENNY AND KATHERINE REID
1975
Oil on wood
35¾ x 47¾ in. (91 x 122 cm.)
Collection: Bristol Museum and Art Gallery, Bristol, England.
Provenance: (Kasmin Gallery Ltd, London).
Exhibitions: *Howard Hodgkin: New Paintings*, Waddington Galleries II, London, May 5–28, 1976, cat. no. 1.
Literature: Graham-Dixon, 1994, p. 30: "Such pictures mischievously suggest the way in which people, to the painter, can be less memorable than the circumstances in which they are encountered, the way in which essentials can be crowded out of the mind by incidentals."

125 · SIMON DIGBY TALKING
1972–75
Oil on wood
25 in. diameter (63.5 cm.)
Collection: City Art Gallery, Southampton, gift of Contemporary Art Society, London.
Provenance: (Kasmin Gallery Ltd, London); Contemporary Art Society, London; (Waddington Galleries, London).
Exhibitions: *Howard Hodgkin: New Paintings*, Waddington Galleries II, London, May 5–28, 1976, cat. no. 9.
Literature: *Through Children's Eyes: A Fresh Look at Contemporary Art*, London: Wildground County Junior School and Arts Council, 1982.

126 · TALKING ABOUT ART
1975
Oil on wood
41¾ x 50 in. (106 x 127 cm.)
Collection: Morgan Grenfell Trustee Services (Guernsey) Ltd, JC Mann & JK Blewett as Trustees of The Haut Brion Trust.
Provenance: (Arnolfini Gallery, Bristol); (Kasmin Gallery Ltd, London).
Exhibitions: Arts Council, 1976, no. 44, ill. color; British Council, 1984, p. 23, ill. color.
Literature: William Feaver, "Hodgkin's Intelligence Tests," *Observer*, March 21, 1976, p. 30; Caroline Tisdall, "Howard Hodgkin," *Guardian*, May 27, 1976; John McEwen, "Introduction," in *Howard Hodgkin: Forty Paintings: 1973–1984*, London: Whitechapel Art Gallery, 1984, pp. 10, 11: "One of the most noticeable aspects of this development is a greater

use of the raw wooden surface itself; the device so successfully, but more archly, introduced with *Talking About Art*."; Gisela Burkamp, "Durch und durch sinnenhaftes Ereignis," *Lippische Landeszeitung*, April 30, 1985, p. 23, ill.; Alistair Hicks, "Talking About Art," *Spectator* 225, September 28, 1985, pp. 35–36: "*Talking About Art* is a satirical work. ... Mr. Hodgkin does not altogether approve of art talk as this painting reveals. It is highly regimented, consisting of well-ordered geometric formations, tightly contained in a heavy purple-painted framework. The planes of colour act as a dictionary of brush strokes, each box enclosing a different technique. The flat surface is broken by the deceptive use of the raw canvas and a glimpse of a fluent and bold stroke, yet this only highlights the two-dimensionality of the conversation. It is not going anywhere."; Ally van der Pauw, "Howard Hodgkins Zuchtjes van Pijn en Plezier," *Haagse Post*, December 7, 1985, pp. 52–55; Graham-Dixon, 1994, p. 161: "Another painting that frames a painting within it, a small oblong surrounded by buzzing confusion, by planes of overlapping colour and pillars of paint which suggest the wider world that all paintings have to define themselves against and compete with. The world, perhaps, of the gallery on opening night, where paintings are treated as things to be glanced at on the way to the bar. ... Hodgkin's pictorial language is extremely matter-of-fact, made of marks that never begin to pretend they are anything other than marks made on a flat surface using a paintbrush."

127 · THE BUCKLEYS AT BREDE
1974–76
Oil on wood
24 x 28 in. (61 x 71 cm.)
Collection: Australian National Gallery, Canberra.
Provenance: (Kasmin Gallery Ltd, London); (Waddington Galleries, London).
Exhibitions: *Howard Hodgkin: New Paintings*, Waddington Galleries II, London, May 5–28, 1976, cat. no. 7; *European Dialogue. The Third Biennale of Sydney at The Art Gallery of New South Wales*, Sydney, April 14–May 27, 1979.

128 · ELLEN SMART'S INDIAN SLIDE SHOW
1974–76
Oil on wood
28³⁄₄ x 42¹⁄₂ in. (73 x 108 cm.)
Collection: Private Collection, Hong Kong.
Provenance: (André Emmerich Gallery, New
York); (Kasmin Gallery Ltd, London); sold
Christie's, London, October 26, 1994, lot 194,
ill. color p. 100 and on cover.
Exhibitions: *Howard Hodgkin: New Paintings*,
Waddington Galleries II, London, May 5–28,
1976, cat. no. 2; *1977 Hayward Annual. Current
British Art Selected by Michael Compton, Howard
Hodgkin and William Turnbull*, Hayward Gallery,
London, Part Two: July 20–September 4, 1977, ill.
p. 112, but not in exhibition; *Howard Hodgkin:
New Paintings*, André Emmerich Gallery, New
York, September 15–October 5, 1977; *Howard
Hodgkin*, André Emmerich Gallery, Zurich,
December 2, 1977–January 7, 1978.
Literature: John McEwen, "Art: Winning,"
Spectator 236, May 15, 1976, p. 29; Donald B.
Kuspit, "Howard Hodgkin at Emmerich," *Art
in America* 65, November–December 1977,
pp. 134–35.
Notes: The title refers to Dr. Ellen S. Smart,
curator of South Asian Art at the San Diego
Museum of Art and a friend of the artist.

**129 · FROM THE HOUSE OF BHUPEN
KHAKHAR**
1975–76
Oil on wood
48⁷⁄₈ x 56³⁄₈ in. (124 x 143 cm.)
Collection: Private Collection.
Provenance: (Kasmin Gallery Ltd, London).
Exhibitions: *Howard Hodgkin: New Paintings*,
Waddington Galleries II, London, May 5–28,

1976, cat. no. 4; *British Painting 1952–1977*,
Royal Academy of Arts, London, September 24–
November 20, 1977, cat. no. 191.
Notes: A view from the house of Bhupen
Khakhar, an Indian representational painter, who
lives and works in Baroda in India, and is also a
part-time chartered accountant. His works were
included in *Contemporary Indian Art II* at the
Royal Academy in London in the fall of 1982.

**130 · INTERIOR WITH A PAINTING BY
STEPHEN BUCKLEY**
1975–76
Oil on wood
49 x 56⁷⁄₈ in. (124.5 x 144.5 cm.)
Collection: J. Sainsbury plc, London.
Provenance: (Kasmin Gallery Ltd, London);
(Waddington Galleries, London).
Exhibitions: *Howard Hodgkin: New Paintings*,
Waddington Galleries II, London, May 5–28,
1976, cat. no. 3; British Council, 1984, p. 27,
ill. color.

131 · MR. AND MRS. STEPHEN BUCKLEY
1974–76
Oil on wood
29 x 42 in. (74 x 107 cm.)
Collection: Tate Gallery, London.
Provenance: (Kasmin Gallery Ltd, London);
James Kirkman, London.
Exhibitions: *The Human Clay, An Exhibition
Selected by R. B. Kitaj*, Hayward Gallery, London,
August 5–30, 1976, no. 58; *Howard Hodgkin:
New Paintings*, André Emmerich Gallery, New
York, September 15–October 5, 1977; *Mixed
Exhibition*, Knoedler Gallery, London, March

1978; *L'Art anglais d'aujourd'hui: Collection
Tate Gallery, Londres*, Musée Rath, Geneva,
July–September 1980, cat. no. 12, ill.
Literature: *The Tate Gallery 1980–82, Illustrated
Catalogue of Acquisitions*, London: Tate Gallery
Publications, 1982, p. 140, ill.; Marina Vaizey,
"The Rebirth of Painting," *Life*, September 1986,
ill. color.
Notes: A portrait of the British artist Stephen
Buckley and his wife. Hodgkin painted a smaller
version of the same subject, *The Buckleys at Brede*,
now in the collection of the Australian National
Gallery, Canberra (see cat. no. 127). The artist has
written: "Both paintings were the result of staying
for the week with the Buckleys in a house they
had borrowed at Brede near Rye, Sussex. The
subject of the picture is simply a family group
sitting round a fire in the evening. I think the time
of year must have been autumn, as I remember it
was quite chilly. ... The picture was painted on a
second-hand wooden drawing board, the surface
of which was not primed in any way. The drawing
pin holes can be seen all over the picture." (Letter
of June 2, 1980, quoted from *The Tate Gallery
1980–82, Illustrated Catalogue of Acquisitions*,
p. 140.) In the same letter, Hodgkin expressed a
preference that the painting be exhibited without
a frame. Signed and dated 1976 on the reverse.

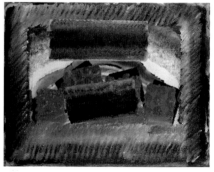

132 · AFTER DINNER
1976–77
Oil on wood
30 x 38³⁄₄ in. (76.2 x 98 cm.)
Collection: Mr. and Mrs. Graham Gund.
Provenance: (Kasmin Gallery Ltd, London);
(André Emmerich Gallery, New York).
Exhibitions: *Howard Hodgkin: New Paintings*,
André Emmerich Gallery, New York, September
15–October 5, 1977; *Howard Hodgkin*, André
Emmerich Gallery, Zurich, December 2, 1977–
January 7, 1978; *A Private Vision: Contemporary
Art from the Graham Gund Collection*, Museum
of Fine Arts, Boston, February 9–April 4, 1982,
ill. p. 57; British Council, 1984, p. 35, ill. color;
Nantes, 1990, no. 4; *Howard Hodgkin*, University
Art Museum, University of California, Berkeley,
September 25–December 16, 1991, no. 1.

Literature: Donald B. Kuspit, "Howard Hodgkin at Emmerich," *Art in America* 65, November–December 1977, pp. 134–35, ill. color p. 135; John McEwen, "Four British Painters," *Artforum*, December 1978, pp. 50–55, ill. color; William Feaver, "Art," *Vogue* (UK) 142, September 1985, pp. 46, 52; Marina Vaizey, "The Intimate Room Within," *Sunday Times*, September 29, 1985; Graham-Dixon, 1994, ill. color p. 76.

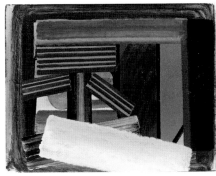

133 · FOY NISSEN'S BOMBAY
1975–77
Oil on wood
28¼ x 36¼ in. (71 x 92 cm.)
Collection: Arts Council Collection, The South Bank Centre, London.
Provenance: (Kasmin Gallery Ltd, London); (Waddington Galleries, London).
Exhibitions: *1977 Hayward Annual. Current British Art Selected by Michael Compton, Howard Hodgkin and William Turnbull*, Hayward Gallery, London, Part Two: July 20–September 4, 1977, ill. p. 113; *To-day: Brittiskt 60-och 70-tal*, Lunds Konsthall, Sweden, April 7–May 6, 1979, no. 46, ill. color p. 25; *The British Art Show: Selected by William Packer* (organized by the Arts Council), Mappin Art Gallery, Sheffield, December 1, 1979–January 27, 1980; Laing Art Gallery, Newcastle-upon-Tyne and Hatton Gallery, University of Newcastle, February 15–March 23, 1980; Arnolfini Gallery, Bristol and Royal West of England Academy, Bristol, April 18–May 24, 1980; *A Mansion of Many Chambers: Beauty and Other Works* (organized by the Arts Council), Cartwright Hall, Bradford, December 12, 1981–January 17, 1982; Art Gallery, Oldham, April 24–May 29, 1982; Gardner Center Gallery, Brighton, June 9–July 7, 1982; Colchester Minories, July 17–August 22, 1982; Mappin Art Gallery, Sheffield, August 28–October 30, 1982; City Art Gallery, Worcester, November 20–January 1, 1983, no. 13, ill.; *Three Little Books About Painting: 2 Movements* (organized by the Arts Council), Graves Art Gallery, Sheffield, November 19–December 18, 1983; Laing Art Gallery, Newcastle-upon-Tyne, January 4–29, 1984; Norwich Castle Museum, February 8–

March 4, 1984; Bolton Museum and Art Gallery, March 10–April 7, 1984, cat. no. 14, ill. p. 17; *The Proper Study: Contemporary Figurative Painting from Britain*, Lalit Kala Akademi, New Delhi, December 1–31, 1984, and Jahangir Nicholson Museum of Modern Art, Bombay, February 1–28, 1985; *2D 3D*, Laing Art Gallery and Northern Centre for Contemporary Art, Newcastle-upon-Tyne, January 14–March 8, 1987; *Masterpieces from the Arts Council Collection*, Ueno Royal Museum, Tokyo, October 25–29, 1990; *The Absent Presence*, Graves Art Gallery, Sheffield, January 19–March 2, 1991.
Literature: James Faure Walker, "Ways of Disclosing: Mapping the Hayward Annual," *Artscribe* 8, September 1977, pp. 20–26, ill. p. 25; *Arts Council Collection, A Concise, Illustrated Catalogue*, London: Arts Council, 1979, p. 129, ill.; Janet Crumbie, ed., "Get the Mod Look," *Observer Magazine*, November 25, 1979, ill. color p. 123; David Brown in *A Mansion of Many Chambers: Beauty and Other Works*, unpaged: "The present picture was based on a visit to the flat of an Indian, Foy Nissen, in Bombay, where the view from the window included vegetation which, in the tropical light, appeared flat like stage scenery."; Julian Spalding, "Movement," in *Three Little Books About Painting*, London: Arts Council, 1983, p. 18: "Howard Hodgkin's painting, *Foy Nissen's Bombay*, radiates energy. This is partly due to the bright colours that vibrate against each other but also due to the slab-like shapes that build up a rhythm of counteracting forces. The painting is in this respect an abstract equivalent to a landscape by Bomberg. Hodgkin was greatly influenced by the Indian landscape and by Indian miniature paintings, by their glowing colours and flat patterns. This painting is a reconstruction of the artist's feeling for India rather than a direct rendering of a particular view."
Notes: Signed and dated on the reverse: Howard Hodgkin 1977 begun 1975.

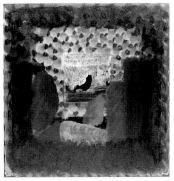

134 · A HENRY MOORE AT THE BOTTOM OF THE GARDEN
1975–77
Oil on wood
40½ x 40½ in. (103 x 103 cm.)
Collection: Saatchi Collection, London.
Provenance: (Kasmin Gallery Ltd, London); (André Emmerich Gallery); Private Collection, Geneva.
Exhibitions: *Howard Hodgkin: New Paintings*, André Emmerich Gallery, New York, September 15–October 5, 1977; *Howard Hodgkin*, André Emmerich Gallery, Zurich, December 2, 1977–January 7, 1978; British Council, 1984, p. 33, ill. color; *Art of Our Time: The Saatchi Collection*, Royal Scottish Academy, Edinburgh, 1988, pp. 14–18, ill. p. 17; Nantes, 1990, no. 2.
Literature: William Feaver, "Full House," *Observer*, July 24, 1977, p. 24: "Howard Hodgkin's cabinned, cribbed interiors and confined views, places so done over with slabs and dabs and wipings of pigment they become vestigial. The title is often a help in terms of sorting out what's basically what. 'A Henry Moore at the Bottom of the Garden', for instance, explains that reclining slug shape in the centre of speckled and glazed areas of what can only be topiary yews framed in their turn by a window. This reading of the painting is more or less incidental: the subject isn't so much the formal garden as memories of it, set down on a wooden panel, worked up, patterned, given a fresh identity. The scene is set, then defocused; the adjustments are made both to clarify and to keep up a sense of emergency, disturbances on the picture surface simultaneously quelled and titivated."; John McEwen, "Hardy Annual," *Spectator*, July 30, 1977, p. 28; John Russell, "Tenacity Keeps British Art Alive," *The New York Times*, September 25, 1977, D33, D36: "I myself took this at first to be a particularly luxuriant evocation of English ornamental gardening, with perfectly kept and very fat trees in the foreground. But what really happens in this painting is that we are sitting indoors with green filing cabinets all around and looking out through

a small square window to a far point in the garden at which the vista is closed by a large reclining figure by Henry Moore."; Noel Frackman, "Howard Hodgkin/Stanley Boxer," *Arts Magazine* 52, November 1977, pp. 29–30; Donald B. Kuspit, "Howard Hodgkin at Emmerich," *Art in America* 65, November–December 1977, pp. 134–35; Leo Rubinfein, "Howard Hodgkin," *Artforum* 16, December 1977, pp. 67–68; Paul Richard, "Howard Hodgkin's Art: Shining Light at the Phillips Collection," *The Washington Post*, October 11, 1984, B1; Mary S. Cowen, "The General Effect is One of Celebration," *The Christian Science Monitor*, December 31, 1984, pp. 22–23, ill. p. 23; Geoffrey Newman, "Celebrations of Radiance," *Times Higher Education Supplement*, May 27, 1988, p. 15; Alistair Hicks, *New British Art in the Saatchi Collection*, London: Thames and Hudson Ltd, 1989, no. 38, ill. color p. 53 and on cover; Graham-Dixon, 1994, ill. color p. 141.

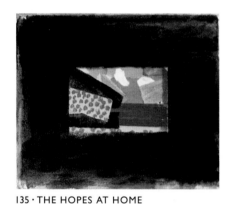

135 · THE HOPES AT HOME
1973–77
Oil on wood
36 x 42 in. (91.4 x 107 cm.)
Collection: Manchester City Art Galleries, acquired with aid of the Wilfred R. Wood Bequest.
Provenance: (Kasmin Gallery Ltd, London); (André Emmerich Gallery, New York).
Exhibitions: *1977 Hayward Annual. Current British Art Selected by Michael Compton, Howard Hodgkin and William Turnbull*, Hayward Gallery, London, Part Two: July 20–September 4, 1977, cat. no. 153; *Howard Hodgkin: New Paintings*, André Emmerich Gallery, New York, September 15–October 5, 1977, ill. color on announcement; *Howard Hodgkin*, André Emmerich Gallery, Zurich, December 2, 1977–January 7, 1978; British Council, 1984, p. 29, ill. color.
Literature: Noel Frackman, "Howard Hodgkin/Stanley Boxer," *Arts Magazine* 52, November 1977, pp. 29–30; Donald B. Kuspit, "Howard Hodgkin at Emmerich," *Art in America* 65, November–December 1977, pp. 134–35;

Asmund Thorkildsen, "En Samtale med Howard Hodgkin," *Kunst og Kultur* 4, Oslo: University Press, National Gallery, April 1987, pp. 220–34; Geoffrey Newman, "Celebrations of Radiance," *Times Higher Education Supplement*, May 27, 1988, p. 15; Graham-Dixon, 1994, ill. color p. 78.

136 · JEALOUSY
1977
Oil on wood
15⅛ x 17¾ in. (38.5 x 45 cm.)
Collection: Private Collection, Dallas.
Provenance: (Kasmin Gallery Ltd, London); (André Emmerich Gallery, New York); sold Christie's, New York, May 6, 1986, lot 54, ill. color.
Exhibitions: *Howard Hodgkin: New Paintings*, André Emmerich Gallery, New York, September 15–October 5, 1977, no. 10; *Howard Hodgkin*, André Emmerich Gallery, Zurich, December 2, 1977–January 7, 1978; British Council, 1984, p. 37, ill. color.
Literature: John Russell, "Tenacity Keeps British Art Alive," *The New York Times*, September 25, 1977, D33: "It helps to know that in 'Jealousy' a victim of that terrible affliction is hiding in a cupboard in the middle of the picture."; Leo Rubinfein, "Howard Hodgkin," *Artforum* 16, December 1977, pp. 67–68, ill. color p. 68; Paul Richard, "Howard Hodgkin's Art: Shining Light at the Phillips Collection," *The Washington Post*, October 11, 1984, B1; Judith Higgins, "In a Hot Country," *ARTnews* 84, Summer 1985, pp. 56–65; Alistair Hicks, "Talking about Art," *Spectator* 225, September 28, 1985, pp. 35–36; Michael McNay, "Howard Hodgkin," *Guardian*, October 12, 1985; Geoffrey Newman, "Celebrations of Radiance," *Times Higher Educational Supplement*, May 27, 1988, p. 15; John Russell, "A Hodgkin Original," *The New York Times Magazine*, November 11, 1990, sec. 6, pp. 56–60, 62, ill. p. 60; Graham-Dixon, 1994, p. 43, ill. color p. 42: "*Jealousy* (1977) is a poisonous little painting of a poisonous little emotion. Here is a life gone terribly wrong condensed into a single, tiny image that defies analysis, or at least makes it inappropriate.

Analyse the painting into its constituent parts, and you are left with nothing much in particular: a red blob silhouetted against a screen of green dots on a yellow ground, triply framed within bands of orange, dark brown and orange again."

137 · MONSOON IN BOMBAY
1975–77
Oil on wood
38¾ x 30 in. (98.4 x 76.2 cm.)
Collection: Private Collection, England.
Provenance: (Kasmin Gallery Ltd, London); (André Emmerich Gallery, New York); (Waddington Galleries, London).
Exhibitions: *This Knot of Life: Paintings and Drawings by British Artists*, L.A. Louver Gallery, Venice, California, Part I: October 23–November 17, 1979; *New Concepts for a New Art, Toyama Now 81*, Museum of Modern Art, Toyama, Japan, July 5–September 23, 1981, ill. p. 88.

138 · NIGHT AND DAY
1976–77
Oil on wood
11¼ x 17¾ in. (28.5 x 45 cm.)
Collection: Unknown.
Provenance: (Kasmin Gallery Ltd, London); (Waddington and Tooth, London).
Exhibitions: *Howard Hodgkin: New Paintings*, André Emmerich Gallery, New York, September 15–October 5, 1977, no. 7; *Howard Hodgkin*, André Emmerich Gallery, Zurich, December 2, 1977–January 7, 1978.
Literature: Noel Frackman, "Howard Hodgkin/Stanley Boxer," *Arts Magazine* 52,

November 1977, pp. 29–30: "*Night and Day* suggests some exotic part of the world; like so many of Hodgkin's paintings, it conveys a sense of opulence."

139 · A SMALL HENRY MOORE AT THE BOTTOM OF THE GARDEN
1975–77
Oil on wood
20³⁄₄ x 21 in. (52.5 x 53 cm.)
Collection: Private Collection, New York, courtesy Jason McCoy, Inc., New York.
Provenance: (Kasmin Gallery Ltd, London); (André Emmerich Gallery, New York); John D. Rothschild, New York; sold Sotheby's, New York, May 9, 1990, sale 6012, lot 215A.
Exhibitions: *Howard Hodgkin: New Paintings*, André Emmerich Gallery, New York, September 15–October 5, 1977; *Howard Hodgkin*, André Emmerich Gallery, Zurich, December 2, 1977–January 7, 1978; British Council, 1984, p. 31, ill. color; Nantes, 1990, no. 3, ill. color p. 17.
Literature: Noel Frackman, "Howard Hodgkin/Stanley Boxer," *Arts Magazine* 52, November 1977, pp. 29–30; Leo Rubinfein, "Howard Hodgkin," *Artforum* 16, December 1977, pp. 67–68; Timothy Hyman, "Making a Riddle Out of the Solution," in *Howard Hodgkin: Small Paintings 1975–1989*, London: The British Council, 1990, p. 12, ill. color p. 17; Graham-Dixon, 1994, ill. color p. 140.
Notes: Signed on the reverse.

140 · SMALL SIMON DIGBY
1977
Oil on wood
13³⁄₄ in. diameter (35 cm.)
Collection: Harvard University Art Museum, 1978.71. Purchase, Richard Norton Fund.
Provenance: (Kasmin Gallery Ltd, London); (Waddington and Tooth, London).
Exhibitions: *1977 Hayward Annual. Current British Art Selected by Michael Compton, Howard Hodgkin and William Turnbull*, Hayward Gallery, London, Part Two: July 20–September 4, 1977, cat. no. 158; *Howard Hodgkin: New Paintings*, André Emmerich Gallery, New York, September 15–October 5, 1977, no. 8; *Howard Hodgkin*, André Emmerich Gallery, Zurich, December 2, 1977–January 7, 1978.
Literature: John Russell, "Tenacity Keeps British Art Alive," *The New York Times*, September 25, 1977, D33: "It helps to know, for instance, that 'Small Simon Digby' started from the memory of an eminent Sanskrit scholar who talks to his students while sitting cross-legged on the floor."; Donald B. Kuspit, "Howard Hodgkin at Emmerich," *Art in America* 65, November–December 1977, pp. 134–35; Caroline A. Jones, *Modern Art at Harvard, The Formation of the Nineteenth- and Twentieth-Century Collections of the Harvard University Art Museums*, New York: Abbeville Press, 1985, no. 126, ill. color p. 126: "*Small Simon Digby* is unusual in its circular shape, whose border, rather than filling the conventional frame's role of a window opening onto a scene, serves as a porthole through which suggestive, boldly painted bars and lush bands of color are seen."

141 · SMALL TREE NEAR CAIRO
1973–77
Oil on wood
11¹⁄₄ x 15³⁄₄ in. (28.5 x 40 cm.)
Collection: Prakapas Gallery, Bronxville, New York.
Provenance: (Kasmin Gallery Ltd, London); (André Emmerich Gallery, New York).
Exhibitions: *Howard Hodgkin: New Paintings*, André Emmerich Gallery, New York, September 15–October 5, 1977.

142 · TEA WITH MRS. PARIKH
1974–77
Oil on wood
12 x 14¹⁄₂ in. (30.5 x 37 cm.)
Collection: Phillip Pollock-Vintage Tyre Supplies.
Provenance: (Kasmin Gallery Ltd, London and Waddington Galleries, London).
Exhibitions: *1977 Hayward Annual. Current British Art Selected by Michael Compton, Howard Hodgkin and William Turnbull*, Hayward Gallery, London, Part Two: July 20–September 4, 1977, cat. no. 157.
Literature: Donald B. Kuspit, "Howard Hodgkin at Emmerich," *Art in America* 65, November–December 1977, pp. 134–35.

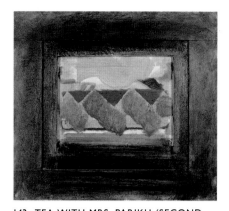

143 · TEA WITH MRS. PARIKH (SECOND VERSION)
1974–77
Oil on wood
18⁵⁄₁₆ x 20³⁄₈ in. (46.5 x 51.7 cm.)
Collection: Private Collection, London.

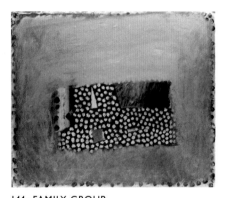

144 · FAMILY GROUP
1973–78
Oil on wood
36 x 42 in. (91.5 x 107 cm.)
Collection: Dr. and Mrs. Michael Shaub.
Provenance: (Waddington Galleries, London);
Barry Morrison, New York; Saatchi Collection,
London; sold Sotheby's, New York, April 30,
1991, lot 2.
Exhibitions: Arts Council, 1976; *European
Dialogue. The Third Biennale of Sydney at The
Art Gallery of New South Wales*, Sydney, April
14–May 27, 1979, ill. color; *This Knot of Life:
Paintings and Drawings by British Artists*,
L.A. Louver Gallery, Venice, California, Part 1:
October 23–November 17, 1979; *Peter Moores
Liverpool Project 5: The Craft of Art*, Walker Art
Gallery, Liverpool, November 3, 1979–February
13, 1980; *New Concepts for a New Art, Toyama
Now 81*, Museum of Modern Art, Toyama, Japan,
July 5–September 23, 1981; Nantes, 1990, no. 1
(titled *Family Portrait*).
Literature: Alistair Hicks, *New British Art in the
Saatchi Collection*, London: Thames and Hudson
Ltd, 1989, no. 35, p. 52.

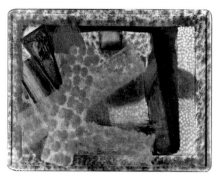

145 · DINNER AT SMITH SQUARE
1975–79
Oil on wood
37¼ x 49¼ in. (94.6 x 125 cm.)
Collection: Tate Gallery, London.
Provenance: (Waddington Galleries, London).
Exhibitions: *John Moores Liverpool Exhibition XI*,
Walker Art Gallery, Liverpool, November 30,
1978–February 25, 1979, no. 42; *The Artist's
Eye: An Exhibition selected by Howard Hodgkin*,
National Gallery, London, June 20–August 19,
1979, p. 22, ill. and comment; *A New Spirit in
Painting*, Royal Academy of Arts, London,
January 15–March 18, 1981, cat. no. 59, ill.
color; *Howard Hodgkin*, M. Knoedler and Co.,
Inc., New York, April 25–May 12, 1981, no.1,
ill. color; *Aspects of British Art Today*, Tokyo
Metropolitan Art Museum, Tokyo, February
27–April 11, 1982, and tour, no. 131, ill. p.
159; British Council, 1984, p. 39, ill. color.
Literature: Louise Collis and Lavinia Learmont,
"London: The Artist's Eye," *Art and Artists* 14,
August 1979, pp. 42–43, ill. p. 43; Fenella
Crichton, "The Artist's Eye: An Exhibition
Selected by Howard Hodgkin," *Pantheon* 37,
October–December 1979, p. 326; Richard Cork,
"Report from London: 'The Artist's Eye,'" *Art in
America* 69, February 1981, pp. 43–55, ill. color
p. 51; Roberta Smith, "Fresh Paint?," *Art in
America* 69, Summer 1981, pp. 70–79, ill. color
p. 73; *The Tate Gallery 1980–82: Illustrated
Catalogue of Acquisitions*, London: Tate Gallery
Publications, 1982, p. 141, ill. p. 140: "Howard
Hodgkin painted 'Dinner at Smith Square' after
dining with long-standing friends who are art
collectors. They were very generous in asking him
to dinner frequently once they knew Hodgkin was
painting the picture, so that he could refresh his
memory of the occasion; once they posed so that
he could make drawings of them and details in the
room. That was probably the only time Hodgkin
has made such studies of sitters for his paintings.
In the catalogue of his exhibition *The Artist's Eye*
at the National Gallery, Hodgkin wrote of 'Dinner
at Smith Square': 'Two old friends talking across
their table below a small painting by Bonnard.
The husband once said "How much more

beautiful is a picture in black and white!" I
tried to do this, but failed.' About two years after
completing this picture Hodgkin painted 'After
Dinner at Smith Square' (private collection) in
which the composition has much in common
with that of 'Dinner at Smith Square.'"; Timothy
Hyman, "Making a Riddle Out of the Solution,"
in *Howard Hodgkin: Small Paintings 1975–1989*,
London: The British Council, 1990, ill. p. 10.
Notes: In an undated note in the artist's archives,
Hodgkin describes this painting: "This is a
picture of 2 very old friends of mine talking to
each other below a small painting by Bonnard.
The husband is on the left of the painting leaning
slightly back from the table and his wife sits
upright on the other side."

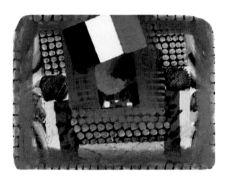

146 · IN A FRENCH RESTAURANT
1977–79
Oil on wood
36 x 48 in. (91 x 122 cm.)
Collection: Private Collection, Switzerland.
Provenance: (Waddington Galleries, London).
Exhibitions: *A New Spirit in Painting*, Royal
Academy of Arts, London, January 15–March
18, 1981, cat. no. 60, ill.; *Howard Hodgkin*, M.
Knoedler and Co., Inc., New York, April 25–May
12, 1981, no. 5, ill. color; *Aspects of British Art
Today*, Tokyo Metropolitan Art Museum, Tokyo,
February 27–April 11, 1982, and tour, cat. no.
133, ill. color p. 157; British Council, 1984,
p. 45, ill. color.
Literature: Jesse Murry, "Reflections on Howard
Hodgkin's Theater of Memory," *Arts Magazine*
55, June 1981, pp. 154–57, ill. color p. 154; John
McEwen, "Introduction," in *Howard Hodgkin:
Forty Paintings: 1973–84*: "*In a French Restaurant*
... was designed as a retort to David Hockney's
picture of an interior at the Louvre, *Contre-jour
in the French Style*. It struck Hodgkin that the
dry and parsimonious nature of Hockney's
picture was the very reverse of French in style.
Accordingly, by way of correction, he painted
a lush, though no less classically symmetrical,
picture."; Milton Gendel, "Report from Venice:
Cultured Pearls at the Biennale," *Art in America*
72, September 1984, pp. 45–53, ill. p. 50; Annelie

Pohlen, "A Few Highlights but no Festival," *Artforum* 23, September 1984, pp. 103–106, ill. color p. 105; Judith Higgins, "In a Hot Country," *ARTnews* 84, Summer 1985, pp. 56–65; Frances Spalding, *British Art Since 1900*, London: Thames and Hudson Ltd, 1986, ill. color fig. 199, p. 227, as *French Restaurant*; Graham-Dixon, 1994, p. 57, ill. color p. 56: "*In a French Restaurant* (1977–79) plays ironically on the contrast between the hesitant evocativeness of Hodgkin's own language and the unequivocal, semaphoric clarity of conventional visual signs—in this case the French flag, painted into the top edge of the picture with deliberate, banal straightforwardness. It looks like a postage stamp stuck, imperfectly, on to a palimpsest, a curious intrusion into a painting whose puzzling depths, spatial ambiguities and vaguely figurative gloamings suggest a world of private emotional complexity charged with private feeling. But the flag may be there to make a point. It turns the picture into a painting that is, on one level, *about* the inadequacy of simple visual conventions as representations of the real."

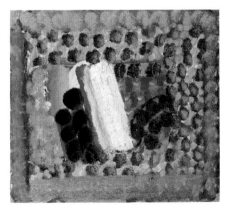

147 · IN ALEXANDER STREET
1977–79
Oil on wood
17³⁄₄ x 20 in. (45 x 51 cm.)
Collection: Private Collection, Los Angeles.
Provenance: (L.A. Louver Gallery, Venice, California); Vincent Price.
Exhibitions: *This Knot of Life: Paintings and Drawings by British Artists*, L.A. Louver Gallery, Venice, California, Part 1: October 23–November 17, 1979, p. 12, ill. color; British Council, 1984, p. 43, ill. color; Nantes, 1990, no. 5, ill. color p. 21; *Howard Hodgkin*, University Art Museum, University of California, Berkeley, September 25–December 16, 1991, no. 2.
Literature: William Feaver, "The State of British Art: 'It's a Bewilderment,'" *ARTnews* 79, January 1980, pp. 62–68, ill. p. 67; Mary S. Cowen, "The General Effect is One of Celebration," *The Christian Science Monitor*, December 31, 1984,

pp. 22–23, ill. p. 22; Naomi Ilzuka, "Splashing Abstractions at the BAC," *After Hours*, January 31, 1985, p. 4.

148 · IN THE STUDIO OF JAMINI ROY
1976–79
Oil on wood
29 x 42 in. (73.7 x 106.6 cm.)
Collection: Government Art Collection, acquired 1980.
Provenance: (Kasmin Gallery Ltd, London).
Exhibitions: *The British Art Show: Selected by William Packer* (organized by the Arts Council), Mappin Art Gallery, Sheffield, December 1, 1979–January 27, 1980; Laing Art Gallery, Newcastle-upon-Tyne and Hatton Gallery, University of Newcastle, February 15–March 23, 1980; Arnolfini Gallery, Bristol and Royal West of England Academy, Bristol, April 18–May 24, 1980, no. 105, ill. p. 64; *Howard Hodgkin*, M. Knoedler and Co., Inc., New York, April 25–May 12, 1981, no. 2, ill. color; *Aspects of British Art Today*, Tokyo Metropolitan Art Museum, Tokyo, February 27–April 11, 1982, and tour, cat. no. 132, ill. p. 158; *The Proper Study: Contemporary Figurative Painting from Britain*, Lalit Kala Akademi, New Delhi, December 1–31, 1984, and Jahangir Nicholson Museum of Modern Art, Bombay, February 1–28, 1985, pp. 72–76, ill. p. 75.
Notes: Jamini Roy is a noted Indian painter.

149 · PRIZEMAN'S PERSPECTIVE
1978–79
Oil on wood
11 x 14¹⁄₂ (27.5 x 37 cm.)
Collection: Roxanne and Bruce Bethany.
Provenance: (Knoedler/Kasmin Gallery

Ltd, London); sold Sotheby's, New York, Contemporary Art, Part II, May 3, 1989, lot no. 217.
Exhibitions: *Painting: Gregory Amenhoff, Howard Hodgkin, Melissa Miller, Katherine Porter, Joan Thorne, Susan Whynne*, Bell Gallery, List Art Center, Brown University, Providence, December 3–30, 1983.
Notes: The title refers to John Prizeman, an architect and friend of the artist.

150 · STILL LIFE IN A RESTAURANT
1976–79
Oil on wood
36¹⁄₂ x 46¹⁄₂ in. (92.7 x 118.1 cm.)
Collection: The British Council.
Provenance: (Kasmin Gallery Ltd, London).
Exhibitions: *Critic's Choice, An Exhibition of Contemporary Art Selected by John McEwen*, ICA Gallery, London, September 7–October 7, 1978, ill.; *John Moores Liverpool Exhibition XII*, Walker Art Gallery, Liverpool, November 27, 1980–February 22, 1981, no. 9, ill.; *Howard Hodgkin*, M. Knoedler and Co., Inc., New York, April 25–May 12, 1981, no. 3, ill. color; *Britische Kunstler, Eine Ausstellung über Malerei*, Neue Galerie, Sammlung Ludwig, Aachen, December 5, 1981–February 16, 1982, and tour, ill. color p. 41; British Council, 1984, p. 41, ill. color; *Current Affairs: British Painting and Sculpture in the 1980s*, Museum of Modern Art, Oxford, March 1–29, 1987; Mucsarnok, Budapest, April 24–May 31, 1987; Narodni Galerie, Prague, June 19–August 7, 1987; Zacheta, Warsaw, September 18–October 31, 1987; *For a Wider World: Sixty Works in the British Council Collection*, 1990.
Literature: John McEwen, "Introduction," in *Critic's Choice*, London: ICA, 1978: "Hodgkin's paintings are a concentrate of experience, technique and presentation. The inspiration itself derives from the momentary concentration of feeling and atmosphere in a particular place at a particular time, snapped like a photograph and developed at leisure. A subject so specific must be painted on something equally specific, not uniform canvas but discarded items made in wood that accordingly have their

own history and obdurate identity. Then he works on and off, correcting and recorrecting for months and even years till he has pinpointed the initial inspiration. In this picture only a glimpse of its representational origin remains. The density, the rough and lumpy surface concentrate the painting into a thing more than ever before, an emblem rather than a memory of the event. 'A picture to hang on a wall,' as the artist said; nothing more, nothing less."; Marco Livingstone, "Restaurant Still Life," in *John Moores Liverpool Exhibition XII, 1980, Guide to the Exhibition*, Liverpool: Walker Art Gallery, 1980, p. 4; Lawrence Gowing, "Howard Hodgkin," in *Howard Hodgkin*, New York: M. Knoedler and Co., Inc., 1981: "In the *Still Life in a Restaurant*, a corner of some fantastically luxurious place, where he finds a new luxury in his old red and green, one could swear that the violet-grey spots ... described real and separate things. ... At another look, they describe nothing."; Jesse Murry, "Reflections on Howard Hodgkin's Theater of Memory," *Arts Magazine* 55, June 1981, pp. 154–57, ill. color; David Sweet, "Howard Hodgkin at Yale Center for British Arts and Larry Poons at André Emmerich," *Artscribe* 52, May–June 1985, pp. 52–53, ill.; Andreas Beyer, "An Interview with Howard Hodgkin," *Kunstforum* 110, November–December 1990, pp. 210–22, ill. p. 215; Graham-Dixon, 1994, p. 57, ill. color p. 55: "It is a painting that defines recollection as a dredging up of remembered fragments from the black pool of the past." Notes: This painting, included in *John Moores Liverpool Exhibition XII*, won 2nd prize under the title *Restaurant Still Life*.

151 · CHEZ SWOB
1977–80
Oil on wood
17½ x 25 in. (44.4 x 63.5 cm.)
Collection: Nancy O'Boyle, Dallas.
Provenance: (M. Knoedler and Co., Inc., New York).
Notes: Mr. and Mrs. Swob are friends of the artist. Signed on the reverse.

152 · DAY DREAMS
1977–80
Oil on wood
23⅛ x 32⅛ in. (58.7 x 81.6 cm.)
Collection: Private Collection, London.
Provenance: (M. Knoedler and Co., Inc., New York); (Waddington Galleries, London).
Exhibitions: *Howard Hodgkin*, M. Knoedler and Co., Inc., New York, April 25–May 12, 1981, no. 7, ill. color; *Aspects of British Art Today*, Tokyo Metropolitan Art Museum, Tokyo, February 27–April 11, 1982, and tour, cat. no. 135; British Council, 1984, p. 51, ill. color.
Literature: Deborah C. Phillips, "Howard Hodgkin," *ARTnews* 80, November 1981, pp. 200, 202; Judith Higgins, "In a Hot Country," *ARTnews* 84, Summer 1985, pp. 56–65, ill. color p. 62; Graham-Dixon, 1994, p. 52, ill. color p. 54: "The attempt to give painted objects the texture of mental phenomena frequently results in compelling weirdness. *Day Dreams* (1977–80) is a picture whose appearance runs counter to its title. It is a painting of dreaminess turning day into night. The image is framed (perhaps with a sidelong glance at Matisse's *French Window at Collioure*) as a view through a window, but the view has been sabotaged by fantasy."

153 · THE GREEN CHATEAU
1976–80
Oil on wood
38⅝ x 48½ in. (98 x 123.1 cm.)
Collection: Private Collection, U.S.A.
Provenance: (M. Knoedler and Co., Inc., New York).
Exhibitions: *A New Spirit in Painting*, Royal Academy of Arts, London, January 15–March 18, 1981, cat. no. 61, ill. color; *Howard Hodgkin*, M. Knoedler and Co., Inc., New York, April 25–May

12, 1981, no. 4, ill. color; British Council, 1984, p. 47, ill. color; *An International Survey of Recent Painting and Sculpture*, Museum of Modern Art, New York, May 17–August 19, 1984, ill. p. 158.
Literature: William Feaver, "A 'New Spirit'—or Just a Tired Ghost?" *ARTnews* 80, May 1981, pp. 114–18, ill. color p. 115; Kathryn Howarth, "Howard Hodgkin at Knoedler," *Art in America* 69, October 1981, pp. 145–46, ill. color p. 114; Graham-Dixon, 1994, ill. color p. 75.

154 · IN THE GUEST ROOM
1978–80
Oil on wood
15¾ x 21 in. (40 x 53.3 cm.)
Collection: The Roc Group, Paris.
Provenance: (M. Knoedler and Co., Inc., New York); Bruce and Judith Eissner; (Waddington Galleries, London).
Exhibitions: *Summer Selection*, M. Knoedler and Co., Inc., New York, July–August 1984, no. 8.

155 · LAWSON UNDERWOOD & SLEEP
1977–80
Oil on wood
24 x 36 in. (60.9 x 91.4 cm.)
Collection: Private Collection.
Provenance: (M. Knoedler and Co., Inc., New York).
Exhibitions: *Howard Hodgkin*, M. Knoedler and Co., Inc., New York, April 25–May 12, 1981, no. 10, ill. color; *Group Show: Summer 1981*, M. Knoedler and Co., Inc., New York, July–August 1981, no. 14; *The British Art Show: Old Allegiances and New Directions 1979–1984*, City of Birmingham Museum and Art Gallery and Ikon Gallery, November 2–December 22, 1984; Royal Scottish Academy, Edinburgh,

January 19–February 24, 1985; Mappin Art Gallery, Sheffield, March 16–May 4, 1985; Southampton Art Gallery, May 18–June 30, 1985; *British Sculpture and Painting in the 1980s,* Museum of Modern Art, Oxford, March 1–29, 1987, and tour.

Literature: Jesse Murry, "Reflections on Howard Hodgkin's Theater of Memory," *Arts Magazine* 55, June 1981, pp. 154–57.

Notes: The title refers to George Lawson, Nicholas Underwood and Wayne Sleep, friends of the artist.

156 · THE MOON
1978–80
Oil on wood
17⅝ x 22 in. (44.7 x 55.8 cm.)
Collection: R. B. Kitaj.
Provenance: (Waddington Galleries, London).
Exhibitions: *Hayward Annual 1980. Contemporary Painting and Sculpture Selected by John Hoyland,* Hayward Gallery, London, August 29–October 12, 1980, ill. p. 36; *Howard Hodgkin,* M. Knoedler and Co., Inc., New York, April 25–May 12, 1981, no. 12, ill. color; *Britische Kunstler, Eine Ausstellung über Malerei,* Neue Galerie, Sammlung Ludwig, Aachen, December 5, 1981–February 16, 1982, and tour, ill. p. 42; British Council, 1984, p. 55, ill. color; Nantes, 1990, no. 6, ill. color p. 23.

Literature: John McEwen, "Introduction," in *Howard Hodgkin: Forty Paintings: 1973–84,* London: Whitechapel Art Gallery, 1984, p. 12: "A most specific rendering of the Indian twilight—known as 'the hour of cowdust' because of the dust clouds raised by the hooves of the returning herds—is nothing less than a reverie."; Michael McNay, "Howard Hodgkin," *Guardian,* October 12, 1985; Keith Clements, "Artists and Places Nine: Howard Hodgkin," *Artist* 101, August 1986, pp. 12–14, ill. p. 14; Luciana Mottola, "I Begin Pictures Full of Hope: Four Questions Posed to Howard Hodgkin," *891, International Artists' Magazine,* vol. III, December 1986, pp. 12–15; Timothy Hyman, "Making a Riddle Out of the Solution," in

Howard Hodgkin: Small Paintings 1975–89, London: The British Council, 1990, pp. 10, 11, ill. color p. 23; Richard Dorment, "Howard's Way," *Telegraph Weekend Magazine,* November 24, 1990, pp. 50–55, ill. color: "A tiny masterpiece of 1978–1980, *The Moon,* a simple circle enclosed in a series of forest-green rectangles, which somehow evokes operatic depths of emotion, drawing out eyes deep into the picture space. It is as though we see the moon reflected at the bottom of a well."; Graham-Dixon, 1994, p. 93, ill. color p. 92, ill. color (side view) p. 150: "When Hodgkin paints *The Moon* (1978–80)—one of the most Cubist in spirit of all his pictures—he emphasizes the artifice of art by engineering a near absolute separation of form and colour, the object and the veil of atmosphere through which it is perceived. Where is Hodgkin's moon, exactly? It is not quite in that disc of unprimed, unpainted wood at the painting's centre ... nor is it in the spreading zones of emerald green that frame that mute brown circle. It is in both places at the same time."

Notes: Hodgkin has stated that this painting was painted on a clock that he found discarded in a street. Signed and dated on the reverse.

157 · PAUL LEVY
1976–80
Oil on wood
20⅞ x 23¾ in. (53 x 60.3 cm.)
Collection: Saatchi Collection, London.
Provenance: (Waddington Galleries, London).
Exhibitions: *Howard Hodgkin,* M. Knoedler and Co., Inc., New York, April 25–May 12, 1981, no. 6, ill. color; *Aspects of British Art Today,* Tokyo Metropolitan Art Museum, Tokyo, February 27–April 11, 1982, and tour, cat. no. 134, ill. p. 159; British Council, 1984, p. 49, ill. color.

Literature: Jesse Murry, "Reflections on Howard Hodgkin's Theater of Memory," *Arts Magazine* 55, June 1981, pp. 154–57; Kathryn Howarth, "Howard Hodgkin at Knoedler," *Art in America* 69, October 1981, pp. 145–46; Alexandra Pringle, "Art: Howard's Blend of Images and Textures," *Harpers and Queen,* June 1984, p. 189; Kenneth

Baker, "Too Much and/or Not Enough: A Note on Howard Hodgkin," *Artforum* 23, February 1985, pp. 60–61; Alistair Hicks, *New British Art in the Saatchi Collection,* London: Thames and Hudson Ltd, 1989, no. 37, ill. color p. 53; Timothy Hyman, "Making a Riddle Out of the Solution," in *Howard Hodgkin: Small Paintings 1975–1989,* London: The British Council, 1990, pp. 12–13, ill. color p. 19: "In *Paul Levy,* for example, the ochre patches and flakes may read as chunks of conversation; just as they elsewhere could, if we're so inclined, embody thought-forms, or suspended auras. And meanwhile their spatial function is often as a kind of auxiliary frame, to mark out the penumbra of peripheral vision."; Graham-Dixon, 1994, ill. color p. 124.

Notes: Paul Levy is a noted food writer and friend of the artist.

158 · READING THE LETTER
1977–80
Oil on wood
17¾ x 20 in. (45 x 50.8 cm.)
Collection: Donald and Barbara Klein, New York.
Provenance: (M. Knoedler and Co., Inc., New York).
Exhibitions: *Howard Hodgkin,* M. Knoedler and Co., Inc., New York, April 25–May 12, 1981, no. 9, ill. color; British Council, 1984, p. 53, ill. color; *Howard Hodgkin,* University Art Museum, University of California, Berkeley, September 25–December 16, 1991, no. 3.

Literature: Jesse Murry, "Reflections on Howard Hodgkin's Theater of Memory," *Arts Magazine* 55, June 1981, pp. 154–57, ill. color p. 155; Kathryn Howarth, "Howard Hodgkin at Knoedler," *Art in America* 69, October 1981, pp. 145–46; John McEwen, "Introduction," in *Howard Hodgkin: Forty Paintings: 1973–84,* London: Whitechapel Art Gallery, 1984, p. 12: "The Hodgkin frame also serves, of course, to heighten the drama by theatrically 'presenting' the internal action of the composition. ... In *Reading the Letter* the frame is dispensed with, to afford the internal elements the appearance of standing proud from the picture plane. As a result the viewer has the sensation of being able to put his

hand in and rip the heart out of the design—a physical response sympathetic to the passionate nature of the subject."; David Sylvester, "Howard Hodgkin Interviewed by David Sylvester," in *Howard Hodgkin: Forty Paintings: 1973–84*, p. 99: "There's a picture called *Reading the Letter* which is in fact a picture about a very anguished and personally unpleasant experience—a letter written to someone else which, without being too specific about it, was very unpleasant for me to hear, and the picture is about the moment when it was being read aloud and I was in the room."; Gregory Galligan, "Howard Hodgkin: Forty Paintings," *Arts Magazine* 59, March 1985, pp. 122–25, ill. color p. 123: "In *Reading the Letter*, there is a dramatic tension between the emotional pulls of black and red across the picture plane that generates an intensity of feeling along the lines of a tone poem."; Eric Gibson, "The Hodgkin Paradox," *Studio International* 198, March 1985, pp. 23–25, plate 4, p. 14, and color detail on cover: "The bottomless space, deep blacks and blazing yellows of *Reading the Letter*, 1977–80, brings to mind a sensation of brooding intensity which perfectly evokes the awkward personal moment that forms its subject."; Marina Vaizey, "The Intimate Room Within," *Sunday Times*, September 29, 1985; David Sylvester, "Artist's Dialogue: Howard Hodgkin—The Texture of a Dream," *Architectural Digest* 44, March 1987, pp. 54, 62, 66, 70, 74, ill. color p. 54; Geoffrey Newman, "Celebrations of Radiance," *Times Higher Educational Supplement*, May 27, 1988, p. 15; Alistair Hicks, *The School of London, The Resurgence of Contemporary Painting*, London: Phaidon, 1989, ill. color plate 4 and detail on cover; Alistair Hicks, "The Fire of London," *Art and Auction* 12, May 1990, pp. 212–17, ill. color p. 214; Graham-Dixon, 1994, ill. color p. 77.

159 · RED BERMUDAS
1978–80
Oil on wood
27¾ x 27¾ in. (70.5 x 70.5 cm.)
Collection: The Museum of Modern Art, New York.
Provenance: (M. Knoedler and Co., Inc., New York); Gerrit L. Lansing.
Exhibitions: *Howard Hodgkin*, M. Knoedler and Co., Inc., New York, April 25–May 12, 1981, no. 11, ill. color.
Literature: Jesse Murry, "Reflections on Howard Hodgkin's Theater of Memory," *Arts Magazine* 55, June 1981, pp. 154–57, ill. color p. 155; Deborah C. Phillips, "Howard Hodgkin," *ARTnews* 80, November 1981, pp. 200, 202; Bruce Chatwin, "A Portrait of the Artist," in *Howard Hodgkin: Indian Leaves*, London and New York: Petersburg Press, 1982, p. 17, ill. color p. 16; Graham-Dixon, 1994, p. 52, ill. color p. 53: "Its subject is not really the red bermuda shorts of the title. They have been transformed into a pair of bold, columnar swipes of red paint at the bottom of the picture. An article of clothing has become a painter's vivid cipher for a thing."

160 · TEA
1977–80
Oil on wood
16¾ x 44 in. (42.5 x 111.7 cm.)
Collection: Private Collection.
Provenance: (M. Knoedler and Co., Inc., New York).
Exhibitions: *Howard Hodgkin*, M. Knoedler and Co., Inc., New York, April 25–May 12, 1981, no. 8, ill. color; British Council, 1984.
Literature: Jesse Murry, "Reflections on Howard Hodgkin's Theater of Memory," *Arts Magazine* 55, June 1981, pp. 154–57; Bruce Chatwin, "A Portrait of the Artist," in *Howard Hodgkin:*

Indian Leaves, London and New York: Petersburg Press, 1982, p. 17: "But who would guess that 'Tea', a panel over-splattered in scarlett, represents a seedy flat in Paddington where a male hustler is telling the story of his life."; David Sylvester, "Howard Hodgkin Interviewed by David Sylvester," in *Howard Hodgkin: Forty Paintings: 1973–84*, London: Whitechapel Art Gallery, 1984, p. 99: "There is another picture of that period that is totally voyeuristic and which is called *Tea*. And that was an extraordinary situation, because I went round to these friends to have tea and this person they hardly knew, who was a male prostitute, though they didn't seem to know that at the time, came round to see them, and we were making sort of ordinary fatuous social conversation and he said what do you do and I said I'm a painter, what do you do, and he said I'm a prostitute, and he seemed a very respectable and intelligent person and I said you must be joking, what do you mean you're a prostitute, and for the next six hours he described what his life as a prostitute was like. It was like something out of Mayhew's London. And nobody moved. I think that was the last voyeuristic painting I made."; Judith Higgins, "In a Hot Country," *ARTnews* 84, Summer 1985, pp. 56–65; Graham-Dixon, 1994, ill. color p. 88.

161 · AFTER DINNER AT SMITH SQUARE
1980–81
Oil on wood
31 x 41 in. (78.7 x 104.1 cm.)
Collection: Israel Assurance Company, Tel Aviv.
Provenance: (M. Knoedler and Co., Inc., New York); Eric F. Menoyo, Boston; William and Penelope Govett, London; Saatchi Collection, London; sold Sotheby's, London, December 5, 1991, lot 53.
Exhibitions: *Britische Kunstler, Eine Ausstellung über Malerei*, Neue Galerie, Sammlung Ludwig, Aachen, December 5, 1981–February 16, 1982, and tour, no cat.; *Howard Hodgkin: Recent Paintings*, M. Knoedler and Co., Inc., New York, November 13–December 9, 1982, no. 13; Nantes, 1990, no. 8.
Literature: Richard Armstrong, "Reviews:

Howard Hodgkin," *Artforum* 21, March 1983, p. 71; John McEwen, "Introduction," in *Howard Hodgkin: Forty Paintings: 1973–84*, London: Whitechapel Art Gallery, 1984, p. 11: "Both versions of *Dinner at Smith Square* pay passing tribute to a Bonnard painting, its framed shape at the centre of each composition."; Eric Gibson, "The Hodgkin Paradox," *Studio International* 198, March 1985, pp. 23–25, ill. color p. 25; Alistair Hicks, *New British Art in the Saatchi Collection*, London and New York: Thames and Hudson, 1989, no. 33, ill. color p. 51. Notes: See also *After Dinner*, cat. no. 132.

162 · FIRST PORTRAIT OF TERENCE McINERNEY
1981
Oil on wood
50½ x 50 in. (128.3 x 127 cm.)
Collection: Nancy M. O'Boyle, Dallas, Texas.
Provenance: (M. Knoedler and Co., Inc., New York).
Exhibitions: *A New Spirit in Painting*, Royal Academy of Arts, London, January 15–March 18, 1981, no. 62, ill; *Aspects of British Art Today*, Tokyo Metropolitan Art Museum, Tokyo, February 27–April 11, 1982, cat. no. 129, ill. color; *Howard Hodgkin: Recent Paintings*, M. Knoedler and Co., Inc., New York, November 13–December 9, 1982, no. 7; British Council, 1984, p. 57, ill. color.
Literature: Ann Schoenfeld, "Howard Hodgkin," *Arts Magazine* 57, January 1983, ill. p. 42; Richard Armstrong, "Reviews: Howard Hodgkin," *Artforum* 21, March 1983, p. 71, ill.; Patrick Kinmouth, "Howard Hodgkin," *Vogue* (UK) 141, June 1984, pp. 140–41; Kenneth Baker, "Too Much and/or Not Enough: A Note on Howard Hodgkin," *Artforum* 23, February 1985, pp. 60–61; John Russell, "London and Yale, Hodgkin at the Whitechapel," *Burlington Magazine* 127, October 1985, pp. 729, 731–32, ill.; Asmund Thorkildsen, "En Samtale med Howard Hodgkin," *Kunst og Kultur* 4, Oslo: University Press, National Gallery, April 1987, pp. 220–34: "The portraits of Terry McInerney

were in fact when I began them incredibly representational, and I was very proud of the way I was able to remember and make a coherent, almost lifesize figure." (p. 10 of English transcript in Hodgkin's archives); Timothy Hyman, "Mapping London's Other Landscape," *Art International* 1, Autumn 1987, pp. 51–61, ill. color p. 61; "Calendar of Events/Preview of Exhibitions," New Haven: Yale Center for British Art, January–August 1988, ill. color; Timothy Hyman, "Making a Riddle Out of the Solution," in *Howard Hodgkin: Small Paintings 1975–89*, London: The British Council, 1990, ill. p. 14; Graham-Dixon, 1994, ill. color p. 168.

163 · IN THE TRAIN
1979–81
Oil on wood
17½ x 17½ in. (44.5 x 44.5 cm.)
Collection: Private Collection.
Provenance: (M. Knoedler and Co., Inc., New York).
Exhibitions: *Howard Hodgkin: Recent Paintings*, M. Knoedler and Co., Inc., New York, November 13–December 9, 1982, no. 14; *Painting: Gregory Amenhoff, Howard Hodgkin, Melissa Miller, Katherine Porter, Joan Thorne, Susan Whynne*, Bell Gallery, List Art Center, Brown University, Providence, December 3–30, 1983.

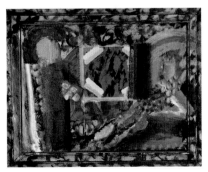

164 · MR. AND MRS. TERENCE CONRAN
1978–81
Oil on wood
39¼ x 49½ in. (100 x 125 cm.)
Collection: Loretta and Robert K. Lifton.

Provenance: (M. Knoedler and Co., Inc., New York).
Exhibitions: *Britische Kunstler, Eine Ausstellung über Malerei*, Neue Galerie, Sammlung Ludwig, Aachen, December 5, 1981–February 16, 1982, and tour, ill. p. 43; *Aspects of British Art Today*, Tokyo Metropolitan Art Museum, Tokyo, February 27–April 11, 1982, no. 18; *Howard Hodgkin: Recent Paintings*, M. Knoedler and Co., Inc., New York, November 13–December 9, 1982, no. 3; *The Window in Twentieth-Century Art*, Neuberger Museum, State University of New York at Purchase, New York, September 21, 1986–January 18, 1987; Contemporary Arts Museum, Houston, April 24–June 29, 1987; *Smith Collects Contemporary*, Smith College Museum of Art, Northampton, Massachusetts, Summer 1991.
Literature: Ruth Bass, "Howard Hodgkin," *ARTnews* 82, February 1983, ill. p. 146; Timothy Hyman, "Mapping London's Other Landscape," *Art International* 1, Autumn 1987, pp. 51–61, ill. color; Alexandra Enders, "At Home and Abroad," *Art & Antiques* 7, November 1990, ill. p. 39.

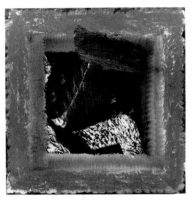

165 · SECOND PORTRAIT OF TERENCE McINERNEY
1981
Oil on wood
50½ x 55 in. (128.3 x 140 cm.)
Collection: Nan and Gene Corman, Beverly Hills, California.
Provenance: (M. Knoedler and Co., Inc., New York).
Exhibitions: *A New Spirit in Painting*, Royal Academy of Arts, London, January 15–March 18, 1981, cat. no. 62, ill. in two versions, unfinished; *Aspects of British Art Today*, Tokyo Metropolitan Art Museum, Tokyo, February 27–April 11, 1982, and tour, cat. no. 129, ill. color; Tochigi Prefectural Museum of Fine Arts, Utsunomiya, April 24–May 30, 1982; National Museum of Art, Osaka, June 12–July 25, 1982; Fukuoka Art Museum, Fukuoka, August 7–29, 1982; Hokkaido Museum of Modern Art, September 9–October 9, 1982, no. 130, ill. color p. 161; *Howard Hodgkin:*

Paintings, M. Knoedler and Co., Inc., New York, November 13–December 9, 1982, no. 8; British Council, 1984, p. 59, ill. color.
Literature: Richard Armstrong, "Reviews: Howard Hodgkin," *Artforum* 21, March 1983, p. 71; Kenneth Baker, "Too Much and/or Not Enough: A Note on Howard Hodgkin," *Artforum* 23, February 1985, pp. 60–61, ill. color p. 60; Judith Higgins, "In a Hot Country," *ARTnews* 84, Summer 1985, pp. 56–65; John Russell, "London and Yale, Hodgkin at the Whitechapel," *Burlington Magazine* 127, October 1985, pp. 729, 731–32: "The big portraits of Terence McInerney ... by far the largest things of their kind that Hodgkin has so far undertaken—had a monumental presence that stood up well to the English seventeenth- and eighteenth-century portraits in the Yale Center's collection."; Asmund Thorkildsen, "En Samtale med Howard Hodgkin," *Kunst og Kultur* 4, Oslo: University Press, National Gallery, April 1987, pp. 220–34, ill. color on cover; Timothy Hyman, "Mapping London's Other Landscape," *Art International* 1, Autumn 1987, pp. 51–61; Timothy Hyman, "Making a Riddle out of the Solution," in *Howard Hodgkin: Small Paintings 1975–1989*, London: The British Council, 1990, ill. p. 14; Graham-Dixon, 1994, ill. color p. 169.

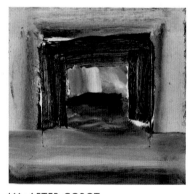

166 · AFTER COROT
1979–82
Oil on board
14½ x 15 in. (36.8 x 38.1 cm.)
Collection: Private Collection, Courtesy L.A. Louver Gallery, Venice, California.
Provenance: (M. Knoedler and Co., Inc., New York).
Exhibitions: *Howard Hodgkin: Paintings*, M. Knoedler and Co., Inc., New York, November 13–December 9, 1982, no. 10; *Painting: Gregory Amenhoff, Howard Hodgkin, Melissa Miller, Katherine Porter, Joan Thorne, Susan Whynne*, Bell Gallery, List Art Center, Brown University, Providence, December 3–30, 1983; British Council, 1984, p. 61, ill. color; Nantes, 1990, no. 7, ill. color p. 25; *Howard Hodgkin*, University

Art Museum, University of California, Berkeley, September 25–December 16, 1991, no. 4.
Literature: Richard Armstrong, "Reviews: Howard Hodgkin," *Artforum* 21, March 1983, p. 71; William Feaver, "Copy, Parody, Variation, Fake," *Observer*, June 17, 1984, p. 19; William Feaver, "Venice: Remembrance of Things Past," *ARTnews* 83, September 1984, pp. 135–37: "*After Corot*, a mind's-eye seascape, all chalky pink, strong French varnish and breezy blues, represented Hodgkinism at its best."; Paul Richard, "Howard Hodgkin's Art: Shining Light at the Phillips Collection," *The Washington Post*, October 11, 1984, B1; Jane Addams Allen, "After 'Year of the French' Can Contemporary Be Far Behind?," *The Washington Times Magazine*, January 4, 1985, ill. color p. 44; Kenneth Baker, "Too Much and/or Not Enough: A Note on Howard Hodgkin," *Artforum* 23, February 1985, pp. 60–61, ill. color p. 60; Michael McNay, "Howard Hodgkin," *Guardian*, October 12, 1985; Luciana Mottola, "I Begin Pictures Full of Hope: Four Questions Posed to Howard Hodgkin," *891, International Artists' Magazine*, vol. III, December 1986, pp. 12–15; Graham-Dixon, 1994, p. 83, ill. color p. 82.
Notes: Hodgkin has described this work as one of his most elaborate uses of framing. The frame here serves as arch, as frame, as spatial device, establishing the foreground of the painting. He has said, further, "I painted *After Corot* because I wanted to paint a picture in the style of Corot's Roman period. ... I found it extremely difficult to paint that little picture." ("A Conversation with Howard Hodgkin," in *Howard Hodgkin*, Anthony d'Offay Gallery, London, 1993, p. 67.)

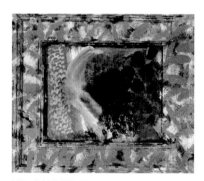

167 · COUNTING THE DAYS
1979–82
Oil on wood
21¾ x 25¼ in. (55.2 x 64.2 cm.)
Collection: Private Collection, Singapore.
Provenance: Alexander M. Ward, U.S.A.; Barry Morrison, New York; (M. Knoedler and Co., Inc., New York); sold Sotheby's, New York, November 8, 1989, lot 73.
Exhibitions: *Howard Hodgkin: Paintings*, M.

Knoedler and Co., Inc., New York, November 13–December 9, 1982, no. 5; British Council, 1984, p. 63 ill. color; Nantes, 1990, ill. color p. 27.
Literature: *Vogue* (Germany), December 1984, ill. color on cover; Richard Dorment, "Howard's Way," *Telegraph Weekend Magazine*, November 24, 1990, pp. 50–55, ill. color p. 53; Graham-Dixon, 1994, ill. color p. 70.
Notes: Signed on the reverse.

168 · GOODBYE TO THE BAY OF NAPLES
1980–82
Oil on wood
22 x 26¼ in. (55.9 x 66.7 cm.)
Collection: Private Collection, U.S.A.
Provenance: (M. Knoedler and Co., Inc., New York).
Exhibitions: *Howard Hodgkin: Paintings*, M. Knoedler and Co., Inc., New York, November 13–December 9, 1982, no. 9, ill. on poster; British Council, 1984, p. 67, ill. color; *1985 Carnegie International*, Museum of Art, Carnegie Institute, Pittsburgh, November 9, 1985–January 5, 1986, ill. p. 140; Nantes, 1990, no. 10, ill. color p. 31; *Howard Hodgkin*, University Art Museum, University of California, Berkeley, September 25–December 16, 1991, no. 5.
Literature: Edward J. Sozanski, "Magnetic Works of Vibrant Color," *The Philadelphia Inquirer*, October 23, 1984, p. 4D, ill.; Richard Lacayo, "Returning to the Frame Game," *Time*, December 3, 1984, p. 72, ill. color; Mark Stevens, "A Palette of the Emotions," *Newsweek*, December 3, 1984, p. 82, ill. color; Bernard Hanson, "Hodgkins On View at Yale," *The Hartford Courant*, February 24, 1985, p. 49, ill.; Timothy Hyman, "Mapping London's Other Landscape," *Art International* 1, Autumn 1987, pp. 51–61; Timothy Hyman, "Making a Riddle Out of the Solution," in *Howard Hodgkin: Small Paintings 1975–89*, London: The British Council, 1990, p. 13, ill. color p. 31: "Doubletakes lie stored behind the gorgeousness of *Goodbye to the Bay of Naples*; the sudden looming into consciousness of the foreground green phallus, set against the blue plane of the Mediterranean, while

Vesuvius behind erupts black lava all around the frame."; Tom Lubbock, "Howard Hodgkin: Small Paintings 1975–89," *Alba*, January–February 1991, p. 29, ill. color; Graham-Dixon, 1994, ill. color p. 109.

169 · IN A HOT COUNTRY
1979–82
Oil on wood
22½ x 25¼ in. (57.2 x 64.2 cm.)
Collection: Private Collection.
Provenance: (M. Knoedler and Co., Inc., New York).
Exhibitions: *Howard Hodgkin: Paintings*, M. Knoedler and Co., Inc., New York, November 13–December 9, 1982, no. 11; British Council, 1984, p. 65, ill. color.
Literature: John Russell, "Art: Works of Hodgkin Displayed at Knoedler's," *The New York Times*, November 19, 1982, ill. C28; Richard Armstrong, "Reviews: Howard Hodgkin," *Artforum* 21, March 1983, p. 71; John McEwen, "Introduction," in *Howard Hodgkin: Forty Paintings: 1973–84*, London: Whitechapel Art Gallery, 1984, p. 12: "*In a Hot Country* … is no reference to India; it is a brazen sexual signal."; John Russell, "Maximum Emotion with a Minimum of Definition," *The New York Times*, April 15, 1984, ill. sec. 2, p. 33; Judith Higgins, "In a Hot Country," *ARTnews* 84, Summer 1985, pp. 56–65, ill. color p. 56; Graham-Dixon, 1994, p. 133, ill. color on cover (detail): "A picture that is also a dream of sexual consummation, a picture in which Hodgkin's device of the heavily framed image becomes charged with sexual, physical intimacy. The inside of the painting is the inside of a body. A body penetrated: the pink arrow at the centre of the painting is the most blatant piece of painter's code in Hodgkin's art."; Marina Vaizey, "Passion for the Physical," [review of Graham-Dixon, 1994] *The Times* (London), July 28, 1994, p. 41, ill. color, incorrectly titled as *In a Hot Country. Shades of India*.

170 · IN THE BAY OF NAPLES
1980–82
Oil on wood
54 x 60 in. (137.2 x 152.5 cm.)
Collection: Sue and David Workman.
Provenance: (M. Knoedler and Co., Inc., New York); Private Collection, New York.
Exhibitions: *Howard Hodgkin: Paintings*, M. Knoedler and Co., Inc., New York, November 13–December 9, 1982, no. 6; British Council, 1984, p. 69, ill. color; *The British Imagination: Twentieth-Century Paintings, Sculpture, and Drawings*, Hirschl & Adler Galleries, New York, November 10, 1990–January 12, 1991, cat. no. 67, ill. color p. 132.
Literature: John Russell, "Art: Works of Hodgkin Displayed at Knoedler's," *The New York Times*, November 19, 1982, C28: "Those paintings of the Bay of Naples have, for instance, the kind of moonstruck lyricism that marks the scenes between Dido and Aeneas in Berlioz's 'The Trojans at Carthage.' Evocative, without ever being directly descriptive, they may well be the best thing that has happened in art to that particular tawdry scene since J.M.W. Turner was carried away by it."; Robert Hughes, "A Peeper into Paradise," *Time*, November 29, 1982, p. 88, ill. color: "The most spectacular painting in the current show, *In the Bay of Naples*, 1980–82, presents itself as a soft hive of colored blobs, blooming and twinkling in rows, against a dark ground. Lit windows? Strings of restaurant lights? A view from a terrace? Then more specific things appear: a pinkish vertical, another stage flat, turns into a stucco wall; a cobalt patch at the center, where the vanishing point would be if there were any perspective, resolves itself as a glimpse of the sea; the S of creamy green paint that lights the whole painting with its contradictory glare, leaping against the more tentative and modulated speckling of the rest of the surface, is the wake of a speedboat, tracing its phosphorescent gesture on the night water."; Manuela Hoelterhoff, "The Venice Biennale: No Paradise for Art," *The Wall Street Journal*, July 31, 1984, p. 32: "His paintings of the Bay of Naples, seen through the filter of memory and affection, are the most gorgeously

colored and composed pictures I have seen in quite a while."; Frederick Hartt, *Art: A History of Painting, Sculpture, Architecture*, vol. II, New York: Harry N. Abrams, Inc., 1985, p. 953, ill. plate 1285: "The suggestions of structure and space are enriched by dark backgrounds so that the bright colors shine like flowers in an illuminated garden at night, and the picture suddenly resolves itself into a view of the great curve of Via Caracciolo seen from a window whose frame appears at the left, with the blue-green water of the bay indicated by a single stroke."; Gregory Galligan, "Howard Hodgkin: Forty Paintings," *Arts Magazine* 59, March 1985, pp. 122–25, ill. color p. 122: "*In the Bay of Naples* makes no clearly discernible reference to the actual physical reality of the site referred to by the title, yet the work oscillates between aquatic blues, greens, and ardent orange-reds, with the temporal immediacy of a Neapolitan climate. This effect sets off an associated mood of sensuous revelry in the spectator, and the painting itself seems to speak of a far more timeless and universal experience than what we might have perceived if Hodgkin were to have depicted the subject in site-specific verity. Thus the painting acts as a cerebral catalyst."; Judith Higgins, "In a Hot Country," *ARTnews*, Summer 1985, pp. 56–65, ill. color p. 63; Asmund Thorkildsen, "En Samtale med Howard Hodgkin," *Kunst og Kultur* 4, Oslo: University Press, National Gallery, April 1987, pp. 220–34, ill. color p. 225; Graham-Dixon, 1994, p. 101, ill. color p. 99: "*In the Bay of Naples* (1980–82) is a tremendously sensual painting, almost a bravura demonstration of the things that the painter can make paint do. … This is not so much a landscape painting as a landscape of paint, a world of pleasure to be entered into. A painting can be, not just the world transfigured, but another world altogether."

171 · IN THE GARDEN OF THE BOMBAY MUSEUM
1978–82
Oil on wood
48½ x 56½ in. (123 x 143 cm.)
Collection: Private Collection.

Provenance: (M. Knoedler and Co., Inc., New York); sold Sotheby's, New York, May 2, 1989, lot 76.

Exhibitions: *Howard Hodgkin: Paintings*, M. Knoedler and Co., Inc., New York, November 13–December 9, 1982, no. 2; *Recent European Paintings*, Solomon R. Guggenheim Museum, New York, May 20–September 4, 1983.

Literature: John McEwen, "Late Bloomer," *Vanity Fair* 47, November 1984, pp. 68–74, 121, ill. color p. 70.

Notes: Signed on the reverse.

172 · IN THE PUBLIC GARDEN, NAPLES
1981–82

Oil on wood

32 x 36¼ in. (81.3 x 92.1 cm.)

Collection: Ann and Robert L. Freedman, New York.

Provenance: (M. Knoedler and Co., Inc., New York); Private Collection, New York.

Exhibitions: *Howard Hodgkin: Paintings*, M. Knoedler and Co., Inc., New York, November 13–December 9, 1982, no. 1; *Painting: Gregory Amenhoff, Howard Hodgkin, Melissa Miller, Katherine Porter, Joan Thorne, Susan Whynne*, Bell Gallery, List Art Center, Brown University, Providence, December 3–30, 1983, ill. color; British Council, 1984, p. 71, ill. color; *The Pastoral Landscape: The Modern Vision*, The Phillips Collection, Washington, D.C., November 6, 1988–January 22, 1989, no. 136, ill. color p. 246.

Literature: William Feaver, "Leaves from India," *Observer*, September 26, 1982, ill. color p. 58; Jane Addams Allen, "Howard Hodgkin: Letting It Flow," *The Washington Times*, October 12, 1984, C1–C2: "One of the loveliest works in the show ... has a luminosity of color that has not been seen in contemporary painting in a long time."; John Russell, "A Hodgkin Original," *The New York Times Magazine*, November 11, 1990, sec. 6, pp. 56–60, 62, ill. color.

Notes: Signed and dated on the reverse.

173 · MR. AND MRS. MICHAEL CHOW
1978–82

Oil on wood

36 x 48 ⅜ in. (91.4 x 171.2 cm.)

Collection: Private Collection.

Provenance: (M. Knoedler and Co., Inc., New York); on loan to the High Museum, Atlanta.

Exhibitions: *Howard Hodgkin: Paintings*, M. Knoedler and Co., Inc., New York, November 13–December 9, 1982, no. 4.

174 · SELF-PITY
1981–82

Oil on wood

23½ x 23½ in. (59.7 x 59.7 cm.)

Collection: Francine Barkan.

Provenance: (M. Knoedler and Co., Inc., New York).

Exhibitions: *Howard Hodgkin: Paintings*, M. Knoedler and Co., Inc., New York, November 13–December 9, 1982, no. 12.

Notes: Signed and dated on the reverse.

175 · SLEEPING FIGURE
1980–82

Oil on wood

8¾ x 11⅝ in. (22.3 x 29.5 cm.)

Collection: Terence McInerney, New York.

Exhibitions: Nantes, 1990, no. 9, ill. color p. 29; *Howard Hodgkin*, University Art Museum, University of California, Berkeley, September 25–December 16, 1991, no. 6.

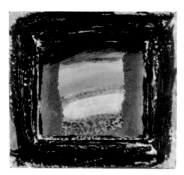

176 · SUNSET IN NAPLES
1979–82

Oil on board

12¾ x 14 in. (32.4 x 35.5 cm.)

Collection: Robert and Mary Looker.

Provenance: L.A. Louver Gallery, Venice, California, Los Angeles.

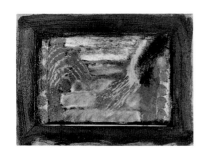

177 · YOU AND ME
1980–82

Oil on wood

17 x 23¼ in. (43 x 59 cm.)

Collection: Unknown.

Provenance: (M. Knoedler and Co., Inc., New York); Mary Newhouse; (M. Knoedler and Co., Inc., New York).

Exhibitions: *Howard Hodgkin: Paintings*, M. Knoedler and Co., Inc., New York, November 13–December 9, 1982, no. 15.

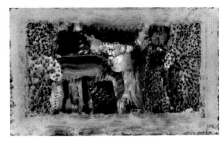

178 · INTERIOR AT OAKWOOD COURT
1978–83
Oil on wood
32 x 54 in. (81.3 x 137.2 cm.)
Collection: Whitworth Art Gallery, University of Manchester, England, purchased with grants from the Victoria and Albert Museum, London, Purchase Grant Fund and the Friends of the Whitworth (0.9.1983).
Provenance: (M. Knoedler and Co., Inc., New York).
Exhibitions: British Council, 1984, p. 73, ill. color; *Howard Hodgkin: Recent Work*, M. Knoedler and Co., Inc., New York, April 21– May 10, 1984, cat. no. 2; *British Art in the 20th Century: The Modern Movement*, Royal Academy of Arts, London, January 15–April 5, 1987, no. 290, ill. color; *Whitworth Art Gallery, The First Hundred Years*, Whitworth Art Gallery, Manchester, 1989, ill. color p. 131: "The artist, in a letter to the Gallery, has said that 'it is simply a portrait of two friends in their apartment in Oakwood Court.'" (entry by GS [Greg Smith])
Literature: Anna Moszynska, *Abstract Art*, London: Thames and Hudson Ltd, 1990, ill. color plate 157, p. 222; Graham-Dixon, 1994, ill. color p. 87.
Notes: Signed, dated and inscribed on the reverse.

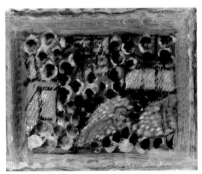

179 · ANECDOTES
1980–84
Oil on board
22³/₄ x 28³/₄ in. (57.8 x 73 cm.)
Collection: Private Collection, England.
Provenance: (M. Knoedler and Co., Inc., New York).
Exhibitions: British Council, 1984, p. 87, ill. color; *Howard Hodgkin: Recent Work*, M.

Knoedler and Co., Inc., New York, April 21– May 10, 1984, cat. no. 4; Nantes, 1990, no. 11, ill. color p. 33.
Literature: Eric Gibson, "The Hodgkin Paradox," *Studio International* 198, March 1985, pp. 23–25, ill. color p. 25; Marina Vaizey, "The Intimate Room Within," *Sunday Times*, September 29, 1985.

180 · CLEAN SHEETS
1982–84
Oil on wood
22 x 36 in. (55.9 x 91.2 cm.)
Collection: Tate Gallery, London, purchased with assistance from Evelyn, Lady Downshire's Trust Fund.
Provenance: (M. Knoedler and Co., Inc., New York); Sally Sirkin Lewis, Los Angeles; John Goode Gallery, New York; sold Sotheby's, New York, November 14, 1991, lot 288, ill. color; Saatchi Collection, London.
Exhibitions: British Council, 1984, p. 85, ill. color; *Howard Hodgkin: Recent Work*, M. Knoedler and Co., Inc., New York, April 21– May 10, 1984, cat. no. 7; Nantes, 1990, no. 14, ill. color p. 41.
Literature: Michael Brenson, "Art: Howard Hodgkin and Paris Legacy," *The New York Times*, April 27, 1984: "*Clean Sheets* suggests something restful and joyful, the color is almost exclusively an ominous green, and we seem to have come in at the beginning of a disquieting drama between an upright and a reclining figure."; Judith Bumpus, "A Dream of Venice," *Art and Artists* 214, July 1984: "He pointed to a picture of billowing green paint: 'That's called "Clean Sheets." It's just the interior of a bedroom. But as someone neatly put it, it's full of Friday night thoughts.'"; Prudence Carlson, "Howard Hodgkin at Knoedler," *Art in America* 72, October 1984; Kenneth Baker, "Too Much and/or Not Enough: A Note on Howard Hodgkin," *Artforum* 23, February 1985; Eric Gibson, "The Hodgkin Paradox," *Studio International* 198, March 1985; Alistair Hicks, *New British Art in the Saatchi Collection*, London: Thames and Hudson Ltd, 1989, no. 36, ill. color p. 52; Graham-Dixon, 1994, ill. color p. 128.

181 · THE CYLINDER, THE SPHERE, THE CONE
1978–84
Oil on board
36¹/₄ x 46 in. (92.1 x 116.8 cm.)
Collection: The Carnegie Museum of Art, Pittsburgh, Gene Baro Memorial Fund and Carnegie International Acquisition Fund.
Provenance: (M. Knoedler and Co., Inc., New York).
Exhibitions: British Council, 1984, p. 77, ill. color; *Howard Hodgkin: Recent Work*, M. Knoedler and Co., Inc., New York, April 21–May 10, 1984, cat. no. 1; *1985 Carnegie International*, Museum of Art, Carnegie Institute, Pittsburgh, November 9, 1985–January 5, 1986, ill. color p. 139.
Literature: Jane Withers and Anthony Fawcett, "The Man on the Flip Side," *The Times* (London), May 19, 1984, p. 12, ill. partial view; Judith Bumpus, "A Dream of Venice," *Art and Artists* 214, July 1984, pp. 14–17, ill.: "*The Cylinder, the Sphere, the Cone* was not, apparently, as abstract as it sounded. Hodgkin was not prepared to discuss its subject matter, but he was happy to talk about his satisfaction at having, at last, completed the painting. 'I'm particularly pleased with it because it's a "trompe l'oeil" space which is terribly difficult to achieve without interrupting the surface, as it were.'"; Prudence Carlson, "Howard Hodgkin at Knoedler," *Art in America* 72, October 1984, pp. 192–93; John Caldwell, "Howard Hodgkin," in *Museum of Art, Carnegie Institute Collection Handbook*, Pittsburgh: Museum of Art, Carnegie Institute, 1985, pp. 320–21, ill. color p. 321: "In *The Cylinder, the Sphere, the Cone* he appears to break his own rules. The title, for example, is quite unlike his others, which usually allude to people or places. It refers, at least on the most obvious level, to Cézanne's famous instruction. ... Hodgkin here is clearly making a joke on several levels. First, his picture contains no cylinder and no sphere, and the 'cone' one first picks out at the left is in fact a triangle, the white sail of a boat. As if to place even this reading of the picture in doubt, the boat sails, when it first appears, on a thin sliver of blue sea that in fact turns out not to

be the sea at all, but the inside edge of the picture frame."; Eric Gibson, "The Hodgkin Paradox," *Studio International* 198, March 1985, pp. 23–25: "There are moments in all of this when Hodgkin's results are a little too off key, becoming either too lush or too flat-footed. *The Cylinder, the Sphere, the Cone*, 1978–84, for example (a reinterpretation of Cézanne's famous dictum) is awkwardly illustrational, as though Hodgkin had reversed himself for once and had pressed a pre-existing vocabulary on to a pre-existing subject. Yet such a picture can also make us realize how good he is at evoking pure sensation."; Judith Higgins, "In a Hot Country," *ARTnews* 84, Summer 1985, pp. 56–65; Graham-Dixon, 1994, pp. 121–22, ill. color p. 123: "Hodgkin has only ever painted one picture that could be described as something like a manifesto for his art. But it is actually (and characteristically) more of an anti-manifesto, a declaration of dissent from the notion that the modern artist needs a theory or a programme to paint by. In 1904, Paul Cézanne famously advised Emile Bernard to 'Treat nature in terms of the cylinder, the sphere, the cone.' Hodgkin has painted his own, tongue-in-cheek response to Cézanne's didactic remark, *The Cylinder, the Sphere, the Cone* (1978–84). The picture is a heavily ironic refutation of systematic painting, a deliberately botched exercise, a work of art that conspicuously fails to simplify the world to a platonically idealized geometry of form."

182 · DARK MOON
1982–84
Oil on wood
12³⁄₈ in. circular (31.4 cm.)
Collection: Dr. Luther W. Brady, Philadelphia.
Provenance: (M. Knoedler and Co., Inc., New York).
Exhibitions: British Council, 1984, exhibited in London only, ill. p. 11 in catalogue supplement; *Howard Hodgkin: Recent Work*, M. Knoedler and Co., Inc., New York, May 10–June 5, 1986, ill. p. 11; Nantes, 1990, no. 15, ill. color p. 43.
Literature: Alistair Hicks, "Talking about Art,"

Spectator 225, September 28, 1985, pp. 35–36; Alistair Hicks, *The School of London, The Resurgence of Contemporary Painting*, London: Phaidon, 1989, p. 40, ill. color plate 20, p. 39; Timothy Hyman, "Making a Riddle Out of the Solution," in *Howard Hodgkin: Small Paintings 1975–1989*, London: The British Council, 1990, p. 13, ill. color p. 43; Graham-Dixon, 1994, ill. color p. 107.

183 · D.H. IN HOLLYWOOD
1980–84
Oil on wood
42½ x 51½ in. (108 x 130.8 cm.)
Collection: Private Collection, England.
Provenance: (M. Knoedler and Co., Inc., New York).
Exhibitions: British Council, 1984, p. 79, ill. color; *Howard Hodgkin: Recent Work*, M. Knoedler and Co., Inc., New York, April 21–May 10, 1984, cat. no. 8.
Literature: John McEwen, "Introduction," in *Howard Hodgkin: Forty Paintings: 1973–1984*, London: Whitechapel Art Gallery, 1984, p. 10: "Here stylistic allusion is made to Hockney's first Californian period. The figure itself, both in its melancholy isolation and waist-deep-in-water pose, recalls that of the art dealer Nick Wilder in his swimming pool in a Hockney painting of 1966. The ironic depiction of Wilder as a forlorn figure in a carefree setting is here turned against its perpetrator, with a suggestion at once more tragic and compassionate. Hodgkin portrays him [Hockney] in middle age, isolated in his own swimming pool and the success it represents. … [a] humorous and nostalgic celebration of an old friendship."; Michael Brenson, "Art: Howard Hodgkin and Paris Legacy," *The New York Times*, April 27, 1984, C23: "In *D.H. in Hollywood*, the reds, greens and columnar pink suggest the more trivial but not less fantastic movie-star world."; William Packer, "Venice through the Looking Glass," *Financial Times*, June 19, 1984, ill.; Judith Bumpus, "A Dream of Venice," *Art and Artists* 214, July 1984, pp. 14–17, ill.: "The portrait of David Hockney in Hollywood was possibly his

first attempt at using a lighter technique. The work was exhibited in the Peter Blake Retrospective at the Tate Gallery in 1982 and readers may remember that Hodgkin was supposed to have submitted three works but only managed this one, and in a very unfinished state at that. Was the decision to paint lightly a stylistic one or had it been suggested by the subject matter? 'Oh, in this case, it was entirely because of the subject matter. It was very much a gesture of acclamation towards David's miraculous early pictures which look, if anything, more wonderful than ever. I wanted to include my feeling about David in that picture.'"; *Il Giornale della Biennale, Il Giornale dell'Arte*, no. 14, July–August 1984, ill. p. 30; Prudence Carlson, "Howard Hodgkin at Knoedler," *Art in America* 72, October 1984, pp. 192–93; Jane Addams Allen, "Howard Hodgkin: Letting it Flow," *The Washington Times*, October 12, 1984, C1–C2; John McEwen, "Late Bloomer," *Vanity Fair* 47, November 1984, pp. 68–74, 121, ill. color p. 74; Kenneth Baker, "Too Much and/or Not Enough: A Note on Howard Hodgkin," *Artforum* 23, February 1985, pp. 60–61; Gordon Burn, "The Middle Age of Mr. Hockney," *Sunday Times*, February 21, 1988; Graham-Dixon, 1994, p. 122, ill. color p. 125: "Painting David Hockney in *D.H. in Hollywood* (1980–84), he turns his subject into a proud erect phallus, a red upstanding penis in the middle of the painting, above a line of blue blobs that reads as the Hockney swimming pool."

184 · EGYPT
1983–84
Oil on wood
20⁷⁄₈ x 24¼ in. (53 x 61.6 cm.)
Collection: Nan and Gene Corman, Beverly Hills, California.
Provenance: (M. Knoedler and Co., Inc., New York).
Exhibitions: British Council, 1984, p. 75, ill. color; *Howard Hodgkin: Recent Work*, M. Knoedler and Co., Inc., New York, April 21–May 10, 1984, cat. no. 5.

Literature: Paul Richard, "Howard Hodgkin's Art: Shining Light at the Phillips Collection," *The Washington Post*, October 11, 1984, B1; Kenneth Baker, "Too Much and/or Not Enough: A Note on Howard Hodgkin," *Artforum* 23, February 1985, pp. 60–61; Graham-Dixon, 1994, ill. color p. 23.

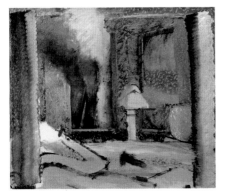

185 · INTERIOR WITH FIGURES
1977–84
Oil on wood
54 x 60 in. (137.2 x 152.5 cm.)
Collection: Ron and Ann Pizzuti.
Provenance: (M. Knoedler and Co., Inc., New York); (John Goode Gallery, New York); Mr. Bernard Lewis, Los Angeles; Saatchi Collection, London; sold Sotheby's, New York, November 13, 1991, lot 26.
Exhibitions: British Council, 1984, p. 95, ill. color, not exhibited in Venice; *An International Survey of Recent Painting and Sculpture*, Museum of Modern Art, New York, May 17–August 19, 1984, ill. p. 159; *Art of Our Time: The Saatchi Collection*, Royal Scottish Academy, Edinburgh, 1988, p. 18, ill.
Literature: John McEwen, "Late Bloomer," *Vanity Fair* 47, November 1984, pp. 68–74, 121, ill. color p. 72; Eric Gibson, "The Hodgkin Paradox," *Studio International* 198, March 1985, pp. 23–25: "*Interior with Figures* exudes the sort of heated eroticism more common to late 19th-century French painting than the aesthetics of the '70s and '80s."; Jeff Perrone, "Entrees: Diaretics: Entreaties: Bowing (Wowing) Out," *Arts Magazine* 59, April 1985, pp. 78–83: "Hodgkin's last effort, *Interior with Figures*, measures 54 x 60 inches, and, by our current standards, that's small, but add to that this meaty piece of information: it took eight years to complete ('1977–1984'). People don't only respond to the thrill of sheer size; they'll accept the prolonged intensity of time spent. Now, one cannot believe that it took Hodgkin eight years to finish the painting, and I'm not saying he's trying to fool us into thinking it did. But it looks impressive."; Judith Higgins, "In a Hot Country," *ARTnews*, Summer 1985, pp.

56–65, ill. color p. 64; Alistair Hicks, "Howard Hodgkin," in *Art of Our Time: The Saatchi Collection*, Edinburgh: Royal Scottish Academy, 1988, pp. 13–14: "In *Interior with Figures* the eye is squeezed into the centre of the room by the pink barley stick sashes of colour. They hang like curtains either side emphasising the forbidden nature of the scene. It is not like looking through a keyhole, because the top and bottom of the picture are open-ended. The figures at the bottom are left undefined and the ecstatic explosion of colour bursts out of the ceiling. The artist builds up the emotional charge with layers of colour, but he contrasts this density with patches of bare wood. There is always ambiguity, ways of escaping, so that the eye is pulled back to the focal points of the work with a renewed force."; Alistair Hicks, *New British Art in the Saatchi Collection*, London: Thames and Hudson Ltd, 1989, no. 41, ill. color p. 55; Graham-Dixon, 1994, ill. color p. 34.
Notes: Signed.

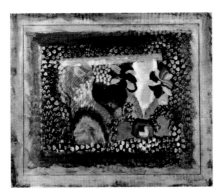

186 · MR. AND MRS. JAMES KIRKMAN
1980–84
Oil on wood
40¾ x 47¾ in. (103.5 x 121.3 cm.)
Collection: Gisela and Dennis Alter.
Provenance: (M. Knoedler and Co., Inc., New York); Private Collection; Hirschl & Adler Galleries, Inc., New York; sold Christie's, New York, May 3, 1995, lot 43, ill. color.
Exhibitions: British Council, 1984, p. 81, ill. color; *Howard Hodgkin: Recent Work*, M. Knoedler and Co., Inc., New York, April 21–May 10, 1984, cat. no. 3; *1985 Carnegie International*, Museum of Art, Carnegie Institute, Pittsburgh, November 9, 1985–January 5, 1986, ill. p. 140; *The British Imagination: Twentieth-Century Paintings, Sculpture and Drawings*, Hirschl & Adler Galleries, New York, November 10, 1990–January 12, 1991, cat. no. 68, ill. color p. 133.
Literature: Dirceu Brisola, "Os eleitos de Veneza," VEJA, June 20, 1984, pp. 134–135, ill. color p. 134; Judith Bumpus, "A Dream of

Venice," *Art and Artists* 214, July 1984, pp. 14–17, ill. p. 15: "'I don't understand why people in this country find my pictures non-representational. I think of them as very representational. Portraits like this one of the art dealer, James Kirkman and his wife, are very recognisable.'"; Prudence Carlson, "Howard Hodgkin at Knoedler," *Art in America* 72, October 1984, pp. 192–93, ill. color p. 192; Gregory Galligan, "Howard Hodgkin: Forty Paintings," *Arts Magazine* 59, March 1985, pp. 122–25; Ursula Bode, "Gefallig verwirren ä, Der Maler Howard Hodgkin in Hannover," *Hannoversche Allgemeine Zeitung*, April 24, 1985, ill.; Edward Lucie-Smith, "Exhibitions," *Illustrated London News* 273, September 1985, p. 76; Sandy Nairne, *State of the Art, Ideas & Images in the 1980s*, London: Chatto and Windus, 1987, ill. color plate 91, p. 120; Martin Gayford and Drusilla Beyfus, "Painted Faces," *Telegraph Weekend Magazine*, November 13, 1993, ill. color pp. 20–21: "A new summer dress played a part in the origins of this portrait of Howard Hodgkin's of his friends, art dealer James Kirkman and his wife Clare Kirkman. Kirkman recalls that the artist admired the appearance of Clare in this dress, and decided to do the painting. He thinks it is possible that Hodgkin, as a long-standing friend of the family, had had it in his mind to do the portrait for some time. ... 'But it was that dress that seemed to encourage him to start,' said Kirkman. 'Clare is represented on the right of the picture and I am the blob on the left.'"; Graham-Dixon, 1994, p. 166, ill. color p. 167: "Mr Kirkman is lost, buried somewhere within the painting's contrived anarchy of mists and splotched veils, but Mrs Kirkman survives as a pink blob with massively outsized earrings and a green necklace."

187 · NONE BUT THE BRAVE DESERVES THE FAIR
1981–84
Oil on wood
24¾ x 30 in. (62.8 x 76.2 cm.)
Collection: Private Collection, New York.

Provenance: (M. Knoedler and Co., Inc., New York).

Exhibitions: British Council, 1984, p. 93, ill. color; *Howard Hodgkin: Recent Work*, M. Knoedler and Co., Inc., New York, April 21–May 10, 1984, cat. no. 12; Nantes, 1990, ill. color p. 39.

Literature: Anthony Fawcett and Jane Withers, "Howard Hodgkin at the Venice Biennale," *Studio International* 197, 1984, pp. 16–17, ill. color p. 16; John McEwen, "Introduction," in *Howard Hodgkin: Forty Paintings: 1973–84*, London: Whitechapel Art Gallery, 1984, p. 11: "How well suited the cavalier 'plumes' of white paint are to the sexually boisterous spirit of *None but the Brave Deserves the Fair*, the freshness and lightness of their application in feathery accord with the paint staining (rather than coating) the central panel."; Paul Richard, "Howard Hodgkin's Art: Shining Light at the Phillips Collection," *The Washington Post*, October 11, 1984, B1; Judith Higgins, "In a Hot Country," *ARTnews* 84, Summer 1985, pp. 56–65; Frederick Lowe, "None But the Brave Deserves the Fair," *Yellow Silk* (USA) 23, July 1987, pp. 41–42, 44, ill. color p. 41; Graham-Dixon, 1994, ill. color p. 129.

188 · PASSION
1980–84
Oil on wood
12½ x 21½ in. (31.8 x 54.6 cm.)
Collection: Waddington Galleries, London.
Provenance: (M. Knoedler and Co., Inc., New York); William Acquavella, New York; Joshua Mack, New York; sold Sotheby's, New York, February 19, 1988, lot 192, ill. color.
Exhibitions: British Council, 1984, p. 89, ill. color; *Howard Hodgkin: Recent Work*, M. Knoedler and Co., Inc., New York, April 21–May 10, 1984, cat. no. 9; *Recent Abstract Painting*, John Good Gallery, New York, January 9–February 8, 1986; Nantes, 1990, no. 13, ill. color p. 37.
Literature: Marina Vaizey, "The Intimate Room," *Sunday Times*, September 29, 1985; Jed Perl, "Winter Notebook: Recent Abstract Painting," *New Criterion* 4, April 1986, pp. 57–58; Graham-Dixon, 1994, ill. color p. 38.
Notes: Signed on the reverse.

189 · SON ET LUMIERE
1983–84
Oil on wood
26½ x 29¼ in. (67.3 x 74.3 cm.)
Collection: Mrs. Helen Portugal.
Provenance: (M. Knoedler and Co., Inc., New York).
Exhibitions: British Council, 1984, exhibited in London only; *The Turner Prize 1984*, Tate Gallery, London, October 25–December 2, 1984.
Literature: Gordon Burn, "The Tate's Bold Stroke for British Art," *Sunday Times Magazine*, November 11, 1984, p. 45, ill.; Roberto Tassi, "Howard Hodgkin: Un Maestro della Pittura Inglese," *Vogue* (Italia), July 1985, pp. 160–65.

190 · SOUVENIRS
1980–84
Oil on wood
60 x 108 in. (152.5 x 274.5 cm.)
Collection: National Gallery of Art, Washington, D.C., Robert and Jane Meyerhoff Collection.
Provenance: (M. Knoedler and Co., Inc., New York).
Exhibitions: British Council, 1984, exhibited in London only; *Howard Hodgkin: Recent Work*, M. Knoedler and Co., Inc., New York, May 10–June 5, 1986, ill. color pp. 8–9.
Literature: Howard Hodgkin and Patrick Caulfield, "Howard Hodgkin and Patrick Caulfield in Conversation," *Art Monthly* 78, July–August 1984, pp. 4–6, ill. p. 5: "I try from time to time to paint pictures that have a sort of multiple viewpoint. But I've never really succeeded and I'm trying to paint one at the moment but I'm having terrible trouble because it's nine feet wide—it's very difficult to make a picture which exists all the way across the surface and I've found it has become centralised ... it was a sort of interior, so that you got views of the different rooms. But eventually, of course, it has become really like all my other pictures in the sense that there is the centre and there are two sides. It's a symmetrical composition all over again. ... It's the largest interior I've ever painted."; Judith Higgins, "In a Hot Country," *ARTnews* 84, Summer 1985, pp. 56–65, ill. color; Graham-Dixon, 1994, p. 71, ill. color p. 73: "One of the largest of all the pictures, whose theme is the appalling struggle of recollection. *Souvenirs* is almost insolently obscurantist, a vast field of dots concealing a hidden world of incident, barely glimpsed. But remembering is like this. The television set of memory is not easily tuned."

191 · STILL LIFE
1982–84
Oil on wood
12⅝ x 13⅜ in. (32.3 x 34 cm.)
Collection: Private Collection.
Provenance: (M. Knoedler and Co., Inc., New York).
Exhibitions: British Council, 1984, exhibited in London only; *The Turner Prize 1984*, Tate Gallery, London, October 25–December 2, 1984.

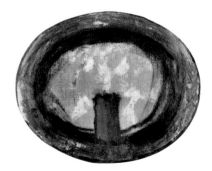

192 · TREE
1982–84
Oil on wood
12⅝ x 16 in. (32.1 x 40.6 cm.)
Collection: Alexander M. Ward.
Provenance: (M. Knoedler and Co., Inc., New York).

Exhibitions: British Council, 1984, not included in Venice, Kestner-Gesellschaft, or Whitechapel Art Gallery exhibitions; *Howard Hodgkin: Recent Work*, M. Knoedler and Co., Inc., New York, April 21–May 10, 1984, cat. no. 11.
Literature: Judith Bumpus, "A Dream of Venice," *Art and Artists* 214, July 1984, pp. 14–17, ill. p. 15; Prudence Carlson, "Howard Hodgkin at Knoedler," *Art in America* 72, October 1984.
Notes: Signed and titled on the reverse.

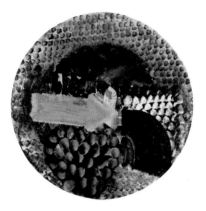

193 · VALENTINE
1978–84
Oil on wood
47½ in. diameter (120.7 cm.)
Collection: Jane and Gerald Katcher.
Provenance: (M. Knoedler and Co., Inc., New York).
Exhibitions: British Council, 1984, p. 83, ill. color; *Howard Hodgkin: Recent Work*, M. Knoedler and Co., Inc., New York, April 21–May 10, 1984, cat. no. 6.
Literature: Michael Brenson, "Art: Howard Hodgkin and Paris Legacy," *The New York Times*, April 27, 1984, C23: "While the title of the painting 'Valentine' suggests American romance, and while the tondo shape brings to mind idyllic paintings by Raphael, the large arrow inside the painting and the hard grays and blacks are more suggestive of the American violence of the St. Valentine's Day Massacre."; Jane Withers and Anthony Fawcett, "The Man on the Flip Side," *The Times* (London), May 29, 1984, p. 12, ill.; Alexandra Pringle, "Art: Howard's Blend of Images and Textures," *Harpers and Queen*, June 1984, p. 189, ill.; John McEwen, "Finding Form at Fifty," *Sunday Times Magazine*, June 10, 1984, pp. 38–41; Judith Bumpus, "A Dream of Venice," *Art and Artists* 214, July 1984, pp. 14–17, ill.: "I [Hodgkin] have been trying to paint more lightly and delicately. It's far more difficult though to paint a picture like 'Interior with figures' than a painting such as 'Valentine'. I use very little paint so there's far less room to manoeuvre. They take longer, strangely enough, because the decisions

have to be even more radical."; Robert Hughes, "Gliding over a Dying Reef—The Venice Biennale," *Time* 214, July 2, 1984, pp. 76–77, ill. color, p. 41: "Not since Robert Rauschenberg's appearance at the Biennale 20 years ago has a show by a single painter so hogged the attention of visitors or looked so effortlessly superior to everything else on view by living artists. ... Hodgkin paints small, and his work combines the intimate with the declamatory. Every image seems to be based either on a room with figures or a peep into a garden from a window, and is regulated by layered memories of conversation, sexual tension and private jokes. But this is conveyed by an extraordinary blooming, spotting, bumbling and streaking of color, an irradiation of the mildly anecdotal by the aggressively visual. The small size of Hodgkin's canvases puts a high premium on their quality of touch ... but the color counts most."; Prudence Carlson, "Howard Hodgkin at Knoedler," *Art in America* 72, October 1984, pp. 192–93; Shirley Gonzales, "Hodgkin's Trip into 'Deep Space,'" *The New Haven Register*, January 20, 1985; Judith Higgins, "In a Hot Country," *ARTnews* 84, Summer 1985, pp. 56–65; Roberto Tassi, "Howard Hodgkin: Un Maestro della Pittura Inglese," *Vogue* (Italia), June 1985, pp. 160–65, ill. color p. 162.
Notes: The arrow form here relates to *In a Hot Country*, cat no. 169.

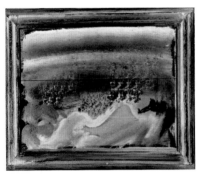

194 · WAKING UP IN NAPLES
1980–84
Oil on wood
23½ x 29½ in. (59.7 x 74.9 cm.)
Collection: Private Collection, London.
Provenance: (M. Knoedler and Co., Inc., New York).
Exhibitions: British Council, 1984, p. 91, ill. color; *Howard Hodgkin: Recent Work*, M. Knoedler and Co., Inc., New York, April 21–May 10, 1984, cat. no. 10; Nantes, 1990, no. 12, ill. color p. 35.
Literature: Anthony Fawcett and Jane Withers, "Howard Hodgkin at the Venice Biennale," *Studio International* 197, 1984, pp. 16–17, ill. color; John McEwen, "Introduction," in *Howard

Hodgkin: Forty Paintings: 1973–84, London: Whitechapel Art Gallery, 1984, p. 11: "The air of southern luxury, calm and voluptuousness of *Waking Up in Naples* is erotically consolidated by deploying the wood as the flesh-colour of the reclining nude, the oil from the surrounding paint giving an impression of seeping from the figure like sweat from the skin, a detail—however fortuitous—that enhances the sensual atmosphere."; Gregory Galligan, "Howard Hodgkin: Forty Paintings," *Arts Magazine* 59, March 1985, pp. 122–25; Judith Higgins, "In a Hot Country," *ARTnews* 84, Summer 1985, pp. 56–65; Luciana Mottola, "I Begin Pictures Full of Hope: Four Questions Posed to Howard Hodgkin," *891, International Artists' Magazine*, vol. III, December 1986, pp. 12–15; Timothy Hyman, "Making a Riddle Out of the Solution," in *Howard Hodgkin: Small Paintings 1975–1989*, London: The British Council, 1990, p. 13, ill. color p. 35; Graham-Dixon, 1994, p. 149, ill. color p. 148: "Everything else in the picture—the sea or sky, some scarlet puffs of paint that could be bedclothes—merely emphasizes that this is, in essence, a painting of a naked back, rendered audaciously by the simple expedient of leaving the wooden support bare to model it."

195 · BUST
1984–85
Oil on wood
13¼ in. diameter (33.5 cm.)
Collection: Bernard Jacobson, London.
Provenance: (M. Knoedler and Co., Inc., New York); (Ganz Gallery, London); Bruce and Judith Eissner.
Exhibitions: British Council, 1984, exhibited in London only, ill. color p. 21 in cat. supp.; *Howard Hodgkin: Recent Work*, M. Knoedler and Co., Inc., New York, May 10–June 5, 1986, ill. color.
Literature: Alistair Hicks, "Talking about Art," *Spectator* 225, September 28, 1985, pp. 35–36: "*Bust* is bound by a strong circle of yellow and it pulls its victims in with the power of a whirlpool. It winds us up until the tension snaps and we are left wondering what happened to us."

196 · EGYPTIAN NIGHT
1983–85
Oil on wood
19½ x 23¼ in. (49.5 x 59 cm.)
Collection: Private Collection.
Provenance: (M. Knoedler and Co., Inc., New York); Stephen Hassenfeld.
Exhibitions: British Council, 1984, exhibited in London only, ill. color p. 15 in cat. supp.; *Howard Hodgkin: Recent Work*, M. Knoedler and Co., Inc., New York, May 10–June 5, 1986, ill. color p. 15; *1900 to Now: Modern Art from Rhode Island Collections*, Museum of Art, Rhode Island School of Design, Providence, Rhode Island, January 22–May 1, 1988, ill. color in brochure.
Literature: Susan Gill, "Howard Hodgkin: Knoedler," *ARTnews* 85, September 1986, pp. 115, 119; Graham-Dixon, 1994, ill. color p. 106.

197 · IN THE HONEYMOON SUITE
1983–85
Oil on wood
23⅜ x 25⅛ in. (59.5 x 64 cm.)
Collection: Private Collection.
Provenance: (M. Knoedler and Co., Inc., New York); Douglas S. Cramer, Los Angeles; sold Christie's, New York, Contemporary Art, November 2, 1994, lot 43, ill. color p. 57.
Exhibition: British Council, 1984, exhibited in London only, ill. color p. 17 in cat. supp.; *Howard Hodgkin: Recent Work*, M. Knoedler and Co., Inc., New York, May 10–June 5, 1986, cat. no. 10, ill. color p. 17; Nantes, 1990, ill. color p. 47.
Literature: Timothy Hyman, "Making a Riddle Out of the Solution," in *Howard Hodgkin: Small Paintings 1975–1989*, London: The British Council, 1990, p. 12, ill. color p. 47.
Notes: Signed, titled and dated on the reverse.

198 · MENSWEAR
1980–85
Oil on wood
32¾ x 42½ in. (83 x 108 cm.)
Collection: Saatchi Collection, London.
Provenance: (M. Knoedler and Co., Inc., New York); (Waddington Galleries, London).
Exhibitions: British Council, 1984, exhibited in London only, ill. color p. 7 in cat. supp.; *1985 Carnegie International*, Museum of Art, Carnegie Institute, Pittsburgh, November 9, 1985–January 5, 1986, ill. p. 141; *Howard Hodgkin: Recent Work*, M. Knoedler and Co., Inc., New York, May 10–June 5, 1986, ill. color p. 7; *British Art in the 20th Century: The Modern Movement*, Royal Academy of Arts, London, January 15–April 5, 1987, no. 291, ill. color.
Literature: Alistair Hicks, *New British Art in the Saatchi Collection*, London: Thames and Hudson Ltd, 1989, no. 40, ill. color p. 54.

199 · RAIN IN VENICE
1983–85
Oil on wood
24 in. diameter (61 cm.)
Collection: Private Collection.
Provenance: (M. Knoedler and Co., Inc., New York).
Exhibitions: *Howard Hodgkin: Recent Work*, M. Knoedler and Co., Inc., New York, May 10–June 5, 1986, ill. color p. 31.
Literature: Gregory Galligan, "A Small Thing But Painting: The New Work of Howard Hodgkin," *Arts Magazine* 61, September 1986, pp. 65–67, ill. color p. 67.

Notes: Hodgkin has described this work as one of only a few in his œuvre that began with an existing frame—in this case a frame chosen for its resemblance to shapes found in Venetian architecture.

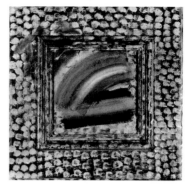

200 · RAINBOW
1983–85
Oil on wood
22⅞ x 21 in. (58 x 53.5 cm.)
Collection: Holly Hunt, Chicago.
Provenance: (M. Knoedler and Co., Inc., New York).
Exhibitions: British Council, 1984, exhibited in London only, ill. color p. 13 in cat. supp.; *Howard Hodgkin: Recent Work*, M. Knoedler and Co., Inc., New York, May 10–June 5, 1986, ill. color p. 13; Nantes, 1990, no. 16, ill. color p. 49.
Literature: Margaret Sheffield, "Frame Ups (and Downs)," *Connoisseur*, March 1988, p. 117, ill. color; Timothy Hyman, "Making a Riddle Out of the Solution," in *Howard Hodgkin: Small Paintings 1975–1989*, London: The British Council, 1990, pp. 11, 12, ill. color p. 49; Graham-Dixon, 1994, ill. color p. 100.

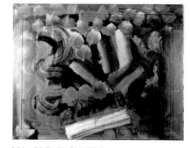

201 · SAD FLOWERS
1979–85
Oil on wood
43½ x 55½ in. (110.5 x 141 cm.)
Collection: Gisela and Dennis Alter.
Provenance: (M. Knoedler and Co., Inc., New York); Lawrence Rubin, New York.
Exhibitions: British Council, 1984, exhibited in London only, ill. color p. 5 in cat. supp.; *The Hard-Won Image: Traditional Method and Subject*

in Recent British Painting, Tate Gallery, London, July 4–September 9, 1984, cat. no. 75, ill. p. 32; *The Proper Study: Contemporary Figurative Painting from Britain*, Lalit Kala Akademi, New Delhi, December 1–31, 1984, and Jahangir Nicholson Museum of Modern Art, Bombay, February 1–28, 1985; *1985 Carnegie International*, Museum of Art, Carnegie Institute, Pittsburgh, November 9, 1985–January 5, 1986, ill. p. 141; *Howard Hodgkin: Recent Work*, M. Knoedler and Co., Inc., New York, May 10–June 5, 1986, ill. color p. 5.

Literature: Marina Vaizey, "The Intimate Room Within," *Sunday Times*, September 29, 1985; Sally Brampton, "Howard Hodgkin: Art into Life," *Elle* (UK), November 1985, p. 86; Sandy Nairne, *State of the Art, Ideas & Images in the 1980s*, London: Chatto and Windus, 1987, ill. color plate 89 and detail plate 90, p. 117; David Sylvester, "Artist's Dialogue: Howard Hodgkin—The Texture of a Dream," *Architectural Digest* 44, March 1987, pp. 54, 62, 66, 70, 74, ill. color p. 62; Graham-Dixon, 1994, ill. color p. 47.

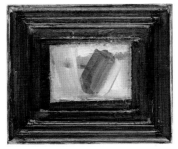

202 · A SMALL THING BUT MY OWN
1983–85
Oil on wood
17¾ x 21¼ in. (45 x 53.5 cm.)
Collection: Dr. and Mrs. Marvin Rotman, New York.
Provenance: (M. Knoedler and Co., Inc., New York).
Exhibitions: *The Turner Prize 1985*, Tate Gallery, London, October 17–December 1, 1985, ill.; *Howard Hodgkin: Recent Work*, M. Knoedler and Co., Inc., New York, May 10–June 5, 1986, ill. color p. 2; Nantes, 1990, ill. color p. 45.
Literature: Alistair Hicks, "Galleries, Turner Prize/Tate," *The Times* (London), November 11, 1985: "*A Small Thing But My Own* mocks the endless rows of standard-size canvases that roll out of modern art factories. Hodgkin has challenged the orthodoxy of museum art. He varies the size and the materials for each subject-matter. He does not want the viewer to walk past lines of canvases enclosed by frames and hung up on the wall. He wants every works to stand out on its own. He paints the frames in order to break

down the barrier between the viewer and the picture. One wants to touch *A Small Thing But My Own* because it has become an object."; Gregory Galligan, "A Small Thing But Painting: The New Work of Howard Hodgkin," *Arts Magazine* 61, September 1986, pp. 65–67, ill. color p. 66; Graham-Dixon, 1994, ill. color p. 134.
Notes: Unsigned.

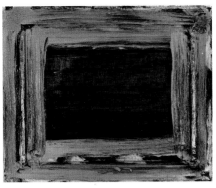

203 · VENICE EVENING
1984–85
Oil on wood
14½ x 17½ in. (37 x 44.5 cm.)
Collection: Nan and Gene Corman, Beverly Hills, California.
Provenance: (M. Knoedler and Co., Inc., New York).
Exhibitions: British Council, 1984, exhibited in London only, ill. color p. 19 in cat. supp.; *Howard Hodgkin: Recent Work*, M. Knoedler and Co., Inc., New York, May 10–June 5, 1986, ill. color p. 19; Nantes, 1990, ill. color p. 53.
Literature: Charles Harrison, "Hodgkin's Moment," *Artscribe* 55, December 1985–January 1986, pp. 62–64, ill. p. 64; Gregory Galligan, "A Small Thing But Painting: The New Work of Howard Hodgkin," *Arts Magazine* 61, September 1986, pp. 65–67; Graham-Dixon, 1994, p. 61, ill. color p. 60: "*Venice Evening* (1984–85) is a picture suspended between recollection and loss. It can be taken entirely literally, as an impressionistic rendering of meteorological fact. ... It is a picture that opens on to a void, a picture with an empty centre."

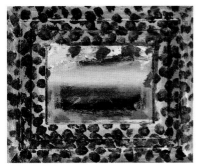

204 · VIEW FROM VENICE
1984–85
Oil on wood
15⅜ x 18½ in. (39 x 47 cm.)
Collection: Private Collection, London.
Exhibitions: British Council, 1984, exhibited in London only, ill. color p. 23 in cat. supp.; *Howard Hodgkin: Recent Work*, M. Knoedler and Co., Inc., New York, May 10–June 5, 1986, ill. color p. 23; Nantes, 1990, no. 18, ill. color p. 55; *Howard Hodgkin: Seven Small Pictures*, British School at Rome, Rome, March 31–May 1, 1992.
Literature: Graham-Dixon, 1994, ill. color p. 68; Andrew Graham-Dixon, "Remembrance of Things Past," *Independent*, July 19, 1994, p. 23, ill.

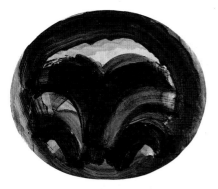

205 · BLUE PALM
1985–86
Oil on wood
11 x 13 in. (27.9 x 33 cm.)
Collection: Dr. and Mrs. John T. Chiles, Toledo, Ohio.
Provenance: (M. Knoedler and Co., Inc., New York).
Exhibitions: *Howard Hodgkin: Recent Work*, M. Knoedler and Co., Inc., New York, May 10–June 5, 1986, ill. color p. 29; Nantes, 1990, no. 24, ill. color p. 71.
Literature: Graham-Dixon, 1994, ill. color p. 157; Julian Bell, "The Great Unpretender," *Times Literary Supplement*, July 22, 1994, p. 16, ill. color.
Notes: Signed on the reverse.

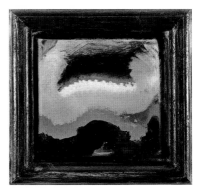

**206 · BURNING THE CANDLE AT
BOTH ENDS**
1982–86
Oil on wood
12¾ x 13½ in. (32.3 x 34 cm.)
Collection: Mary Ryan Gallery, New York.
Provenance: (M. Knoedler and Co., Inc., New York).
Exhibitions: *Howard Hodgkin: Recent Work*, M. Knoedler and Co., Inc., New York, May 10–June 5, 1986, not in cat.
Notes: Signed and dated upper left on the reverse.

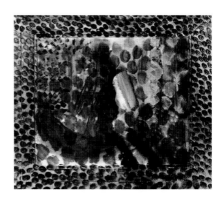

207 · HEIRLOOMS
1984–86
Oil on wood
39¾ x 46¾ in. (100 x 118.7 cm.)
Collection: Private Collection, Chicago.
Provenance: (M. Knoedler and Co., Inc., New York).
Exhibitions: *Howard Hodgkin: Recent Work*, M. Knoedler and Co., Inc., New York, May 10–June 5, 1986, not in cat.
Literature: David Sylvester, "Artist's Dialogue: Howard Hodgkin—The Texture of a Dream," *Architectural Digest* 44, March 1987, pp. 54, 62, 66, 70, 74, ill. color p. 62.

208 · IN A CROWDED ROOM
1981–86
Oil on wood
45⅜ x 47½ in. (115.3 x 120.7 cm.)
Collection: The Saint Louis Art Museum. Funds given by the Shoenberg Foundation, Inc.
Provenance: (M. Knoedler and Co., Inc., New York).
Exhibitions: *Howard Hodgkin: Recent Work*, M. Knoedler and Co., Inc., New York, May 10–June 5, 1986, ill. color p. 33.
Literature: *The Saint Louis Art Museum Annual Report 1986*, p. 36, ill. p. 4; Susan Gill, "Howard Hodgkin: Knoedler," *ARTnews* 85, September 1986, pp. 115, 119, ill. p. 116: "This picture is quintessential Hodgkin, based on figures in an interior and worked on over an extended period, five years in this instance."; Lynne Cooke, "Special Report: British Art in the Eighties," *Journal of Art* 2, November 1989, pp. 24–26, ill. p. 24; John Russell, "A Hodgkin Original," *The New York Times Magazine*, November 11, 1990; Graham-Dixon, 1994, ill. color p. 33.

209 · IN A HOTEL BEDROOM
1985–86
Oil on wood
28⅜ x 29⅜ in. (72 x 74.6 cm.)
Collection: Katherine and Keith Sachs, Philadelphia.
Provenance: (M. Knoedler and Co., Inc., New York).
Exhibitions: *Studies of the Nude*, Marlborough Fine Art Ltd, London, March–May 1986; *Howard Hodgkin: Recent Work*, M. Knoedler and Co., Inc., New York, May 10–June 5, 1986, ill. color.

210 · IN CENTRAL PARK
1983–86
Oil on wood
19 x 25 in. (48.3 x 63.5 cm.)
Collection: Mr. Howard Weingrow.
Provenance: (M. Knoedler and Co., Inc., New York).
Exhibitions: *Howard Hodgkin: Recent Work*, M. Knoedler and Co., Inc., New York, May 10–June 5, 1986, ill. color p. 27; Nantes, 1990, no. 17, ill. color p. 51.
Literature: Gregory Galligan, "A Small Thing But Painting: The New Work of Howard Hodgkin," *Arts Magazine* 61, September 1986, pp. 65–67; Graham-Dixon, 1994, ill. color p. 108.

211 · IN THE GREEN ROOM
1984–86
Oil on wood
69 x 75 in. (175.3 x 190.5 cm.)
Collection: Private Collection, Mexico.
Provenance: (M. Knoedler and Co., Inc., New York).
Exhibitions: *British Art in the 20th Century: The Modern Movement*, Royal Academy of Arts, London, January 15–April 5, 1987, no. 289, ill. color p. 385.
Literature: Norman Rosenthal, "Three Painters of this Time: Hodgkin, Kitaj and Morley," in *British Art in the 20th Century: The Modern Movement*, London: Royal Academy of Arts, 1987, p. 382: "The surface of *In the Green Room* ... seems to break out in large, freely applied brushmarks of scintillating orange paint and due to their joyful intensity, the resulting surface gives an impression of freedom. Yet Hodgkin has worked on the

picture for at least three years, adjusting the relationship of one section to another. The effect of spontaneity is achieved by controlled and painstaking effort which finally results in a composition which combines logic and sensuality in a unique way."; Asmund Thorkildsen, "En Samtale med Howard Hodgkin," *Kunst og Kultur* 4, Oslo: University Press, National Gallery, April 1987, pp. 220–34.

212 · SMALL VIEW IN VENICE
1984–86
Oil on wood
17 x 18 in. (43.2 x 45.7 cm.)
Collection: Private Collection.
Provenance: (M. Knoedler and Co., Inc., New York); sold Sotheby's, London, December 2, 1993, lot 44.
Exhibitions: *Howard Hodgkin: Recent Work*, M. Knoedler and Co., Inc., New York, May 10–June 5, 1986, ill. color p. 25; Nantes, 1990, ill. color p. 57.
Literature: Andrew Graham-Dixon, "On the Edge," *Independent*, April 5, 1988, p. 13, ill.: "Without the frame, that particular central image would be vulnerable in all kinds of ways. One of the reasons I use frames in the way that I do—and I think it goes back to Romantic artists like Turner, who deliberately chose very sturdy, thick frames for some of his smallest, most evanescent pictures—has to do with my instinct that the more tenuous or fleeting the emotion you want to present the more it's got to be protected from the world." (Howard Hodgkin quoted); Graham-Dixon, 1994, ill. color p. 45; Marco Livingstone, "Howard's Way," *Vogue* (UK), July 1994, p. 26, ill. color [reviewing Graham-Dixon, 1994]: "Other, equally fanciful, interpretations appear to be at odds with the title, as in his description of *Small View in Venice*, to my eyes a fairly direct rendering of a heavy, moist atmosphere at sunset, as 'so overt a code for flesh that looking at it feels like walking in on someone in the nude.'"
Notes: Signed on the reverse.

213 · AUTUMN LAKE
1984–87
Oil on wood
13¾ x 18 in. (35 x 45.7 cm.)
Collection: L'Amministrazione Provinciale di Messina, Italy.
Provenance: (Salvatore Ala Gallery, Inc., New York).
Exhibitions: *Howard Hodgkin: New Paintings*, Waddington Galleries, London, August 24–September 17, 1988, and M. Knoedler and Co., Inc., New York, October 8–November 3, 1988, ill. color p. 9; Nantes, 1990, no. 22, ill. color p. 65.
Literature: Alistair Hicks, "Beneath the Surface. Howard Hodgkin: Waddington Galleries," *The Times* (London), September 6, 1988, p. 16; Marina Vaizey, "British Shows of Strength," *Sunday Times*, September 11, 1988, C11, ill.; John Russell, "The Poetic Renderings of Howard Hodgkin," *The New York Times*, October 14, 1988, C24: "As for *Autumn Lake*, which has been bought by a museum in Sicily, it shows the aesthetic potential of the beat-up old wooden frame at its maximum. Those yellow pawmarks on an underlying field of pale green lead us into the main image as surely as if the artist had put his hand on our shoulder and were pushing us gently in the right direction."; Brooks Adams, "Howard Hodgkin at Knoedler," *Art in America* 77, January 1989, pp. 143–44; Christopher Andreae, "Each Hodgkin Painting Holds Layers of Pondering," *The Christian Science Monitor* 81, April 13, 1989, pp. 10–11, ill. color p. 10; Alistair Hicks, "Howard Hodgkin—The Artist as Collector," *Antique*, Summer 1989, pp. 21–24, ill. color p. 22.

214 · PORTRAIT OF THE ARTIST
1984–87
Oil on wood
30¾ x 35¾ in. (78.1 x 90.8 cm.)
Collection: Holly Hunt, Chicago.
Exhibitions: *State of the Art*, ICA, London, January 14–March 1, 1987; Laing Art Gallery, Newcastle-upon-Tyne, March 13–April 26, 1987; Harris Museum and Art Gallery, Preston, May 9–June 21, 1987; Cartwright Hall, Bradford, June 27–August 23, 1987.

215 · THE SPECTATOR
1984–87
Oil on wood
45 x 49½ in. (114.3 x 125.7 cm.)
Collection: Private Collection, London.
Provenance: The artist; sold Sotheby's, London, July 1, 1987, lot 739, ill. color p. 27 and on cover.
Literature: Asmund Thorkildsen, "En Samtale med Howard Hodgkin," *Kunst og Kultur* 4, Oslo: University Press, National Gallery, April 1987, pp. 220–34; Colin Gleadell, "The Art Market, Auction Trends in the Eighties," *Art International* 9, Winter 1989, pp. 72–75, ill.; Graham-Dixon, 1994, p. 30, ill. color p. 31: "Announces the absolute disengagement of art from attempted likeness. It is a self-portrait conceived as an index of the kinds of marks that the artist uses to paint his world rather than a picture of what he himself looks like."
Notes: Formerly titled *Portrait of the Artist*. Signed on the reverse.

216 · VENETIAN GLASS
1984–87
Oil on wood
13½ x 16¾ in. (34.3 x 42.5 cm.)
Collection: Private Collection, Davos, Switzerland.
Provenance: (M. Knoedler and Co., Inc., New York); (Waddington Galleries, London); sold Sotheby's, New York, November 9, 1989, lot 233.
Exhibitions: *Howard Hodgkin: New Paintings*, Waddington Galleries, London, August 24–September 17, 1988, and M. Knoedler and Co., Inc., New York, October 8–November 3, 1988, ill. color p. 5; Nantes, 1990, ill. color p. 59.
Literature: *Encounter* (London) 69, December 1987, ill. color cover; David Sylvester, "Colour Dialogue," *Vogue* (UK), January 1988, ill. color p. 125; Graham-Dixon, 1994, p. 89, ill. color p. 86: "One of Hodgkin's tiniest pictures, and one of his most apparently literal. It looks like ... what its title suggests: a tiny piece of glass, housed in a dense frame of painted blue. The brilliancy of its colours ... makes this a painting that seems to aspire to the condition of stained glass."
Notes: Signed twice, titled and dated 1984–87 on the reverse.

217 · VENICE LAGOON
1984–87
Oil on wood
17¾ x 22 in. (45.1 x 55.9 cm.)
Collection: Private Collection, London.
Provenance: (M. Knoedler and Co., Inc., New York and Waddington Galleries, London); Private Collection.
Exhibitions: *Howard Hodgkin: New Paintings*, Waddington Galleries, London, August 24–

September 17, 1988, and M. Knoedler and Co., Inc., New York, October 8–November 3, 1988, ill. color p. 7; Nantes, 1990, no. 21, ill. color p. 63.

218 · VENICE RAIN
1984–87
Oil on wood
23 x 23 in. (58.4 x 58.4 cm.)
Collection: Unknown.
Provenance: (M. Knoedler and Co., Inc., New York, 1988); Private Collection, Los Angeles; (Adelson Galleries, New York).
Exhibitions: *The British Picture*, L.A. Louver Gallery, Venice, California, February 5–March 5, 1988; *The World of Art Today 1988*, Milwaukee Art Museum, May 6–August 28, 1988, no. 25; *Howard Hodgkin: New Paintings*, Waddington Galleries, London, August 24–September 17, 1988, and M. Knoedler and Co., Inc., New York, October 8–November 3, 1988, ill. color p. 21; Nantes, 1990, no. 20, ill. color p. 61; *The Poetic Trace. Aspects of British Abstraction Since 1945*, Adelson Galleries, Inc., New York, May 12–June 30, 1992, no. 17.
Literature: William Feaver, "Whoosh in Venice," *Observer*, April 9, 1988, p. 38; Andrew Graham-Dixon, "Drawing on Life," *Independent*, September 6, 1988, p. 16; Timothy Hyman, "Making a Riddle Out of the Solution," in *Howard Hodgkin: Small Paintings 1975–1989*, London: The British Council, 1990, p. 12, ill. color p. 61; Richard Dorment, "Howard's Way," *Telegraph Weekend Magazine*, November 24, 1990, pp. 50–55, ill.

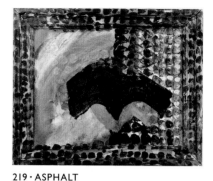

219 · ASPHALT
1985–88
Oil on wood
27⅛ x 33⅛ in. (69 x 84 cm.)
Collection: Private Collection, New York.
Provenance: (M. Knoedler and Co., Inc., New York); Douglas Feurring, Florida.
Exhibitions: *Howard Hodgkin: New Paintings*, Waddington Galleries, London, August 24–September 17, 1988, and M. Knoedler and Co., Inc., New York, October 8–November 3, 1988, ill. color p. 31.
Literature: Brooks Adams, "Howard Hodgkin at Knoedler," *Art in America* 77, January 1989, pp. 143–44.

220 · DINNER IN PALAZZO ALBRIZZI
1984–88
Oil on wood
46¼ x 46¼ in. (117.5 x 117.5 cm.)
Collection: Modern Art Museum of Fort Worth, Texas.
Provenance: (M. Knoedler and Co., Inc., New York).
Exhibitions: *Howard Hodgkin: New Paintings*, Waddington Galleries, London, August 24–September 17, 1988, and M. Knoedler and Co., Inc., New York, October 8–November 3, 1988, ill. color p. 11.
Literature: William Feaver, "Whoosh in Venice," *Observer*, April 9, 1988, p. 38; Alistair Hicks, "Beneath the Surface. Howard Hodgkin: Waddington Galleries," *The Times* (London), September 6, 1988, p. 16; Peter Fuller, "Howard

Hodgkin and Robert Natkin," *Modern Painters* 1, Autumn 1988, pp. 76–77, ill. color; Brooks Adams, "Howard Hodgkin at Knoedler," *Art in America* 77, January 1989, pp. 143–44; Peggy Cyphers, "New York in Review: Howard Hodgkin," *Arts Magazine* 65, January 1989, ill. p. 106; Christopher Andreae, "Each Hodgkin Painting Holds Layers of Pondering," *The Christian Science Monitor* 81, April 13, 1989, pp. 10–11, ill. color; Robert Hughes, "Aftershock of the New," *Observer Magazine*, August 25, 1991, pp. 22–25, ill. color p. 25; Graham-Dixon, 1994, ill. color p. 164; A. S. Byatt, "The Colour of Feeling," *Independent Sunday Review*, July 10, 1994, pp. 30–31, ill. color.
Notes: This painting was exhibited in its first state at Waddington Galleries, London, and then later in its second state at M. Knoedler and Co., Inc., New York.

221 · DOWN IN THE VALLEY
1985–88
Oil on wood
29 x 36 in. (73.7 x 91.5 cm.)
Collection: Bruce and Judith Eissner, Massachusetts.
Provenance: (M. Knoedler and Co., Inc., New York).
Exhibitions: *Howard Hodgkin: New Paintings*, Waddington Galleries, London, August 24–September 17, 1988, and M. Knoedler and Co., Inc., New York, October 8–November 3, 1988, ill. color p. 25.
Literature: William Feaver, "Whoosh in Venice," *Observer*, April 9, 1988, p. 38; Alistair Hicks, "Beneath the Surface. Howard Hodgkin: Waddington Galleries," *The Times* (London), September 6, 1988, p. 16; Peter Fuller, "Howard Hodgkin and Robert Natkin," *Modern Painters* 1, Autumn 1988, pp. 76–77; John Russell, "The Poetic Renderings of Howard Hodgkin," *The New York Times*, October 14, 1988, C24; Brooks Adams, "Howard Hodgkin at Knoedler," *Art in America* 77, January 1989, pp. 143–44; Christopher Andreae, "Each Hodgkin Painting Holds Layers of Pondering," *The Christian Science Monitor* 81, April 13, 1989, pp. 10–11,

ill. color p. 10; Graham-Dixon, 1994, ill. color p. 156; Andrew Graham-Dixon, "The Way It Was," *World of Interiors* 14, July 1994, pp. 86–89, ill. color.

222 · HAVEN'T WE MET?
1985–88
Oil on wood
19¼ x 25¼ in. (48.9 x 64.2 cm.)
Collection: Saatchi Collection, London.
Provenance: (M. Knoedler and Co., Inc., New York).
Exhibitions: *Howard Hodgkin: New Paintings*, Waddington Galleries, London, August 24–September 17, 1988, and M. Knoedler and Co., Inc., New York, October 8–November 3, 1988, ill. color p. 23; Nantes, 1990, ill. color p. 73.
Literature: William Feaver, "Whoosh in Venice," *Observer*, April 9, 1988, p. 38; Andrew Graham-Dixon, "Drawing on Life," *Independent*, September 6, 1988, p. 16: "*Haven't We Met* is a masterpiece of obfuscation, featuring the rendezvous of, respectively, a column and a cloud of variegated greens, and a free-floating lozenge of black. Hodgkin's art specialises in such encounters—enigmatic abuttals, thronging with shapes that tempt but don't permit identification."; Alistair Hicks, "Beneath the Surface. Howard Hodgkin: Waddington Galleries," *The Times* (London), September 6, 1988, p. 16; Alistair Hicks, *New British Art in the Saatchi Collection*, London: Thames and Hudson Ltd, 1989, no. 39, ill. color p. 54; Richard Dorment, "Howard's Way," *Telegraph Weekend Magazine*, November 24, 1990, pp. 50–55, ill. color pp. 52–53; Graham-Dixon, 1994, ill. color p. 165; Andrew Graham-Dixon, "The Way It Was," *World of Interiors* 14, July 1994, pp. 86–89, ill. color p. 86.

223 · HOUSE NEAR VENICE
1984–88
Oil on wood
20 x 22⅛ in. (50.8 x 56.2 cm.)
Collection: Private Collection.
Provenance: (M. Knoedler and Co., Inc., New York).
Exhibitions: *Howard Hodgkin: New Paintings*, Waddington Galleries, London, August 24–September 17, 1988, and M. Knoedler and Co., Inc., New York, October 8–November 3, 1988, ill. color p. 17; Nantes, 1990, ill. color p. 69.
Literature: Graham-Dixon, 1994, pp. 62–69, ill. color p. 63: "*House Near Venice* (1984–88), which is faintly reminiscent of Girtin's famous watercolour, *The White House*, is a painting of a building and its reflection in water. That is to see it literally, but it is also an image that tries to picture a state of mind. It is a painting of something looming out of obscurity, emerging from the loose fluid veils and stains of paint that are so often Hodgkin's shorthand for weather, in his Venetian paintings and elsewhere."

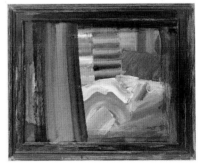

224 · IN BED IN VENICE
1984–88
Oil on wood
38⅝ x 46⅞ in. (98.2 x 119.1 cm.)
Collection: Paine Webber Group, Inc., New York.
Provenance: (M. Knoedler and Co., Inc., New York).
Exhibitions: *Howard Hodgkin: New Paintings*, Waddington Galleries, London, August 24–September 17, 1988, and M. Knoedler and

Co., Inc., New York, October 8–November 3, 1988, ill. color p. 13.

Literature: David Sexton, "Howard's Way Back," *Sunday Telegraph Magazine*, August 21, 1988, p. 65, ill. color; Richard Dorment, "Drawn Towards the Light," *Daily Telegraph*, August 26, 1988, p. 12, ill.; Tim Hilton, "Beyond the Boundary," *Guardian*, August 31, 1988, p. 17: "*In Bed in Venice*, however, seems to be in homage of classic Venetian painting."; Andrew Graham-Dixon, "Drawing on Life," *Independent*, September 6, 1988, p. 16: "Some are easier to read than others. *In Bed in Venice* clearly features a reclining figure, rendered in a few arcs of glowing red and yellow, and the painting's space, equally clearly, suggests an interior, its most noticeable features a divan and a theatrical swathe of curtain drawn over part of the righthand edge. If this *is* Hodgkin's memory of a scene from his past, it has been filtered through the painter's formidable knowledge of art history, with its ... references to the nude tradition, to the art of Titian or Delacroix."; Alistair Hicks, "Beneath the Surface. Howard Hodgkin: Waddington Galleries," *The Times* (London), September 6, 1988, p. 16; Michael Shepherd, "Hodgkin's Venetian Hours," *Sunday Telegraph*, September 11, 1988, p.19; Brooks Adams, "Howard Hodgkin at Knoedler," *Art in America* 77, January 1989, pp. 143–44, ill. color.

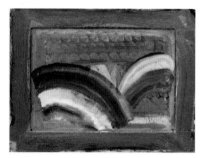

225 · LEAVES
1987–88
Oil on wood
19³⁄₄ x 25³⁄₄ in. (50.2 x 65.4 cm.)
Collection: Private Collection, Connecticut.
Provenance: (M. Knoedler and Co., Inc., New York).
Exhibitions: *Howard Hodgkin: New Paintings*, Waddington Galleries, London, August 24–September 17, 1988, and M. Knoedler and Co., Inc., New York, October 8–November 3, 1988, ill. color p. 27; Nantes, 1990, no. 25, ill. color p. 75.
Literature: Michael Archer, "Howard Hodgkin," *Art Monthly* 120, October 1988, pp. 16–17, ill.; Graham-Dixon, 1994, ill. color p. 160.

226 · LOVE LETTER
1984–88
Oil on wood
20¹⁄₄ x 24¹⁄₂ in. oval (51.5 x 62.2 cm.)
Collection: Private Collection, New York.
Provenance: (M. Knoedler and Co., Inc., New York).
Exhibitions: *Howard Hodgkin: New Paintings*, Waddington Galleries, London, August 24–September 17, 1988, and M. Knoedler and Co., Inc., New York, October 8–November 3, 1988, ill. color p. 15.
Literature: Andrew Graham-Dixon, "Drawing on Life," *Independent*, September 6, 1988; Alistair Hicks, "Beneath the Surface. Howard Hodgkin: Waddington Galleries," *The Times* (London), September 6, 1988, p. 16; Peter Fuller, "Howard Hodgkin and Robert Natkin," *Modern Painters* 1, Autumn 1988, pp. 76–77; Brooks Adams, "Howard Hodgkin at Knoedler," *Art in America* 77, January 1989, pp. 143–44; Peggy Cyphers, "New York in Review: Howard Hodgkin," *Arts Magazine* 65, January 1989, p. 106; Margaret Moorman, "Howard Hodgkin," *ARTnews* 88, January 1989, ill. color p. 129; Graham-Dixon, 1994, p. 40, ill. color p. 41.

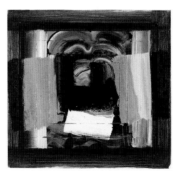

227 · ON THE RIVIERA
1987–88
Oil on wood
41¹⁄₈ x 43⁷⁄₈ in. (104.5 x 111.5 cm.)
Collection: Private Collection.
Provenance: (M. Knoedler and Co., Inc., New York); Private Collection, Connecticut.
Exhibitions: *Howard Hodgkin: New Paintings*, Waddington Galleries, London, August 24–September 17, 1988, and M. Knoedler and Co., Inc., New York, October 8–November 3, 1988, ill. color p. 29.
Literature: William Feaver, "Whoosh in Venice," *Observer*, April 9, 1988, p. 38; Giles Auty, "Howard's Way," *Spectator* 261, September 3, 1988, p. 30, ill. color; Mark Currah, "Visual Arts," *City Limits*, September 8–15, 1988, p. 81, ill.; Larry Berryman, "Howard Hodgkin," *Arts Review* 40, September 9, 1988, ill. p. 616; Graham-Dixon, 1994, p. 14, ill. color p. 6: "To look at a much later painting like *On the Riviera* (1987–88) is to see the same conception of what a memory is [i.e., the same conception as *Memoirs*, 1949]—something illogical, subject to the vagaries of feeling and attention—pushed as it so often is in Hodgkin's mature art to the extremes of near-illegibility. Remembered things (flags, sea and sky, perhaps the whitewashed side of a building) merge and blend, melt into each other like the elements of a collage that have been liquefied."

228 · PYRAMID
1986–88
Oil on wood
7¹⁄₂ x 9³⁄₈ in. (19 x 23.8 cm.)
Collection: Private Collection, London.

229 · SUNDAY IN BERLIN
1987–88
Oil on wood
37¹⁄₂ x 70¹⁄₂ in. (95.5 x 179 cm.)
Collection: Private Collection.
Provenance: (M. Knoedler and Co., Inc., New York).
Exhibitions: *Howard Hodgkin: New Paintings*, Waddington Galleries, London, August 24–September 17, 1988, and M. Knoedler and Co., Inc., New York, October 8–November 3, 1988,

ill. color pp. 32–33; *Bilderstreit: Widerspruch, Einheit und Fragment in der Kunst seit 1960*, Museum Ludwig, Cologne, 1989, no. 265, p. 515; *The British Imagination: Twentieth-Century Paintings, Sculpture and Drawings*, Hirschl & Adler Galleries, New York, November 1990–January 12, 1991, cat. no. 66, ill. color p. 131.
Literature: Brooks Adams, "Howard Hodgkin at Knoedler," *Art in America* 77, January 1989, pp. 143–44.

230 · VENICE/SHADOWS
1984–88
Oil on wood
16¼ x 18¼ in. (41.3 x 46.4 cm.)
Collection: Collection Laura and Barry Townsley, London.
Provenance: (M. Knoedler and Co., Inc., New York, and Waddington Galleries, London).
Exhibitions: *Howard Hodgkin: New Paintings*, Waddington Galleries, London, August 24–September 17, 1988, and M. Knoedler and Co., Inc., New York, October 8–November 3, 1988, ill. color p. 19; Nantes, 1990, no. 23, ill. color.
Literature: William Feaver, "Whoosh in Venice," *Observer*, April 9, 1988, p. 38; William Feaver, "Hodgkin's Venice: The Greedy Eye Attracted," *World of Interiors*, September 1988, p. 173, ill. color; Tom Lubbock, "Viewer Virtuosity and Red Herrings," *Independent on Sunday*, December 16, 1990, p. 19, ill. color; Graham-Dixon, 1994, ill. color p. 64.

231 · FIRE IN VENICE
1986–89
Oil on wood
19 x 22⅛ in. (49 x 56.5 cm.)
Collection: Ron and Ann Pizzuti.
Provenance: (M. Knoedler and Co., Inc., New York).
Exhibitions: *Howard Hodgkin: Recent Paintings*, Michael Werner Gallery, Cologne, September 18–October 15, 1990, and M. Knoedler and Co., Inc., New York, November 6–December 1, 1990, no. 4, ill. color.
Literature: Andreas Beyer, "An Interview with Howard Hodgkin," *Kunstforum* 110, November–December 1990, pp. 210–22, ill.; Raimund Stecker, "Venesianische Emotionen—Howard Hodgkin, ein nicht nur englischer Maler," *Kunst-Bulletin*, January 1992, pp. 19–25, ill. color p. 20; Zoe Heller, "Howard's Way," *Harpers and Queen*, April 1992, pp. 152–56, ill. color p. 155; Graham-Dixon, 1994, ill. color.

232 · FRUIT
1988–89
Oil on wood
13 x 16 in. (32.5 x 40.5 cm.)
Collection: Mary Tyler Moore and Dr. S. Robert Levin.
Provenance: (M. Knoedler and Co., Inc., New York).
Exhibitions: *Howard Hodgkin: Recent Paintings*, Michael Werner Gallery, Cologne, September 18–October 15, 1990, and M. Knoedler and Co., Inc., New York, November 6–December 1, 1990, no. 9, ill. color.
Literature: Andreas Beyer, "An Interview with

Howard Hodgkin," *Kunstforum* 110, November–December 1990, pp. 210–22, ill. p. 216; Andreas Beyer, "Howard Hodgkin, Galerie Michael Werner, Koln," *Artis, Zeitschrift für neue Kunst* 42, December 1990–January 1991, pp. 70–71, ill. color p. 70; Graham-Dixon, 1994, ill. color p. 96.

233 · INDIAN SKY
1988–89
Oil on wood
21⅜ x 27¾ in. (54.1 x 70.2 cm.)
Collection: Private Collection, New York.
Exhibitions: *Glasgow's Great British Art Exhibition*, Glasgow Museums and Art Galleries, March 27–May 9, 1990, p. 76, as *Sky*; *Howard Hodgkin: Recent Paintings*, Michael Werner Gallery, Cologne, September 18–October 15, 1990, and M. Knoedler and Co., Inc., New York, November 6–December 1, 1990, no. 8, ill. color.
Literature: "Galeries: Hodgkin en couleurs," *Connaissance des arts* 465, November 1990, p. 28, ill. color; Andreas Beyer, "An Interview with Howard Hodgkin," *Kunstforum* 110, November–December 1990, pp. 210–22, ill. p. 213; William Crozier, "Howard Hodgkin: The Artist's Eye," *Modern Painters* 3, Winter 1990–91, pp. 16–21; Graham-Dixon, 1994, ill. color p. 145.

234 · OLD MONEY
1987–89
Oil on wood
39½ x 53⅛ in. (100.5 x 135 cm.)
Collection: Mr. and Mrs. Robert Meyerhoff, Maryland.
Provenance: (M. Knoedler and Co., Inc., New York).

235 · ON THE EDGE OF THE OCEAN
1986–89
Oil on wood
29⅞ x 36⅞ in. (76 x 93.5 cm.)
Collection: Steve Mazoh, New York.
Exhibitions: *Howard Hodgkin: Recent Paintings*,
Michael Werner Gallery, Cologne, September
18–October 15, 1990, and M. Knoedler and Co.,
Inc., New York, November 6–December 1, 1990,
no. 6, ill. color.
Literature: Andreas Beyer, "An Interview
with Howard Hodgkin," *Kunstforum* 110,
November–December 1990, pp. 210–22, ill. p.
212; William Crozier, "Howard Hodgkin: The
Artist's Eye," *Modern Painters* 3, Winter 1990–91,
pp. 16–21, ill. color p. 21; Frances Spalding,
"An Interview with Howard Hodgkin," *The
Charleston Magazine* 6, Winter–Spring 1992–93,
pp. 26–33, ill. color p. 27.

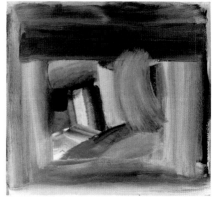

236 · RAIN
1984–89
Oil on wood
64½ x 70½ in. (163.8 x 179 cm.)
Collection: Tate Gallery, London.
Exhibitions: *Glasgow's Great British Art
Exhibition*, Glasgow Museums and Art Galleries,
March 27–May 9, 1990, ill. pp. 76–77 (printed
upside down); *Howard Hodgkin: Recent
Paintings*, Michael Werner Gallery, Cologne,
September 18–October 15, 1990, and M.
Knoedler and Co., Inc., New York, November
6–December 1, 1990, no. 3, ill. color.
Literature: Andrew Graham-Dixon, "Velazquez:
the Greatest Living Artist," *Vogue* (UK), March

1990, pp. 314–18, 368, ill. color p. 317; Andreas
Beyer, "An Interview with Howard Hodgkin,"
Kunstforum 110, November–December 1990,
pp. 210–22, ill. p. 219; William Crozier, "Howard
Hodgkin: The Artist's Eye," *Modern Painters*
3, Winter 1990–91, pp. 16–21; Andrew Graham-
Dixon, "Heavy Rain," *Independent Magazine*,
February 16, 1991, pp. 36–37, ill. color; Raimund
Stecker, "Venesianische Emotionen—Howard
Hodgkin, ein nicht nur englischer Maler,"
Kunst-Bulletin, January 1992, pp. 19–25, ill.
color p. 25 (printed upside down); Graham-
Dixon, 1994, p. 94, ill. color p. 95 (detail),
p. 139: "*Rain* (1984–89) is one of Hodgkin's
largest paintings. But it does not look large. It
possesses the brilliant density of a miniature.
It is a painter's response to a self-imposed
challenge: how to invest a painting of an
utterly inconsequential event (it is always raining,
somewhere) with a charge of remembered feeling
that will raise it above the mundanity of its subject
matter; how, in short, to turn raw experience
into art."

237 · STILL LIFE
1987–89
Oil on wood
14¾ x 14⅞ in. (37 x 38 cm.)
Collection: The artist (Courtesy Anthony d'Offay
Gallery, London).
Exhibitions: *Howard Hodgkin: Recent Paintings*,
Michael Werner Gallery, Cologne, September 18–
October 15, 1990, and M. Knoedler and Co., Inc.,
New York, November 6–December 1, 1990, no.
7, ill. color.
Literature: Andreas Beyer, "An Interview with
Howard Hodgkin," *Kunstforum* 110, November–
December 1990, pp. 210–22, ill. p. 215; "Art For
Sale," [a review of the London art market]
Guardian, July 1992, ill. color on cover and cat.
no. 5, p. 8.

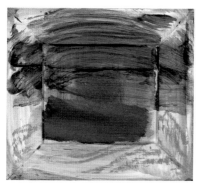

238 · VENICE GREY WATER
1988–89
Oil on wood
26 x 29½ in. (66 x 75 cm.)
Collection: Private Collection, London.
Exhibitions: Nantes, 1990, no. 26, ill. color
p. 77; *Howard Hodgkin: Seven Small Pictures*,
British School at Rome, Rome, March 31–May 1,
1992; *Paintmarks*, Kettle's Yard, University of
Cambridge, July 17–September 4, 1994, and tour.
Literature: Graham-Dixon, 1994, ill. color p. 66.

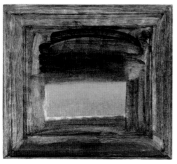

239 · VENICE IN THE AUTUMN
1986–89
Oil on wood
19⅛ x 21¾ in. (48.5 x 55.5 cm.)
Collection: Unknown.
Exhibitions: *Howard Hodgkin: Recent Paintings*,
Michael Werner Gallery, Cologne, September
18–October 15, 1990, and M. Knoedler and Co.,
Inc., New York, November 6–December 1, 1990,
no. 5, ill. color.
Literature: Andreas Beyer, "An Interview with
Howard Hodgkin," *Kunstforum* 110, November–
December 1990, pp. 210–22, ill. p. 214; Ian
Brunskill, "Hodgkin Steps Out," *Artscribe
International* 84, November–December 1990,
pp. 14–15, ill. p. 15; Robert C. Morgan, "Howard
Hodgkin," *Arts Magazine* 65, February 1991,
p. 78, ill. color; Raimund Stecker, "Venesianische
Emotionen—Howard Hodgkin, ein nicht nur
englischer Maler," *Kunst-Bulletin*, January 1992,
pp. 19–25, ill. color p. 24.

240 · VENICE SUNSET
1989
Oil on wood
10¼ x 11⅞ in. (26 x 30 cm.)
Collection: Private Collection, England.
Provenance: (Anthony d'Offay Gallery, London).
Exhibitions: Nantes, 1990, no. 27, ill. color p. 79; *Howard Hodgkin: Seven Small Pictures*, British School at Rome, Rome, March 31–May 1, 1992; *Howard Hodgkin*, Anthony d'Offay Gallery, London, October 19–November 24, 1993, and M. Knoedler and Co., Inc., New York, December 4, 1993–January 15, 1994, ill. color p. 15.
Literature: Marina Vaizey, "Flying International Colours," *Sunday Times*, December 16, 1990, sec. 5, p. 8, ill. color; William Crozier, "Howard Hodgkin: The Artist's Eye," *Modern Painters* 3, Winter 1990–91, pp. 16–21, ill. color p. 17, identified as *Sunset in Venice*; Zoe Heller, "Howard's Way," *Harpers and Queen*, April 1992, pp. 152–56, ill. color p. 154; Graham-Dixon, 1994, ill. color p. 67; Richard Shone, "London and New York: Howard Hodgkin," *Burlington Magazine* 136, January 1994, pp. 45–46, ill. no. 41, p. 45.

241 · DISCARDED CLOTHES
1985–90
Oil on wood
31¼ x 36¾ in. (79.5 x 93 cm.)
Collection: Susan Kasen Summer and Robert D. Summer.
Provenance: (M. Knoedler and Co., Inc., New York).
Exhibitions: *Howard Hodgkin: Recent Paintings*, Michael Werner Gallery, Cologne, September 18–October 15, 1990, and M. Knoedler and Co., Inc., New York, November 6–December 1, 1990, no. 1, ill. color.
Literature: Andreas Beyer, "An Interview with Howard Hodgkin," *Kunstforum* 110, November–December 1990, pp. 210–22, ill. p. 217; Michael Kimmelman, "Howard Hodgkin/The British Imagination: 20th-Century Paintings, Sculpture and Drawings," *The New York Times*, November 23, 1990, C4: "Of the works at Knoedler, he is at his most seductive when mixing bold bands of red, white and blue in a work like *Discarded Clothes*."; Graham-Dixon, 1994, p. 51, ill. color p. 50: "*Discarded Clothes* ... is a picture about absence, a picture that talks of the human presence that it does not contain. It consists of swathes of bright paint that have the quality of abandoned garments, haphazardly piled, left by someone who has exited from the picture. The identity of the person remains concealed. The painting is about remembering somebody in their absence, almost fetishistically, through the details of things that they have left behind, things that once touched them or were part of them. But beyond that, it is a painting about the nature of all painting (certainly all of Hodgkin's painting)."

242 · IN TANGIER
1987–90
Oil on wood
64½ x 70½ in. (163.5 x 179 cm.)
Collection: Private Collection.
Provenance: (M. Knoedler and Co., Inc., New York).
Exhibitions: *Howard Hodgkin: Recent Paintings*, Michael Werner Gallery, Cologne, September 18–October 15, 1990, and M. Knoedler and Co., Inc., New York, November 6–December 1, 1990, no. 13, ill. color.
Literature: Andreas Beyer, "An Interview with Howard Hodgkin," *Kunstforum* 110, November–December 1990; John Russell, "A Hodgkin Original," *The New York Times Magazine*, November 11, 1990: "'In Tangier' is not a homage to Matisse," he says, "though it shows the view from a hotel that he knew well. And although it was ... affected by my feeling for the friends who were sitting there with me, it does not portray them"; Richard Cork, "Painting to Ease the Passing of Time," *Times Saturday Review*, December 1, 1990; William Crozier, "Howard Hodgkin: The Artist's Eye," *Modern Painters* 3, Winter 1990–91; Raimund Stecker, "Venesianische Emotionen—Howard Hodgkin, ein nicht nur englischer Maler," *Kunst-Bulletin*, January 1992; Graham-Dixon, 1994, ill. color p. 105; A. S. Byatt, "The Colour of Feeling," *Independent on Sunday*, July 10, 1994.

243 · IN THE BLACK KITCHEN
1984–90
Oil on wood
27½ x 41 in. (70 x 104 cm.)
Collection: Private Collection, Connecticut.
Provenance: (M. Knoedler and Co., Inc., New York).
Exhibitions: *Howard Hodgkin: Recent Paintings*, Michael Werner Gallery, Cologne, September 18–October 15, 1990, and M. Knoedler and Co., Inc., New York, November 6–December 1, 1990, no. 2, ill. color.
Literature: Alexandra Enders, "At Home and Abroad," *Art & Antiques* 7, November 1990, p. 39, ill. color: "Sprang from a friend's (all-black) kitchen in New York he once visited."; John Russell, "A Hodgkin Original," *The New York Times Magazine*, November 11, 1990, sec. 6, pp. 56–60, 62, ill. color p. 59: "There are people in the kitchen, and they gave me the motivation for the picture, but they are no longer visible. The kitchen in question is in New York, and it's a wonderfully warm room, with a lot of glossy black in it, and the emotional charge in the picture comes above all from the people who were there. But you don't see them."; Robert G. Edelman, "Howard Hodgkin," *ARTnews* 90, February 1991, p. 134, ill.

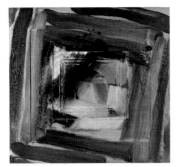

244 · IT CAN'T BE TRUE
1987–90
Oil on wood
30¼ x 28 in. (76.5 x 71 cm.)
Collection: Blackburn Collection, London.
Exhibitions: *Howard Hodgkin: Recent Paintings*,
Michael Werner Gallery, Cologne, September
18–October 15, 1990, and M. Knoedler and Co.,
Inc., New York, November 6–December 1, 1990,
no. 12, ill. color.
Literature: Andreas Beyer, "An Interview with
Howard Hodgkin," *Kunstforum* 110, November–
December 1990, pp. 210–22, ill. p. 220; Olivier
Revault D'Allonnes, "The Dreaming Hand,"
Tema Celeste, January–March 1992, no. 34, p. 86,
ill. color; Graham-Dixon, 1994, p. 158, ill. color
p. 159: "A picture that contains a picture that
contains a picture. Here, the characteristic device
of framing one image within another has been
taken to an extreme, so the painting actually
frames itself three times—but it is also, at the
same time, unframed, since the frame that
defines the outer edge of the painting has itself
been painted upon and so cannot really be
counted part of the frame. ... The painting has
the character of a puzzle or paradox. It reverses
conventional perspective, which normally leads
the eye *into* space. ... But what this picture
houses, at its centre, is a flat and resistant patch
of blankness eaten into but unrelieved by strokes
of bright colour ... a place that offers nothing to
look at and returns the eye, instead, to the
periphery of the image."

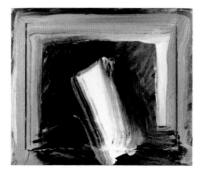

245 · LIKE AN OPEN BOOK
1989–90
Oil on wood
20½ x 24¾ in. (52 x 63 cm.)
Collection: Private Collection, England.
Exhibitions: *Howard Hodgkin*: *Recent Paintings*,
Michael Werner Gallery, Cologne, September 18–
October 15, 1990, and M. Knoedler and Co., Inc.,
New York, November 6–December 1, 1990.
Literature: William Crozier, "Howard Hodgkin:
The Artist's Eye," *Modern Painters* 3, Winter
1990–91, pp. 16–21; Andreas Beyer, "An
Interview with Howard Hodgkin," *Kunstforum*
110, November–December 1990, pp. 210–22;
Graham-Dixon, 1994, p. 146, ill. color p. 144:
"A painting scaled to the size of an open book,
something small enough to hold in the palm of
your hand."

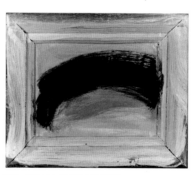

246 · SMALL INDIAN SKY
1990
Oil on wood
27 x 33 in. (68.5 x 83.8 cm.)
Collection: Private Collection, London.
Provenance: The artist.
Exhibitions: *Howard Hodgkin: Seven Small
Pictures*, British School at Rome, Rome, March
31–May 1, 1992; *Paintmarks*, Kettle's Yard,
University of Cambridge, July 17–September 4,
1994; Southampton City Art Gallery, September
29–November 6, 1994; Mead Gallery, University
of Warwick, November 12–December 10, 1994.

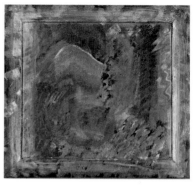

247 · SMALL RAIN
1990
Oil on wood
34 x 37½ in. (86.5 x 95 cm.)
Collection: Yoh Ikeda, Osaka, Japan.
Exhibitions: *Howard Hodgkin: Recent Paintings*,
Michael Werner Gallery, Cologne, September 18–
October 15, 1990, and M. Knoedler and Co., Inc.,
New York, November 6–December 1, 1990, no.
10, ill. color.
Literature: William Crozier, "Howard Hodgkin:
The Artist's Eye," *Modern Painters* 3, Winter
1990–91, pp. 16–21; Raimund Stecker,
"Venesianische Emotionen—Howard Hodgkin,
ein nicht nur englischer Maler," *Kunst-Bulletin*,
January 1992, pp. 19–25, ill. color p. 25.

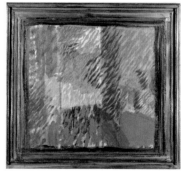

248 · A VISIT TO PAUL AND BERNARD
1990
Oil on wood
52 x 56¾ in. (132.5 x 144 cm.)
Collection: Private Collection.
Provenance: (M. Knoedler and Co., Inc.,
New York).
Exhibitions: *Howard Hodgkin: Recent Paintings*,
Michael Werner Gallery, Cologne, September 18–
October 15, 1990, and M. Knoedler and Co., Inc.,
New York, November 6–December 1, 1990, no.
14, ill. color.
Literature: Mark Stevens, "Shades of the Past,"
Vanity Fair 53, December 1990, pp. 172–73, ill.
color pp. 172–73.
Notes: The title refers to Paul Hallam and
Bernard Walsh, friends of the artist.

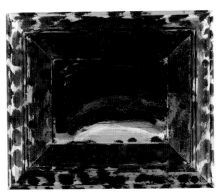

249 · HOME
1988–91
Oil on wood
14¾ x 17⅝ in. (37.5 x 45 cm.)
Collection: Private Collection, London.
Provenance: (Anthony d'Offay Gallery, London).
Exhibitions: *Howard Hodgkin: Seven Small Pictures*, British School at Rome, Rome, March 31–May 1, 1992; *Howard Hodgkin*, Anthony d'Offay Gallery, London, October 19–November 24, 1993, and M. Knoedler and Co., Inc., New York, December 4, 1993–January 15, 1994, ill. color p. 19.
Literature: Graham-Dixon, 1994, ill. color p. 44.

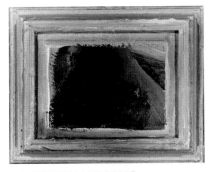

250 · ITALIAN LANDSCAPE
1990–91
Oil on wood
14½ x 18½ in. (36.8 x 46.8 cm.)
Collection: Robert R. Littman and Sully Bonnelly, New York.
Provenance: (Anthony d'Offay Gallery, London, and M. Knoedler and Co., Inc., New York).
Exhibitions: *Howard Hodgkin: Seven Small Pictures*, British School at Rome, Rome, March 31–May 1, 1992; *Howard Hodgkin*, Anthony d'Offay Gallery, London, October 19–November 24, 1993, and M. Knoedler and Co., Inc., New York, December 4, 1993–January 15, 1994, ill. color p. 27.
Literature: Graham-Dixon, 1994, ill. color p. 170.

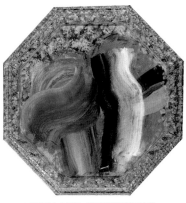

251 · KEITH AND KATHY SACHS
1988–91
Oil on wood
45¾ x 45¾ in. (116 x 116 cm.)
Collection: Katherine and Keith Sachs, Philadelphia.
Provenance: (Anthony d'Offay Gallery, London, and M. Knoedler and Co., Inc., New York).
Exhibitions: *Howard Hodgkin*, Anthony d'Offay Gallery, London, October 19–November 24, 1993, and M. Knoedler and Co., Inc., New York, December 4, 1993–January 15, 1994, ill. color p. 21.
Literature: Richard Cork, "Painting to Ease the Passing of Time," *Times Saturday Review*, December 1, 1990, pp. 16–17: "He has also been invited by Mr. and Mrs. Sachs, collectors of contemporary art in Philadelphia, to paint their portrait commemorating the anniversary of their marriage. 'It would have been impossible to do if I didn't know them,' he explains, 'so we've been meeting for several years now and the painting is almost complete. Although they have sat still for me to look at them, I wouldn't draw them from life. The picture may not look like a portrait at all by the time I've finished.'"; Graham-Dixon, 1994, ill. color frontispiece; Lilly Wei, "Howard Hodgkin's Mandarin Pastimes," *Art in America* 82, April 1994, pp. 92–97, ill. color p. 96; "Howard's Way," *Harpers and Queen*, July 1994, ill. color p. 20.
Notes: For this work, Hodgkin chose an elaborate Louis XIV frame to lend a formal quality to the portrait and to suggest the shape of a fifteenth-century Italian marriage salver.

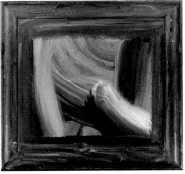

252 · THE LAST TIME I SAW PARIS
1988–91
Oil on wood
44¼ x 50 in. (113 x 127 cm.)
Collection: Private Collection.
Exhibitions: *Howard Hodgkin*, Anthony d'Offay Gallery, London, October 19–November 24, 1993, and M. Knoedler and Co., Inc., New York, December 4, 1993–January 15, 1994, ill. color p. 23.
Literature: Graham-Dixon, 1994, ill. color p. 112.

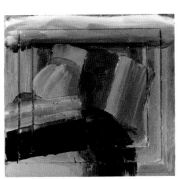

253 · READING IN BED
1990–91
Oil on wood
28½ x 31¾ in. (72.3 x 80.6 cm.)
Collection: Mr. and Mrs. Jeffrey Brotman, Medina, Washington.
Provenance: (Anthony d'Offay Gallery, London); (M. Knoedler and Co., Inc., New York).
Exhibitions: *Life into Paint: British Figurative Painting in the Twentieth Century*, Israel Museum, Jerusalem, November 10, 1992–February 9, 1993; *Howard Hodgkin*, Anthony d'Offay Gallery, London, October 19–November 24, 1993, and M. Knoedler and Co., Inc., New York, December 4, 1993–January 15, 1994, ill. color p. 24.
Literature: Edward Lucie-Smith, "In Profile: Howard Hodgkin," *Arts Review* 45, October 1993, pp. 4–6, ill. color p. 5; Richard Cork, "Painting from Memory," *The Times* (London), November 2, 1993, p. 41, ill. color: "As for *Reading in Bed*, it shows how Hodgkin regards painting as an intensely physical act. The blocks and bars of glowing colour seem to aspire to the

thickness of the panel beneath. There is a sturdiness about his work which looks built to last, countering the vagaries of memory with a fierce yet joyful affirmation that redeems the loss of the past."; Jeffrey Kastner, "Anthony d'Offay Gallery, London; exhibitions," *Flash Art* 174, January–February 1994, p. 103, ill.

Notes: In a BBC radio interview aired in London on November 27, 1994, Hodgkin described this painting as "one of my most literally representational pictures insofar as what is left in the final version."

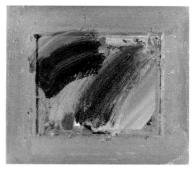

254 · AFTER THE SHOP HAD CLOSED
1992
Oil on wood
12½ x 14½ in. (31.7 x 36.8 cm.)
Collection: Private Collection, Davos, Switzerland.
Provenance: (Anthony d'Offay Gallery, London).
Exhibitions: *Howard Hodgkin*, Anthony d'Offay Gallery, London, October 19–November 24, 1993, and M. Knoedler and Co., Inc., New York, December 4, 1993–January 15, 1994, ill. color p. 41.
Literature: Tom Lubbock, "Howard Hodgkin: For Me," *Modern Painters* 6, Autumn 1993, pp. 34–37, ill. color p. 36; Graham-Dixon, 1994, ill. color p. 80.

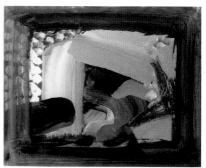

255 · AFTER VISITING DAVID HOCKNEY
1991–92
Oil on wood
19¼ x 24¼ in. (48.9 x 61.6 cm.)
Collection: Barclays Bank Collection.
Provenance: (Anthony d'Offay Gallery, London).

Exhibitions: *Howard Hodgkin*, Anthony d'Offay Gallery, London, October 19–November 24, 1993, and M. Knoedler and Co., Inc., New York, December 4, 1993–January 15, 1994, ill. color p. 37 (dimensions incorrectly given as 21¼ x 24¼ in.); *Paintmarks*, Kettle's Yard, University of Cambridge, July 17–September 4, 1994; Southampton City Art Gallery, September 29–November 6, 1994; Mead Gallery, University of Warwick, November 12–December 10, 1994.
Literature: Tom Lubbock, "Howard Hodgkin: For Me," *Modern Painters* 6, Autumn 1993, pp. 34–37, ill. color p. 36; John McEwen, "Colour Too Deep for Comfort," *Sunday Telegraph*, October 10, 1993, p. 6, ill. color; Andrew Graham-Dixon, "Truants of the Memory," *Independent Magazine*, October 16, 1993, pp. 38–43, 45, ill. color p. 1; Graham-Dixon, 1994, ill. color p. 132; Richard Shone, "London and New York: Howard Hodgkin," *Burlington Magazine* 136, January 1994, pp. 45–46, ill. no. 43, p. 46: "In the larger, more complicated *After Visiting David Hockney* (Fig. 43), with its open and closed space like stage flats, the artist's house is evoked as well as, perhaps, its Californian setting, establishing a conflict of indoor and outdoor, frankness and concealment, bravura and inhibition. My reading may be haywire, quite different from another's, let alone Hodgkin's own intention, but there is no doubting the impact—the memory of the painting itself outweighs any peckish appetite for biography."; Andrew Graham-Dixon, "The Way It Was," *World of Interiors* 14, July 1994, pp. 86–89, ill. color; A. S. Byatt, "The Colour of Feeling," *Independent on Sunday*, July 10, 1994, pp. 30–31, ill. color p. 31.

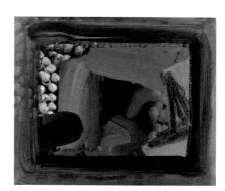

256 · AFTER VISITING DAVID HOCKNEY (SECOND VERSION)
1991–92
Oil on wood
19¼ x 24¼ in. (48.9 x 61.6 cm.)
Collection: Private Collection, London.

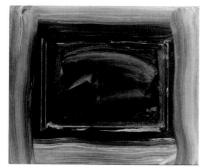

257 · IN THE BLUE ROOM
1990–92
Oil on wood
12¾ x 15½ in. (32.4 x 39.4 cm.)
Collection: Private Collection, New York.
Provenance: (Anthony d'Offay Gallery, London, and M. Knoedler and Co., Inc., New York).
Exhibitions: *Howard Hodgkin*, Anthony d'Offay Gallery, London, October 19–November 24, 1993, and M. Knoedler and Co., Inc., New York, December 4, 1993–January 15, 1994, ill. color p. 33.
Literature: Lilly Wei, "Howard Hodgkin's Mandarin Pastimes," *Art in America* 82, April 1994, pp. 92–97, ill. color p. 93.

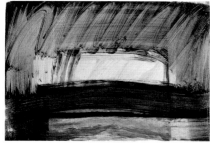

258 · KERALA
1992
Oil on wood
9¼ x 14 in. (23.5 x 35.6 cm.)
Collection: Private Collection, Singapore.
Provenance: (Anthony d'Offay Gallery, London).
Exhibitions: *Howard Hodgkin*, Anthony d'Offay Gallery, London, October 19–November 24, 1993, and M. Knoedler and Co., Inc., New York, December 4, 1993–January 15, 1994, ill. color p. 39.
Literature: Edward Lucie-Smith, "In Profile: Howard Hodgkin," *Arts Review* 45, October 1993, pp. 4–6, ill. color p. 5; Graham-Dixon, 1994, ill. color p. 113.

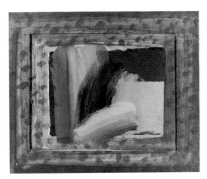

259 · A LEAP IN THE DARK
1992
Oil on wood
14 x 16⅞ in. (35.6 x 42.7 cm.)
Collection: Katherine and Keith Sachs, Philadelphia.
Provenance: (Anthony d'Offay Gallery, London).
Exhibitions: *Howard Hodgkin*, Anthony d'Offay Gallery, London, October 19–November 24, 1993, and M. Knoedler and Co., Inc., New York, December 4, 1993–January 15, 1994, ill. color p. 43.
Literature: Graham-Dixon, 1994, ill. color p. 172.

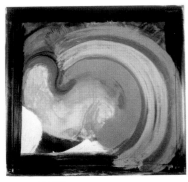

260 · LOVERS
1984–92
Oil on wood
67½ x 72⅞ in. (171.5 x 185.4 cm.)
Collection: Private Collection.
Exhibitions: *Howard Hodgkin*, Anthony d'Offay Gallery, London, October 19–November 24, 1993, and M. Knoedler and Co., Inc., New York, December 4, 1993–January 15, 1994, ill. color p. 29.
Literature: Edward Lucie-Smith, "In Profile: Howard Hodgkin," *Art Review* 45, October 1993, pp. 4–6, ill. color p. 4; Andrew Graham-Dixon, "Truants of the Memory," *Independent Magazine*, October 16, 1993, pp. 38–43, 45, ill. color pp. 38–39; James Hall, "Souvenirs of Life," *Guardian*, October 25, 1993, pp. 4, 6, ill. b/w pp. 4–5: "*Lovers* ... is one of Hodgkin's largest works, yet it still feels small and looks better shrunk in reproduction, a rainbow of green and red balloons just beyond the right edge of its painted

black frame. A tumescent orange biomorph emerges from the rainbow's centre and pushes up against the left edge of the frame. The ensemble looks like an exotic snail surmounted by a technicolour shell. The end product is both primal and banal—the most basic lesson imaginable in push and pull."; *The Art Book*, London: Phaidon Press Ltd, 1994, ill. color p. 221; Graham-Dixon, 1994, ill. color p. 48; Richard Shone, "London and New York: Howard Hodgkin," *Burlington Magazine* 136, January 1994, pp. 45–46, ill. no. 42: "In *Lovers* ... for example, a chink of intense blue acts both as pictorial oxygen—a sign of the work's making—and as an expansion of content, something hard and clear in a painting of rampant sensuality."; Lilly Wei, "Howard Hodgkin's Mandarin Pastimes," *Art in America* 82, April 1994, pp. 92–97, ill. color p. 92.

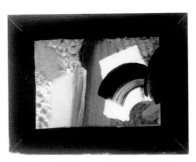

261 · PATRICK CAULFIELD IN ITALY
1987–92
Oil on wood
43½ x 57½ in. (110.5 x 146 cm.)
Collection: Private Collection, Mexico.
Provenance: (Anthony d'Offay Gallery, London, and M. Knoedler and Co., Inc., New York).
Exhibitions: *Howard Hodgkin*, Anthony d'Offay Gallery, London, October 19–November 24, 1993, and M. Knoedler and Co., Inc., New York, December 4, 1993–January 15, 1994, ill. color p. 31.
Literature: Martin Filler, "Howard Hodgkin is Tired of Being a Minor Artist," *The New York Times*, December 5, 1993, p. 43, ill.; Graham-Dixon, 1994, ill. color p. 130.

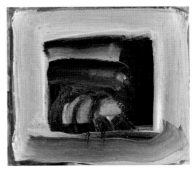

262 · WATERFALL
1991–92
Oil on wood
17⅞ x 21¼ in. (45.5 x 54.1 cm.)
Collection: Private Collection, Switzerland.
Provenance: (Anthony d'Offay Gallery, London).
Exhibitions: *Howard Hodgkin: Seven Small Pictures*, British School in Rome, Rome, March 31–May 1, 1992; *Life into Paint, British Figurative Painting in the Twentieth Century*, Israel Museum, Jerusalem, November 10, 1992–February 9, 1993; *Howard Hodgkin*, Anthony d'Offay Gallery, London, October 19–November 24, 1993, and M. Knoedler and Co., Inc., New York, December 4, 1993–January 15, 1994, ill. color p. 35.

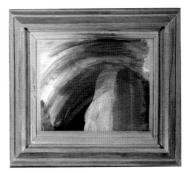

263 · AFTER DEGAS
1993
Oil on wood
26 x 30 in. (66 x 76 cm.)
Collection: Private Collection.
Provenance: (Anthony d'Offay Gallery, London).
Exhibitions: *Howard Hodgkin*, Anthony d'Offay Gallery, London, October 19–November 24, 1993, and M. Knoedler and Co., Inc., New York, December 4, 1993–January 15, 1994, ill. color p. 55.
Literature: Edward Lucie-Smith, "In Profile: Howard Hodgkin," *Arts Review* 45, October 1993, pp. 4–6, ill. color p. 1; Tom Lubbock, "Howard Hodgkin: For Me," *Modern Painters* 6, Autumn 1993, pp. 34–37, ill. color p. 34: "It is a melange of several Degas elements, the frame alluding to the bright green frames that Degas used for his photographs and for some of his pastels; and the image referring to two different

periods of his life: in its colours, to the early Italian period, and in motif, to the late landscape monotypes."; Graham-Dixon, 1994, ill. color p. 85; William Feaver, "Anthony d'Offay, London; exhibit.," *ARTnews* 93, January 1994, p. 173, ill. color: "When he paints *After Degas*, he is reminding us of drawings in which the French master transformed the body of a woman into a remote landscape."; Eric Gibson, "Exhibition Notes," *New Criterion*, March 1994, pp. 41–42: "A painting of shadowy rusts and oranges framed in lime green, has an ominous interior space and is suffused with an overripe heat suggestive of a storm about to break or an impending emotional crisis. The reference to Degas calls to mind his 1868 *Interior* ... in the McIlhenny Collection at the Philadelphia Museum of Art. But even if one doesn't make the association, it remains a powerful picture."; Lilly Wei, "Howard Hodgkin's Mandarin Pastimes," *Art in America* 82, April 1994, pp. 92–97, ill. color p. 97.

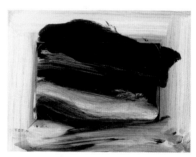

264 · FISHERMAN'S COVE
1993
Oil on wood
11⅛ x 15 in. (28.3 x 38 cm.)
Collection: Private Collection.
Provenance: (Anthony d'Offay Gallery, London, and M. Knoedler and Co., Inc., New York).
Exhibitions: *Howard Hodgkin*, Anthony d'Offay Gallery, London, October 19–November 24, 1993, and M. Knoedler and Co., Inc., New York, December 4, 1993–January 15, 1994, ill. color p. 53.
Literature: Graham-Dixon, 1994, ill. color p. 97; Eric Gibson, "Exhibition Notes," *New Criterion*, March 1994, pp. 41–42: "Paintings which, when they didn't look rushed, looked aimless, even lazy. *Fisherman's Cove* (1993) was one of these, with the added deficiency of being too literal, too close an illustration of its title. Hodgkin's style does not lend itself to representation in any form."; Andrew Graham-Dixon, "The Way It Was," *World of Interiors* 14, July 1994, pp. 86–89, ill. color.

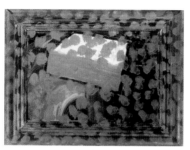

265 · IN RUTLAND GATE
1990–93
Oil on wood
38 x 50 in. (96.5 x 127 cm.)
Collection: Private Collection.
Provenance: (Anthony d'Offay Gallery, London, and M. Knoedler and Co., Inc., New York).
Exhibitions: *Howard Hodgkin*, Anthony d'Offay Gallery, London, October 19–November 24, 1993, and M. Knoedler and Co., Inc., New York, December 4, 1993–January 15, 1994, ill. color p. 17.
Literature: Celia Lyttelton, "Howard's Way," *Tatler*, October 1993, ill. color, misidentified as *Kerala*; Tim Hilton, "Obscure Objects of Desire," *Sunday Independent*, October 31, 1993, p. 35, ill. color; Martin Filler, "Howard Hodgkin is Tired of Being a Minor Artist," *The New York Times*, December 5, 1993, p. 43, ill.

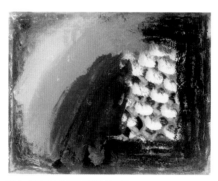

266 · KATHY AT THE RITZ
1991–93
Oil on wood
14⅛ x 18 in. (36 x 45.7 cm.)
Collection: Private Collection.
Provenance: (Anthony d'Offay Gallery, London, and M. Knoedler and Co., Inc., New York).
Exhibitions: *Howard Hodgkin*, Anthony d'Offay Gallery, London, October 19–November 24, 1993, and M. Knoedler and Co., Inc., New York, December 4, 1993–January 15, 1994, ill. color p. 49.
Literature: Graham-Dixon, 1994, ill. color p. 58.

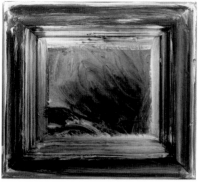

267 · MUD ON THE NILE
1993
Oil on wood
16¼ x 18 in. (41.3 x 45.7 cm.)
Collection: Government Art Collection, London.
Provenance: (Anthony d'Offay Gallery, London).
Exhibitions: *Howard Hodgkin*, Anthony d'Offay Gallery, London, October 19–November 24, 1993, and M. Knoedler and Co., Inc., New York, December 4, 1993–January 15, 1994, ill. color p. 57.
Literature: Tim Hilton, "Obscure Objects of Desire," *Sunday Independent*, October 31, 1993, p. 35, ill. color.

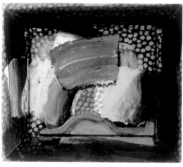

268 · PATRICK IN ITALY
1991–93
Oil on wood
25⅝ x 29¼ in. (65.1 x 74.3 cm.)
Collection: Morgan Grenfell Trustee Services (C.I.) Ltd, JC Mann, JK Blewett as trustees of The Figeac Trust.
Provenance: (Anthony d'Offay Gallery, London).
Exhibitions: *Howard Hodgkin*, Anthony d'Offay Gallery, London, October 19–November 24, 1993, and M. Knoedler and Co., Inc., New York, December 4, 1993–January 15, 1994, ill. color p. 50.
Literature: John McEwen, "Colour Too Deep for Comfort," *Sunday Telegraph*, October 10, 1993, p. 6, ill. color; Brian Sewell, "The Mark of a Lesser Spotted Leopard," *Evening Standard* (London), October 28, 1993, pp. 28–29, ill. p. 29; Daniel Farson, "Knight Errant," *Daily Mail*, November 7, 1993, p. 34, ill. color; Graham-

Dixon, 1994, ill. color p. 131; Eric Gibson, "Exhibition Notes," *New Criterion*, March 1994, pp. 41–42: "*Patrick in Italy* (1991–1993) is informed by an exuberance of mood and handling, as well as an inner warmth reminiscent of Matisse's Moroccan paintings."

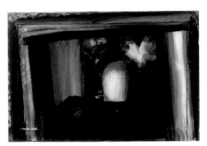

269 · SNAPSHOT
1984–93
Oil on wood
59 x 88¾ in. (150 x 225.4 cm.)
Collection: Private Collection.
Provenance: (Anthony d'Offay Gallery, London, and M. Knoedler and Co., Inc., New York).
Exhibitions: *Howard Hodgkin*, Anthony d'Offay Gallery, London, October 19–November 24, 1993, and M. Knoedler and Co., Inc., New York, December 4, 1993–January 15, 1994, ill. color p. 59.
Literature: John McEwen, "Colour Too Deep for Comfort," *Sunday Telegraph*, October 10, 1993, p. 6: "'Of a holiday. The Dolomites. No, no more clues!' he laughs." (Howard Hodgkin quoted); Andrew Graham-Dixon, "Truants of the Memory," *Independent Magazine*, October 16, 1993, pp. 38–43, 45, ill. color pp. 40–41: "Howard Hodgkin's *Snapshot* is a painting that seems calculated to provoke: a red rag waved in the faces of those who, when it comes to subject matter, like their art unambiguous and unequivocal, as plain as the nose on your face. Its title invokes the sudden and uncalculated truth-to-life of a quickly taken photograph ... but the painting itself defeats the expectations raised by its title, presenting the eye with a collage of barely decipherable painted forms, wedges and swipes and discs of vivid but complicated paint."; Graham-Dixon, 1994, p. 142, ill. color p. 137: "A very large picture with a private erotic quality more often associated with very small pictures. That brown slope of paint in a field of green ... could be a sun or an electric light ... that curtain of green could be landscape or, simply, curtains. It is painted on the monumental scale of the history painting, of the grand narrative art of the past, which, since the picture offers no obvious moral and tells no clear story, intensifies its own mysteriousness. ... *Snapshot* is one of Hodgkin's largest pictures, but it is also a picture that

subverts the idea of large."; Eric Gibson, "Exhibition Notes," *New Criterion*, March 1994, pp. 41–42: "*Snapshot* (1984–93) aims for an epic grandeur, a leap from Vuillard to Turner. ... Smaller, it might have worked. Scaled as it is, the painting is simply too large for what it had to say."; Lilly Wei, "Howard Hodgkin's Mandarin Pastimes," *Art in America* 82, April 1994, pp. 92–97, ill. color p. 97.

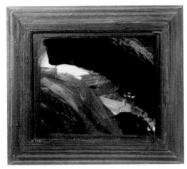

270 · SUNSET
1990–93
Oil on wood
22½ x 25¾ in. (57 x 65.5 cm.)
Collection: Sandy and Harold Price, Laguna Beach, California.
Provenance: (Anthony d'Offay Gallery, London).
Exhibitions: *Howard Hodgkin*, Anthony d'Offay Gallery, London, October 19–November 24, 1993, and M. Knoedler and Co., Inc., New York, December 4, 1993–January 15, 1994, ill. color p. 47.
Literature: Andrew Graham-Dixon, "Truants of the Memory," *Independent Magazine*, October 16, 1993, pp. 38–43, 45, ill. color p. 45: "Melancholy and eros coincide in Hodgkin's new paintings, the most affecting of which is a modestly scaled picture called simply *Sunset*. What is the painting of, exactly? Well, nothing much, at least ostensibly: two great swathes of dark blue and near-black paint occlude a bright riot of colour, peeping through but almost obscured by them. Rephrase the question. What does the painting show us? It shows us that painting can be another way of thinking and feeling about the things that touch us, about darkness closing in, vitality and life and colour threatened. It shows us that a painter can meditate on life and its inevitable passing and can distil (*sic*) his meditations on to a small coloured tablet of wood. It shows us that art does not need to be hedged about with words."; Graham-Dixon, 1994, pp. 151–52, ill. color p. 153: "*Sunset* (1990–93) is one of the saddest and most moving of all the paintings. ... The painting is about death, or at least a violent morbidity. The dim shining of the sun, late in the day, is reincarnated as a *memento mori*."

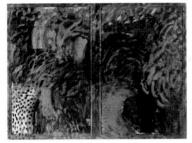

271 · WHEN DID WE GO TO MOROCCO?
1988–93
Oil on wood
77½ x 106 in. (196.9 x 269.2 cm.)
Collection: Metropolitan Museum of Art, New York, Purchase, Lila Acheson Wallace Gift, 1994.
Provenance: (Anthony d'Offay Gallery, London, and M. Knoedler and Co., Inc., New York).
Exhibitions: *Howard Hodgkin*, Anthony d'Offay Gallery, London, October 19–November 24, 1993, and M. Knoedler and Co., Inc., New York, December 4, 1993–January 15, 1994, ill. color p. 45.
Literature: Edward Lucie-Smith, "In Profile: Howard Hodgkin," *Arts Review* 45, October 1993, pp. 4–6, ill. color: "I have to admit that it is undoubtedly a very good picture, perhaps more like Bonnard (if anyone) than Matisse. The colour is as refulgent as ever, the coding of the experience just as mysterious. As an artist, Hodgkin is still someone who withholds meaning just as he seems on the point of offering it."; Andrew Graham-Dixon, "Truants of the Memory," *Independent Magazine*, October 16, 1993, pp. 38–43, 45, ill. color pp. 42–43; Graham-Dixon, 1994, ill. color p. 102; *Recent Acquisitions, a Selection 1993–1994*, New York: Metropolitan Museum of Art, 1994, p. 78, ill. color, notes by Nan Rosenthal; William Feaver, "Anthony d'Offay, London; exhibit.," *ARTnews* 93, January 1994, p. 173: "And when he supplies a title like *When Did We Go To Morocco?*, his conversational ploy has a way of pulling the viewer in. The dating of this large, two-panel painting—1988–93— suggests that he has grown forgetful over the years, that the person he is supposedly addressing will be able to remember, inspired by the work's riot of color (orange, scarlet, blue, plus a dash of emerald green), the date and circumstances of the visit."; Lilly Wei, "Howard Hodgkin's Mandarin Pastimes," *Art in America* 82, April 1994, pp. 92–97, ill. color pp. 94–95.

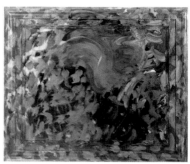

272 · WRITING
1991–93
Oil on wood
45½ x 54½ in. (115.6 x 138.4 cm.)
Collection: Private Collection, London.
Provenance: (Anthony d'Offay Gallery, London,
and M. Knoedler and Co., Inc., New York).
Exhibitions: *Howard Hodgkin*, Anthony d'Offay
Gallery, London, October 19–November 24,
1993, and M. Knoedler and Co., Inc., New
York, December 4, 1993–January 15, 1994,
ill. color p. 61.
Literature: Tim Hilton, "Obscure Objects of
Desire," *Sunday Independent*, October 31,
1993, p. 35, ill. color; Graham-Dixon, 1994,
ill. color p. 20.

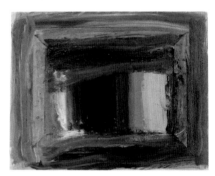

273 · AFTER MORANDI
1989–94
Oil on board
21 x 27 in. (53.3 x 68.6 cm.)
Collection: The artist (Courtesy Anthony d'Offay
Gallery, London, and Gagosian Gallery, New
York).

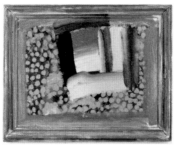

274 · BEDROOM WINDOW
1992–94
Oil on board
43 x 54¼ in. (109.5 x 137.5 cm.)
Collection: Kronos Collection.
Provenance: (Anthony d'Offay Gallery, London).

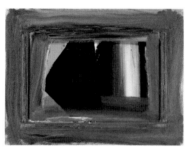

275 · HAVEN'T WE MET? OF COURSE WE HAVE
1994
Oil on board
23¼ x 31¾ in. (59.5 x 80.5 cm.)
Collection: The artist (Courtesy Anthony d'Offay
Gallery, London, and Galerie Lawrence Rubin,
Zurich).

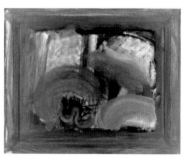

276 · RAIN IN RUTLAND GATE
1992–94
Oil on wood
50 x 60⅛ in. (127 x 152.6 cm.)
Collection: Mr. and Mrs. Jeffrey Brotman,
Medina, Washington.
Provenance: (Anthony d'Offay Gallery, London).
Exhibitions: *Here and Now*, Serpentine Gallery,
London, June 11–July 10, 1994.
Literature: Sue Hubbard, "Brief History of
Paint," *New Statesman & Society* 7, July 1,
1994, pp. 32–33, ill. color p. 32.

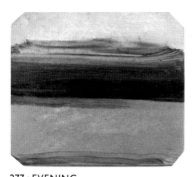

277 · EVENING
1994–95
Oil on wood
15½ x 18 in. (39.3 x 45.6 cm.)
Collection: The artist (Courtesy Anthony d'Offay
Gallery, London, and Galerie Lawrence Rubin,
Zurich).

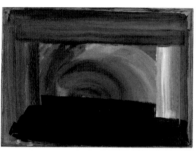

278 · GOSSIP
1994–95
Oil on wood
46 x 65½ in. (117 x 166 cm.)
Collection: The artist (Courtesy Anthony d'Offay
Gallery, London, and Gagosian Gallery, New
York).

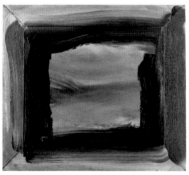

279 · SCOTLAND
1994–95
Oil on wood
20¾ x 23½ in. (52.7 x 59.7 cm.)
Collection: Kronos Collection.
Provenance: (Anthony d'Offay Gallery, London,
and Galerie Lawrence Rubin, Zurich).

CHRONOLOGY

1932	Born August 6, London
1940–43	Lived in the United States
1948	First return visit to the United States
1949–50	Studied at the Camberwell School of Art, London
1950–54	Studied at the Bath Academy of Art, Corsham
1954–56	Taught at Charterhouse School, Surrey
1955	Married Julia Lane (two sons)
1956–66	Taught at the Bath Academy of Art, Corsham
1964	First visited India
1966–72	Taught at the Chelsea School of Art, London
1970–76	Trustee of the Tate Gallery, London
1976/80	Awarded Second Prize at the John Moores exhibition
1976–77	Artist in Residence, Brasenose College, Oxford
1977	Appointed CBE (Commander of the British Empire)
1978–85	Appointed Trustee of the National Gallery, London
1984	Represented Britain at the XLI Venice Biennale
1985	Awarded 1985 Turner Prize Appointed D. Litt., University of London
1988	Appointed Honorary Fellow of Brasenose College, Oxford
1989	Committee, National Art Collections Fund
1992	Awarded Knighthood

ONE-MAN EXHIBITIONS

1962

Howard Hodgkin, Arthur Tooth and Sons Ltd, London, October 16–November 10, 1962.

1964

Howard Hodgkin: Recent Paintings, Arthur Tooth and Sons Ltd, London, January 21–February 15, 1964.

1967

Howard Hodgkin: Recent Paintings, Arthur Tooth and Sons Ltd, London, February 28–March 25, 1967.

1969

Howard Hodgkin: New Paintings, Kasmin Gallery Ltd, London, March 1969.

1970

Howard Hodgkin, Arnolfini Gallery, Bristol, September 16–October 22, 1970.

1971

Howard Hodgkin, Galerie Müller, Cologne, January 15–February 25, 1971.

Howard Hodgkin: Recent Paintings, Kasmin Gallery Ltd, London, March–April 1971.

1973

Howard Hodgkin, Kornblee Gallery, New York, February 17–March 8, 1973.

1976

Howard Hodgkin: Forty-five Paintings, 1949–1975 (organized by the Arts Council of Great Britain), Serpentine Gallery, London, May 1–31, 1976; Turnpike Gallery, Leigh, June 5–26, 1976; Laing Art Gallery, Newcastle-upon-Tyne, July 3–August 8, 1976; Aberdeen Art Gallery, Aberdeen, August 14–September 4, 1976; Graves Art Gallery, Sheffield, September 11–October 3, 1976.

Howard Hodgkin: New Paintings, Waddington Galleries II, London, May 5–28, 1976.

1977

Howard Hodgkin: New Paintings, André Emmerich Gallery, New York, September 15–October 5, 1977.

1977–78

Howard Hodgkin, André Emmerich Gallery, Zurich, December 2, 1977–January 7, 1978.

1981

Howard Hodgkin, M. Knoedler and Co., Inc., New York, April 25–May 12, 1981.

1982

Howard Hodgkin: Recent Paintings, M. Knoedler and Co., Inc., New York, November 13–December 9, 1982.

1984

Howard Hodgkin: Recent Work, M. Knoedler and Co., Inc., New York, April 21–May 10, 1984.

1984–85

Howard Hodgkin: Forty Paintings, 1973–84 (organized by the British Council of Arts), British Pavilion, Venice Biennale, June 10–September 23, 1984; Phillips Collection, Washington, D.C., October 13–December 13, 1984; Yale Center for British Art, New Haven, Connecticut, January 16–March 17, 1985; Kestner Gesellschaft, Hannover, April 19–May 27, 1985; Whitechapel Art Gallery, London, September 20–November 3, 1985.

1986

Howard Hodgkin: Recent Work, M. Knoedler and Co., Inc., New York, May 10–June 5, 1986.

1988

Howard Hodgkin: New Paintings, Waddington Galleries, London, August 24–September 17, 1988, and M. Knoedler and Co., Inc., New York, October 8–November 3, 1988.

1990

Howard Hodgkin: Recent Paintings, Michael Werner Gallery, Cologne, September 18–October 15, 1990, and M. Knoedler and Co., Inc., New York, November 6–December 1, 1990.

1990–91

Howard Hodgkin: Small Paintings (organized by the British Council of Arts), Musée des Beaux-Arts, Nantes, June 15–September 15, 1990; Caixa de Pensions, Barcelona, October–November 1990; Scottish National Gallery of Modern Art, Edinburgh, December 8, 1990–February 24, 1991; Douglas Hyde Gallery, Trinity College, Dublin, March–May 1991.

1991

Howard Hodgkin, University Art Museum, University of California, Berkeley, September 25–December 16, 1991.

1992

Howard Hodgkin: Seven Small Pictures, British School at Rome, Rome, March 31–May 1, 1992.

1993–94

Howard Hodgkin, Anthony d'Offay Gallery, London, October 19–November 24, 1993, and M. Knoedler and Co., Inc., New York, December 4, 1993–January 15, 1994.

GROUP EXHIBITIONS

1959

London Group 1959. Annual Exhibition, RBA Galleries, London, April 18–May 8, 1959.

1960

London Group 1960. Annual Exhibition, RBA Galleries, London, January 15–February 5, 1960.

1961

London Group 1961. Annual Exhibition, RBA Galleries, London, March 9–29, 1961.

Contrasts: An Exhibition of Work by Members of the AIA, AIA Gallery, London, May 1961 .

Twenty Painters, AIA Gallery, London, September 1961.

1962

Two Young Figurative Painters [with Allen Jones], ICA Gallery, London, February 14–March 24, 1962.

British Painting and Sculpture, Today and Yesterday, Arthur Tooth and Sons Ltd, London, April 3–28, 1962.

1962–63

Britisk Kunst, Sammenslutningen af Danske Kunstforeininger, Denmark, 1962–63.

1963

1962: One Year of British Art Selected by Edward Lucie-Smith, Arthur Tooth and Sons Ltd, London, January 22–February 9, 1963.

British Painting in the Sixties: An Exhibition Organized by the Contemporary Art Society, Two Sections, Tate Gallery and Whitechapel Art Gallery, London, June 1–30, 1963.

Critic's Choice: An Exhibition of Contemporary British Painting and Sculpture Selected by Philip James, C.B.E., Stone Gallery, St.Mary's Place, Newcastle-upon-Tyne, July 1963.

1964

Figuratie en Defiguratie, Museum voor Schone Kunsten, Ghent, 1964.

London, the New Scope, Arthur Tooth and Sons Ltd, London, 1964.

Profile III: Englische Kunst der Gegenwart, Stadtische Kunstgalerie, Bochum, April–July 1964.

Britische Malerei der Gegenwart, Kunstverein für die Rheinlande und Westfalen, Düsseldorf, May 24–July 5, 1964.

Nieuwe Realisten, Haags Gemeentemuseum, The Hague, June 24–August 8, 1964.

New Painting 1961–1964, Arts Council of Great Britain, July 11–October 24, 1964.

The New Image, Arts Council Gallery, Belfast, September 1964.

1965

Op & Pop, Aktuell Engelsk Konst, Riksforbundet für bildande konst och SAN, Stockholm, 1965.

British Painters, Arthur Tooth and Sons Ltd, London, January 12–30, 1965.

Pop Art, Nouveau Realisme, etc..., Palais des Beaux-Arts de Bruxelles, Brussels, February 5–March 1, 1965.

Corsham Painters and Sculptors (organized by the Arts Council of Great Britain), Bath Festival, June 1965.

Trends in Contemporary British Painting, Bear Lane Gallery, Oxford, June 1965.

25 Peintres, 5 Pays, Château de la Sarraz, Prix International de Peinture, Vaud, Switzerland, June 6–September 26, 1965.

Quattordicesimo premio Lissone, Biennale internazionale di pittura, Lissone, Italy, October 17–31, 1965.

1965–66

London: The New Scene, Walker Art Center, Minneapolis, February 6–March 14, 1965; Washington Gallery of Modern Art, Washington, D.C., April 1–May 2, 1965; Institute of Contemporary Art, Boston, June 12–July 25, 1965; Seattle Art Museum, Seattle, September 8–October 10, 1965; Vancouver Art Gallery, Vancouver, October 30–November 28, 1965; Art Gallery of Ontario, Toronto, January 8–February 6, 1966; National Gallery of Canada, Ottawa, February 18–March 20, 1966.

1966

Colour, Form and Texture, Arthur Tooth and Sons Ltd, London, February 1–19, 1966.

Howard Hodgkin, Peter Philips, Allen Jones, Galerie Aujourd'hui, Brussels, May 1966.

London Under Forty, Galleria Milano, Milan, June 7–25, 1966.

1967

Recent British Painting: The Peter Stuyvesant Foundation Collection, Tate Gallery, London, November 15–December 22, 1967.

1968

First Triennale—India 1968, Lalit Kala Akademi, New Delhi, and National Gallery of Modern Art, New Delhi, February 11–March 31, 1968.

Contemporary Art Fair, Palazzo Strozzi, Florence, November 16–December 8, 1968.

1969

Artists from the Kasmin Gallery, Arts Council Gallery, Belfast, August 1–30, 1969.

1970

Pop Art-Nouveau Realisme, Casino Communal, Knokke-Le Zoute, June–September 1970.

Contemporary British Art, National Museum of Modern Art, Tokyo, September 9–October 25, 1970.

AIA Retrospective 1930–1970, AIA Gallery, London, October 1970.

1971

Critic's Choice 1971 (selection by Robert Melville), Arthur Tooth and Sons Ltd, London, March 2–26, 1971.

Art Spectrum South, Southampton City Art Gallery, Southampton, June 5–July 4, 1971; Folkestone Arts Centre, Folkestone, July 9–August 1, 1971; Royal West of England Academy, Bristol, August 20–September 18, 1971.

1972

Patrick Caulfield, Howard Hodgkin, Michael Moon, Galerie Stadler, Paris, March 21–April 15, 1972.

John Moores Liverpool Exhibition 8, Walker Art Gallery, Liverpool, April 27–July 2, 1972.

1973

La Peinture anglaise aujourd'hui, Musée d'art moderne de la ville de Paris, Paris, February 7–March 11, 1973.

Henry Moore to Gilbert & George, Modern British Art from the Tate Gallery, Palais des Beaux-Arts, Brussels, September 28–November 17, 1973.

1974

An Exhibition of Contemporary British Painters and Sculptors, Lefevre Gallery, London, April 18–May 18, 1974.

John Moores Liverpool Exhibition 9, Walker Art Gallery, Liverpool, June 13–September 15, 1974.

Group Exhibition Selected by Peter Blake, Festival Gallery, Linley House, Bath, August 23–September 14, 1974.

New Image in Painting: 1st International Biennial Exhibition of Figurative Painting, Tokyo Department Store, Tokyo, September 6–18, 1974.

British Painting '74, Arts Council of Great Britain, London, September 26–November 17, 1974.

1975

The British are Coming, De Cordova Museum, Lincoln, Massachusetts, 1975.

Contemporary Arts Society Art Fair, Mall Galleries, London, January 15–23, 1975.

British Art mid-70s, Englische Kunst Mitte der Siebzigerjahre, Jahrhunderthalle Hoechst, March 26–April 25, 1975, and Forum Leverkusen, May 7–28, 1975.

British Exhibition Art 5'75, Schweizer Mustermesse, Basel, June 18–23, 1975.

1976

John Moores Liverpool Exhibition 10, Walker Art Gallery, Liverpool, May 6–August 8, 1976.

The Human Clay, An Exhibition Selected by R.B. Kitaj, Hayward Gallery, London, August 5–30, 1976.

1977

1977 Hayward Annual. Current British Art Selected by Michael Compton, Howard Hodgkin and William Turnbull, Hayward Gallery, London, Part One: May 25–July 4, 1977, Part Two: July 20–September 4, 1977.

British Painting 1952–1977, Royal Academy of Arts, London, September 24–November 20, 1977.

1978

Mixed Exhibition, Knoedler Gallery, London, March 1978.

Critic's Choice, An Exhibition of Contemporary Art Selected by John McEwen, ICA Gallery, London, September 7–October 7, 1978.

1978–79

John Moores Liverpool Exhibition XI, Walker Art Gallery, Liverpool, November 30, 1978–February 25, 1979.

1979

To-day: Brittiskt 60-och 70-tal, Lunds Konsthall, Sweden, April 7–May 6, 1979.

European Dialogue. The Third Biennale of Sydney at The Art Gallery of New South Wales, Sydney, April 14–May 27, 1979.

Contemporary Art for 17 Charterhouse Street, Mall Galleries, London, May 21–25, 1979.

The Artist's Eye, An Exhibition selected by Howard Hodgkin, National Gallery, London, June 20–August 19, 1979.

This Knot of Life: Paintings and Drawings by British Artists, L.A. Louver Gallery, Venice, California, Part I: October 23–November 17, 1979.

1979–80

Narrative Paintings: Figurative Art of Two Generations, Arnolfini Gallery, Bristol, September 1–October 20, 1979; ICA Gallery, London, October 26–November 25, 1979; City Museum and Art Gallery, Stoke-on-Trent, January 5–February 2, 1980; Fruit Market Gallery, Edinburgh, February 9–March 29, 1980.

Peter Moores Liverpool Project 5: The Craft of Art, Walker Art Gallery, Liverpool, November 3, 1979–February 13, 1980.

The British Art Show: Selected by William Packer (organized by the Arts Council of Great Britain), Mappin Art Gallery, Sheffield, December 1, 1979–January 27, 1980; Laing Art Gallery, Newcastle-upon-Tyne and Hatton Gallery, University of Newcastle, February 15–March 23, 1980; Arnolfini Gallery and Royal West of England Academy, Bristol, April 18–May 24, 1980.

1980

Pictures for An Exhibition, Whitechapel Art Gallery, London, March 30–May 18, 1980.

L'Art anglais d'aujourd'hui: Collection Tate Gallery, Londres, Musée Rath, Geneva, July–September 1980.

British Art 1940–1980 (Arts Council Collection), Hayward Gallery, London, July 9–August 10, 1980.

Hayward Annual 1980. Contemporary Painting and Sculpture Selected by John Hoyland, Hayward Gallery, London, August 29–October 12, 1980.

1980–81

John Moores Liverpool Exhibition XII, Walker Art Gallery, Liverpool, November 27, 1980–February 22, 1981.

1981

A New Spirit in Painting, Royal Academy of Arts, London, January 15–March 18, 1981.

Alistair Smith, A Personal Selection, Ulster Museum, Belfast, May 29–August 23, 1981.

Group Show: Summer 1981, M. Knoedler and Co., Inc., New York, July–August 1981.

New Concepts for a New Art, Toyama Now 81, Museum of Modern Art, Toyama, Japan, July 5–September 23, 1981.

1981–82

Britische Kunstler, Eine Ausstellung über Malerei, Neue Galerie, Sammlung Ludwig, Aachen, December 5, 1981–February 16, 1982; Kunstverein, Manheim, February 28–April 4, 1982; Kunstverein, Braunschweig, June 8–September 19, 1982.

1981–83

A Mansion of Many Chambers: Beauty and Other Works (organized by the Arts Council of Great Britain), Cartwright Hall, Bradford, December 12, 1981–January 17, 1982; Art Gallery, Oldham, April 24–May 29, 1982; Gardner Center Gallery, Brighton, June 9–July 7, 1982; Colchester Minories, July 17–August 22, 1982; Mappin Art Gallery, Sheffield, August 28–October 30, 1982; City Art Gallery, Worcester, November 20–January 1, 1983.

1982

A Private Vision: Contemporary Art from the Graham Gund Collection, Museum of Fine Arts, Boston, February 9–April 4, 1982.

Aspects of British Art Today, Tokyo Metropolitan Art Museum, Tokyo, February 27–April 11, 1982; Tochigi Prefectual Museum of Fine Arts, Utsunomiya, April 24–May 30, 1982; National Museum of Art, Osaka, June 12–July 25, 1982; Fukuoka Art Museum, Fukuoka, August 7–29, 1982; Hokkaido Museum of Modern Art, Hokkaido, September 9–October 9, 1982.

1983

The Granada Collection: Recent British Painting and Drawing, Whitworth Art Gallery, University of Manchester, England, January 15–February 26, 1983.

Recent European Paintings, Solomon R. Guggenheim Museum, New York, May 20–September 4, 1983.

Painting: Gregory Amenhoff, Howard Hodgkin, Melissa Miller, Katherine Porter, Joan Thorne, Susan Whynne, Bell Gallery, List Art Center, Brown University, Providence, December 3–30, 1983.

1983–84

Three Little Books About Painting: 2 Movements (organized by the Arts Council of Great Britain), Graves Art Gallery, Sheffield, November 19–December 18, 1983; Laing Art Gallery, Newcastle-upon-Tyne, January 4–29, 1984; Norwich Castle Museum, Norwich, February 8–March 4, 1984; Bolton Museum and Art Gallery, Bolton, March 10–April 7, 1984.

1984

An International Survey of Recent Painting and Sculpture, Museum of Modern Art, New York, May 17–August 19, 1984.

Summer Selection, M. Knoedler and Co., Inc., New York, July–August 1984.

The Hard-Won Image: Traditional Method and Subject in Recent British Painting, Tate Gallery, London, July 4–September 9, 1984.

The Turner Prize 1984, Tate Gallery, London, October 25–December 2, 1984.

1984–85

The British Art Show: Old Allegiances and New Directions 1979–1984, City of Birmingham Museum and Art Gallery and Ikon Gallery, Birmingham, November 2–December 22, 1984; Royal Scottish Academy, Edinburgh, January 19–February 24, 1985; Mappin Art Gallery, Sheffield, March 16–May 4, 1985; Southampton Art Gallery, May 18–June 30, 1985.

The Proper Study: Contemporary Figurative Painting from Britain, Lalit Kala Akademi, New Delhi, December 1–31, 1984, and Jahangir Nicholson Museum of Modern Art, Bombay, February 1–28, 1985.

1985

The Turner Prize 1985, Tate Gallery, London, October 17–December 1, 1985.

1985–86

1985 Carnegie International, Museum of Art, Carnegie Institute, Pittsburgh, November 9, 1985–January 5, 1986.

1986

Recent Abstract Painting, John Good Gallery, New York, January 9–February 8, 1986.

Studies of the Nude, Marlborough Fine Art Ltd, London, March–May 1986.

1986–87

The Window in Twentieth-Century Art, Neuberger Museum, State University of New York at Purchase, New York, September 21, 1986–January 18, 1987; Contemporary Arts Museum, Houston, April 24–June 29, 1987.

Looking into Paintings: 2 Portraits (organized by the Arts Council of Great Britain), Castle Museum, Nottingham, November 22, 1986–January 1, 1987; Shipley Art Gallery, Gateshead, January 10–February 8, 1987; Cartwright Hall, Bradford, February 14–March 15, 1987; City Museum and Art Gallery, Plymouth, March 21–April 26, 1987.

1987

2D 3D, Laing Art Gallery and Northern Centre for Contemporary Art, Newcastle-upon-Tyne, January 14–March 8, 1987.

State of the Art, ICA Gallery, London, January 14–March 1, 1987; Laing Art Gallery, Newcastle-upon-Tyne, March 13–April 26, 1987; Harris Museum and Art Gallery, Preston, May 9–June 21, 1987; Cartwright Hall, Bradford, June 27–August 23, 1987.

British Art in the 20th Century: The Modern Movement, Royal Academy of Arts, London, January 15–April 5, 1987.

Current Affairs: British Sculpture and Painting in the 1980s, Museum of Modern Art, Oxford, March 1–29, 1987; Mucsarnok, Budapest, April 24–May 31, 1987; Narodni Galerie, Prague, June 19–August 7, 1987; Zacheta, Warsaw, September 18–October 31, 1987.

1988

Art of Our Time, The Saatchi Collection, Royal Scottish Academy, Edinburgh, 1988.

1900 to Now: Modern Art from Rhode Island Collections, Museum of Art, Rhode Island School of Design, Providence, Rhode Island, January 22–May 1, 1988.

The British Picture, L.A. Louver Gallery, Venice, California, February 5–March 5, 1988.

The World of Art Today 1988, Milwaukee Art Museum, Milwaukee, May 6–August 28, 1988.

1988–89

The Pastoral Landscape: The Modern Vision, The Phillips Collection, Washington, D.C., November 6, 1988–January 22, 1989.

Corsham: A Celebration, The Bath Academy of Arts 1946–72, Victoria Art Gallery, Bath, December 10, 1988–January 14, 1989; Brighton Polytechnic Gallery, Brighton, January 23–February 14, 1989; Michael Parkin Gallery, London, February 22–March 24, 1989.

1989

Bilderstreit: Widerspruch, Einheit und Fragment in der Kunst seit 1960, Museum Ludwig, Cologne, 1989.

Whitworth Art Gallery, The First Hundred Years, Whitworth Art Gallery, Manchester, 1989.

Twentieth-Century Works, Waddington Galleries, London, April 26–May 20, 1989.

1990

Glasgow's Great British Art Exhibition, Glasgow Museum and Art Galleries, Glasgow, March 27–May 9, 1990.

Masterpieces from the Arts Council Collection, Ueno Royal Museum, Tokyo, October 25–29, 1990.

1990–91

The British Imagination: Twentieth-Century Paintings, Sculpture, and Drawings, Hirschl & Adler Galleries, New York, November 10, 1990–January 12, 1991.

1991

The Absent Presence, Graves Art Gallery, Sheffield, January 19–March 2, 1991.

Smith Collects Contemporary, Smith College Museum of Art, Northampton, Massachusetts, Summer 1991.

Not Pop: What the Others were Doing, Bernard Jacobson Gallery, London, September 10–October 8, 1991.

1991–92

British Contemporary Art 1910–1990. 80 Years of Collecting in the Contemporary Art Society, Hayward Gallery, London, December 3, 1991–January 19, 1992.

1992

The Poetic Trace. Aspects of British Abstraction Since 1945, Adelson Galleries, Inc., New York, May 12–June 30, 1992.

1992–93

Life into Paint: British Figurative Painting in the Twentieth Century, Israel Museum, Jerusalem, November 10, 1992–February 9, 1993.

1993

The Sixties Art Scene in London, Barbican Art Gallery, London, March 11–June 13, 1993.

1994

Here and Now, Serpentine Gallery, London, June 11–July 10, 1994.

Paintmarks, Kettle's Yard, University of Cambridge, July 17–September 4, 1994; Southampton City Art Gallery, Southampton, September 29–November 6, 1994; Mead Gallery, University of Warwick, November 12–December 10, 1994.

SELECTED BIBLIOGRAPHY

This bibliography does not include unpublished material. Where periodical and newspaper articles have been cited without page references the compiler has studied the texts in Howard Hodgkin's archives, but has not been able to trace them further.

ARTIST'S STATEMENTS AND INTERVIEWS

Reichardt, Jasia (ed.). "On Figuration and the Narrative in Art: Statements by Howard Hodgkin, Patrick Hughes, Patrick Procktor, and Norman Toynton." *Studio International* vol. 172, September 1966, pp. 140–44.

Forge, Andrew, Howard Hodgkin and Philip King. "The Relevance of Matisse." *Studio International* vol. 176, July/August 1968, pp. 9–17.

Hodgkin, Howard. "A Recorded Talk on his Paintings—Indian Views, Screenprints and Lithographs." Pamphlet published by the British Council, November 1976.

Brighton, Andrew and Lynda Morris (eds.). *Towards Another Picture: An Anthology of Writings by Artists Working in Britain 1945–77.* Nottingham: Midland Group, 1977, pp. 76–77, 96.

Lucie-Smith, Edward. "Interview with Howard Hodgkin." *Quarto* no. 19, July 1978, pp. 15–17.

Hodgkin, Howard. "An Artist in Residence." *Oxford Art Journal* vol. 1, October 1978, pp. 36–37.

Hyman, Timothy. "Interview with Howard Hodgkin." *Artscribe* no. 15, December 1978, pp. 25–28.

Hodgkin, Howard. "Artist's Notes." *Howard Hodgkin: Indian Leaves.* London and New York: Petersburg Press, 1982, pp. 51–53.

Hodgkin, Howard. "How to be an Artist." *Burlington Magazine* vol. 124, September 1982, pp. 552–54. (Edited version of the William Townsend Memorial Lecture given at the Slade School of Fine Art, University College, London, December 15, 1981.)

"Peter Blake and Howard Hodgkin in California." *Ambit*, 1983, pp. 3–17.

Sylvester, David. "Howard Hodgkin Interviewed by David Sylvester." *Howard Hodgkin: Forty Paintings: 1973–1984.* London: Whitechapel Art Gallery, 1984.

Hodgkin, Howard and Patrick Caulfield. "Howard Hodgkin and Patrick Caulfield in Conversation." *Art Monthly* vol. 78, July/August 1984, pp. 4–6.

Sylvester, David. "Colour Dialogue." *Vogue* (UK) vol. 149, January 1988, pp. 122–25.

Hodgkin, Howard. "On and Off the Wall." *Observer*, July 3, 1988, p. 43.

Graham-Dixon, Andrew. "Hanging in the Balance." *Independent*, July 10, 1990, p. 11.

Beyer, Andreas. "An Interview with Howard Hodgkin." *Kunstforum* vol. 110, November–December 1990, pp. 210–22.

Simmons, Rosemary. "Howard Hodgkin: New Hand-Coloured Prints." *Printmaking Today* no. 2, Spring 1991.

Hall, James. "The Essence of Paris." *Independent Magazine*, August 31, 1991, pp. 42–45.

Crane, H. R. and Steven Vita. "Interview." *Veery* no. 2. Chicago: The Foxglove Company, 1992, pp. 1–2.

Spalding, Frances. "An Interview with Howard Hodgkin." *The Charleston Magazine* no. 6, Winter 1992–Spring 1993, pp. 26–33.

Peattie, Antony. "A Conversation with Howard Hodgkin." *Howard Hodgkin.* London: Anthony d'Offay Gallery, and New York: Knoedler and Co., Inc., 1993, pp. 63–70.

BOOKS

Read, Herbert. *Contemporary British Art.* Harmondsworth: Penguin Books (Revised edition), 1964, p. 48.

Robertson, Bryan, John Russell, and Lord Snowden. *Private View.* London: Thomas Nelson and Sons Ltd, 1965, pp. 28, 278–79.

Pellegrini, Aldo. *New Tendencies in Art.* (Translated by Robin Carson). London: Elek, 1967, pp. 207, 223.

Jones, Christopher, and G. D. Thorneley. *Creative Method in Painting (Conference of Design Methods).* London: Pergamon Press, 1968.

Tate Gallery Report: Acquisitions 1968–70. London: Tate Gallery Publications, 1970, p. 89.

Lucie-Smith, Edward and Patricia White. *Art in Britain 1969–1970.* London: J. M. Dent and Sons Ltd, 1970, p. 96.

Dypréau, Jean. Essay in *Figurative Art Since 1945.* London: Thames and Hudson Ltd, 1971, p. 166.

Shone, Richard. *The Century of Change: British Painting Since 1900.* Oxford: Phaidon, 1977, pp. 11, 34, 42, 219.

The Tate Gallery 1976–78: Illustrated Catalogue of Acquisitions. London: Tate Gallery Publications, 1978, p. 96.

Ford, Jackie. *Arts Council Collection, A Concise Illustrated Catalogue of Paintings, Drawings, Photographs and Sculpture Purchased for the Arts Council of Great Britain between 1942–1978.* London: Arts Council of Great Britain, 1979, p. 129.

Chatwin, Bruce. "A Portrait of the Artist." *Howard Hodgkin: Indian Leaves.* London and New York: Petersburg Press, 1982, pp. 5–17.

Caldwell, John. "Howard Hodgkin." *Museum of Art, Carnegie Institute Collection Handbook.* Pittsburgh: Museum of Art, Carnegie Institute, 1985, pp. 320–21.

Hartt, Frederick. *Art: A History of Painting, Sculpture, Architecture*, vol. II. New York: Harry N. Abrams, Inc., 1985, p. 953.

Jones, Caroline A. *Modern Art at Harvard, The Formation of the Nineteenth- and Twentieth-Century Collections of the Harvard University Art Museums.* New York: Abbeville Press, 1985, p. 126.

Arnason, H. Harvard, *History of Modern Art.* New York: Harry N. Abrams, Inc. (Third edition), 1986, pp. 661–62.

The Saint Louis Art Museum Annual Report, Saint Louis: Saint Louis Art Museum, 1986, p. 36.

Nairne, Sandy. *State of the Art, Ideas & Images in the 1980s*. London: Chatto and Windus, 1987, p. 117.

Smith, Greg. "Interior at Oakwood Court." *The Whitworth Art Gallery. The First Hundred Years*. Manchester: Whitworth Art Gallery, 1988, pp. 130–31.

Hicks, Alistair. *New British Art in the Saatchi Collection*. London: Thames and Hudson Ltd, 1989, pp. 7, 11, 14, 15, 46–55.

Hicks, Alistair. *The School of London, The Resurgence of Contemporary Painting*. Oxford: Phaidon, 1989, pp. 12, 14, 18, 37–40, 60.

Lucie-Smith, Edward. *Art Today*. London: Phaidon (First published 1977. Third edition, enlarged), 1989, pp. 508–09.

Moszynska, Anna. *Abstract Art*. London: Thames and Hudson Ltd, 1990, pp. 221–24.

Wilson, Simon. *Tate Gallery: An Illustrated Companion*. London: Tate Gallery Publications, 1990, p. 223.

Hughes, Robert. *The Shock of the New*. London: BBC Books and Thames and Hudson Ltd, 1991, pp. 415–16.

Sontag, Susan, and Howard Hodgkin. *The Way We Live Now*. London: Jonathan Cape, 1991.

Graham-Dixon, Andrew. *Howard Hodgkin*. London: Thames and Hudson Ltd, 1994.

Recent Acquisitions, A Selection, 1993–94. New York: Metropolitan Museum of Art, 1994, p. 78.

ONE-MAN EXHIBITION CATALOGUES

Lucie-Smith, Edward. *Howard Hodgkin*. London: Arthur Tooth and Sons Ltd, 1962.

Morphet, Richard. *Howard Hodgkin, Forty-five Paintings: 1949–75*. London: Arts Council of Great Britain, 1976.

Marcus, Penelope. *Howard Hodgkin: Complete Prints*. Oxford: Museum of Modern Art, 1977.

Gowing, Lawrence. *Howard Hodgkin*. New York: Knoedler and Co., Inc., 1981.

Compton, Michael. *Howard Hodgkin: Indian Leaves*. London: Tate Gallery Publications, 1982.

Rainbird, Sean. *Howard Hodgkin: Recent Print*. Queensland: University of Queensland Art Museum, 1982.

McEwen, John. "Introduction." *Howard Hodgkin: Forty Paintings: 1973–84*. London: Whitechapel Art Gallery, 1984.

Howard Hodgkin: Ten Paintings, 1979–85. (Supplement), London: Whitechapel Art Gallery, 1985.

Morphet, Richard. *Howard Hodgkin: Prints 1977 to 1983*. London: Tate Gallery Publications, 1985.

Howard Hodgkin. New York: M. Knoedler and Co., Inc., 1986.

Howard Hodgkin. London: Waddington Galleries, and New York: M. Knoedler and Co., Inc., 1988.

Dickhoff, Wilfried, and Timothy Hyman. *Howard Hodgkin*. Cologne: Michael Werner, and New York: M. Knoedler and Co., Inc., 1990.

Hyman, Timothy, Henry Claude-Cousseau and Deepak Ananth. *Howard Hodgkin: Small Paintings 1975–1989*. London: British Council, 1990.

Russell, John. *Howard Hodgkin. Graphic Work: 14 Hand-coloured Lithographs and Etchings 1977–1987*. London: Lumley Cazalet Gallery, 1990.

Howard Hodgkin. London: Anthony d'Offay Gallery, and New York: Knoedler and Co., Inc., 1993.

GROUP EXHIBITION CATALOGUES

Coleman, Roger. *Two Young Figurative Painters: Howard Hodgkin, Allen Jones*. London: Institute of Contemporary Arts, 1962.

Alley, Ronald. *New Paintings 61–64*. Arts Council of Great Britain Touring Exhibition, 1964.

Friedman, Martin and Alan Bowness. *London: The New Scene*. Minneapolis: Walker Art Center, 1965.

Bowness, Alan (ed.). *Recent British Painting: The Peter Stuyvesant Foundation Collection*. (Exhibition at the Tate Gallery, London, 1967), London: Lund Humphries, 1968, pp. 9–24, 122–24.

Causey, Andrew. *Contemporary British Art*. Tokyo: National Museum of Modern Art, 1970, pp. 12–13.

Patrick Caulfield, Howard Hodgkin, Michael Moon. Paris: Galerie Stadler, March–April 1972.

Lucie-Smith, Edward. *La Peinture anglaise moderne aujourd'hui*. Paris: Musée d'Art Moderne de la ville de Paris, 1973.

Seymour, Anne. "A New Approach to the Figurative Image." *Henry Moore to Gilbert & George, Modern British Art from the Tate Gallery*. (Palais des Beaux-Arts, Brussels), London: Tate Gallery Publications, and the British Council, 1973, pp. 103–08.

Forge, Andrew. *British Painting '74*. Arts Council of Great Britain Touring Exhibition, 1974.

Compton, Michael. *1977 Hayward Annual*. London: Hayward Gallery, 1977.

Gore, Frederick. *British Painting 1952–1977*. London: Royal Academy of Arts, 1977.

Hodgkin, Howard. *The Artist's Eye: An Exhibition Selected by Howard Hodgkin*. London: National Gallery, 1979.

Hyman, Timothy. *Narrative Paintings: Figurative Art of Two Generations*. Bristol: Arnolfini Gallery, 1979.

Joachimides, Christos. *A New Spirit in Painting*. London: Royal Academy of Arts, 1981.

Banham, Reyner. *Four Rooms: Howard Hodgkin, Marc Camille Chaimowicz, Richard Hamilton, Anthony Caro*. Arts Council of Great Britain Touring Exhibition, 1984.

McEwen, John. "Howard Hodgkin." (Intr. Norbert Lynton) *The Proper Study: Contemporary Figurative Painting from Britain*. British Council Touring Exhibition, 1984, pp. 72–76, 118.

Morphet, Richard. *The Hard-Won Image: Traditional Method and Subject in Recent British Painting*. London: Tate Gallery Publications, 1984.

Current Affairs: British Painting and Sculpture in the 1980s. Oxford: Museum of Modern Art, 1987.

Rosenthal, Norman. "Three Painters of this Time: Hodgkin, Kitaj and Morley." *British Art in the 20th Century.* London: Royal Academy of Arts, 1987, pp. 382–87, 434.

Lucie-Smith, Edward. "British Art in the Twentieth Century." *The British Imagination: Twentieth-Century Paintings, Sculpture, and Drawings.* New York: Hirschl and Adler Galleries, 1990, pp. 15, 129–33.

Ready Steady Go: Painting of the Sixties from the Arts Council Collection. Arts Council of Great Britain Touring Exhibition, 1992.

PERIODICAL AND NEWSPAPER ARTICLES

1962

del Renzio, Toni. "Away from Kitchen Sink Realism." *Topic* no. 1, February 10, 1962, p. 30.

Lucie-Smith, Edward. "Two Figurative Painters (ICA)." *New Statesman* vol. 63, February 16, 1962, p. 240.

Thompson, David. "Two Young Figurative Painters." *The Times* (London), February 21, 1962, p. 13.

Maddox, Conroy. "Two Young Figurative Painters, ICA." *Arts Review* vol. 14, February 24, 1962, p. 19.

Sutton, Keith. "Around the London Art Galleries." *Listener* no. 117, March 1, 1962, p. 382.

Russell, John. "The World of Art: Henry Moore in Manhattan." *Sunday Times*, April 8, 1962, p. 39.

Bowen, Denis. "William Brooker and Howard Hodgkin." *Arts Review* vol. 14, October 20–November 3, 1962, p. 19.

Denny, Robyn. "London Letter." *Kunstwerk* no. 16, November–December 1962, pp. 70–80.

Mullins, Edwin. "Other Exhibitions: Two Painters at Tooths." *Apollo* vol. 76, November 1962, p. 714.

Whittet, G. S. "Nature Still Gets in the Picture." *Studio* vol. 164, December 1962, pp. 250–52.

1963

Hodin, J. P. "Londres: Pop-Art or Art." *Quadrum* vol. 14, 1963, pp. 161–64.

Anon. "New Year Exhibitions in London." *Apollo* vol. 127, January 1963, p. 54.

Anon. "One Choice of British Art: Formula Changed." *The Times* (London), January 30, 1963, p. 13.

Reichardt, Jasia. "Pop Art and After." *Art International* vol. 7, February 1963, pp. 42–47.

Lynton, Norbert. "London Letter." *Art International* vol. 7, March 1963, p. 58.

Melville, Robert. "Exhibitions." *Architectural Review* vol. 133, April 1963, pp. 288–90.

Lucie-Smith, Edward. "The Impact-Makers." *Vogue* (UK) vol. 120, August 1963, pp. 58–59.

Stockwood, Jane. "Sometimes it Makes a Good Portrait." *Harper's Bazaar*, November 1963, pp. 107–8, 110.

1964

Coleman, Roger. "Up with the Jones's." *Arts Review* vol. 16, January 12–February 8, 1964, p. 4.

Berthoud, Roger. "One-Man Show by One of Our Best." *Evening Standard* (London), January 24, 1964, p. 5.

Anon. "London Day by Day: All Shapes and Sizes." *Daily Telegraph*, January 25, 1964, p. 8.

Levey, Michael. "Twist and Shout." *Sunday Times*, January 26, 1964, p. 32.

Lynton, Norbert. "Great High Spirits." *New Statesman* vol. 67, January 31, 1964, pp. 179–80.

Burr, James. "Round the London Galleries: Born of Stress." *Apollo* vol. 79, February 1964, pp. 146–47.

Mullins, Edwin. "Unknown Master." *Sunday Telegraph*, February 2, 1964, p. 13.

Wraight, Robert. "On Galleries: Buskin' with Ruskin." *Tatler* no. 251, February 5, 1964, p. 283.

Anon. "Mr. Howard Hodgkin." *The Times* (London), February 6, 1964, p. 6.

Stone, Peter. "A Potential Renoir." *Jewish Chronicle*, February 6, 1964, p. 33.

Lynton, Norbert. "London Letter." *Art International* vol. 8, April 25, 1964, pp. 73–78.

1965

Lucie-Smith, Edward. "Howard Hodgkin." *London Magazine* vol. 4, March 1965, pp. 71–75.

Schulze, Franz. "London's Boisterous New Art." *Chicago Daily News*, March 6, 1965, p. 5.

Melville, Robert. "Gallery: Objets d'Art." *Architectural Review* vol. 137, April 1965, pp. 291–93.

"Howard Hodgkin." *ARK, the Journal of the Royal College of Art* no. 38, Summer 1965, pp. 18–21.

Reichardt, Jasia. "La Jeune génération en Grande Bretagne." *Aujourd'hui* no. 50, July 1965, pp. 68–81.

Wilson, Patricia Boyd. "The Home Forum." *The Christian Science Monitor*, vol. 57, July 17, 1965, p. 8.

1967

Groome, Susan. "Howard Hodgkin." *Arts Review* vol. 19, March 4, 1967, p. 64.

Brett, Guy. "Painter's Series of Shaped Canvases." *The Times* (London), March 11, 1967, p. 7.

Sutton, Keith. "Galleries." *London Look*, March 11, 1967, p. 44.

Gosling, Nigel. "Heroic Pessimism on a Bicycle." *Observer*, March 12, 1967, p. 25.

Thompson, David. "Art: Howard Hodgkin." *Queen* no. 428, March 15, 1967, p. 24.

Robertson, Bryan. "Howard's End?" *Spectator*, March 24, 1967, pp. 347–48.

Lucie-Smith, Edward. "London Commentary." *Studio International* vol. 173, April 1967, pp. 196–98.

Lynton, Norbert. "London Letter." *Art International* vol. 11, April 20, 1967, pp. 46–50.

Russell, John. "Hodgkin Color Locals." *ARTnews* vol. 66, May 1967, p. 62.

Thompson, David. "Recent British Painting: The Stuyvesant Collection." *Studio International* vol. 174, December 1967, pp. 253–61.

1969

Mullins, Edwin. "Not What He Thought." *Sunday Telegraph*, March 30, 1969, p. 13.

Russell, John. "Quality and Quantity." *Sunday Times*, March 30, 1969, p. 57.

Field, Simon. "London: Objects—More or Less." *Art and Artists* vol. 4, April 1969, p. 57.

Melville, Robert. "Problem Solved." *New Statesman* vol. 77, April 4, 1969, p. 490.

Brett, Guy. "On and Off the Square." *The Times* (London), April 10, 1969, p. 7.

Dunlop, Ian. "April Bulge in Art-exhibitions." *Evening Standard* (London), April 14, 1969, p. 17.

Gosling, Nigel. "Prime Pop Ancestors." *Observer*, April 20, 1969, p. 26.

Anon. "Kasmin: Howard Hodgkin." *Art and Antiques (Weekly)* vol. 1, April 26, 1969, p. 13.

Russell, John. "London." *ARTnews* vol. 68, May 1969, p. 43.

Kenedy, R. C. "London Letter." *Art International* vol. 13, Summer 1969, pp. 43–44.

1970

Richards, Bryn. "Howard Hodgkin." *Manchester Guardian*, February 10, 1970.

Lucie-Smith, Edward. "Force of Tradition." *Sunday Times*, September 20, 1970, p. 30.

Rowan, Eric. "Private Lives." *The Times* (London), October 1, 1970, p. 15.

Richards, Bryn. "Bristol Art—Howard Hodgkin." *Manchester Guardian*, October 2, 1970.

1971

Gosling, Nigel. "Art—A Trio of Extremists." *Observer*, April 4, 1971, p. 34.

Fuller, Peter. "Howard Hodgkin." *Arts Review* vol. 23, April 10, 1971, p. 206.

Russell, John. "The Life of Colors." *Sunday Times*, April 11, 1971, p. 29.

Cork, Richard. "An English Game—Keeping All the Options Open." *Evening Standard* (London), April 21, 1971, p. 16.

Hilton, Timothy. "UK Commentary." *Studio International* vol. 181, June 1971, pp. 268–71.

Feaver, William. "Art: Exhibitionism." *London Magazine* vol. 11, August–September 1971, pp. 112–20.

1972

Hackney, Arthur. "David Hockney, Howard Hodgkin." *Arts Review* vol. 24, February 26, 1972, p. 105.

Hardie, Shelagh. "Howard Hodgkin, John Hoskin." *Arts Review* vol. 24, July 1, 1972, p. 398.

1973

Russell, John. "The English Conquest." *Sunday Times*, February 11, 1973, p. 27.

Vaizey, Marina. "British Allsorts." *Financial Times*, February 19, 1973, p. 173.

Kramer, Hilton. "Howard Hodgkin." *The New York Times*, February 24, 1973, p. 25.

Henry, Gerrit. "Howard Hodgkin." *ARTnews* vol. 72, March 1973, p. 75.

Denvir, Bernard. "London Letter." *Art International* vol. 17, April 1973, pp. 42–47.

Lubell, Ellen. "Howard Hodgkin." *Arts Magazine* vol. 47, April 1973, p. 82.

Schwartz, Sanford. "New York Letter." *Art International* vol. 17, May 1973, p. 42.

Clay, Julien. "La Peinture anglaise aujourd'hui." *XXᵉ Siècle* vol. 41, December 1973, pp. 174–76.

1974

Vaizey, Marina. "The Arts—Signs of Life." *Sunday Times*, September 29, 1974, p. 35.

Cork, Richard. "Trapped in the Old-boy Net." *Evening Standard* (London), October 10, 1974, pp. 24–25.

1975

Hyman, Timothy. "Howard Hodgkin." *Studio International* vol. 189, May–June 1975, pp. 178, 180–181, 183.

Hyman, Timothy. "Correspondence: Howard Hodgkin." *Studio International* vol. 190, July–August 1975, p. 88.

Feaver, William. "All This and Real Beer, Too." *Observer*, October 19, 1975, p. 26.

McEwen, John. "Howard Hodgkin." *Spectator* no. 7689, November 8, 1975, p. 611.

1976

Haworth-Booth, Mark. "Salon and Workshop." *Times Literary Supplement*, March 19, 1976, p. 318.

Feaver, William. "Hodgkin's Intelligence Tests." *Observer*, March 21, 1976, p. 30.

Overy, Paul. "Joseph Albers: Round and Round the Square." *The Times* (London), March 30, 1976, p. 14.

Packer, William. "Keith Vaughan and Howard Hodgkin." *Financial Times*, March 30, 1976, p. 3.

Morris, Lynda. "Hodgkin and Caulfield." *Listener* no. 95, April 1, 1976, p. 417.

Vaizey, Marina. "Kaleidoscopes." *Sunday Times*, April 4, 1976, p. 39.

Burr, James. "Round the Galleries: Bold Banalities." *Apollo* vol. 103, May 1976, p. 444.

Morphet, Richard. "Howard Hodgkin: Assessment." *Studio International* vol. 191, May–June 1976, pp. 297–98.

Robertson, Bryan. "Art." *Harpers and Queen*, May 1976, p. 76.

Feaver, William. "Over and Out." *Observer*, May 9, 1976, p. 27.

Overy, Paul. "Moores the Pity: Time to Change the Rules?" *The Times* (London), May 11, 1976, p. 13.

Clifford, Jane. "Exhibition Shows Patrons Generosity." *Daily Telegraph*, May 13, 1976, p. 6.

Osborne, Harold. "Howard Hodgkin." *Arts Review* vol. 28, May 14, 1976, p. 239.

McEwen, John. "Art: Winning." *Spectator* vol. 236, May 15, 1976, p. 29.

Cork, Richard. "Every Blob Counts." *Evening Standard* (London), May 20, 1976, p. 24.

Vaizey, Marina. "British Understatement." *Sunday Times*, May 23, 1976, p. 35.

Tisdall, Caroline. "Howard Hodgkin." *Guardian*, May 27, 1976.

Ingham, Margo. "John Moores Liverpool Exhibition 10." *Arts Review* vol. 28, May 28, 1976, p. 264.

Denvir, Bernard and Lavinia Learmont. "London." *Art and Artists* vol. 11, June 1976, pp. 40–43.

Crichton, Fenella. "London Letter." *Art International* vol. 20, Summer 1976, p. 14.

Reichardt, Jasia. "Howard Hodgkin and Portraiture." *Architectural Design* vol. 46, July 1976, p. 444.

McEwen, John. "Howard Hodgkin at the Serpentine Gallery." *Art in America* vol. 64, July–August 1976, pp. 103, 113.

del Renzio, Toni. "Pop." *Art and Artists* vol. 11, August 1976, pp. 15–19.

Feaver, William. "The View from Europe: England." *ARTnews* vol. 75, October 1976, pp. 33–35.

1977

McEwen, John. "A Letter from London." *Artscanada* vol. 34, May–June 1977, pp. 31–32.

Quantrill, Malcolm. "London Letter." *Art International* vol. 21, July–August 1977, p. 69.

Cork, Richard. "The Fresh Energies Which May Help to Change British Art..." *Guardian*, July 20, 1977, p. 10.

Lynton, Norbert, Francis Golding, and Paul Overy. "How Newspaper Critics Paint Art." *Guardian*, July 23, 1977, p. 6.

Feaver, William. "Full House." *Observer*, July 24, 1977, p. 24.

Shepherd, Michael. "The Better Half." *Sunday Telegraph*, July 24, 1977, p. 14.

Lucie-Smith, Edward. "Squeaks from the South Bank." *Evening Standard* (London), July 28, 1977, p. 16.

Vaizey, Marina. "The Best of British." *Sunday Times*, July 31, 1977, p. 39.

Hilton, Timothy. "South Bank-ruptcy." *Times Literary Supplement*, August 5, 1977, p. 960.

Spalding, Frances and Barbara Wright. "Hayward Annual Part II." *Arts Review* vol. 29, August 5, 1977, p. 508.

Faure Walker, James. "Ways of Disclosing: Mapping the Hayward Annual." *Artscribe* no. 8, September 1977, pp. 20–26.

Shone, Richard. "Gallery: Painting and Performance." *Architectural Review* vol. 162, September 1977, pp. 184–86.

Bernard, Bruce. "Personalities of British Painting." *Sunday Times Magazine*, September 4, 1977, pp. 34–41.

Russell, John. "Tenacity Keeps British Art Alive." *The New York Times*, September 25, 1977, D33.

Frackman, Noel. "Howard Hodgkin/Stanley Boxer." *Arts Magazine* vol. 52, November 1977, pp. 29–30.

Kuspit, Donald B. "Howard Hodgkin at Emmerich." *Art in America* vol. 65, November–December 1977, pp. 134–35.

Rubinfein, Leo. "Howard Hodgkin." *Artforum* vol. 16, December 1977, pp. 67–68.

Anon. "Emmerich in Zurich: Hodgkin und Hockney." *Basler Zeitung* vol. 30, no. 327, December 31, 1977.

1978

Chambers, Robert. "Why the Art Market Nurtures Its Own Star System." *Financial Times*, May 12, 1978.

Bolton, Linda Lee. "Howard Hodgkin." *Arts Review* vol. 30, October 13, 1978, p. 551.

Januszczak, Waldemar. "A Train that has Run Out of Steam but Refuses to Stop for More Coal." *Guardian*, November 29, 1978, p. 12.

McEwen, John. "Four British Painters." *Artforum* vol. 17, December 1978, pp. 50–55.

McEwen, John. "Abstract Prizes." *Spectator* vol. 241, December 9, 1978, pp. 36–37.

Packer, William. "Critics Choice at the ICA." *Financial Times*, December 16, 1978.

1979

Anon. "News Desk: The Artist's Eye." *Art and Antiques (Weekly)* vol. 36, May 19, 1979, p. 11.

Packer, William. "Hodgkin's Eye at the National Gallery." *Financial Times*, June 23, 1979, p. 14.

Spurling, John. "Hangman." *New Statesman* vol. 97, June 29, 1979, pp. 963–64.

Riley, Noël. "Highlights: Hodgkin's Eye." *Antique Dealer and Collectors Guide*, July 1979, p. 63.

Shone, Richard. "Current and Forthcoming Exhibitions: London." *Burlington Magazine* vol. 121, July 1979, p. 456.

Cooper, Emmanuel. "A Personal Choice." *Morning Star*, July 2, 1979, p. 4.

Lucie-Smith, Edward. "Getting It All Together." *Evening Standard* (London), July 4, 1979, p. 32.

Januszczak, Waldemar. "The Artist's Eye." *Guardian*, July 6, 1979, p. 8.

Watson, Francis. "London Reviews: The Artist's Eye." *Arts Review* vol. 31, July 6, 1979, p. 357.

McEwen, John. "Art: Artist's Eye." *Spectator* vol. 243, July 7, 1979, p. 25.

MacKenzie, Andrew. "Painter's View of his Work." *Sheffield Morning Telegraph*, July 10, 1979, p. 4.

Collis, Louise and Lavinia Learmont. "London: The Artist's Eye." *Art and Artists* vol. 13–14, August 1979, pp. 42–43.

Shepherd, Michael. "Hodgkin's Eye." *What's On In London*, August 10, 1979.

Feaver, William. "Loiterings with Deep Intent." *Observer*, September 16, 1979, p. 15.

Crichton, Fenella. "The Artist's Eye: An Exhibition Selected by Howard Hodgkin." *Pantheon* vol. 37, October–December 1979, p. 326.

Volsky, Glenn Sujo. "Narrative Painting 2: At Arnolfini." *Art Monthly* vol. 30, October 1979, pp. 19–21.

Muchnic, Suzanne. "British Artists Painting the Town." *Los Angeles Times* Part IV, November 9, 1979, pp. 1, 10.

1980

Feaver, William. "The State of British Art: 'It's a Bewilderment.'" *ARTnews* vol. 79, January 1980, pp. 62–68.

Searle, Adrian. "London: Narrative Paintings." *Artforum* vol. 18, January 1980, pp. 76–77.

Berthoud, Roger. "Howard Hodgkin behind the Enemy's Lines." *The Times* (London), April 17, 1980, p. 6.

Russell Taylor, John. "Temperament Vividly Revealed in Abstract." *The Times* (London), September 2, 1980, p. 7.

McEwen, John. "Pastiches." *Spectator* vol. 245, September 13, 1980, pp. 27–28.

Berthoud, Roger. "Academy to Display 'New Spirit' in Painting with First International Exhibition." *The Times* (London), October 10, 1980, p. 6.

Piechocinski, Roman. "John Moores Liverpool Exhibition XII." *Arts Alive Merseyside*, December 1980–January 1981, p. 4.

1981

Cork, Richard. "Audacious, Outspoken—A Spur for Things to Come." *Evening Standard* (London), January 15, 1981, p. 19.

Bindman, David. "The Good Old Avant-Garde." *Times Literary Supplement*, January 23, 1981, p. 82.

Levin, Bernard. "A New Spirit in Painting. Mammoth Footprints seen in Piccadilly." *The Times* (London), January 28, 1981, p. 14.

Cork, Richard. "Report from London: 'The Artist's Eye.'" *Art in America* vol. 69, February 1981, pp. 43–55.

Faure Walker, James. "Awkward Moments." *Artscribe* no. 27, February 1981, pp. 12–15.

de Souza, Eunice. "Pursuing Culture." *Economic Times*, February 22, 1981, p. 3.

Shone, Richard. "London: A New Spirit in Painting at the Royal Academy." *Burlington Magazine* vol. 123, March 1981, pp. 182–85.

Sweet, David. "The Decline of Composition." *Artscribe* no. 28, March 1981, pp. 18–23.

Gilmour, Pat. "Howard Hodgkin." *Print Collector's Newsletter* vol. 12, March–April 1981, pp. 2–5.

French, P. D. "Diluted Abstractions: Richard Phipps, Howard Hodgkin." *Artweek* vol. 12, April 25, 1981, p. 8.

Feaver, William. "A 'New Spirit'—Or Just a Tired Ghost?" *ARTnews* vol. 80, May 1981, pp. 114–18.

Kramer, Hilton. "Howard Hodgkin." *The New York Times*, May 8, 1981, C18.

Murry, Jesse. "Reflections on Howard Hodgkin's Theatre of Memory." *Arts Magazine* vol. 55, June 1981, pp. 154–57.

Smith, Roberta. "Fresh Paint?" *Art in America* vol. 69, Summer 1981, pp. 70–79.

Lucie-Smith, Edward. "Howard Hodgkin." *Quarto*, July 1981, pp. 15–17.

Howarth, Kathryn. "Howard Hodgkin at Knoedler." *Art in America* vol. 69, October 1981, pp. 145–46.

Phillips, Deborah C. "Howard Hodgkin." *ARTnews* vol. 80, November 1981, pp. 200, 202.

1982

Anon. "The Harveys Collection." *Arnolfini Review*, February 1982, p. 8.

Bevan, Roger. "Howard Hodgkin: Indian Leaves." *Event*, September 22, 1982.

Spalding, Frances. "Howard Hodgkin." *Arts Review* vol. 33, September 24, 1982, p. 484.

Feaver, William. "Leaves from India." *Observer*, September 26, 1982, p. 32.

Geddes-Brown, Leslie. "Painter of Perfection." *Sunday Times*, September 26, 1982, p. 31.

Vaizey, Marina. "The Spirit of India." *Sunday Times*, September 26, 1982, p. 31.

Russell Taylor, John. "Tradition Remaining Strong and Rich: Howard Hodgkin, Indian Leaves." *The Times* (London), September 28, 1982, p. 8.

Cork, Richard. "Fragments and Figments." *Evening Standard* (London), October 14, 1982, p. 23.

Motion, Andrew. "Illusions of Freedom." *Times Literary Supplement*, October 22, 1982, p. 1160.

Kapur, Geeta. "Hodgkin's Indian Leaves." *Art Monthly* vol. 61, November 1982, p. 10.

Russell, John. "Art: Works of Hodgkin Displayed at Knoedler's." *The New York Times*, November 19, 1982, C28.

Hughes, Robert. "A Peeper into Paradise." *Time*, November 29, 1982, p. 88.

1983

Schoenfeld, Ann. "Howard Hodgkin." *Arts Magazine* vol. 57, January 1983, p. 42.

McEwen, John. "Howard Hodgkin—Indian Leaves." *Studio International* vol. 196, January–February 1983, p. 57.

Bass, Ruth. "Howard Hodgkin." *ARTnews* vol. 82, February 1983, p. 146.

Armstrong, Richard. "Reviews: Howard Hodgkin." *Artforum* vol. 21, March 1983, p. 71.

Cran, Robert A. D. "Hodgkin's Choice: an Exhibition of Indian Drawings." *Art International* vol. 26, September–October 1983, pp. 27–28.

1984

Fawcett, Anthony, and Jane Withers. "Howard Hodgkin at the Venice Biennale." *Studio International* vol. 197, 1984, pp. 16–17.

Mathews, Oliver. "Indian Paintings and Drawings: Howard Hodgkin." *Antique Collector*, March 1984, pp. 58–59.

Van Hensbergen, Gijs. "Howard's Hues." *Ritz* 86, March 1984, p. 6.

Ellis, Charlotte. "Four Rooms." *Architectural Review* vol. 175, April 1984, pp. 62–63.

Shone, Richard. "London: Four Rooms and Other Exhibitions." *Burlington Magazine* vol. 126, April 1984, pp. 244–47.

Russell, John. "Maximum Emotion With a Minimum of Definition." *The New York Times*, April 15, 1984, sec. 2, p. 33.

Brenson, Michael. "Art: Howard Hodgkin and Paris Legacy." *The New York Times*, April 27, 1984, C23.

Larson, Kay. *New York Magazine*, May 28, 1984, p. 94.

Withers, Jane, and Anthony Fawcett. "The Man on the Flip Side." *The Times* (London), May 29, 1984, p. 12.

Kinmonth, Patrick. "Howard Hodgkin." *Vogue* (UK) vol. 141, June 1984, pp. 140–41.

Pringle, Alexandra. "Art: Howard's Blend of Images and Textures." *Harpers and Queen*, June 1984, p. 189.

McEwen, John. "Finding Form at Fifty." *Sunday Times Magazine*, June 10, 1984, pp. 38–41.

Vaizey, Marina. "Dancing Among the Ruins." *Sunday Times*, June 10, 1984, p. 39.

Taylor, John Russell. "Myth Taking on the Cloak of Reality." *The Times* (London), June 12, 1984, p. 9.

Feaver, William. "Copy, Parody, Variation, Fake." *Observer*, June 17, 1984, p. 19.

Packer, William. "Venice Through the Looking Glass." *Financial Times*, June 19, 1984, p. 19.

Brisola, Dirceu. "Os eleitos de Veneza." *VEJA*, June 20, 1984, pp. 134–35.

Mullaly, Terence. "Abstracts in Abundance—and in a Setting to Suit." *Daily Telegraph*, June 23, 1984, p. 11.

Bumpus, Judith. "A Dream of Venice." *Art and Artists* no. 214, July 1984, pp. 14–17.

Hughes, Robert. "Gliding Over a Dying Reef—The Venice Biennale." *Time* no. 214, July 2, 1984, pp. 76–77.

Hoelterhoff, Manuela. "The Venice Biennale: No Paradise for Art." *The Wall Street Journal*, July 31, 1984, p. 32.

Anon. *Il Giornale della Biennale, Il Giornale dell'Arte* no. 14, July–August 1984, p. 30.

Feaver, William. "Venice: Remembrance of Things Past." *ARTnews* vol. 83, September 1984, pp. 135–37.

Gendel, Milton. "Report from Venice: Cultured Pearls at the Biennale." *Art in America* vol. 72, September 1984, pp. 45–53.

Pohlen, Annelie. "A Few Highlights but no Festival." *Artforum* vol. 23, September 1984, pp. 103–106.

Yau, John. "Howard Hodgkin." *Artforum* vol. 23, September 1984, p. 117.

Bortolon, Liana. "I Misteriosi Giardini di Hodgkin." *Grazia*, September 2, 1984.

Carlson, Prudence. "Howard Hodgkin at Knoedler." *Art in America* vol. 72, October 1984, pp. 192–93.

Richard, Paul. "Howard Hodgkin's Art: Shining Light at the Phillips Collection." *The Washington Post*, October 11, 1984, B1.

Allen, Jane Addams. "Howard Hodgkin: Letting It Flow." *The Washington Times*, October 12, 1984, C1–C2.

Sozanski, Edward J. "Magnetic Works of Vibrant Color." *The Philadelphia Inquirer*, October 23, 1984, 4D.

McEwen, John. "Late Bloomer." *Vanity Fair* vol. 47, November 1984, pp. 68–74, 121.

Burn, Gordon. "The Tate's Bold Stroke for British Art." *Sunday Times Magazine*, November 11, 1984, p. 45.

Lacayo, Richard. "Returning to the Frame Game." *Time*, December 3, 1984, p. 72.

Stevens, Mark. "A Palette of the Emotions." *Newsweek*, December 3, 1984, p. 82.

Cohen, Mary S. "The General Effect is One of Celebration." *The Christian Science Monitor* vol. 77, December 29, 1984, pp. 24–25.

1985

Allen, Jane Addams. "After 'Year of the French' Can Contemporary Be Far Behind?" *The Washington Times Magazine*, January 4, 1985.

Gonzales, Shirley. "Hodgkin's Trip into 'Deep Space.'" *New Haven Register*, January 20, 1985.

Ilzuka, Naomi. "Splashing Abstractions at the BAC." *After Hours*, January 31, 1985, p. 4.

Baker, Kenneth. "Too Much and/or Not Enough: A Note on Howard Hodgkin." *Artforum* vol. 23, February 1985, pp. 60–61.

Feaver, William. "Inside Europe: England." *ARTnews* vol. 85, February 1985, pp. 57–59.

Raynor, Vivien. "At Yale, the 'Afterthoughts' of Howard Hodgkin." *The New York Times*, February 10, 1985, C24.

Hanson, Bernard. "Hodgkins on View at Yale." *The Hartford Courant*, February 24, 1985, p. 49.

Galligan, Gregory. "Howard Hodgkin: Forty Paintings." *Arts Magazine* vol. 59, March 1985, pp. 122–25.

Gibson, Eric. "The Hodgkin Paradox." *Studio International* vol. 198, March 1985, pp. 23–25.

Perrone, Jeff. "Entrees: Diaretics: Entreaties: Bowing (Wowing) Out." *Arts Magazine* vol. 59, April 1985, pp. 78–83.

Bode, Ursula. "Gefallig verwirren ä, Der Maler Howard Hodgkin in Hannover." *Hannoversche Allgemeine Zeitung*, April 24, 1985.

Burkamp, Gisela. "Durch und durch sinnenhaftes Ereignis." *Lippische Landeszeitung*, April 30, 1985.

Sweet, David. "Howard Hodgkin at Yale Center for British Arts and Larry Poons at Andre Emmerich." *Artscribe* no. 52, May–June 1985, pp. 52–53.

Tassi, Roberto. "Howard Hodgkin: Un Maestro della Pittura Inglese." *Vogue* (Italia), June 1985, pp. 160–65.

Temin, Christine. "Hodgkin Paints Sensual Emotions." *The Boston Globe*, June 27, 1985.

Higgins, Judith. "In a Hot Country." *ARTnews* vol. 84, Summer 1985, pp. 56–65.

Feaver, William. "Art." *Vogue* (UK) vol. 142, September 1985, pp. 46, 52.

Hyman, Timothy. "Howard Hodgkin—Making a Riddle out of the Solution." *Art and Design* vol. 1, September 1985, pp. 6–11.

Lucie-Smith, Edward. "Exhibitions." *Illustrated London News* vol. 273, September 1985, p. 76.

Marks, Laurence. "Portrait of the Artist as a Compulsive Collector." *Sunday Observer*, September 15, 1985, p. 19.

Shepherd, Michael. "Hodgkin at the New Whitechapel." *Sunday Telegraph*, September 22, 1985, p. 15.

Packer, William. "An Anniversary and Return." *Financial Times*, September 24, 1985, p. 19.

Hicks, Alistair. "Talking About Art." *Spectator* vol. 255, September 28, 1985, pp. 35–36.

Vaizey, Marina. "The Intimate Room Within." *Sunday Times*, September 29, 1985.

Russell, John. "London and Yale, Hodgkin at the Whitechapel." *Burlington Magazine* vol. 127, October 1985, pp. 729, 731–32.

Sewell, Brian. "The Mark of a Hypnotist." *Evening Standard* (London), October 3, 1985, p. 23.

Spurling, John. "Dotted About the Place." *New Statesman* vol. 110, October 4, 1985, p. 32.

McNay, Michael. "Howard Hodgkin." *Guardian*, October 12, 1985, p. 10.

Brampton, Sally. "Howard Hodgkin: Art into Life." *Elle* (UK), November 1985, p. 86.

Graham-Dixon, Andrew. "Art: The Abstract Threshold." *Literary Review*, November 1985, pp. 28–29.

Hicks, Alistair. "Galleries." *The Times* (London), November 19, 1985, p. 10.

Harrison, Charles. "Hodgkin's Moment." *Artscribe* no. 55, December 1985–January 1986, pp. 62–64.

van der Pauw, Ally. "Howard Hodgkins Zuchtjes van Pijn en Plezier." *Haagse Post*, December 7, 1985, pp. 52–55.

1986

Feaver, William. "London: Allusions Veiled and Classical." *ARTnews* vol. 85, January 1986, p. 119.

Fisher, Susan. "Dolan Maxwell Gallery, Philadelphia." *New Art Examiner* vol. 13, April 1986, p. 60.

Perl, Jed. "Winter Notebook: Recent Abstract Painting." *The New Criterion* vol. 4, April 1986, pp. 57–58.

Clements, Keith. "Artists and Places Nine: Howard Hodgkin." *The Artist* vol. 101, August 1986, pp. 12–14.

Galligan, Gregory. "A Small Thing But Painting: The New Work of Howard Hodgkin." *Arts Magazine* vol. 61, September 1986, pp. 65–67.

Gill, Susan. "Howard Hodgkin: Knoedler." *ARTnews* vol. 85, September 1986, pp. 115, 119.

Dunham, Judith. "Howard Hodgkin's Accumulated Memories." *Print News* no. 8, Winter 1986, pp. 4–7, 25.

Mottola, Luciana. "I Begin Pictures Full of Hope: Four Questions Posed to Howard Hodgkin." *891, International Artists' Magazine* vol. III, no. 7, December 1986, pp. 12–15.

1987

Sylvester, David. "Artist's Dialogue: Howard Hodgkin—The Texture of a Dream." *Architectural Digest* vol. 44, March 1987, pp. 54, 62, 66, 70, 74.

Thorkildsen, Asmund. "En Samtale med Howard Hodgkin." *Kunst og Kultur* 4, Oslo: University Press, National Gallery, April 1987, pp. 220–34.

Lowe, Frederick. "None But the Brave Deserves the Fair." *Yellow Silk* (USA) vol. 23, July 1987, pp. 41–42, 44.

Hyman, Timothy. "Mapping London's Other Landscape." *Art International* vol. 1, Autumn 1987, pp. 51–61.

Urbanelli, Lora. "Museum Notes 1987." *Rhode Island School of Design Museum Notes* vol. 74, October 1987, pp. 40–41.

1988

Sheffield, Margaret. "Frame Ups (and Downs)." *Connoisseur*, March 1988, p. 117.

Graham-Dixon, Andrew. "On the Edge." *Independent*, April 5, 1988, p. 13.

Feaver, William. "Whoosh in Venice." *Observer*, April 9, 1988, p. 38.

Newman, Geoffrey. "Celebrations of Radiance." *Times Higher Education Supplement*, May 27, 1988, p. 15.

Sewell, Brian. "Art." *Evening Standard* (London), August 9, 1988.

Sexton, David. "Howard's Way Back." *Sunday Telegraph Magazine*, August 21, 1988, p. 65.

Dorment, Richard. "Drawn Towards the Light." *Daily Telegraph*, August 26, 1988, p. 12.

Hilton, Timothy. "Beyond the Boundary." *Guardian*, August 31, 1988, p. 17.

Fuller, Peter. "Howard Hodgkin and Robert Natkin." *Modern Painters* vol. 1, Autumn 1988, pp. 76–77.

Feaver, William. "Hodgkin's Venice: the Greedy Eye Attracted." *World of Interiors*, September 1988, p. 173.

Auty, Giles. "Howard's Way." *Spectator* vol. 261, September 3, 1988, p. 30.

Graham-Dixon, Andrew. "Drawing on Life." *Independent*, September 6, 1988, p. 16.

Hicks, Alistair. "Beneath the Surface. Howard Hodgkin: Waddington Galleries." *The Times* (London), September 6, 1988, p. 16.

Packer, William. "Overlaid with Witty Eroticism." *Financial Times*, September 6, 1988.

Currah, Mark. "Visual Arts." *City Limits*, September 8–15, 1988, p. 81.

Berryman, Larry. "Howard Hodgkin." *Arts Review* vol. 40, September 9, 1988, p. 616.

Shepherd, Michael. "Hodgkin's Venetian Hours." *Sunday Telegraph*, September 11, 1988, p. 19.

Vaizey, Marina. "British Shows of Strength." *Sunday Times*, September 11, 1988, C11.

Archer, Michael. "Howard Hodgkin." *Art Monthly* vol. 120, October 1988, p. 16–17.

Russell, John. "The Poetic Renderings of Howard Hodgkin." *The New York Times*, October 14, 1988, C24.

1989

Adams, Brooks. "Howard Hodgkin at Knoedler." *Art in America* vol. 77, January 1989, pp. 143–44.

Cyphers, Peggy. "New York in Review: Howard Hodgkin." *Arts Magazine* vol. 65, January 1989, p. 106.

Moorman, Margaret. "Howard Hodgkin." *ARTnews* vol. 88, January 1989, p. 129.

Walker, Patricia G. "Howard Hodgkin; M. Knoedler & Co., Inc." *Cover*, January 1, 1989, p. 16.

Cecil, Mirabel. "Howard's Way." *The World of Interiors*, February 1989, pp. 70–79.

Andreae, Christopher. "Each Hodgkin Painting Holds Layers of Pondering." *The Christian Science Monitor* (World Edition) vol. 81, April 13, 1989, pp. 10–11.

Hicks, Alistair. "Howard Hodgkin—The Artist as Collector." *Antique*, Summer 1989, pp. 21–24.

Peters, Pauline. "The Collector." *Telegraph Weekend Magazine*, October 28, 1989, pp. 18–27.

Gleadell, Colin. "The Art Market, Auction Trends in the Eighties." *Art International* vol. 9, Winter 1989, pp. 72–75.

Cooke, Lynne. "Special Report: British Art in the Eighties." *Journal of Art* vol. 2, November 1989, pp. 24–26.

1990

Graham-Dixon, Andrew. "Velazquez: the Greatest Living Artist." *Vogue* (UK) vol. 154, March 1990, pp. 314–18, 368.

Hicks, Alistair. "The Fire of London." *Art and Auction* vol. 12, May 1990, pp. 212–17.

Burn, Guy. "Prints: Lumley Cazalet, London." *Arts Review* vol. 42, July 1990, pp. 374–75.

Anon. "Galeries: Hodgkin en couleurs." *Connaissance des arts* no. 465, November 1990, p. 28.

Brunskill, Ian. "Hodgkin Steps Out." *Artscribe International* no. 84, November–December 1990, pp. 14–15.

Enders, Alexandra. "At Home and Abroad." *Art and Antiques* vol. 7, November 1990, p. 39.

Stemp, Robin. "Ganz Gallery, Cambridge, England." *Arts Review* vol. 42, November 2, 1990, p. 600.

Russell, John. "A Hodgkin Original." *The New York Times Magazine*, November 11, 1990, sec. 6, pp. 56–60, 62.

Kimmelman, Michael. "Howard Hodgkin/The British Imagination: 20th-Century Paintings, Sculpture and Drawings." *The New York Times*, November 23, 1990, C4.

Dorment, Richard. "Howard's Way." *Telegraph Weekend Magazine*, November 24, 1990, pp. 50–55.

Thomas, Michael M. "He Behaved at the Pierre, Got Shocked at Bergdorf's..." *The New York Observer*, November 26, 1990, pp. 1, 17.

Stevens, Mark. "Shades of the Past." *Vanity Fair* vol. 53, December 1990, pp. 172–73.

Cork, Richard. "Painting to Ease the Passing of Time." *The Times Saturday Review* (London), December 1, 1990, pp. 16–17.

Lubbock, Tom. "Viewer Virtuosity and Red Herrings." *Independent on Sunday*, December 16, 1990, p. 19.

Vaizey, Marina. "Flying International Colors." *Sunday Times*, December 16, 1990, sec. 5, p. 8.

Crozier, William. "Howard Hodgkin: The Artist's Eye." *Modern Painters* vol. 3, Winter 1990–91, pp. 16–21.

Beyer, Andraes. "Howard Hodgkin, Galerie Michael Werner, Koln." *Artis, Zeitschrift für neue Kunst* 42, December 1990–January 1991, pp. 70–71.

1991

Lubbock, Tom. "Howard Hodgkin: Small Paintings 1975–89." *Alba*, January–February 1991, p. 29.

Edelman, Robert G. "Howard Hodgkin." *ARTnews* vol. 90, February 1991, p. 134.

Morgan, Robert C. "Howard Hodgkin." *Arts Magazine* vol. 65, February 1991, p. 78.

Graham-Dixon, Andrew. "Heavy Rain." *Independent Magazine*, February 16, 1991, pp. 36–37.

Greig, Geordie. "The Fine Art of Healing." *Sunday Times Magazine*, March 10, 1991, pp. 42–46.

Dunne, Aidan. "The Howard Way to Make a Breadboard Sensual." *The Sunday Tribune*, March 31, 1991, p. 22.

Fallon, Brian. "The Colour of Saying." *Irish Times*, April 2, 1991, p. 8.

Courtney, Cathy. " Artist's Books: The Way We Live Now." *Art Monthly* vol. 146, May 1991, p. 27.

Hughes, Robert. "Aftershock of the New." *Observer Magazine*, August 25, 1991, pp. 22–25.

1992

Stecker, Raimund. "Venesianische Emotionen—Howard Hodgkin, ein nicht nur englischer Maler." *Kunst-Bulletin*, January 1992, pp. 19–25.

MacAdams, Barbara. "Speaking of the Unspeakable." *ARTnews* vol. 91, March 1992, p. 20.

Heller, Zoe. "Howard's Way." *Harpers and Queen*, April 1992, pp. 152–56.

Parham, Maggie. "Art for AIDS sake." *Evening Standard Magazine*, May 8, 1992, pp. 76–77.

1993

Russell, John. "In New Delhi, Pursued by an Enormous Tree." *The New York Times*, March 28, 1993, p. 33.

Lubbock, Tom. "Howard Hodgkin: For Me." *Modern Painters* vol. 6, Autumn 1993, pp. 34–37.

Levy, Paul. "What's New From Freud and Hodgkin." *The Wall Street Journal*, September 18, 1993.

Lucie-Smith, Edward. "In Profile: Howard Hodgkin." *Arts Review* vol. 45, October 1993, pp. 4–6.

McEwen, John. "Colour Too Deep for Comfort." *Sunday Telegraph*, October 10, 1993, p. 6.

Graham-Dixon, Andrew. "Truants of the Memory." *Independent Magazine*, October 16, 1993, pp. 38–43, 45.

Marks, Laurence. " Every One on Board." *Sunday Observer*, October 17, 1993, p. 8.

Hall, James. "Souvenirs of Life." *Guardian*, October 25, 1993, pp. 4, 6.

Sewell, Brian. "The Mark of a Lesser Spotted Leopard." *Evening Standard* (London), October 28, 1993, pp. 28–29.

Smith, Giles. "A Stripe is a Stripe, A Splodge is a Splodge." *Independent on Sunday*, October 30, 1993, p. 52.

Hilton, Tim. "Obscure Objects of Desire." *Independent on Sunday*, October 31, 1993, p. 35.

Cork, Richard. "Painting From Memory." *The Times* (London), November 2, 1993, p. 41.

Farson, Daniel. "Knight Errant." *Daily Mail*, November 7, 1993, p. 34.

Filler, Martin. "Howard Hodgkin Is Tired of Being a Minor Artist." *The New York Times*, December 5, 1993, p. 43.

1994

Feaver, William. "Anthony d'Offay, London; exhibit." *ARTnews* vol. 93, January 1994, p. 173.

Shone, Richard. "London and New York: Howard Hodgkin." *Burlington Magazine* vol. 136, January 1994, pp. 45–46.

Kastner, Jeffrey. "Anthony d'Offay Gallery, London; exhibitions." *Flash Art* (International Edition) vol. 174, January–February 1994, p. 103.

Gibson, Eric. "Exhibition Notes." *The New Criterion* vol. 12, March 1994, pp. 41–42.

Wei, Lilly. "Howard Hodgkin's Mandarin Pastimes." *Art in America* vol. 82, April 1994, pp. 92–97.

Anon. "Howard's Way." *Harpers and Queen*, July 1994, p. 20.

Graham-Dixon, Andrew. "The Way It Was." *World of Interiors* vol. 14, July 1994, pp. 86–89.

Livingstone, Marco. "Howard's Way." *Vogue* (UK) vol. 160, July 1994, p. 26.

Hubbard, Sue. "Brief History of Paint." *New Statesman and Society* vol. 7, July 1, 1994, pp. 32–33.

Billen, Andrew. "The Life Interview." *Observer Magazine*, July 10, 1994, pp. 10–13.

Byatt, A. S. "The Colour of Feeling." *Independent on Sunday*, July 10, 1994, pp. 30–31.

Graham-Dixon, Andrew. "Remembrance of Things Past." *Independent*, July 19, 1994, p. 23.

Bell, Julian. "The Great Unpretender." *Times Literary Supplement*, July 22, 1994, p. 16.

Vaizey, Marina. "Passion for the Physical." *The Times* (London), July 28, 1994, p. 41.

Sylvester, David. "An Artist whose Métier is Black and White." *Daily Telegraph*, August 6, 1994, p. 6.

Ross, Alan. "Painted Memoirs." *London Magazine*, October–December 1994, pp. 138–39.

Motion, Andrew. "Once More with Feeling." *Modern Painters* vol. 7, Winter 1994, pp. 83–85.

Lewis, Jim. "Howard Hodgkin." *Harper's Bazaar*, December 1994, pp. 182–87.

FILMS, TELEVISION, RADIO AND AUDIO-VISUAL PROGRAMMES

Howard Hodgkin: Indian Views, a recorded talk on his paintings with Timothy Hyman. The British Council, 1976.

Conversations with Artists: Edward Lucie-Smith talks to Howard Hodgkin. BBC Radio 3, February 1, 1981.

Howard Hodgkin. London Weekend Television, The South Bank Show, March 29, 1981.

Howard Hodgkin. Directed by Judy Marle, Landseer, The Arts Council of Great Britain, 1982.

Howard Hodgkin Interviewed by Richard Cork. Lecon Arts Enterprises, London, 1984.

Four Rooms. Howard Hodgkin in conversation with Nigel Finch. BBC Arena, February 21, 1984.

Howard Hodgkin. Sponsored by the Phillips Collection, Washington, D.C., WETA-TV, Channel 26, Washington, D.C., November 11 and 14, 1984.

Arts Section. Entertainment UK: Howard Hodgkin. Directed by Fiona Adam, produced by Elaine Gallagher, ITV, October 26, 28 and 30, 1993.

The Late Show: Howard Hodgkin. Directed by Bernadette O'Brien, BBC 2, October 26 and 30, 1993.

Nightwaves: Howard Hodgkin. Interviewed by Christopher Cook, BBC Radio 3, October 28, 1993.

Desert Island Discs: Howard Hodgkin. Interviewed by Sue Lawley, BBC Radio 4, November 27, and December 2, 1994.

INDEX

Figures in *italic* refer to the page numbers of illustrations